Union Public Library

W9-BLH-141

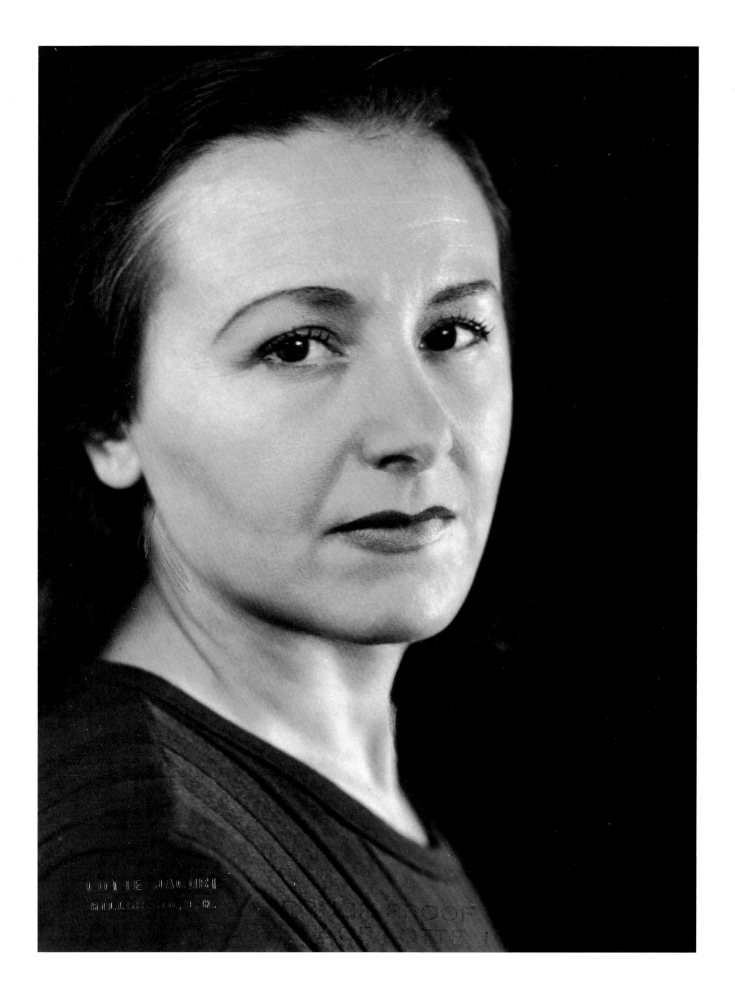
LOTTE JACOBI

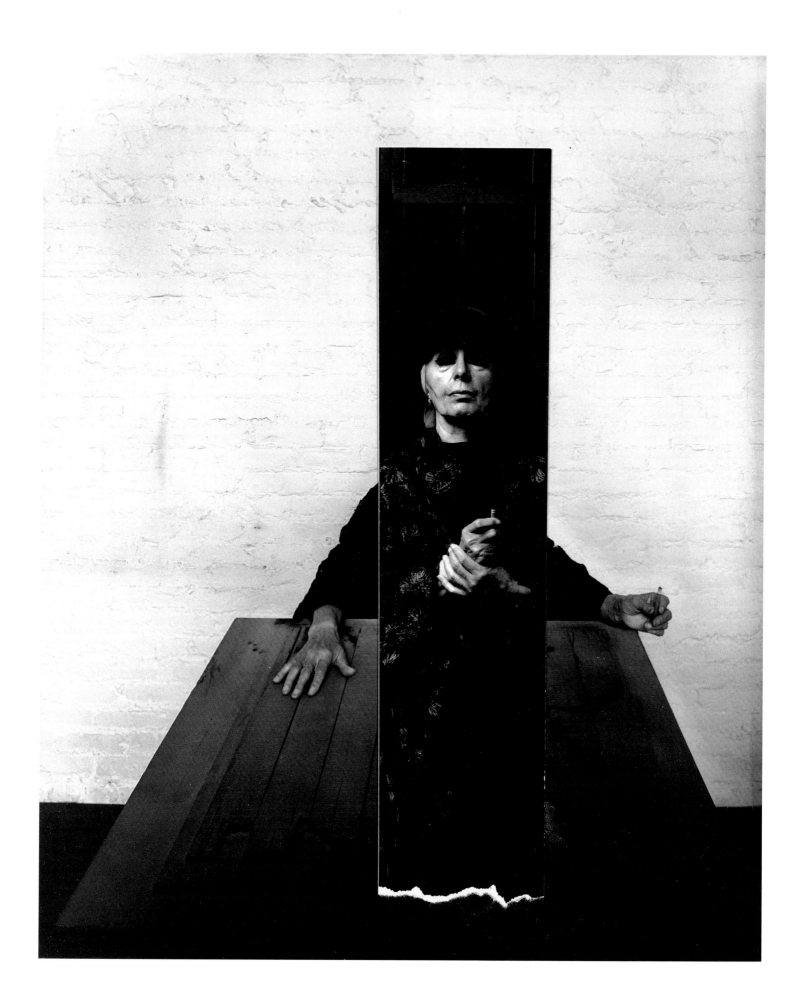

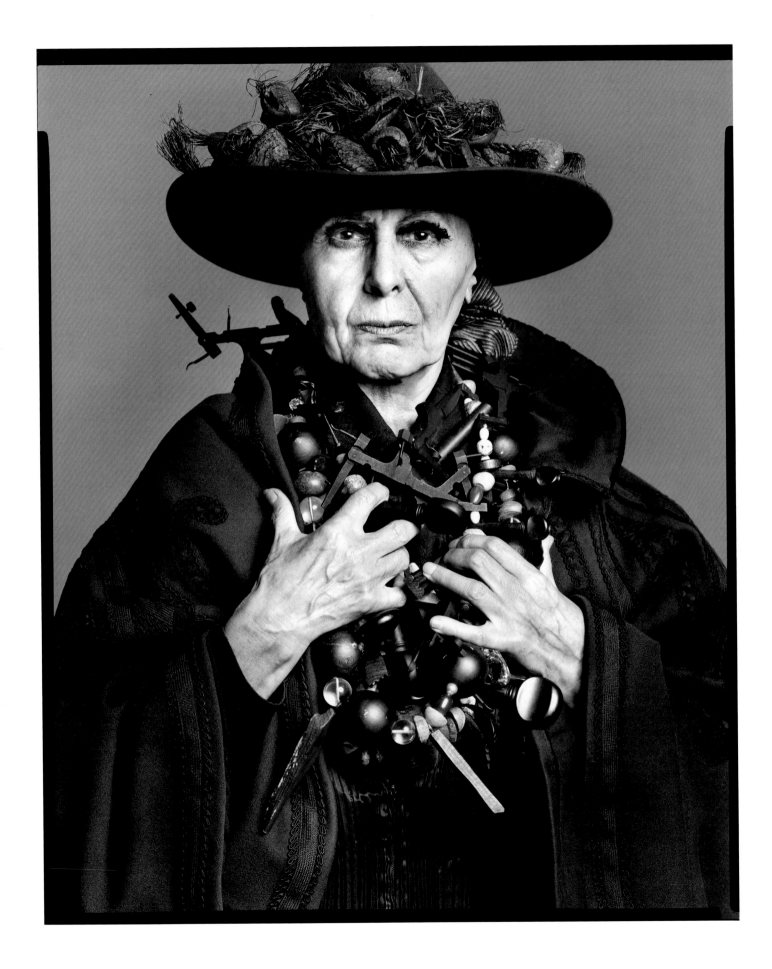

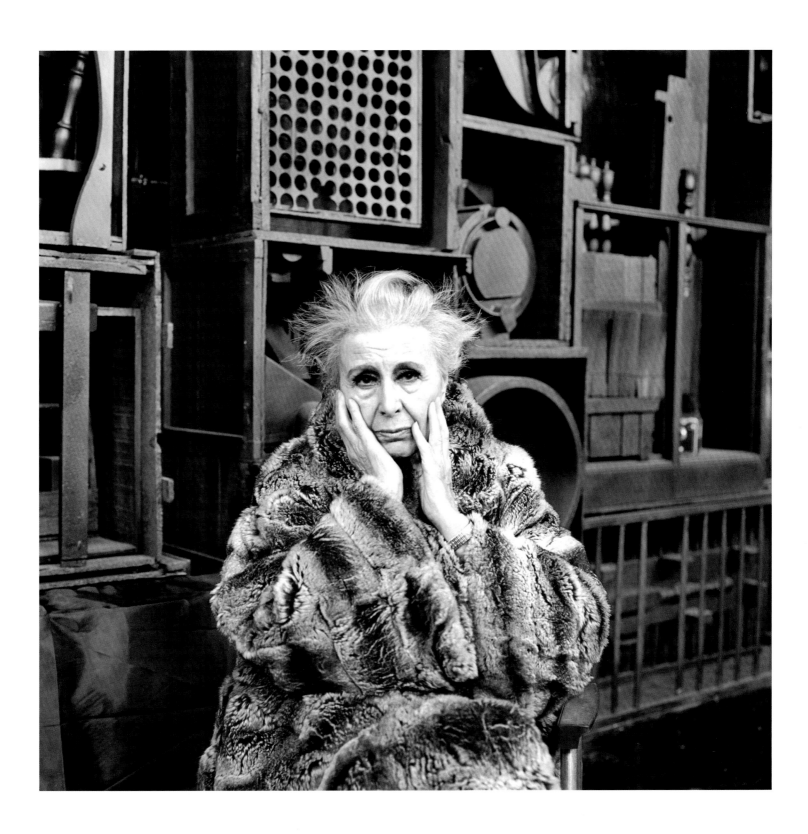

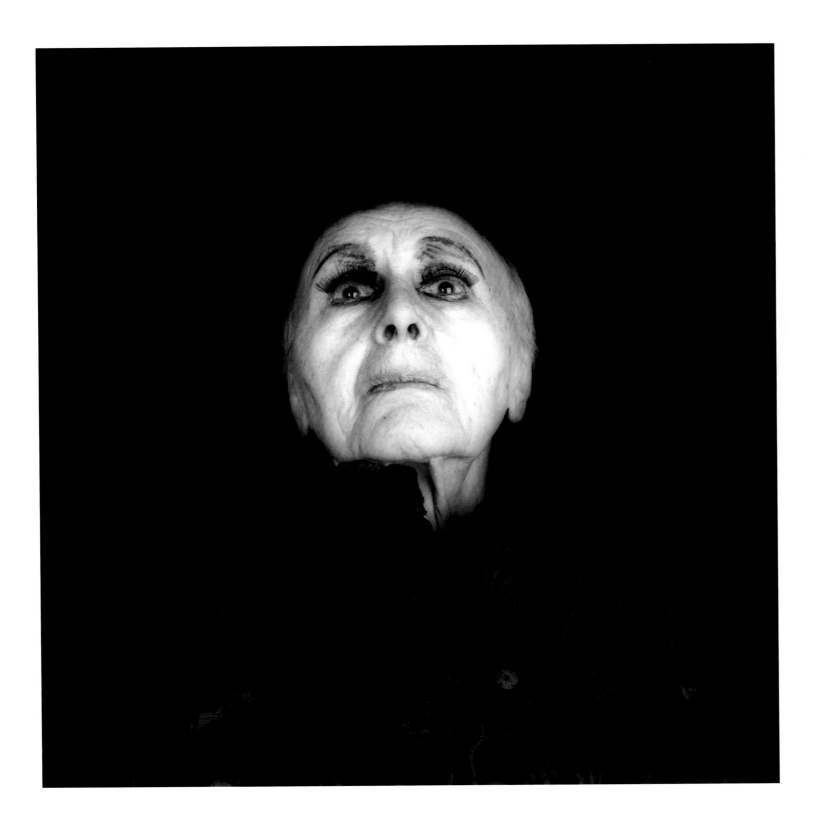

THE SCULPTURE OF LOUISE NEVELSON

CONSTRUCTING A LEGEND

Edited by Brooke Kamin Rapaport

ESSAYS BY
Arthur C. Danto
Brooke Kamin Rapaport
Harriet F. Senie
Michael Stanislawski

CHRONOLOGY BY
Gabriel de Guzman

Union Public Library

The Jewish Museum, New York
Under the auspices of the Jewish Theological Seminary of America

Yale University Press
New Haven and London

This book has been published in conjunction with the exhibition *The Sculpture of Louise Nevelson: Constructing a Legend,* organized by The Jewish Museum.

The Jewish Museum, New York
May 5–September 16, 2007

Fine Arts Museums of San Francisco, de Young
October 27, 2007–January 13, 2008

Copyright © 2007 by The Jewish Museum, New York, and Yale University. All rights reserved. This book may not be reproduced, in whole or in part, including illustrations, in any form (beyond that copying permitted by Sections 107 and 108 of the U.S. Copyright Law and except by reviewers for the public press), without written permission from the publishers.

All artworks by Louise Nevelson © 2007 Estate of Louise Nevelson / Artists Rights Society (ARS), New York

The essay "Black, White, Gold: Monochrome and Meaning in the Art of Louise Nevelson" is copyright © 2007 by Arthur C. Danto. All rights reserved.

The Jewish Museum
EXHIBITION CURATOR:
 Brooke Kamin Rapaport
MANAGER OF CURATORIAL PUBLICATIONS:
 Michael Sittenfeld
CURATORIAL PROGRAM COORDINATOR:
 Gabriel de Guzman
MANUSCRIPT EDITOR:
 Stephanie Emerson
EXHIBITION DESIGN:
 Tod Williams Billie Tsien Architects
EXHIBITION GRAPHIC DESIGN:
 Miko McGinty

Yale University Press
PUBLISHER, ART AND ARCHITECTURE:
 Patricia Fidler
EDITOR, ART AND ARCHITECTURE:
 Michelle Komie
MANUSCRIPT EDITOR:
 Heidi Downey
PRODUCTION MANAGER:
 Mary Mayer
PHOTO EDITOR AND ASSISTANT PRODUCTION COORDINATOR:
 John Long

DESIGNED BY
 Miko McGinty
TYPESET BY
 Tina Henderson
SET IN
 Futura and Garamond
PRINTED IN ITALY
 by Conti Tipocolor S.p.A.

The Jewish Museum
1109 Fifth Avenue
New York, New York 10128
www.thejewishmuseum.org

Yale University Press
P.O. Box 209040
New Haven, Connecticut 06520-9040
yalebooks.com

LIBRARY OF CONGRESS CATALOGING-IN-PUBLICATION DATA

Nevelson, Louise, 1899–1988.
 The sculpture of Louise Nevelson : constructing a legend / edited by Brooke Kamin Rapaport ; essays by Arthur C. Danto . . . [et al.] ; chronology by Gabriel de Guzman.
 p. cm.
 Catalog of an exhibition held at the Jewish Museum, New York.
 Includes bibliographical references and index.
 ISBN: 978-0-300-12172-8 (cloth : alk. paper)
 ISBN: 978-0-87334-201-8 (pbk. : alk. paper)
 1. Nevelson, Louise, 1899–1988—Exhibitions. I. Rapaport, Brooke Kamin. II. Danto, Arthur Coleman, 1924– III. Jewish Museum (New York, N.Y.) IV. Title.
 NB237.N43A4 2007
 730.92—dc22 2006031684

A catalogue record for this book is available from the British Library.

The paper in this book meets the guidelines for permanence and durability of the Committee on Production Guidelines for Book Longevity of the Council on Library Resources.

10 9 8 7 6 5 4 3 2 1

p. i: Lotte Jacobi (American, born West Prussia, 1896–1990), *Louise Nevelson,* c. 1943. Gelatin-silver print, 8¹¹⁄₁₆ × 6¼ in. (22.1 × 15.9 cm). Courtesy of Diana MacKown

p. ii: Hans Namuth (American, born Germany, 1915–1990), *Louise Nevelson,* 1960. Gelatin-silver print. Courtesy of Hans Namuth Ltd.

p. iii: Arnold Newman (American, 1918–2006), *Louise Nevelson, New York, N.Y.,* 1972. Gelatin-silver print, 10 × 8 in. (25.4 × 20.3 cm). The Jewish Museum, New York, Gift of Augusta and Arnold Newman, 2004–72

p. iv: Richard Avedon (American, 1923–2004), *Louise Nevelson, Sculptress, New York City, May 13, 1975.* Gelatin-silver print. Courtesy The Richard Avedon Foundation

p. v: Cecil Beaton (British, 1904–1980), *Louise Nevelson,* 1978. Vintage bromide print, 10¾ × 10⅜ in. (27.3 × 26.5 cm). Courtesy of the Cecil Beaton Studio Archive, Sotheby's

p. vi: Robert Mapplethorpe (American, 1946–1989), *Louise Nevelson,* 1986. Gelatin-silver print, 24 × 20 in. (61 × 50.8 cm). Courtesy Art + Commerce

Cover illustrations: front, *Sky Cathedral Presence,* 1951–64 (detail of pl. 8); back, *Dawn's Wedding Chapel II,* 1959 (detail of pl. 26)

CONTENTS

SPONSOR STATEMENT

The Homeland Foundation is very pleased to sponsor the catalogue for the exhibition *The Sculpture of Louise Nevelson: Constructing a Legend* at The Jewish Museum. It is quite fitting that the Foundation, which supports a wide range of cultural, charitable, and religious programs and organizations, is helping The Jewish Museum to publish the present volume, especially since there has not been a full-scale exhibition of Nevelson's sculpture in over a generation.

The Homeland Foundation was founded in 1938 by financier and philanthropist Chauncey D. Stillman. Since Mr. Stillman's death in 1989, the Foundation has continued to honor his memory through its generosity in funding cultural, intellectual, and religious enterprises and in its aid to impoverished populations around the world. The Homeland Foundation has sponsored many projects in the art world. Its interest in sponsoring the catalogue for the Louise Nevelson exhibition arises from the artist's highly creative and pioneering efforts in environmental art and sculpture, which involve or surround the observer with nonfigurative sculptures and assemblages. In this respect, Nevelson was the premier exponent of such American sculpture in the twentieth century.

Homeland's philanthropy in the art world has included support for the restoration of several Renaissance masterpieces, including Raphael's tapestry *The Healing of the Lame Man* in the Pinacoteca Vaticana and frescoes by Perugino and Cosimo Rosselli on the walls of the Sistine Chapel at the Vatican Museum, and sponsorship of major U.S. exhibitions, such as the Fra Angelico show at the Metropolitan Museum of Art in New York in 2005.

Homeland is proud to provide funding for this publication, which will allow readers and visitors to the exhibition to gain a deeper understanding and appreciation of Louise Nevelson and her splendid art and sculpture. The Homeland Foundation would like to thank The Jewish Museum's trustees and director and staff for organizing this wonderful exhibition and publishing this beautiful catalogue.

E. Lisk Wyckoff, Jr.
President
Homeland Foundation

DONORS TO THE EXHIBITION

*The Sculpture of Louise Nevelson:
Constructing a Legend*
is made possible by major grants from
The Henry Luce Foundation,
the National Endowment for the Arts,
and Irving Schneider and Family.

The exhibition catalogue is
generously underwritten by
the Homeland Foundation.

Important support has been provided by

Lipman Family Foundation

Mildred and George Weissman

Joseph Alexander Foundation

Dedalus Foundation

and other donors.

LENDERS TO THE EXHIBITION

Albright-Knox Art Gallery, Buffalo
Harry W. and Mary Margaret Anderson
The Art Institute of Chicago
Birmingham Museum of Art, Alabama
Brooklyn Museum, New York
Carolyn and Preston Butcher
Farnsworth Art Museum, Rockland, Maine
Feibes and Schmitt Architects
Fine Arts Museums of San Francisco
Carol and Arthur Goldberg
Hirshhorn Museum and Sculpture Garden, Smithsonian
 Institution, Washington, D.C.
Hyogo Prefectural Museum of Art, Japan
The Jewish Museum, New York
The JPMorgan Chase Art Collection, New York
Reed and Delphine Krakoff, New York
Emily Fisher Landau, New York
Rosalind Avnet Lazarus
Mr. and Mrs. Richard S. Levitt
Barrett M. Linde

Peter and Beverly Lipman
Lowe Art Museum, University of Miami, Coral Gables, Florida
Diana MacKown, Ellington, New York
The Menil Collection, Houston
The Metropolitan Museum of Art, New York
Minneapolis Institute of Arts
The Museum of Contemporary Art, Los Angeles
The Museum of Modern Art, New York
National Gallery of Art, Washington, D.C.
National Museum of Women in the Arts, Washington, D.C.
Osaka City Museum of Modern Art, Japan
Pace Editions, New York
PaceWildenstein, New York
Private collection, formerly Dorothy C. Miller Collection
Private collections
San Francisco Museum of Modern Art
Smithsonian American Art Museum, Washington, D.C.
Solomon R. Guggenheim Museum, New York
Walker Art Center, Minneapolis
Whitney Museum of American Art, New York

FOREWORD

The Jewish Museum is always grateful for a timely and thoughtful proposal that comes from a curator outside the museum's staff. Brooke Kamin Rapaport's interest in the life and work of Louise Nevelson coincided ideally with a program of exhibitions over the past four years that has featured monographic shows of women artists and exhibitions that highlighted the influence of particular Jewish women on art history and cultural history. Starting in 2004 with a small show about the diverse cultural heritage of Frida Kahlo, these exhibitions have included monographic shows on Friedl Dicker-Brandeis, Joan Snyder, and Eva Hesse, as well as an examination of the life and art of actress Sarah Bernhardt and an exhibition exploring the historical phenomenon of Jewish women and their salons. An exhibition on Louise Nevelson in 2007 not only seemed appropriate with this particular feminist thread of our exhibition program, it also provided a segue into a concentration on midcentury American artists that will be a theme of the exhibition program over the next few years.

Nevelson's work is immediately recognizable by collectors and museum and gallery visitors of the last forty years. The preponderance of her public art pieces and her popularity in the sixties and seventies, as well as her ubiquitous, grand presence at openings and other art-world gatherings, engendered a sense of familiarity with this petite yet flamboyant figure. Yet overexposure can make one lose sight of the breadth and importance of an artist's work, especially when we are not afforded the benefit of historical perspective. This exhibition gives us the opportunity to look afresh at Nevelson, seeing her as a pioneer—in her forceful presence as a woman artist in a male-dominated field of large-scale sculpture, in her use of found objects in monumental works, in her deliberate interweaving of biography with abstract art, and in her creation of beautiful, if less well-known, drawings and prints.

The authors of this book—Brooke Kamin Rapaport, Michael Stanislawski, Arthur C. Danto, and Harriet Senie—take the reader on a journey that truly opens our eyes to the remarkable development of Nevelson herself, to the professional, historical, and personal influences that she ultimately absorbed into her oeuvre, and to her identity as an icon of postwar American art.

The global, multimedia, multidimensional art world of 2007 is a far different milieu from that of the mid-sixties, when The Jewish Museum first showed Nevelson's work. Yet today's interest in the interplay of formal elements and autobiography, in feminist art history, and in seeing art in new historical and social contexts makes the Nevelson show a pertinent one. And indeed this exhibition creates a new perspective for the viewer as it offers multiple contexts: the artist's immigrant experience, her single-minded strength in pursuing a career, her self-creation, and her sui generis creativity. All of these are reasons to marvel at and respect Nevelson's art.

Many thanks to Brooke Kamin Rapaport, guest curator, for her thorough and thoughtful work and her enthusiasm for using the context of The Jewish Museum for a new look at Nevelson. I also wish to express my gratitude for the insightful essays in this volume and for the invaluable contributions of Curatorial Program Coordinator Gabriel de Guzman and the other Jewish Museum staff members who were involved in all aspects of bringing this project to fruition.

The work of consultants and staff was made possible with financial support from donors whose wonderful contributions gave us the ability to obtain generous loans from public and

private collections, create this catalogue, and mount the exhibition with all of its attendant education and marketing programs. My great thanks to The Henry Luce Foundation, the National Endowment for the Arts, and Irving Schneider and family for major grants; to the Lipman Family Foundation, Mildred and George Weissman, the Joseph Alexander Foundation, and the Dedalus Foundation for their essential financial contributions to the exhibition; to the Homeland Foundation for its generosity in underwriting the catalogue; and to the magnanimous lenders listed on page xiii. Finally, I extend my deep appreciation to The Jewish Museum Board of Trustees for its steadfast commitment to this project and its dedication to a wide-ranging exhibition program that engages and stimulates people of all cultural backgrounds.

Joan Rosenbaum
Helen Goldsmith Menschel Director
The Jewish Museum

PREFACE

Louise Nevelson constructed her past much as she constructed her sculpture: both were shaped by the artist's legendary sense of self. Nevelson's extraordinary iconography was formed by infusing abstract art with her personal story. In that story, disparate chapters—the epic Jewish migration to the United States between the 1880s and 1920s, her personal narrative as a woman artist, and the unfolding of American modernism—converge as sources in Nevelson's body of work. Because of her longevity—she lived from 1899 to 1988 and journeyed to America from the Ukraine in 1905—Nevelson witnessed exceptional historical events that distinguish the twentieth century. She was similarly mindful of the sweeping changes in American art but forged a distinct visual language that earned her the title "grande dame of contemporary sculpture." Because of her outsize public persona, Nevelson in her day was as much a fixture on the art scene as Andy Warhol.

But unlike Warhol, who enshrined the everyday object, Nevelson subsumed the found object into her wood sculpture. Her unique contribution to American modernism was to create an iconography of the self from cast-off wood parts—street throwaways—transformed with monochromatic spray paint into powerful, layered work. Nevelson's sculpture developed from tabletop pieces to human-scale columns to room-size walls and ultimately environments and public art that competed with the monumentality of their architectural surroundings. Her subjects were personal and collective and included matrimony, royalty, displacement, loss, and mortality. It has been more than a generation since American audiences have beheld this lifelong achievement. For the opportunity to display and document Louise Nevelson's art, I thank the staff of The Jewish Museum for welcoming me as a guest curator.

We are delighted that the exhibition will travel to the Fine Arts Museums of San Francisco, de Young. John E. Buchanan Jr., director of the Fine Arts Museums, was an early supporter of bringing the project to California. Timothy Burgard, the Ednah Root Curator of American Art and curator-in-charge, American art, has supervised the details of installation and design with a clear understanding of Nevelson's art. Krista Davis, director of exhibitions planning, worked diligently with The Jewish Museum on all aspects of exhibition travel.

In addition to the generous donors acknowledged by Joan Rosenbaum in her Foreword, I wish to personally thank E. Lisk Wyckoff Jr., president of the Homeland Foundation, for providing a munificent contribution to support all aspects of producing the exhibition catalogue.

This volume examines Louise Nevelson from various viewpoints. My essay considers Nevelson's independent iconography. I am indebted to playwright Edward Albee, former Walker Art Center director Martin Friedman, and Nevelson granddaughter Maria Nevelson for agreeing to be interviewed about their recollections of the artist. Michael Stanislawski, Nathan J. Miller Professor of Jewish History at Columbia University, scrutinizes *Dawns + Dusks,* Nevelson's autobiography, as a window into her self-conceptualization. Arthur C. Danto, emeritus Johnsonian Professor of Philosophy at Columbia University and art critic at the *Nation,* examines the use of monochromatic color in modern art, focusing on Nevelson's sculpture as a particularly resonant example. Harriet Senie, the director of museum studies and professor of art history at City College in New York, highlights Nevelson's outdoor work in the context of the burgeoning public art movement of the 1970s. I wish to thank Professors Stanislawski, Danto, and Senie for their remarkable contributions. In the section

titled "Three Artists Reflect on Louise Nevelson," contemporary sculptors Chakaia Booker, Mark di Suvero, and Ursula von Rydingsvard show a profound awareness of the aesthetic challenges that faced the artist. Nevelson's longtime studio assistant and friend Diana MacKown has shared memories and photographs. I am grateful for her generosity of spirit.

Planning and realizing an exhibition of this scope has been thrilling and challenging. At The Jewish Museum, it was Joan Rosenbaum, the Helen Goldsmith Menschel Director, who first agreed that Nevelson's art was lately so little seen that it warranted a reevaluation. Her commitment has been unwavering and invaluable. Museum trustee H. Axel Schupf had meaningful insights from the start. Ruth Beesch, deputy director for program, has been a steadfast advocate of the project and offered wise counsel in curatorial and editorial matters. Norman L. Kleeblatt, Susan and Elihu Rose Chief Curator, avidly supported a Nevelson exhibition while reaffirming the artist's significance in The Jewish Museum collection. Jane Rubin, director of collections and exhibitions, added keen judgment and expertise throughout. Julie Maguire, associate registrar, and Dolores Pukki, coordinator of exhibitions, managed myriad details of exhibition coordination with great skill. Al Lazarte, director of operations, finessed the logistics of the exhibition design and installation.

Michael Sittenfeld, manager of curatorial publications, saw to the details of this catalogue with the rigor of a scholar and the negotiating tools of a skilled attorney. Stephanie Emerson, manuscript editor, and Miko McGinty, graphic designer, realized their work with a true enthusiasm for Louise Nevelson's sculpture. I also wish to thank Beth Turk, curatorial program associate at the museum, and Sarah Raymond, publications intern, for their essential assistance with the catalogue. At Yale University Press, many staff members contributed to the success of this volume, especially Patricia Fidler, Michelle Komie, Heidi Downey, Mary Mayer, and John Long.

Gabriel de Guzman, curatorial program coordinator, attended to the details of this project with diligence, directness, and diplomacy. His chronology, exhibition history, and bibliography will serve as standard sources on Nevelson's life and work.

Many other staff members at The Jewish Museum were fervent supporters of this effort. Sarah Himmelfarb, Susan Wyatt, and Elyse Buxbaum in the development office worked creatively to generate exhibition funding. In the education department, Nelly Benedek, Jane Fragner, and Jennifer Mock oversaw varied and stimulating public programs. Filmmaker Robin White Owen, as well as Aviva Weintraub, associate curator and director of the New York Jewish Film Festival, and Andrew Ingall, assistant curator, realized the exhibition video with true professionalism. Anne Scher, director of communications, and Grace Rapkin, director of marketing, shared their deep interest in Nevelson's work with the press and the public. At Antenna Audio, Sandy Goldberg and Anne Byrd facilitated a terrific audio guide that illuminates the artist's work for museum visitors.

I can think of no better team to conceptualize the exhibition design than architects Tod Williams and Billie Tsien. Their sensitive command of Nevelson's art produced a design of understatement and elegance. Peter Warren, in the Tod Williams Billie Tsien Architects office, worked devotedly on all details of the installation.

This exhibition could not have happened without the loans of Louise Nevelson's sculpture and works on paper. For this, I join Joan Rosenbaum in expressing gratitude to those whose names and institutions are listed on page xiii. At the lending institutions, our colleagues endorsed loan requests with great magnanimity: Paul Schimmel, chief curator, and George Davis, assistant registrar, Museum of Contemporary Art, Los Angeles; Valerie Fletcher, senior curator, Hirshhorn Museum and Sculpture Garden, Smithsonian Institution, Washington,

D.C.; Denise D. Womaling, collections manager, graphic arts, Smithsonian American Art Museum; Kara Schneiderman, registrar, Lowe Art Museum, University of Miami in Coral Gables, Florida; James Rondeau, Frances and Thomas Dittmer Curator of Contemporary Art, Barbara Hall, objects conservator, and Nora Riccio, collections manager, Department of Contemporary Art, Art Institute of Chicago; Suzette Lane McAvoy, chief curator, and Angela Waldron, registrar, Farnsworth Art Museum, Rockland, Maine; Dennis Michael Jon, associate curator of prints and drawings, Minneapolis Institute of Arts; Kathy Halbreich, director, Siri Engberg, curator, Joseph King, associate registrar, Heather Scanlan, assistant registrar, and Jill Vetter Vuchetich, archivist, Walker Art Center, Minneapolis; Arnold Lehman, director, Kevin Stayton, chief curator, Charlotta Kotik, John and Barbara Vogelstein Curator of Contemporary Art, Marilyn Kushner, former curator of prints and drawings, Deirdre Lawrence, principal librarian, Brooklyn Museum; Douglas Dreishpoon, senior curator, Albright-Knox Art Gallery, Buffalo; Lisa Dennison, director, Solomon R. Guggenheim Museum, New York; Gary Tinterow, Englehard Curator in Charge of the Department of Nineteenth-Century, Modern, and Contemporary Art, Perrin Chernow Stein, curator, Department of Drawings and Prints, Yale Kneeland, objects conservator, and Ida Balboul, research associate, The Metropolitan Museum of Art, New York; John Elderfield, chief curator, and Cora Rosevear, associate curator, Department of Painting and Sculpture, Museum of Modern Art, New York; Adam Weinberg, Alice Pratt Brown Director, Dana A. Miller, associate curator, Barbi Spieler, senior registrar, and Carol Rusk, Benjamin and Irma Weiss Librarian, Whitney Museum of American Art, New York; Joseph Helfenstein, director, and Matthew Drutt, former chief curator, the Menil Foundation, Houston; Tomoko Ogawa, curator, and Tsukasa Kumada, chief curator, Osaka City Museum of Modern Art; Yusuke Nakahara, director, Tadashi Hattori and Tadashi Kobayashi, assistant curators, Hyogo Prefectural Museum of Art; Joy R. Weiner, reference specialist at the New York branch of the Archives of American Art; and Loretta Howard, Jacobson Howard Gallery, New York .

At PaceWildenstein in New York, Milly and Arne Glimcher's continued support of Nevelson's work is a testament to their devotion to Nevelson's memory. Beth Zopf, former director of photography archives, Jon Mason, director of research and archives, and Richard Solomon and Kristina Sumption of Pace Prints shared essential information.

From the earliest stages of exhibition conceptualization, friends and colleagues have been unstintingly generous with their time and counsel. Mickey and Martin Friedman have been immensely supportive. Carol C. Clark, professor of fine arts and American studies at Amherst College, offered key critical judgment on a draft of my essay. Layla S. Diba provided guidance and good humor throughout. Teresa and David Bull added professional expertise when considering the complicated issues of restoring Nevelson's works. Conversations with John Newman were revelatory. Virginia and Arthur Z. Kamin, Blair Kamin and Barbara Mahany, and Lois Shugar were steadfast. For Richard and our sons.

Brooke Kamin Rapaport

ESSAYS

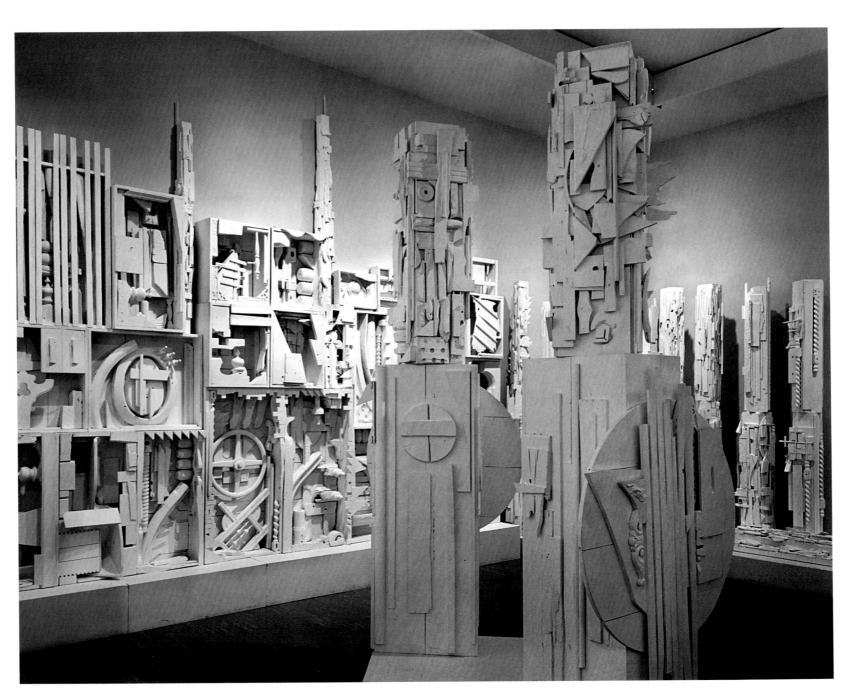

Installation view of *Dawn's Wedding Feast* at the Museum of Modern Art, New York, 1959

BROOKE KAMIN RAPAPORT

LOUISE NEVELSON A STORY IN SCULPTURE

In 1959, Louise Nevelson was invited by the Museum of Modern Art, New York, to participate in *Sixteen Americans,* the latest in its series of exhibitions of new American art. Up to that time, Nevelson's sculpture had largely consisted of found wood objects painted black, and yet her immediate response to curator Dorothy C. Miller was: "Dear, we'll make a white show."[1] According to Miller, Nevelson made the momentous change from all-black to all-white sculpture "just like that." In this breakout project Nevelson created a room-sized environment entitled *Dawn's Wedding Feast* (fig. 1). Her project—an innovative harbinger of the installation art that ensuing decades would witness in droves—was double-edged: it was created both as an eloquent paean to the dawn of the new day, symbolized by her breakthrough into white sculpture, and as emotional payback for the artist's own failed marriage thirty years before. Both factors must be kept in mind, for the most important thing about *Dawn's Wedding Feast* may be the way it personified Nevelson's singular ability to endow formal abstraction with a life story—her own.

Sixteen Americans identified a seismic shift in the art world. The exhibition featured leading members of a new generation, among them Jasper Johns, Ellsworth Kelly, Robert Rauschenberg, and Frank Stella—artists who balked at the orthodoxy of Abstract Expressionism.[2] In 1959, Johns was twenty-nine years old; Kelly was thirty-six; Rauschenberg was thirty-four; and Stella was just twenty-three. Nevelson, whose pioneering white installation was her true public debut, was sixty years old. Of her inclusion in *Sixteen Americans,* she remarked, "My whole life's been late . . ."[3]

What took this artist so long to make it to the marquee? The answer lies in the subject matter that ignited Nevelson's work: herself. Much of the literature on Louise Nevelson has focused on the constant (often grueling) progression of her work from figuration to abstraction to the crucible of her found object. Critically, however, Nevelson's use of her own life experience affected both the work itself and the way it was received. Her work is, above all, a metaphorical story about herself, told in sculpture.

Clearly, Nevelson was an individual possessed of a powerful sense of self, a persona reflected in the terms people used to describe her. By the time she was presented with the National Medal of Arts in 1985 she had become known as "the grande dame of contemporary sculpture," "sculpture's queen bee," "grand mistress of the marvelous," "a national monument," and "one of America's most imaginative and original sculptors on the American scene" (see chronology, fig. 21).[4] And having created copious amounts of sculpture in varied materials, Nevelson would appear in public bedecked in a way that suggested she herself was an artistic creation—wearing lustrous multi-textured, colored, and layered couture, ethnographic costume, fanciful headgear, and massive neckwear, with eyes defined by black kohl and numerous layers of false eyelashes. "I don't feel dressed without my eyelashes," she told her longtime assistant Diana MacKown. "I don't wear one pair. . . . I glue several pairs together and then put them on. I like it and it's dramatic, so why not."[5] The artist's outsized presence and her work became inseparable. Nevelson was a walking sculpture, though more flamboyant than any wood object she ever created.

Through her elegant, monochromatic room-size works, Nevelson regularly summoned themes linked to her complicated past, fractious present, and anticipated future. Whether

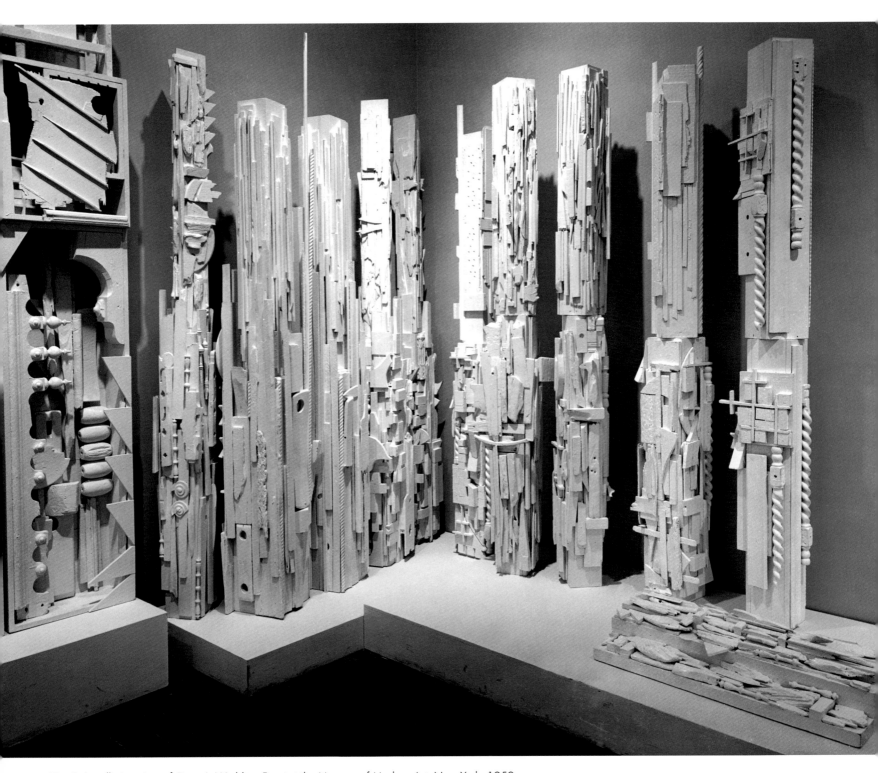

Fig. 1. Installation view of *Dawn's Wedding Feast* at the Museum of Modern Art, New York, 1959

The Self of you

" " " me

Who cares about 1-2-3

The Self of you

" " " me .

Fig. 2. Louise Nevelson's poem "The Self of You" in her own hand. Louise Nevelson Papers, Archives of American Art, Smithsonian Institution

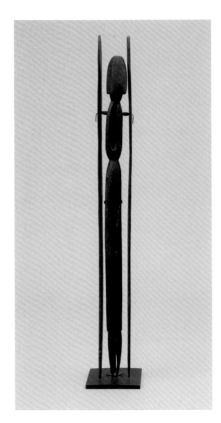

Fig. 3. Louise Bourgeois (American, born France, 1911), *Sleeping Figure*, 1950. Painted balsa wood, 74½ × 11⅝ × 11¾ in. (189.2 × 29.5 × 29.9 cm). The Museum of Modern Art, New York, Katherine Cornell Fund

expressed literally or metaphorically, in representational paintings or outsize abstract sculpture, in early self-portraits or edgy middle-year projects, her sense of selfhood was the force that propelled her work. In 1961, she wrote a poem about that subject (fig. 2):

> The Self of you
> " " " me
> Who cares about 1–2–3.
> The Self of you
> " " " me.[6]

Establishing "the self of me" as a woman artist in the male-dominated art world of the time was complicated and difficult. Her longtime friend, the playwright Edward Albee, who in 2001 wrote a play about Nevelson called *Occupant,* said that Nevelson's "recurring complaint [was] that it was tough for a woman starting out."[7]

Defining herself as a woman artist had its own problems. For reasons that are unclear, Nevelson was not initially invited to join the artist-run Sculptors Guild (established in 1937) or the American Abstract Artists (founded in 1936), though these organizations had a handful of women members. (She joined the Sculptors Guild in 1954, and eventually the AAA.) Nevelson's generational female colleagues in sculpture included Worden Day, Dorothy Dehner, Blanche Dombek, Minna Harkavy, and Concetta Scaravaglione. However, it was Louise Bourgeois who was Nevelson's true peer in sculpture, and the critical spotlight veered between the two artists. Bourgeois and Nevelson, who were acquainted, were at varying times in their careers called by some insiders "the other Louise," and in the 1940s and 1950s their work shared certain traits, especially their use of organic forms and a preferred material: wood (fig. 3).

By 1971, when Linda Nochlin's pioneering article on feminist art theory appeared in *ARTnews* and provoked readers into confronting the question "Why Have There Been No Great Women Artists?" Nevelson was already recognized for her singular contributions in sculpture. In the text, Nochlin listed her among Artemesia Gentileschi, Angelica Kauffman, Rosa Bonheur, Georgia O'Keeffe, Helen Frankenthaler, and others in a comparison with famous women writers. Nochlin argued that the art of each woman reflected the spirit of her time rather than the spirit of female-ness.[8] *ARTnews* invited Elaine deKooning, Rosalyn Drexler, Marjorie Strider, Lynda Benglis, Suzi Gablik, Eleanor Antin, Rosemarie Castoro, and Nevelson to respond to Nochlin's text in the same issue. Nevelson expressed that works of art reflect the individual rather than "masculine-feminine labels." Finally, however, she wished to be absolved from pursuing an extended reply. "The whole slant of this article is a personal interpretation on the nature of art and the so-called nature of women," she wrote. "And to comment further in depth would mean a line-to-line analysis and that of course would interrupt my art."[9] Indeed, Nevelson's work seems to call into question such "masculine-feminine labels." Embodying "masculine" qualities in its architectural scale and edgy toughness, it exposes the misleading assumptions underlying these labels. Rather than focusing on a role such as "woman artist" she chose to focus on her work itself, where her selfhood could be best expressed.

She was uniquely positioned to find the most effective means of expression. Nevelson's life span across the twentieth century allowed her to witness not only the most significant historic events of the time, but also the march of modernism, decade by decade. Within Nevelson's work, these two realms—world history and art history—merged with her ongo-

ing self-examination to define her art. Her work is therefore not easily allied with any one movement, though it has been variously linked by some to Cubism, Dada, Surrealism, Abstract Expressionism, Minimalism, feminism, and installation art. While it is always difficult to relate sculptors to aesthetic movements, which often coalesced around the medium of painting, we also see in Nevelson an artist who created diverse kinds of abstract work rather than maintained one consistent style, and one who imbued most of her work with an iconography of her own devising that relied on her experience.

THE IMMIGRANT

Fig. 4. Berliawsky family photograph, c. 1906. From left: Anita, Nathan, Isaac, Lillian (on lap), Minna, and Louise

Louise Nevelson was born Leah Berliawsky in Ukraine in 1899 to Minna and Isaac Berliawsky, who had married two years earlier.[10] Isaac Berliawsky's family consisted of comfortable landowners, yet Nevelson's uncles and aunts had left Eastern Europe for America in the 1880s to escape the pogroms in the Russian Empire. Living under harsh treatment from the tsars, separated from non-Jews by physical and language barriers, and enduring oppressive laws and massacres, multitudes of Jews fled. Between the years of 1880 and 1924, nearly three million Eastern European Jews came to America. By 1920, more than one-third of the Jewish population of the Russian Empire had immigrated—and their rate of return migration was close to zero.[11]

As the youngest child, Isaac Berliawsky had to stay on to care for the family land and for his parents, unable to immigrate until his mother's death, when he was already married and had children—over twenty years after his siblings—in 1902 or 1903. Nevelson's siblings were her brother Nachman, whose name was Americanized to Nathan (born 1898), and her sisters Chaya, later called Anita (born 1902), and Lillian (born in America, 1906) (fig. 4).

During Isaac's passage to America the Berliawskys moved in with Minna's parents in a home outside of Kiev to wait for word from Isaac. As a little girl, Nevelson felt abandoned by her father. In a tale that is either family lore or the truth, she felt his temporary loss so keenly that she was mute for six months. Fact or fiction, her father's exodus left Louise bereft.

The Berliawsky family's story—including their early life in Eastern Europe, the deteriorating conditions for Jews, and their eventual immigration and settlement in America—is not unique. More unusual is that Isaac Berliawsky, unlike the majority of Jewish immigrants, who settled in America's large urban centers, chose to move to Rockland, Maine, a town with a population of about eight thousand and few Jewish families.

In 1905, Isaac provided boat passage for his family to join him in Rockland. The Berliawskys were adrift in the alien New England setting. "We were an immigrant family, foreigners in a Daughters of the Revolution town . . . they needed foreigners like I need ten holes in my head," Nevelson remembered.[12] The Berliawskys spoke Yiddish at home, though the children quickly took to English.

In *Dawns + Dusks,* a 1976 book of transcribed audio conversations between Nevelson and Diana MacKown that serves as the artist's autobiography, Nevelson alludes to her father's initial depression in Rockland—a condition that must have struck many immigrants. As Isaac's attempts to establish himself failed, he was bedridden for months at a time, which compounded the harsh transition he faced as the head of a large family in a new country.[13] He worked first as a woodcutter and then opened a junkyard in town.[14] Isaac eventually adjusted to American life, but Minna never did. Despite their limited finances, Minna Berliawsky, whose life centered on the children, took pains to dress them and herself in a manner that would have been regarded as sophisticated in the Old Country. Nevelson recalled her

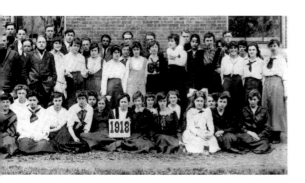

Fig. 5. Rockland High School graduation photograph, 1918, with Louise Nevelson (standing, eighth from right)

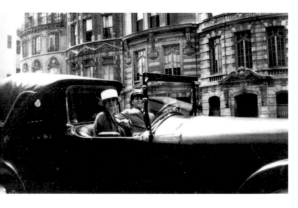

Fig. 6. Louise and Charles Nevelson in a Peerless automobile, Riverside Drive, New York, 1922

mother's rouging her cheeks when leaving the house and clothing her youngsters in lush apparel, a style that contrasted with the sensible, durable wear of Rockland's citizenry. Minna's habits would reflect on Nevelson, who as an adult was noted for her draped, eccentric dress, while Isaac's occupation would find its echo in his daughter's willingness to scavenge the streets of New York in search of wood scraps she would turn into sculpture.[15]

Her parents offered support at an early age when she told them she wanted to be an artist, and Nevelson mythologized her youthful conception of her destiny. On a trip to the Rockland Public Library when she was nine, young Louise conjured the independence and fortitude of her mature self: after peering at a plaster cast of Joan of Arc in the library rotunda, she proclaimed to the librarian that she was going to be a sculptor.[16] Yet life in Rockland for Louise—complicated by economic disadvantage, language differences, religious discrimination, even Louise's academic standing in the "commercial course" at Rockland High School—was that of an outsider, and she yearned to escape to New York.

In her senior year of high school, in 1918, Louise took a job as a legal stenographer in a law office in Rockland, where she met Bernard Nevelson, one of four who formed the Nevelson Brothers Company, a shipping concern (fig. 5). Rockland's harbor activity during World War I brought the brothers to the town frequently. Bernard, who was married, was determined that his younger brother, Charles, meet Louise. The two met, and in June 1920 were married by a rabbi at the Copley Plaza Hotel in Boston, settling afterward in New York. The marriage was Louise's way out of Rockland and at the same time a likely fulfillment of her parents' wish for their daughter to marry into an established, financially secure Jewish family— the great American success story seen from two perspectives.

The glow would fade, however, with Nevelson's turn toward art and away from what she thought was a stifling domestic life. Louise and Charles Nevelson's son, Myron (nicknamed Mike), was born in 1922, and the family lived comfortably on Riverside Drive, enjoying the life of privileged New Yorkers. A photograph from 1922 shows Charles and Louise in a fine Peerless convertible automobile (fig. 6). Although Louise had jewelry and furs, as well as the time to pursue her own interests, such as studying at New York's Art Students League with American scene painter Kenneth Hayes Miller in 1929 and 1930, the Nevelson family did not appreciate her professional goals. Arne Glimcher, an art dealer and the sculptor's longtime friend, later quoted the artist as saying: "My husband's family was terribly refined. Within their circle you could know Beethoven, but God forbid if you were Beethoven. You were not allowed to be a creator, you were just supposed to be an audience."[17]

In 1924, Charles, Louise, and Mike moved to a new home in Mount Vernon, New York, then a Jewish enclave in Westchester County. The move upset Nevelson because it took her away from city life and its prospects for her future as an artist, and because it increased her sense of encroaching isolation as a young mother. And while Nevelson never denied her religion, it did not figure prominently in her day-to-day life. Nevelson's granddaughter, Maria Nevelson, said recently that Louise Nevelson was not a practicing Jew, and as the artist aged, she began studying metaphysics, an expansive philosophy that questions the nature of reality. "She was always talking about letting go of conventions. . . . That you were a Jewess, a mother . . . same with the feminist movement. She said 'I'm not a feminist. I'm an artist who happens to be a woman.' She was always shedding all of these labels, all of these boxes. She was creating her own reality."[18] As she wrestled with these conflicting realities, the situation became untenable.

By 1931, Louise had packed it in. She brought Mike to stay with her family in Maine and went alone to Europe. She abandoned her charade as a comfortable Jewish society matron; her goal was to study Cubism with the painter Hans Hofmann at his Munich atelier.

Although she had an awareness of the Cubist movement through the work of Picasso (and she later saw his *Guernica* at the Museum of Modern Art, probably first in 1939 when it was on view in *Picasso: Forty Years of His Art*), she felt that Hofmann's instruction in the "push and pull" of the Cubist style would serve to define her as an artist. She studied at Hofmann's school for three months in Munich and then traveled throughout Europe. Plagued with guilt about leaving her young son in Maine, and aware of the growing strength of the Nazi party in Germany ("I had to pass Hitler's house every day from the pensione to the school, and it was always busy," she said), the artist went home, stayed for a brief time, and then returned to Europe, this time to visit Paris.[19] Despite America's economic misery during the Great Depression and Nevelson's statement of her family's financial reversals, family support enabled her to afford these European passages. She returned to the United States in 1932 when Hofmann came to New York to teach at the Art Students League.[20] (In 1932 or 1933, Nevelson briefly assisted Diego Rivera on the murals he was creating in New York. She painted portraits, including one of Rivera in 1932 [fig. 7]. Nevelson was also acquainted with Frida Kahlo and attended evening gatherings at the couple's home, where guests ranged from prominent figures to workmen.)

Hofmann insisted that his students "discipline" themselves in their practice through the use of a limited palette, such as black and white, colors that would become the bulwark of Nevelson's oeuvre.[21] Through her early two- and three-dimensional work, Nevelson credited the geometric stability of the cube per se as her core, emotionally and aesthetically. At a time of turmoil—her young son left behind and her marriage broken—Cubism offered a discrete subject of study with a defined visual form upon which she could focus her energies and fulfill her professional ambitions. Ironically, Cubism's practitioners sought not to stabilize a composition but rather to destabilize it by presenting it through multiple points of view simultaneously. The basis of the style would have a profound influence on her work. She later said, "The Cubist movement was one of the greatest awarenesses that the human mind has ever come to. Of course, if you read my work, no matter what it is, it still has that stamp. The box is a cube."[22]

Nevelson's work of the 1930s demonstrates varied interest in painting, sculpture, and works on paper, often exemplifying an established modernist style. Her ink and pencil drawings of nudes were reminiscent of the fluid lines of Henri Matisse's figures. She also created sculpture of semi-abstract animals, such as blocky cats, ducks, fish, and owls in terra-cotta, and painted portraits, self-portraits, and other subjects in oil.

Some of Nevelson's sculptures from the early 1940s are chunky objects that sift the figure through a Cubist sieve, such as her bronze *Self-Portrait* of 1940 (see pl. 3).[23] The human body has elongated arms and blocky legs in motion, serving to enhance the form's vigor. The work is not identifiably female, and for a small object it surges forth with an independent demeanor characteristic of the artist herself and related to her interest in modern dance. In addition to bronze, Nevelson experimented with other materials and varied methods of displaying them. *Moving-Static-Moving Figures* of 1945 is a multipart terra-cotta and tattistone work in which each abstracted figure can turn on its sticklike central axis (see pl. 6). Many of the fifteen two-foot-high figures have incised lines indicating facial features, body parts, or simple decoration. When the work is installed on one platform, it is a remarkably innovative sculpture. Within this figurative village of Cubist-derived rotating sculptures, there exist metaphors for the fluctuation of form and variability that would become one hallmark of Nevelson's installation work.

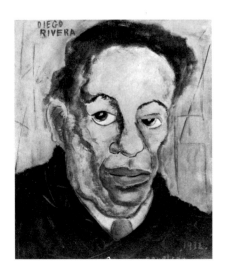

Fig. 7. Louise Nevelson, *Portrait of Diego Rivera,* 1932. Oil on canvas. Collection unknown

Without a prescribed installation plan for *Moving-Static-Moving Figures,* the parts inter-relate differently each time the full work is on view. If *Moving-Static-Moving Figures* exemplified instability and temporality, two issues that were to preoccupy the artist throughout her career, other early pieces point to conditions that would compel the mature Nelson—such as the juxtaposition of found objects in surreal combinations, reflecting the Surrealist movement's liberation of the unconscious. Martin Friedman, who organized a major exhibition of Nevelson's wood sculptures at the Walker Art Center in Minneapolis in 1973, said that Nevelson fused Surrealism in her work intuitively, that "she came to it instinctively, rather than historically."[24] These objects served the artist in her exploration of media as she moved from the figuration seen in the painted portraits and early drawings to the abstract forms that were to become her seminal contribution to American modernist sculpture.

Much like the American painters prior to and during World War II who looked to Europe for inspiration, progressive sculptors—Alexander Calder, Ibram Lassaw, Isamu Noguchi, Theodore Roszak, and David Smith—understood Surrealism and Constructivism as movements that could be assimilated into an American vision (figs. 8–10). Though Nevelson was about the same age as these artists, her work did not resemble theirs in material or subject matter. By the 1940s the generation of sculptors who began to experiment with welded metal abstractions by using the oxyacetylene torch—including Smith, Roszak, David Hare, Herbert Ferber, and Seymour Lipton—would forge ahead in the language of sculptural form. Their work would be labeled by some the "new sculpture."

Fig. 8. David Smith (American, 1906–1965), *Detroit Queen,* 1957. Bronze, 71 × 25 × 25½ in. (180.3 × 63.5 × 64.8 cm). Courtesy of the Fogg Art Museum, Harvard University Art Museums, Gift of Lois Orswell, 1994.15. Art © Estate of David Smith / Licensed by VAGA, New York

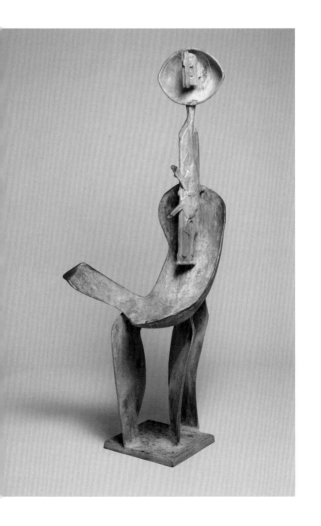

Fig. 9. Isamu Noguchi (American, 1904–1988), *Monument to Heroes,* 1943. Wood, paper, bone and string, 28¼ × 15½ × 14 in (71.8 × 39.4 × 35.6 cm). The Noguchi Museum, New York

Fig. 10. Alexander Calder (American, 1898–1976), *Hollow Egg,* 1939. Wire and paint, 54 × 39½ × 38⅛ in (137.2 × 100.3 × 96.8 cm). The Phillips Collection, Washington, D.C., Partial and promised gift in memory of Betty Milton, a close friend of Louisa Calder, 2001

The vanguard New York sculptors working in metal in the 1940s were linked formally and philosophically with the freedoms of the Abstract Expressionist painters such as Jackson Pollock, Willem de Kooning, and Franz Kline, who sought to convey the troubled condition of mid-twentieth-century America, most significantly the political and existential crisis created by World War II. In a 1951 radio interview, Pollock pointed to the complex technologies of the war that simultaneously embodied progress and distress as evidence for the sources in his painting: "It seems to me," he said, "that the modern painter cannot express this age, the airplane, the atom bomb, the radio, in the old forms of the Renaissance or any other past culture. Each age finds its own technique."[25]

Unlike the male artists who welded in metal, Nevelson found the use of that material too closely allied with war materiel. In addition, welding in metal required special tools, while working with found wood objects was virtually cost-free. But she also veered from metal largely because she simply didn't like the idea of welding and all it entailed: "I didn't like the welding . . . nor did I like the performance of it for a woman. . . . I didn't want to put on pads and weld—it didn't appeal to me. . . . you couldn't get material and it was prohibited [in wartime] and I'm walking up the street and I saw things and I thought this was odd, I'm not going to wait till the war is over."[26] Nevelson had acute and personal knowledge of the war—her son was serving in the merchant marine.

Her work changed significantly, and she began to focus largely on sculpture made of found objects. This radical shift from bronze and terra-cotta sculpture and portrait painting to sculpture created from scavenged wood objects was the inauguration of the artist's signature style and resulted from a confluence of her personal condition, the flourishing of an avant-garde in New York, and America's involvement in the war.

Nevelson said that she was "emotionally caught in war." With her son stationed in Egypt or Russia on secret missions, she did not hear from him for months at a time.[27] Her role as a mother was complicated—while she discredited the nurturing duties of motherhood, she yearned for her son. She told an interviewer that, with her son away and the world in the throes of international conflagration, she created boxes, sealed coffinlike with closed lids.

> It threw me into a great state of despair. And I recall that my work was black and it was all enclosed—all enclosed. . . . I would use black velvet and close the boxes. In other words, this was a great place of secrecy within myself. I didn't even realize the motivation of it; it was all subconscious, it was the expression of a mood. But it isn't only one son. It's also that the world was at war and every son was at war. . . . That was when I began using found objects. I had all this wood lying around and I began to move it around, I began to compose. Anywhere I found wood, I took it home and started working with it. It might be on the streets, it might be from furniture factories. Friends might bring me wood. It really didn't matter.[28]

This period in Louise Nevelson's life foretold her later interest in subjects related to the larger culture, specifically the Holocaust. Creating sculpture in found wood addressed issues of the deepest importance to her.

Nevelson's use of wood was extraordinarily liberating. It gave her, as a woman artist, a medium apart from the welded metal of her peers. She also looked askance at professional carpenter's methods, preferring to work intuitively and accumulatively in creating her work. "I have used a scissors to cut wood and that is out of order as far as professional carpentry would have it and so I invent methods as I go along according to the means. Now I naturally have used nails, hammers, saws, glues and it always depends more or less on the woods themselves. But it isn't a carving process. It really is an additive. You add and add and add."[29] Yet in one poignant sculpture that is modest in scale but substantial in conception, *Exotic Landscape* of 1942–45, she venerated the ordinary activity of the carpenter (fig. 11). The artist took a simple carpenter's toolbox—the ultimate workaday symbol of the woodman's trade—to create a landscape of form where various wood objects sit in the box as if waiting their turn in the carpenter's tasks. This one tabletop object—a hardware-store standard stuffed with wood exotica—sets up the scenario for Nevelson's particular dialogue in her chosen medium.

Nevelson composed *Ancient City* of 1945 of cast-off wood pieces that include two griffins with scarlet wings (see pl. 5). They sit atop a wood slab with unrelated objects: a circular wood form at left and a planetary stand-in at right. The fabulous beasts are menacingly alert, about to pounce. Nevelson said of this work, "The griffins I have used as our worldly symbols for flight. The round object in back represents the sun."[30] She continued to physically assemble the pieces of wood herself, initially in intimate scale, ultimately in room-size environments. And wood was hers—a material that she could command viscerally because of childhood associations with her father's work as a lumberman. After abandoning traditional family roles as wife and mother, and following trials with other artistic media, Nevelson found her life's work in foraged wood. This material, coupled with her ability to sever her home life from her artwork, was Nevelson's salvation. "She never felt she belonged in her background," Albee

Fig. 11. Louise Nevelson, *Exotic Landscape,* 1942–45. Black painted wood, 12 × 27 × 11¼ in. (30.5 × 68.6 × 28.6 cm). Private collection

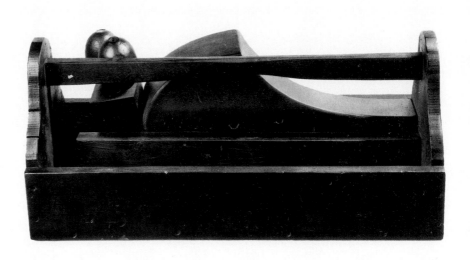

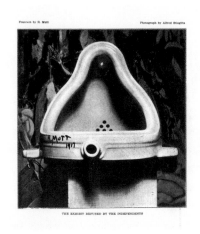

Fig. 12. Marcel Duchamp (American, b. France 1887–1968), *Fountain*, 1917. Photograph by Alfred Stieglitz. Page from *The Blind Man (No. 2)*, May 1917. Periodical with paper covers, sheet: 11¼ × 8³⁄₁₆ in. (28.6 × 21 cm). Philadelphia Museum of Art; The Louise and Walter Arensberg Collection, 1950

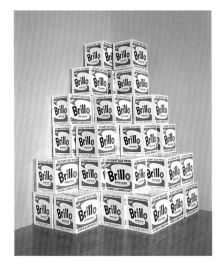

Fig. 13. Andy Warhol (American, 1928–1987), *Brillo Boxes*, 1969. Acrylic silkscreen on wood, 100 boxes, each 20 × 20 × 17 in. (50.8 × 50.8 × 43.2 cm). Norton Simon Museum, Pasadena, California, Gift of the artist, 1969

said. "She was not interested in upper-middle-class Jewish life. That's why she questioned her identity. Maybe she didn't find it until she 'stood up the wood' for the first time."[31]

When she located those banister fragments, baseball bat shards, chair backs, racquet heads, lumberyard detritus, and sections of crates and saturated them with black spray paint, Nevelson became Nevelson. She felt that "black contained all color. . . . It was an acceptance. . . . Black is the most aristocratic color of all."[32] Her synthetic treatment of the wood fragment differed from the use of found objects in earlier modern sculpture. Marcel Duchamp's 1917 readymade, *Fountain,* was shocking when submitted (and rejected as non-art) from the Society of Independent Artists in New York because the artist did not attempt to disguise the white porcelain urinal that he anointed a sculpture (fig. 12). Half a century later, Andy Warhol's iconic Pop art *Brillo Boxes* confounded viewers by equating commercial culture with high culture when first exhibited at the Stable Gallery in New York in 1964 (fig. 13). Warhol and Duchamp are the archetypal artists who riffed ironically on the everyday object, turning it into a vaunted artwork by virtue of its display and intention, rather than by means of actual manipulation. By contrast, once Nevelson had possession of the found object, its origins were disguised with a surfeit of paint—all black, all white, or all gold—to foster an elegant uniformity, an equality of meaning and a distinct iconography. She conceals (rather than reveals) any allusion to history, to the past. By assembling disparate objects into a new whole, the incomplete becomes complete.

From the 1940s through the mid-1950s, those parts were human scale. Eventually the work grew to a monumental size, and Nevelson's room-size sculptures would overcome the viewer. Her wood walls met the floor without the aid of the pedestal, thereby solving one of the conundrums of display for many modern sculptors. In this way, the sculpture and the viewer were literally on the same plane. The found object placed in a box was repeated again and again to make informal grids reminiscent of Nevelson's earlier allegiance to Cubism.

Modestly scaled objects, made to be viewed in the round, were created nearly simultaneously with Nevelson's complete environments in wood—works that although wall reliefs, were remarkable for their multilayered complexity. Those environments incorporated both large- and small-scale pieces, and the largest works took center stage in the room-size dance of sculpture she choreographed. By the mid-1950s, when Nevelson showed her work in commercial and nonprofit galleries in New York, she treated each room as a world in which to compose an otherworldly environment. The power and scale of what she called the "overwhelming" ancient pyramids in Oaxaca, Mexico City, and the Yucatan and the Mayan ruins and stele in Guatemala (which she saw during travels in the late 1940s and early 1950s) may have served as one visual impetus for the artist to increase the size of her own work.[33] The geometric structure of the pyramid forms must have been a special lure for Nevelson, with their massive stepped shelves of limestone. The change in scale also brought Nevelson's sculpture in league with the grand scale of Abstract Expressionist painting, as well as that of the earlier mural paintings by Rivera.

Newspaper and magazine critics of Nevelson's New York exhibitions focused largely on a formal analysis of her work. Writers neither sought a historical context for the sculpture, nor did they recognize Nevelson's selfhood in their articles. Rather, critics watched the progression of her work and reviewed its continuum: certain materials were abandoned in favor of found wood, themes were maintained, the scale of the art increased. The influential American art critic Clement Greenberg, who strongly advocated painting, barely mentioned Nevelson's sculpture in his writings in *Partisan Review, the Nation,* or *Art in America.* (Although Greenberg championed sculptor David Smith.) And despite slim art world attention to women artists at mid-century, Nevelson's work was treated respectfully and ultimately confirmed her stature. Diana MacKown said recently that Nevelson always read the reviews of her work, feeling satisfied that critical attention had come her way after early years of diligence outside the spotlight.[34]

Critics were captivated by Nevelson's debut on the scene, although she was initially denigrated as simply a "woman artist." Nevelson exhibited in New York in 1941, 1942, and 1943 at the Nierendorf Gallery. Of her 1941 exhibition of plaster works, a critic in *Cue* magazine wrote, "We learned the artist is a woman, in time to check our enthusiasm. Had it been otherwise, we might have hailed these sculptural expressions as by surely a great figure among moderns."[35] And: "Nevelson is a sculptor; she comes from Portland, Maine. You'll deny both these facts and you might even insist Nevelson is a man, when you see her *Portraits in Paint,* showing this month at the Nierendorf Galleries."[36] But for the 1942 show, which included representational objects in plaster, tattistone, and bronze, the *New York Times* art critic Howard Devree wrote that she "carries forward the experimental promise of earlier work."[37]

Fig. 14. Invitation to Grand Central Moderns exhibition opening for 1955 Nevelson exhibition in New York. Louise Nevelson Papers, Archives of American Art, Smithsonian Institution

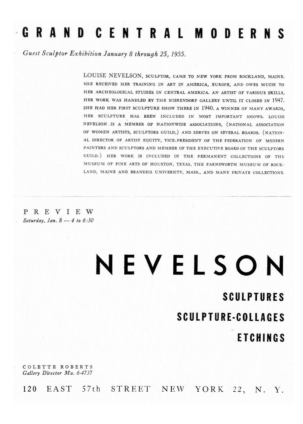

GRAND CENTRAL MODERNS

Guest Sculptor Exhibition January 8 through 25, 1955.

LOUISE NEVELSON, SCULPTOR, CAME TO NEW YORK FROM ROCKLAND, MAINE. SHE RECEIVED HER TRAINING IN ART IN AMERICA, EUROPE, AND OWES MUCH TO HER ARCHEOLOGICAL STUDIES IN CENTRAL AMERICA. AN ARTIST OF VARIOUS SKILLS, HER WORK WAS HANDLED BY THE NIERENDORF GALLERY UNTIL IT CLOSED IN 1947. SHE HAD HER FIRST SCULPTURE SHOW THERE IN 1940. A WINNER OF MANY AWARDS, HER SCULPTURE HAS BEEN INCLUDED IN MOST IMPORTANT SHOWS. LOUISE NEVELSON IS A MEMBER OF NATIONWIDE ASSOCIATIONS, (NATIONAL ASSOCIATION OF WOMEN ARTISTS, SCULPTORS GUILD,) AND SERVES ON SEVERAL BOARDS. (NATIONAL DIRECTOR OF ARTIST EQUITY, VICE-PRESIDENT OF THE FEDERATION OF MODERN PAINTERS AND SCULPTORS AND MEMBER OF THE EXECUTIVE BOARD OF THE SCULPTORS GUILD.) HER WORK IS INCLUDED IN THE PERMANENT COLLECTIONS OF THE MUSEUM OF FINE ARTS OF HOUSTON, TEXAS, THE FARNSWORTH MUSEUM OF ROCKLAND, MAINE AND BRANDEIS UNIVERSITY, MASS., AND MANY PRIVATE COLLECTIONS.

PREVIEW
Saturday, Jan. 8 — 4 to 6:30

NEVELSON

SCULPTURES

SCULPTURE-COLLAGES

ETCHINGS

COLETTE ROBERTS
Gallery Director Mu. 6-4737

120 EAST 57th STREET NEW YORK 22, N. Y.

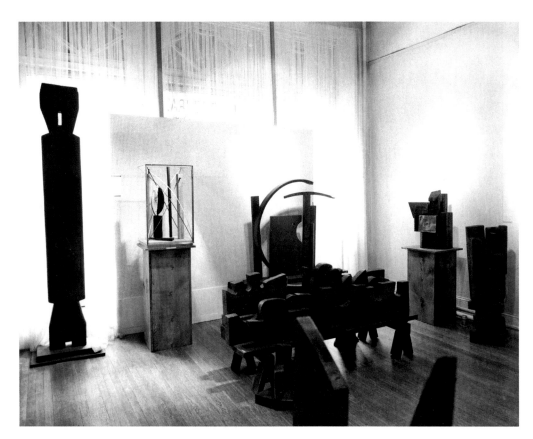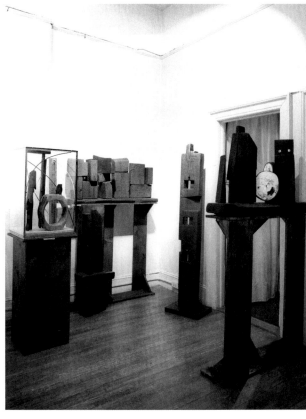

Figs. 15 and 16. Installation views of *The Royal Voyage* at Grand Central Moderns, New York, 1956

Despite a lack of sales, Nevelson carried on, showing again at Nierendorf in 1946. That same year, her bronze sculpture *Young Bird* was included in the *Whitney Museum Annual Exhibition of Contemporary American Sculpture, Watercolors, and Drawings,* featuring new talent, including sculptors Alexander Calder, Isamu Noguchi, and David Smith. In the ensuing decades she would be a fixture in that series of Whitney exhibitions.

When Nevelson met Colette Roberts, the director of the nonprofit gallery Grand Central Moderns in New York in 1952, the artist was included in a group exhibition. The work there bore extraordinary confidence and mastery. Beginning in 1955 and annually for the next four years, Nevelson had thematic one-woman shows at the gallery's East 56th Street home and then 1080 Madison Avenue address. Each was an environment that featured found wood objects: *Ancient Games and Ancient Places* opened in 1955, *The Royal Voyage of the King and Queen of the Sea* in 1956, *The Forest* in 1957, and *Moon Garden + One* in 1958 (figs. 14–18). The critic Hilton Kramer, writing in *Arts* magazine in June 1958, called this series of exhibitions "remarkable and unforgettable."[38]

These projects marked a definitive change for the artist, for she conceived of the sculpture as part of a complete surround. As Nevelson increased the scale of her work, the objects continued to reveal personal stories. The blackness mandated for her found objects engulfed the gallery space, and she created settings of sculpture that were harbingers of the installation movement that so consumed artists in the 1980s. Nevelson called these works environments, and she labeled herself the grandmother of environment, referring to her ability to implode a sculptural space with objects to encompass the viewer.[39]

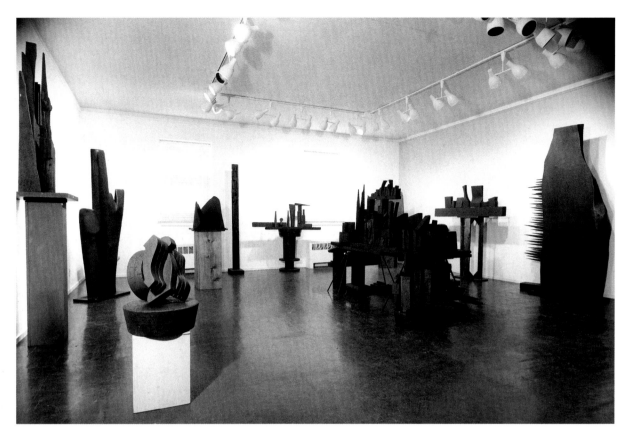

Fig. 17. Installation view of *The Forest* at Grand Central Moderns, New York, 1957

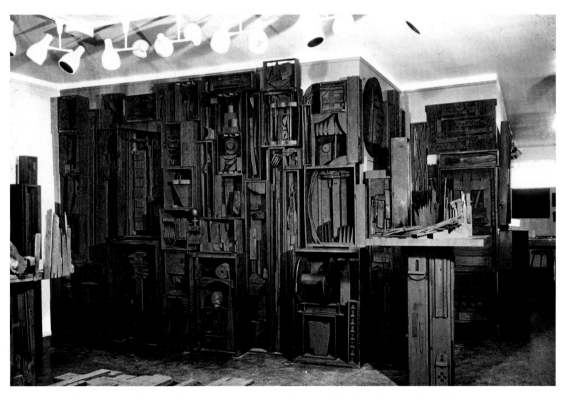

Fig. 18. Installation view of *Moon Garden + One* at Grand Central Moderns, New York, 1958

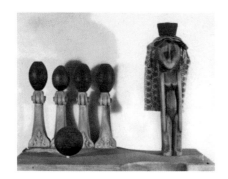

Fig. 19. Louise Nevelson, *Bride of the Black Moon,* 1955. Painted wood, 20 × 40 × 16 in. (50.8 × 101.6 × 40.6 cm). Collection unknown

The centerpiece of *Ancient Games and Ancient Places* was a large work, *Bride of the Black Moon* (fig. 19). Nevelson told biographer Laurie Lisle that the bride was a metaphorical self-portrait: "*Bride of the Black Moon* is me, of course"[40] Over her lifetime Nevelson frequently used the symbol of the bride. For an individual who strove to escape marriage, her regular summoning of matrimony suggests its presence in her conceptualization and its unceasing reflection on her earlier life.[41]

Married figures also dominate *The Royal Voyage.* In this project, *The King and Queen of the Sea* commands center stage with its large abstract presence of discarded timber beams. Nevelson stationed the king somewhat apart from the queen, in a realm of coexistence but not mutual reliance, somewhat similar to her marital relationship (see figs. 15, 16). Both the King and the Queen were totemic objects that pay homage to the simplicity of forms in Native American, African, and South American art. Nevelson had collected artifacts from these and other cultures.[42] Additionally, part of the installation included a 1955 work that sat on the floor, *Indian Chief* (or *Chief*) (see pl. 18). Nevelson titled the piece based on her knowledge of Native American culture: the object is sharp-edged with forms jutting rigidly from its trunk to recall primal ritual or elaborate costuming. The chief's relationship to the King and Queen is unclear, as his status is diminutive while their presence is commanding. The "voyage" of the work's title refers to the seafaring couple and their water journey: two enclosed glass boxes atop rough-hewn wood pedestals, one titled *Undermarine Scape,* recall a deep-sea treasure chest of objects in the manner of Joseph Cornell. Another interpretation of this particular voyage is linked to Nevelson's personal journey—first her immigration by ship to America followed by her youthful memories of the Maine coast, then her experience with her husband's shipping concern, and finally her travels as an artist.

Critics took notice of this exhibition. Dore Ashton, in the *New York Times,* remarked that Nevelson's work is "always cadenced and witty, juxtaposing blocky, rough-hewn forms in infinitely varied relationships." James Mellow in *Arts* wrote: "This one piece, assembled with others, forms a small universe of sentinel shapes charged with personality."[43] The personality to which he referred was Nevelson's. She had, at the age of fifty-seven, achieved a vanguard sculptural statement with these installation projects.

Similarly, *The Forest* was a window into the artist's internal life. The work takes its symbolic subject not from the sea, but from the land—the terra firma of Nevelson's childhood: first the family "woods" in Ukraine, and then the Maine forest, with what she described as its suffocating richness.[44] An abstract self-portrait in the guise of a bride forms the centerpiece of the environment *First Personage,* acquired by the Brooklyn Museum in 1957 (see pl. 19). The façade of the almost eight-foot-tall sculpture is a thick, undulating slab with a large wood knot in the figure's upper register. The knot, Nevelson said, was a mouth that spoke to her when she was creating the work.[45] If the bride's mouth was speaking to its creator, it revealed that Nevelson's true self was buried, for lurking behind the composed ego of *First Personage* is a spiky column, the agitated id claiming center stage in the artist's autobiography. *The Forest* included other sculptural objects, some recalling tree forms, one an outsize leaf, and a dense cluster of undergrowth, either atop platforms or resting on the floor.

With critical attention now listing in her favor and with Nevelson further energized by her continued projects at Grand Central Moderns, in January of 1958 she opened *Moon Garden + One,* a tour de force that firmly planted the artist as a player in the avant-garde. The exhibition was covered by *Arts, ARTnews,* the *New York Herald Tribune,* the *New York Times, Time,* and *Life,* signifying that she had critical appeal not only in the art publications but also in national mass-circulation newspapers and magazines.[46] Departing from the stan-

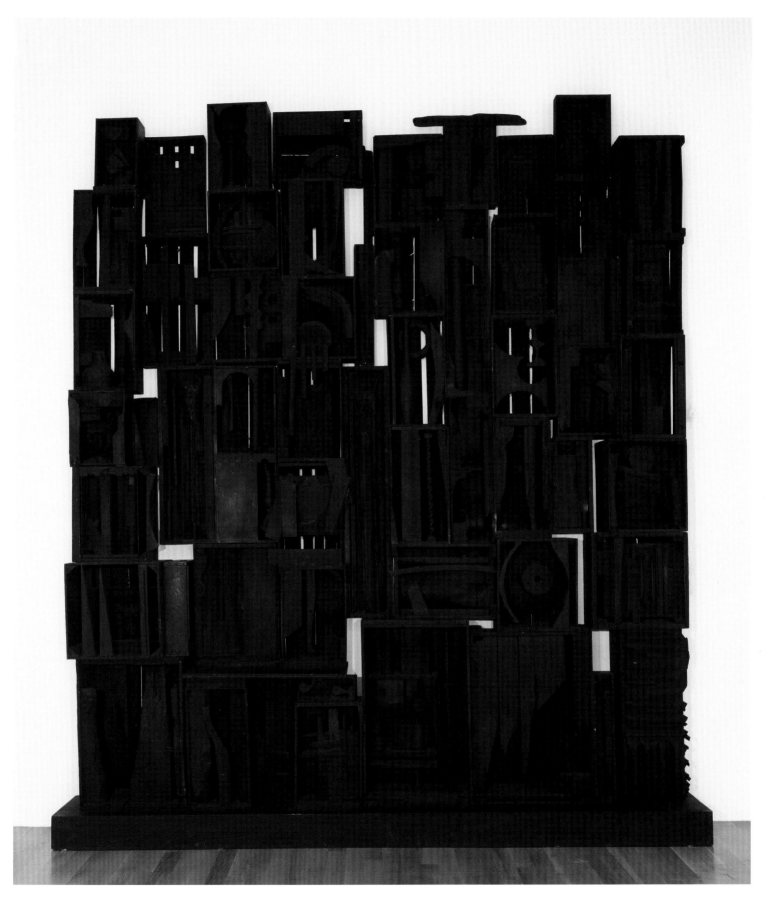

Fig. 20. Louise Nevelson, *Sky Cathedral,* 1958. Wood construction painted black, 11 ft. 3 ½ in. × 10 ft. 1 ¼ in. × 18 in. (344.2 × 302.2 × 45.7 cm). The Museum of Modern Art, New York, Gift of Mr. and Mrs. Ben Mildwoff

dard art writer's analysis of an exhibition, the *Life* reporter focused on the large number of boxes that composed the work (116), the asking price of the complete installation ($18,000), and the fact that Nevelson "parted with individual boxes for as little as $95."

In *Moon Garden + One,* Nevelson created a complete surround in the gallery and on the spot during an on-site installation period—assembling boxes in combinations that most satisfied her and that recalled the spontaneity and all-over quality of the Abstract Expressionist action painters. Dark walls and blue lightbulbs dimly illuminated the space, causing a three-dimensional *sfumato* in Grand Central Moderns. One gallery window was masked with paper. Sculpture was stuffed into the window ledge, forming an additional layer of Nevelson box.[47] Black assemblages, the *Sky Cathedrals,* hugged the gallery perimeters, becoming part of them and earning Nevelson's large works the title "walls" (fig. 20). They emanated as complicated, constructed reliefs in which each box—every horizontal or vertical square or rectangle, some with swinging, hinged doors—was brimming with remnants, Nevelson's unique testament to the process of gathering materials and carefully nailing, cutting, and gluing bits to form this black tableau of assemblage.

Fig. 21. Louise Nevelson, *Sky Cathedral—Moon Garden Wall,* 1956–59. Wood painted black, 85⅝ x 75¼ x 12½ in. (217.5 x 191.1 x 31.8 cm). The Cleveland Museum of Art, Gift of the Mildred Andrews Fund, 1974.76

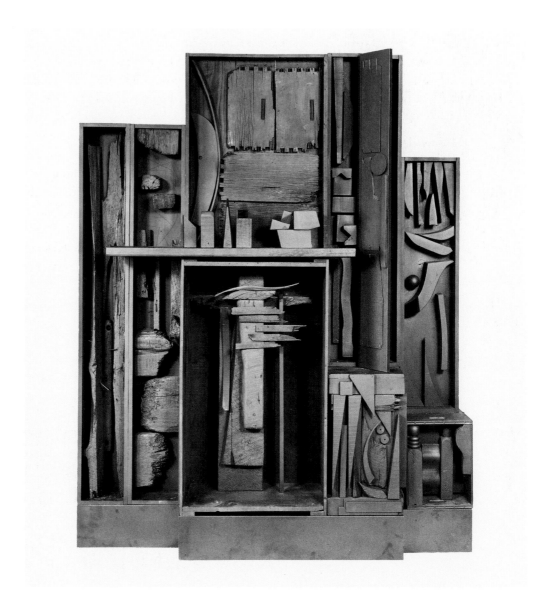

Some of the works (for example, *Moon Dial* and *Moon Fountain*) were placed on pedestals in the center of the installation; however, the mainstays of the show were the stacked black boxes that lined the gallery walls (see pl. 20).[48] There are many sculptures whose conception has been attributed to this project, some created for the Grand Central Moderns show, others as ongoing work, including: *Sky Cathedral Presence* of 1951–64, *Sky Cathedral—Moon Garden Wall* of 1956–59 (fig. 21), *Sky Cathedral—Moon Garden + One* of 1957–60, and *Sky Cathedral* of 1958. With the artist's propensity for disassembling and reassembling her sculpture and working in series, it is likely that sections of these walls were in the original 1959 installation.

SIXTEEN AMERICANS AND THE WHITE WORK

In addition to the noteworthy critical reception of *Moon Garden + One,* Nevelson's work now had the potential for commercial viability. She was invited to show with the for-profit Martha Jackson Gallery.[49] Additionally, the Museum of Modern Art acquired one of the *Sky Cathedrals* in 1958, and this led to her inclusion in 1959 in *Sixteen Americans,* the showcase of avant-garde contemporary work. Published reports disagree over whether Nevelson's submission, *Dawn's Wedding Feast,* was her first major foray into white wood sculpture; nonetheless, it was her first public project in white and a spellbinding presentation in a museum setting.

Again compelled by the theme of matrimony, the work was a blinding environment of painted wood objects: up to four wedding chapels, a wedding cake, a wedding chest, a wedding mirror and pillow, several attendants in the guise of stationary and hanging columns, and the columnar bride and groom (see pls. 24–35). In *Dawn's Wedding Mirror* the abstract portrait of the bride's face is skewed through a Cubist composition: a round picture frame serves as the female's head and decorative dowels become hair ornament (fig. 22). Her hair is a gentle wood arc and the bride's visage bears a T-form, summoning remnants of Kasimir Malevich's Suprematist compositions. The *Wedding Chest* and *Dawn's Wedding Pillow* (fig. 23) are a packed trousseau; they reflect Nevelson's need to save, to scavenge. Each *Chapel* forms a monument to memory and the future, where marriage is exemplified by the white environment's associations with purity.

The assembled chapel reliefs were installed around the 14 × 24 × 22-foot MoMA gallery, with the wedding party huddled in the space's center. Though it was not meant literally as *her* wedding, she called the display a "transition to a marriage with the world."[50] Referencing herself and her own failed marriage, the room-size work is an effort at redemption veiled in the whiteness often associated with new beginnings. Nevelson hoped the entire installa-

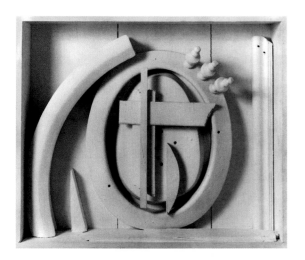

Fig. 22. Louise Nevelson, *Dawn's Wedding Mirror,* from *Dawn's Wedding Feast,* 1959. Wood painted white, 26½ × 31 × 7½ in. (67.3 × 78.7 × 19.1 cm). Collection unknown

Fig. 23. Louise Nevelson, *Dawn's Wedding Pillow,* from *Dawn's Wedding Feast,* 1959. Wood painted white, 6½ × 36 × 13 in. (16.5 × 91.4 × 33 cm). Collection unknown

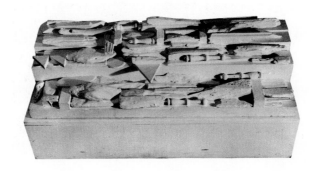

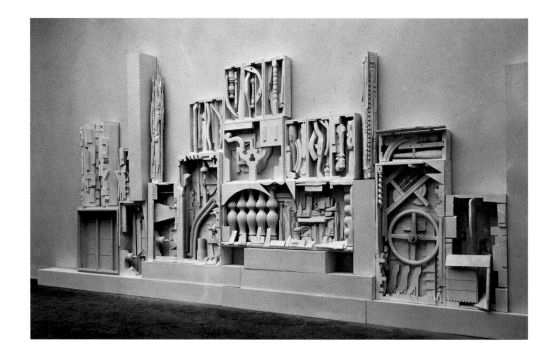

Fig. 24. Installation of *Voyage* at the
Venice Biennale, 1962. Painted wood

tion could remain intact, but the parts were separated and used by the artist in ongoing works
or dispersed into various collections. For example, sections of *Dawn's Wedding Feast* were later
incorporated into *America-Dawn* of 1962 (see pl. 24). A large part of the work was eventually
reassembled for *Atmospheres and Environments,* the 1980 exhibition at the Whitney Museum
of American Art. Much of the work has been located and is reunited in the present exhibi-
tion at The Jewish Museum.

Soon after *Sixteen Americans,* Nevelson was invited to represent America in the 1962
Venice Biennale, where she created another white project, *Voyage* (fig. 24), which also included
parts of *Dawn's Wedding Feast.* At this time the artist formed a short-term association with the
Sidney Janis Gallery in New York. And before the Biennale, in 1961, through Martha Jackson,
Nevelson had an exhibition with Arne Glimcher, then twenty-three years old, who headed
Pace Gallery in Boston and later New York. Glimcher remained Nevelson's dealer and confi-
dant for the rest of her life.

STREETS PAVED WITH GOLD

The white works led the artist to construct monochromatic sculpture in brilliant gold—a
true departure from the understated palette of her black or white art. Nevelson conceived of
black as relating to the night and the passage of the hours of the day. She thought of white
as the color that summoned the early morning and emotional promise. Her gold wood walls
ensued, representing royalty and riches, in what one critic called her "baroque phase."[51]
Nevelson remarked that, as a child coming to America, she had been promised that the streets
"would be paved with gold," an association that never left her.[52] She was also inspired by gold
because of its contradictory associations with natural cycles of the day versus materialism or
hedonism: the sun and the shining moon compared to earthen metals, alchemy, and man-
made riches. The gold-spun silk fabric of Japanese Noh robes and the gold coins that bedecked
it, which the artist viewed in New York's Metropolitan Museum of Art, were also sources for
her use of gold.

Nevelson's wall structures proved quite flexible in accommodating this change of color: the assembled wood objects turned to shimmering surfaces once they achieved their golden tones in objects such as *Royal Tide I* of 1960 and *Golden Gate* of 1961–70 (see pls. 37, 38). The gold works, on display at the Martha Jackson Gallery in 1961, were well regarded by some critics, one noting, "The effect of the change in color is profound. . . . These grandiose effects are produced, as always, through the transmutation of the most mundane means."[53]

As much as the color gold altered Nevelson's work, so too did the change in the materials' form. Instead of rough-hewn, scavenged found objects, she also used wood pieces produced in the studio for her sculptural walls and boxes. In contrast to her roughcast sculptures of the 1950s, this work had a sleeker look, in keeping with the mass-produced character of the rising Minimalist aesthetic of the 1960s and 1970s. As if to declare this gradual departure from sculpture composed of street finds to work with a cooler line, Nevelson even created a sculptural wall in this format titled *Self-Portrait: Silent Music IV,* 1964 (see pl. 42). It is a towering figure of twenty-four boxes each with black internal forms more reminiscent of hard-edged geometry than edgy castoffs.

Two 1970s series, the *Cryptics* and *Dream Houses,* both mystical black box structures with multiple doors and entryways—one tabletop size, the other human scale—employed similar methods and reflected the artist's 29 Spring Street home and studio (see pls. 53, 55). Visitors there often remarked that it was a living sculpture: a crammed setting where—like the *Cryptics* and *Dream Houses*—objects lined every wall and the interiors of cupboards and closets were carefully loaded with dishes and clutter as if backstage waiting for showtime, the opportunity to star in a Nevelson sculpture. True furniture was scant in favor of wood fragments proliferating throughout the house and garage. It was also during this period that Nevelson engaged Diana MacKown, who lived, worked, and traveled with the artist from 1963 to Nevelson's death in 1988.

NEW MATERIALS

Although the selection of the color gold and the transition from incorporating found objects to ersatz or studio-produced objects was a departure for Nevelson, her work in the 1960s and 1970s pushed the color and material boundaries even further. Secure in her role as one of America's preeminent artists and probably urged by those around her to update her materials, Nevelson began to experiment with materials, colors, and forms that stand apart from the powerful linear progression of her wood sculpture.

Her range of materials reflected her earliest inquisitiveness for creating objects of varied tactile modes. She crafted editions of tabletop pieces in Plexiglas, including *Transparent Sculpture IV,* 1968, and *Transparent Sculpture VI,* 1967–68 (see pls. 50, 51). These Plexiglas boxes differ from the labored intensity of the wood boxes, as their subject is light rather than light and shadow. Her driven selfhood is also somehow lost in this material, but for the fact that it represented one more opportunity for experimentation. Nevelson also created collages by combining diminutive pieces of wood with household materials and cardboard adhered to matboard, as in *Untitled* of 1981 (see pl. 60). And large outdoor works, realized through prestigious public commissions, were made of metal. For the artist who once veered from the aggressive qualities of metalwork, the material now had enormous appeal because it symbolized a fundamental break from the path of her work in wood, as in her *Atmospheres and Environments* series of the late 1960s (see pl. 46). She said to MacKown: "Remember, I was in my

early seventies when I came to the monumental outdoor sculpture. . . . I had been through the enclosures of wood, I had been through the shadow. I had been through the enclosure of light and reflection. And now I was ready to take away the enclosures and come out into the open. . . . The new materials like Plexiglas or Cor-ten [steel] are just a blessing for me. Because I was ready for them and the material was ready for me."[54]

Nevelson was attracted to the idea that she could create long-lasting commissioned work that would withstand the climatic changes of the outdoors. Curiously, these works were made of metal and evoked natural forms, a marked turn from her reliance on wood to exemplify the self and the life cycle. If there were physical limitations to the scale of the sculpture in wood, metal projects were able to grow and reach architectural scale, specifically *Sky Tree* of 1976 at the Embarcadero Center in San Francisco, which ascends to fifty-four feet, *Shadows and Flags* of 1977–78, the forty-foot-tall centerpiece of Louise Nevelson Plaza in lower Manhattan (see Senie essay, figs. 8, 9), and *Dawn Shadows,* originally outdoors in Madison Plaza in downtown Chicago measuring thirty-one feet high. She installed work on university campuses, including *Atmosphere and Environment X* at Princeton in 1969–70 and *Transparent Horizon* at the Massachusetts Institute of Technology in 1975 (see Senie essay, figs. 4, 17). To commemorate her seventieth birthday the artist created a series of aluminum sculptures resembling tree forms titled *Seventh Decade Garden.* These pieces were constructed at the Lippincott Foundry in North Haven, Connecticut, with an experienced crew who worked in concert with the artist either by intuitive on-site creation or by studying her models and sketches prior to realizing the large public work.

These massive objects are not Nevelson's strongest sculpture. In contrast to the works in wood, her hand—the sculptor's intuitive gesture—is not evident in the hulking works of steel. Nevelson's humanistic content, be it self-referential or a collective metaphor, had largely disappeared with these sculptures. However, the works were created because the public art field burgeoned in the 1970s. Corporations were seen as contributing to the quality of community life if outsize sculpture sprawled on manicured campus lawns or adorned company lobbies. Government funding and sponsorship for art in public places was realized through the General Services Administration Art in Architecture program, an initiative begun in Washington, D.C., in 1972.

THE LARGER SOCIETY AS SUBJECT

If the metal pieces veered from the rich narrative in wood, Nevelson recaptured subject matter in other wood works created at the same time. By the 1960s and 1970s, with her reputation firmly established as sculpture's grande dame, Nevelson created room-size pieces that reflected personal, religious, and social issues. As often as Nevelson had looked inward to find her ultimate subject, she now made works relating to the larger culture. Her black walls—already doleful tombs of objects once relating to an individual's life—were well suited to themes of memory, decay, and death. It was therefore appropriate that Nevelson created two memorials to the Holocaust, *Homage to 6,000,000 I* of 1964 now in the Osaka City Museum of Modern Art in Japan and *Homage to 6,000,000 II* of 1964 in the Israel Museum collection (fig. 25; see pl. 43). The first *Homage* is a somber work in two parts where no box resembles the other—the artist's recognition of the vast numbers of individuals lost to Hitler's con-

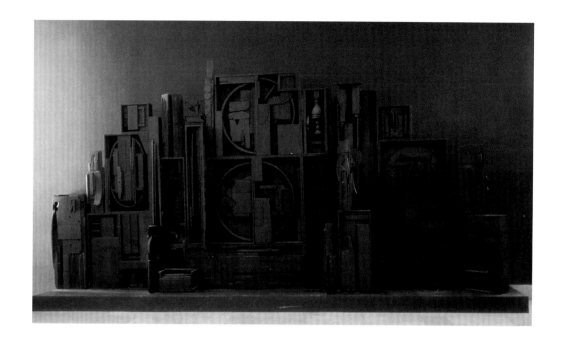

Fig. 25. Louise Nevelson, *Homage to 6,000,000 II*, 1964, Wood, 126 × 236 in. (320 × 600 cm). The Israel Museum, Jerusalem, Gift of the artist to America-Israel Cultural Foundation, B66.1694

quests. Compelled by the same subject, she took on a commission for a synagogue sanctuary and created a white environment, titled *The White Flame of the Six Million* of 1970–71, at Temple Beth-El in Great Neck, New York (see pl. 54 and Senie essay, figs. 14, 15). Her 1973 project for Temple Israel in Boston is titled *Sky Covenant* and is a Cor-ten steel relief on the building's façade (see Senie essay, fig. 16). For the interior of the five-sided Erol Beker Chapel of the Good Shepherd at St. Peter's Lutheran Church in New York City, white wall reliefs refer to a heavenly force and surround the viewer (see Senie essay, fig. 13). Questioned about her role as a Jewish artist creating an environment for Christian worship, Nevelson replied that her work was abstract and therefore "transcended" religious barriers.[55]

BACK TO THE SELF

Simultaneous to these projects and reminiscent of the *Cryptic* boxes and *Dream Houses,* the artist worked for over a decade (between 1964 and 1977) on *Mrs. N's Palace,* a walk-in black sculpture summoning a house with a black gridded and mirrored floor and a black backyard "garden" (figs. 26, 27; see pl. 45). Returning conceptually to her earliest self-portraits, Nevelson created in this room-size piece an homage to herself: a vast windowless chamber referring to her work, the passage of time, and the insularity of the artist's life. Though she was a recognizable public figure in New York cultural circles, Nevelson's home was her private world, and Mrs. N was so named by the local children, who knew the artist as a Little Italy neighborhood fixture.

Nevelson was consumed by images of royalty, so it is not surprising that she conceived of this culminating sculpture as a palace: kings and queens and their journeys and travails appear consistently throughout her work. Alongside its associations with sovereigns and finery, *Mrs. N's Palace* is also a tomb. It is a smothering, in-the-round black coffin with remnants of a life's work affixed to every inch of a carpenter-constructed wood box. Once that box was made, Nevelson conjured an elaborate plan whereby the interior and exterior, ceiling and floor, front and back, served to display sculpture, the product of a life's work. Like

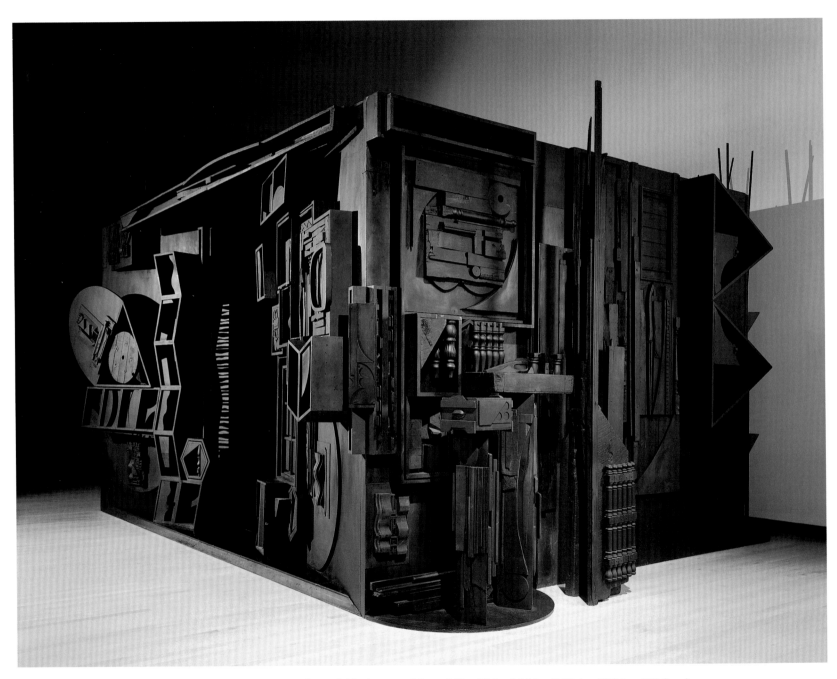

Fig. 26. Louise Nevelson, *Mrs. N's Palace*, 1964–77. Painted wood, black mirrored floor, 140 × 239 × 180 in. (355.6 × 607.1 × 457.2 cm). The Metropolitan Museum of Art, New York, Gift of the artist, 1985 (1985.41)

an ancient Egyptian king's tomb that held earthly treasures to consume in the afterlife, *Mrs. N's Palace* conceptually and retrospectively reviews the artist's life of object making. Around the time she was building *Mrs. N's Palace*, Nevelson told Diana MacKown: "I have never feared not living, never, not even in youth. . . . You know, an interviewer had read somewhere that I had had a wonderful collection of American Indian pottery and quoted me as saying that if I were reincarnated, I would like to come back as an American Indian. . . . And so she asked me, at this point, how I felt about it. I don't believe in reincarnation but let's assume that I'll accept the question. She said, 'What would you like to come back as in your next life?' I said, 'Louise Nevelson'" [laughs].[56]

In 1988, the last year of her life, when she was eighty-nine years old, Nevelson created *Mirror-Shadow VII* (see pl. 62), a sculpture that is the understated antidote to *Mrs. N's Palace*. If the latter was the grand gesture of bravura about the public self, *Mirror-Shadow VII* is a private dirge that summarizes old age and the toil of the artist. In selecting her signature found objects painted black, the artist summons a survey of her life's work in which remnants of an inward-facing chair push through a sculptural box, another box filled with studio detritus swings free, and a circular form poised on a shelf has a boundless openness. At Nevelson's death the common wood chair in *Mirror-Shadow VII* remained physically empty, filled only with a lifetime of achievement that created a story in sculpture.

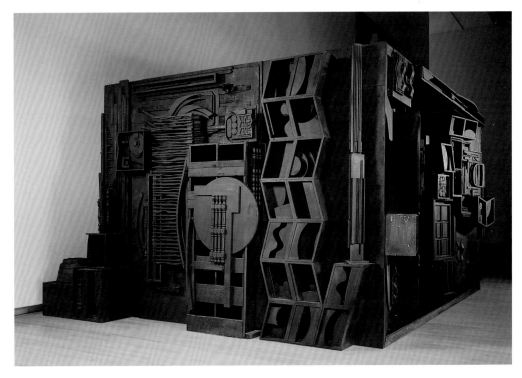

Fig. 27. Louise Nevelson, *Mrs. N's Palace*, 1964–77. Painted wood, black mirrored floor, 140 × 239 × 180 in. (355.6 × 607.1 × 457.2 cm). The Metropolitan Museum of Art, New York, Gift of the artist, 1985 (1985.41)

MICHAEL STANISLAWSKI

LOUISE NEVELSON'S SELF-FASHIONING "THE AUTHOR OF HER OWN LIFE"

Opposite: Louise Nevelson, c. 1931. Louise Nevelson Papers, Archives of American Art, Smithsonian Institution

Fig. 1. Louise Nevelson and Edward Albee in the Erol Beker Chapel of the Good Shepherd, St. Peter's Lutheran Church, New York, c. 1979. Photograph by Pedro E. Guerrero

In the introduction to his 1972 study of the art of Louise Nevelson, her close friend and dealer Arnold Glimcher wrote: "Louise Nevelson's life is such an intricate pattern of fantasy synthesized with reality that separation of myth and fact is nearly impossible. Nevelson rejects the ordinary and conjures her own history, eliminating what is beneath her notice and amplifying the important. . . . Nevelson's life itself is her greatest work of art." Quoting her oft-expressed statement "I'll use a lie if it works," he continued, "I have come to realize that Louise Nevelson is, if not a writer, the author of her own life."[1]

Eight years later a similar sentiment was expressed by another of Nevelson's close friends, the playwright Edward Albee, in an introduction to a new catalogue of her work:

> Nevelson has said, "I seek truth. What I seek is anything that will work for me; I'll use a lie if it works, and that [becomes] the truth." While Nevelson does not share Blanche DuBois' credo, "I tell what ought to be true" (indeed, I know no person more candid than Nevelson about the implications of facts), she does share the commonly held view among creative artists that facts are less interesting than truth and that, given your lights, you can let a fact lead you into either a pit of darkness or almost blinding illumination.[2]

What is fascinating is that, while Glimcher and Albee—and all others who have written about her life and its connection with her art—acknowledge their subject's "awry" connection with facts and historical truth, when they come to write her life story they nonetheless present as utterly factual the story of that life as she told it, down to its specific details.[3] To anyone who has studied the genre of autobiographical writing and its reception, this is hardly surprising. Indeed, it is more common than not, if still noteworthy, whenever it occurs. As a culture we know and regularly experience the fact that autobiographies and memoirs are selective and highly unreliable accounts of lives lived. Though such works are often deeply fictionalized, we still have an all but insatiable appetite for them. We tend to believe their representations of reality and hence are shocked to discover that the authors have not told the truth, the whole truth, and nothing but the truth—and oftentimes have wandered very far from the truth.[4]

Given the paucity of surviving materials about Nevelson's life that do not come from interviews with her, I will not attempt to establish the authoritative "truth" about Nevelson's life and its relationship to her art. Rather, I shall try to sort through the story of her life as she herself told it—and very often retold it—primarily but not exclusively in the most extensive autobiographical work she collaborated in producing: *Dawns + Dusks,* published in 1976. I will examine these texts with the goal of explaining how Nevelson crafted a highly controlled and controlling "self-fashioning"—not only a view of self presented to her close friends and to the world at large, but one that, most likely, she herself came to believe. I will focus on her early life, from her birth in 1899 to her emergence as a sculptor in the 1930s, largely because this is the period in which Nevelson claims to have formed the blueprint for the rest of her life, and secondarily because other essays in this volume will concentrate on the rest of her life, as expressed primarily through her art.

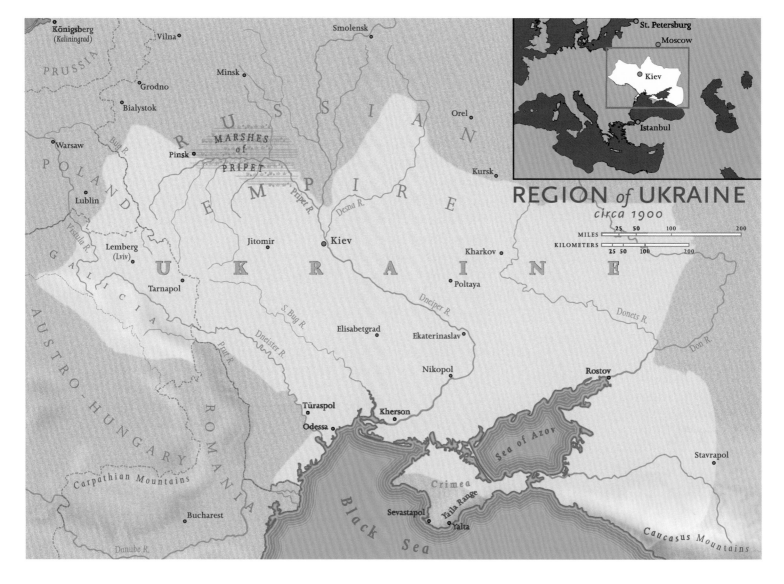

Fig. 2. Ukraine, c. 1900. Map by
Adrian Kitzinger

It is important, if unpleasant, to begin by unpacking some of the simple errors of fact that
Nevelson and others have presented about her life. The first problem concerns the very place
of her birth: Nevelson always claimed that she was born in "Kiev, Russia," and this "fact" has
been repeated in every biographical notice about her, every scholarly or popular article on her
life, every catalogue of her work, whether in English, French, Italian, Swedish, Danish, Ger-
man, or Dutch. But Kiev, Russia, is a place that existed only in the minds of Russian chau-
vinists such as Alexander Solzhenitsyn, who deny the very existence of a Ukrainian nation,
or of less extreme Russian nationalists who ahistorically believe that the medieval state known
as Rus—of which Kiev was the capital and main city—was "Russian" by ethnicity and hence
the precursor of the Muscovite state that came to be known in Russian as "Rossiya" and then
the Russian Empire, *rossiskaia imperiia* (the Slavic roots "rus-" and "ross-" are quite distinct).
The undisputable historical fact is that after the destruction of the medieval Rus state in the
thirteenth century Kiev became part of the Duchy of Lithuania, which then entered into a
union with Poland to form the Polish-Lithuanian Commonwealth, one of the largest and
most powerful states in early modern Europe. In 1654, after a bloody peasant and Cossack
uprising in which tens of thousands of Jews and Poles were killed, Kiev formally became part
of the Russian Empire, a vast colonial giant that conquered and acquired territories from the

Baltic Sea to the Pacific Ocean, and hence included dozens of national, tribal, and religious groups distinct from the ethnic "Russians" proper. Indeed, the part of Ukraine that includes Kiev and was annexed to the Russian Empire was supposed, by treaty, to retain substantial autonomy within the empire, but that treaty was gradually ignored by the tsarist regime as early as the late seventeenth century, and the promised autonomy was never realized as eastern Ukraine was increasingly integrated into the Imperial Russian state. Nonetheless, to say Kiev, Russia, is almost exactly parallel to calling the capital of India before 1947 New Delhi, England, or New Delhi, Britain.

To be sure, Nevelson was hardly alone in making this error about the city of her birth, which was undoubtedly repeated by thousands of other Jewish immigrants from Kiev and its surroundings in the late nineteenth and early twentieth centuries. (One of the greatest mysteries to me about American-Jewish history is why the vast majority of the children and grandchildren of Jewish immigrants to the United States—as opposed to their Italian- or Irish- or Polish-American counterparts—do not know, never knew, or deliberately have forgotten the names of the cities, towns, and villages from which their families hailed, and often even the countries in which they lived.) But the fact that Nevelson herself made this error does not absolve others of repeating this elementary mistake.

Most important, this is not simply a pedantic toponymic point: it bespeaks a fundamental misapprehension of the economic and social status of Nevelson's family of origin, the Berliawskys, in much of the literature about her, including the most extensive biographical accounts of her life.[5] Her parents' origins in Kiev and its surroundings reveal a great deal about Nevelson's background, as well as the formative early decades of her life in America. Far from being stereotypical Eastern European "shtetl" Jews, her parents' families were upper-middle-class landowners and timber merchants, part of the substantial russified and modernized upper bourgeoisie that emerged among the Jews of the Russian Empire in the last decades of the nineteenth century and the first seventeen years of the twentieth. Although it is widely believed that Jews in the Russian Empire were forbidden from owning land, this is simply not true: until the abolition of serfdom in 1861, they were forbidden from owning land that was populated by serfs, but they were free to own (and to lease) other forms of real estate, including forests and agricultural estates. After 1861, Jews were able to own outright (and to lease) any form of real property throughout the empire, except for peasant villages that remained in a convoluted semifeudal legal morass until the Revolution of 1917. In any event, even before 1861 and certainly thereafter, Jews owned a great deal of land in the Russian Empire, and upper-middle-class and wealthier Jews often owned massive tracts of land, including—importantly for Nevelson's father—forests rich with timber, fur, and other natural resources. Indeed, for centuries Jews were the mainstays of the timber and fur businesses throughout the western portions of the Russian Empire, and especially in Ukraine. Moreover, Kiev had the right (highly unusual in the so-called Pale of Settlement) to restrict Jewish residence in its midst, and so the vast majority of the Jews who managed to live there legally were in fact upper-middle-class Jews, often involved in white-collar professions or in large entrepreneurial enterprises.[6] Thus, it seems reasonable to accept Nevelson's claim that her father and his brothers were upper-middle-class Kievan Jews involved in the lumber business in Ukraine before their immigration to America at the turn of the twentieth century.

This would explain her father's otherwise seemingly odd choice of Rockland, Maine, as his residence in the New World. Maine was a logical place for a man trained in the lumber business and its ancillary enterprises to seek to make his fortune. Nevelson characteristically presented this matter in the following words (her syntax was often unclear and always con-

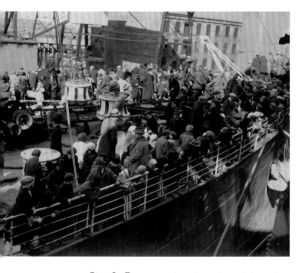

Fig. 3. European immigrants arriving at the Port of Boston on the *Carmania* on November 1, 1923. Boston Public Library, Print Department

voluted—though it must be recognized that almost all the quotations we have from her are from transcribed oral presentations rather than from edited written prose): "My father came to America. And we came to America. . . . My father's family had a lot of land. 'Woods,' I think they called them. And he had brothers and sisters, and almost all of them, especially the males, came to America. They had an uncle that was a so-called governor; he had the highest honors and position that our people could have in Russia at that time."[7] What Nevelson was probably referring to here was the status of "Honorary Citizen," the highest non-noble position in the Russian Empire, conferred by the regime on many wealthy—or otherwise "worthy"—Jews in what the historian Benjamin Nathans has felicitously termed "selective emancipation."[8] This was not, in fact, the highest position Jews could hold in the Russian Empire—they could be nobles, as the richest Jews in the empire indeed were, although in most cases their patents of nobility were issued by German principalities and only ratified by the tsarist regime. No unbaptized Jew was ever a "governor" in Imperial Russia, but this term, like its English equivalent, was frequently used by peasants in the Russian Empire to express respect to wealthy employers.

Interestingly, in describing her family's move to America, Nevelson recalled the bleak underbelly of Jewish immigration to this country, often ignored in the literature: the dislocation and indeed depression that awaited many immigrants, and, for the upper-middle class among them, the harsh reality of at least temporary downward social mobility—the opposite of what they had expected, and what we expect to read about: "My father had to establish himself. He was a very loyal man to the family, and he did whatever he could, but until he established himself, he didn't know what he was going to do. I remember my mother saying that he was never lazy in Europe, yet when he first came, he lay in bed for months. He went through transition, not knowing what to do. And the language. All these things."[9]

But soon he seems to have recovered and to have restored his family's previous social and economic status. "Then when he got started, you couldn't stop him. Sooner or later he began feeling out—just like in Russia—about land. So he got land. And then he got lumber. And then he built houses. . . . He had lumber and he had maybe a lumberyard."[10]

This upper-middle-class background, properly understood, can also serve to elucidate a matter central to Nevelson's later self-fashioning: her mother's sense of superiority to those surrounding her in this small and provincial New England town, her reported interest in high fashion and the "better things" in life, and her consequent severe depressions. Nevelson recalls that her mother came from a "small town near Kiev where my father owned land," and loved another man whom she was not permitted to marry, so she settled on Nevelson's father, with whom she was never happy, especially after their immigration to America. As opposed to her husband, who quickly adapted to America by involving himself in more and more lucrative businesses, "my mother never did."

> She was a brilliant woman, and she was a beautiful woman. When we were growing up in Rockland, she dressed for New York. She used to rouge her face and everything when they didn't do it. She brought that from the Old World. She had a great flair. But I knew she was very unhappy. I had great sympathy for her, because she was misplaced—on land, misplaced socially. She was misplaced in every conceivable way. She didn't want to get married either. Marriage made her very unhappy. . . . And she was sick all her life. She had a sense of humor, but she'd get into bed and stay for several weeks at a time.[11]

Fig. 4. Louise Nevelson (fourth from the left), with her classmates, 1913. Louise Nevelson Papers, Archives of American Art, Smithsonian Institution

As we shall see, almost every aspect of this depiction of Mrs. Berliawsky became a central facet of Nevelson's own persona and her subsequent self-representation: a beautiful woman with great flair but unsuited to marriage and profoundly unhappy and given to clinical depressions after she was married.

But we are getting ahead of our story. In an amusing variation on a tale common to East European Jews both in the Old Country and in the New World, Nevelson explained in an unpublished interview that she never was sure what her real birthday was, and why it has been variously reported as September 23 and October 16 (or 17): "When we came to this country, in Russia anyway they didn't write down the dates, so when I had to go to school I asked my mother when I was born, and she said after a certain holiday so—anyway—they put down October 16th of that year [1899]. But years later I became a little interested in astrology, so I asked a friend to go to a synagogue to find out what that holiday was there that year, and they told me September 23, so I took both dates."[12]

In actuality, September 23, 1899, was the fifth day of the holiday of Sukkot (Tabernacles) and so October 16, 1899, was weeks after the end of that holiday, and the fall Jewish festival season as a whole. And so the September date fits more logically into Nevelson's story than October 16—though that too was "after a certain holiday."

But what is absolutely crucial to Nevelson's self-fashioning is her firm belief, repeated countless times in her reminiscences and interviews, that from the earliest age she knew that she was not only exceptional, but an artist. This was her fate, she knew it from birth, and she planned her life based on this self-knowledge. Indeed, her most extended autobiographical interview begins with this point:

> My theory is that when we come on this earth, many of us are ready-made. Some of us—most of us—have genes that are ready for certain performances. Nature gives you these gifts. There's no denying that Caruso came with a voice, there's no denying that Beethoven came with music in his soul. Picasso was drawing like an angel in the crib. You're born with it.
>
> I claim for myself I was born in this way. From earliest, earliest childhood I knew I was going to be an artist. I felt like an artist. You feel it—just like you feel you're a singer if you have a voice. So I have that blessing, and there was never a time that I questioned it or doubted it.
>
> Some people are here on earth and never knew what they wanted. I call them unfinished business. I had a blueprint all my life from childhood and I knew exactly what I demanded of this world. Now, some people may not demand of life as much as I did. But I wanted one thing that I thought belonged to me. I wanted the whole show. For me, that is living.[13]

The first time she revealed this inner, genetically predetermined life plan to anyone, she continued, was when she was nine years old:

> You know people always ask children, what are you going to be when you grow up? I remember going to the library. I couldn't have been more than nine. I went with another little girl to get a book. The librarian was a fairly cultivated woman, and she asked my little friend, "What are you going to be?" And she said she was going to be a bookkeeper. There was a big plaster Joan of Arc in the center of the library, and I looked at it. Sometimes I would be frightened of

things I said because they seemed to be so automatic. The librarian asked me what I was going to be, and of course I said: "I'm going to be an artist." "No," I added, "I want to be a sculptor. I don't want color to help me." I got so frightened, I ran home crying. How did I know that when I never thought of it before in my life?[14]

In the prologue to Glimcher's study cited above, Nevelson repeated this story and answered her own question: she ran away crying because "I was only following the blueprint for my life." And then she directly tied this early self-awareness to the specific nature of her mature art: "My life had a blueprint from the beginning, and that is the reason I don't need to make blueprints or drawings for my sculpture."[15]

I shall soon return to Nevelson's highly romantic (and "High Romantic") notion of an inborn artist. But before doing so, it seems imperative, if a tad impertinent, to call into question the veracity of this early memory—especially since, in this version, she added: "I knew that I was coming to New York when I was a baby. What was I going to do anywhere but New York? Consequently, as a little girl I never made strong connections in Rockland because I was leaving. I told my mother I wasn't going to get married or be tied down. I planned to go to Pratt Art Institute so I could teach and support myself."[16]

In her most extensive interview, however, she related the somewhat more credible story that she heard about the Pratt Institute from her high school art teachers, all of whom she thought went to Pratt, and particularly from a Miss Cleveland. This Miss Cleveland impressed the young Louise Berliawsky with her independence, her sophistication, and her clothes, especially a purple hat and a purple coat—"for Rockland, that was something!"[17] Nevelson admits clearly modeling herself on Miss Cleveland, notably in designing her own rather outlandish clothes—a penchant for which she was known her whole life.

But the young Louise could not fulfill one aspect of her putative childhood self-recognition or replication of Miss Cleveland's experience: Louise married the wealthy Charles Nevelson of New York. In the Glimcher prologue, she wrote, "Well, I did get married, and when I met my husband, I think I willed myself on him because I knew that he was going to propose."[18]

It is not at all clear what this last sentence is supposed to mean, but it is amplified by the story of her marriage as she presented it in her autobiographical interview, published in 1976. Here, in her rather idiosyncratic prose, is how Nevelson began that story:

> I met Nevelson, who was a New York sophisticated man, when I [was] between seventeen and eighteen. Usually you say seventeen until you are eighteen, but let's say I was between seventeen and eighteen because it was the graduation year. It was during the First World War. The Nevelson family in the Wall Street section was in the shipping business. And the government took their ships for the war. Well, some of them were damaged. And we had shipyards in Maine. So they brought some of their ships to Maine. And that is how I met him.[19]

Well, not quite. She continues to spin a rather convoluted tale: there were four Nevelson brothers, all involved in the shipping business though divided by some "spat." They were not only wealthy but also well connected in Washington, with "entrance," as she put it, to Woodrow Wilson. The eldest, Bernard, came to Rockland to inspect work on one of his ships,

and while there "was interested enough to know if there were any people of our kind in this city." He then met Mr. Berliawsky and was introduced to the young Louise (she claimed six decades later that Bernard, who was married, carried on a clandestine correspondence with her, which she interpreted as an invitation to an extramarital affair). But soon his youngest brother, Charles, came to Rockland on a follow-up business trip, and he called to invite her to dinner:

> And I knew that I was in the driver's seat because of the letters. I took my mother into the kitchen and I said "Mr. Nevelson is here, and he's going to propose to me this evening and I'm accepting." After I had educated her that I was not going to get married and live a conventional life, because I was going to be an artist. It was a very important time in my life because I had just graduated from high school and was ready that fall to go to Pratt Art Institute. Well, my mother was bewitched and bewildered. Once I say no and once I say yes and wasn't it hard for her to go along with me? But she trusted me. She said, "You know, it's going to be a hard life, being an artist, to live that way." I said, "It isn't how you live, it's how you finish." And that's exactly what I'm doing.[20]

We can easily imagine a far more credible explanation for all of this: a wealthy Jewish shipowner comes to a small town in Maine on business, naturally seeks out the other Jews in town, and meets a local well-heeled Jewish businessman who has a beautiful and eligible young daughter. The visitor is impressed and recommends the young woman to his unmarried brother, who then meets the young woman on his own visit to Maine and proposes to her, which absolutely thrills her parents—what a wonderful match for a provincial New England Jewish girl, especially the daughter of upper-middle-class East European Jews who felt themselves culturally and economically superior to their lower- and middle-class Yankee neighbors. There is, of course, no way of knowing whether this narrative is closer to what actually happened than Nevelson's presentation, but what does strain credulity is Nevelson's version of willful predestination.

In any event, the marriage did not work out. The new Mrs. Nevelson was allowed to attend music and art lessons, as she desired, but not to live the life of a bohemian artiste to which she later claimed she already aspired. She therefore dabbled in all sort of hobbies, experimented with theosophy, and came to hate her husband's family and social circle, which she consistently represents as wealthy but utterly philistine. "I saw through all that. That's all so superficial. And I think having been brought up in the country, also, knowing pretty much what I was about to do, I couldn't quite reconcile myself to think that that was the height of life."[21] Although she claims that she and Charles had agreed not to have children, she gave birth to a son named Myron (known as Mike) in 1922 and was apparently thrown into a severe postpartum depression that was relieved, she tells us, only by the sight of colored chairs she saw in a shop window, and by an exhibition of Japanese Noh kimonos at the Metropolitan Museum of Art—a style of clothing that the older Nevelson would adapt as her own idiosyncratic signature fashion. "And then I knew and I said 'oh, my God, life is worth living if a civilization can give us this great weave of gold and pattern.' And so I sat there and sat and wept and wept and sat."[22]

She continued to study art both in New York and in Boothbay Harbor, Maine, and at the newly constructed Museum of Modern Art, where she soon hit upon the discovery that changed her life:

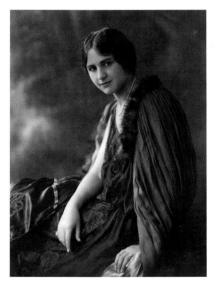

Fig. 5. Louise Nevelson, c. 1922. Louise Nevelson Papers, Archives of American Art, Smithsonian Institution

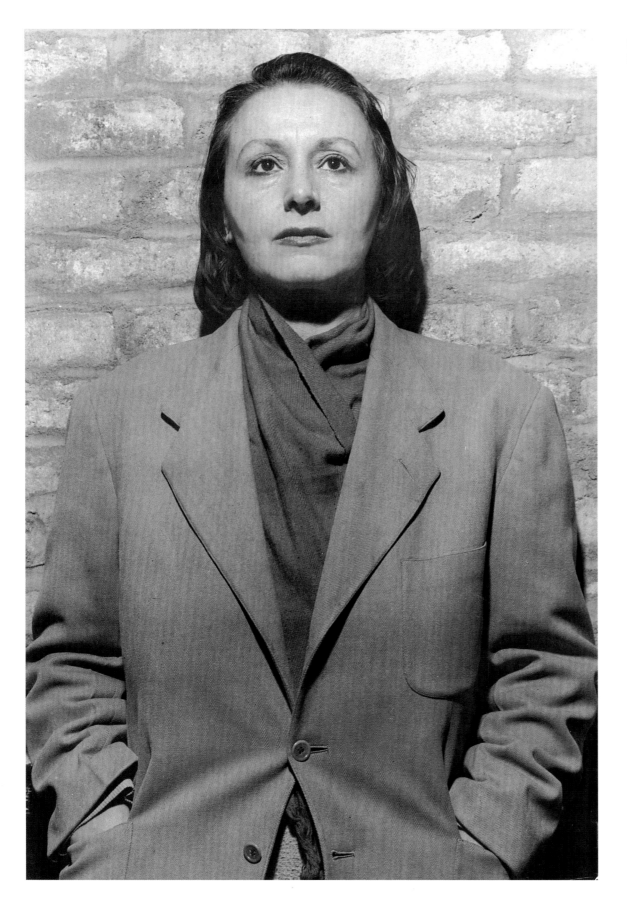

Fig. 6. Louise Nevelson, c. 1954.
Photograph by Jeremiah W. Russell

Picasso had appeared, and Matisse, and that whole movement was *breaking*. I saw the first Picassos and it gave me a definition of structure in the world and every object in the world.

Without Picasso giving us the cube I would not have freed myself for my own work. But suppose I *had* made these without Picasso, say one hundred years ago? No one would look at them. They wouldn't have any meaning. So Picasso changed our thinking and he gave us structure. Of course, when you realize that, you can vary it. But that is your foundation.[23]

Her second formative artistic movement, she continued, was meeting Louis Eilshemius, from whom she learned much about art, poetry, and the world. Nevelson soon came to the realization that she had to go to Europe to study with Hans Hofmann, reputed to be the greatest art teacher in the world. She reports discussing this with her mother, who was very ill but nevertheless encouraged her to go to Munich, promising to give her an allowance and to take care of Mike, and giving her permission to divorce Charles. "She said, 'Look, you don't have to stay married. Before that you were so vital.' By Christ, she sensed it. I was crippled up. . . . If you've got a living force and you're not using it, nature kicks you back." Thus putting into effect her mother's repressed aspirations, Nevelson struck out on her own, divorcing Charles, moving to Munich, studying with Hofmann, and encountering African sculpture in Paris. Her life's plan—or, as she believed, her predetermined blueprint—was now being actualized. This included a philosophy of personal life from which she never deviated: "No more marriages for me. Because I recognized the bondage. I think romance is great, and I think love affairs are marvelous, and I certainly think that sex is here to stay, and I love it. As long as you meet as companions and you perform as lovers, that's fine. But the minute you get that two-dollar paper, a marriage license, that becomes a business. . . . It's a lot of work and it's not that interesting. I wouldn't marry God if he asked me."[24]

Despite this liberated approach, she did feel guilty about leaving her child with her parents. She returned to Maine and then moved to New York with Mike and began to establish herself in the city. On the boat from Europe she met and had a love affair with the author Louis-Ferdinand Céline, whom she found utterly fascinating. She continued to see him in New York, but she claims to have rejected his marriage proposal because "I wasn't about to marry a man who hated Jews."[25] In New York she continued studying with Hofmann and with George Grosz, and she met Diego Rivera and Frida Kahlo, who she claimed had a great influence on her life and art, as did Ellen Kearns, with whom she studied dance for over two decades.

Although her artistic course was well along its "predestined path," she continued to suffer from pervasive severe depressions and seriously considered suicide but she rejected the thought because she had a child to whom she felt obligated. Remarkably, she claims that she did not seek out what would have been the obvious treatment for someone in her time, place, and artistic environment—psychoanalysis—until much later in her life, when she already was a celebrated sculptor and

had problems with the young man who was working with me that I wanted to straighten out. So I thought as long as I was coming to [an analyst] I would like to look into my own life, so as to get a greater insight. And this analyst said, "Mrs. Nevelson, you are the most masochistic person I have ever met."

So I said, "How do you account for my arriving in the art world to the degree that I have, if I'm so masochistic." And he said, "Well, you've done it in spite of

yourself." Now, of course, I can't quite agree with that statement. The nature of creation is that you have to go inside and dig out. The very nature of creation is not a performing glory on the outside, it's a painful, difficult search within.[26]

This is, in fact, the most self-revealing comment in all of Nevelson's autobiographical corpus, and, not surprisingly, it directly contradicts (though she was apparently unaware of the contradiction) the fundamental conceit of her self-fashioning—that her life was all preordained, a blueprint to follow from birth. To be sure, the deepest layers of this "painful, difficult search within" can never be known to us, though the other essays in this volume grapple with the extent to which this search was refracted in Nevelson's sculpture.

What we can see, however, is that the fundamental conceit of her self-fashioning was, for all its fascinating idiosyncrasy, profoundly embedded in two complementary literary and ideational traditions. First, it is all but canonical in the genres of autobiography, memoir, and confessional writing for the author to deny that he or she is penning such a work because of the importance or inherent interest of his or her own life; indeed, in self-consciously "postmodern" autobiographies, this canonical demurral of interest in the self has been transmuted, and thus merely reiterated, in a denial of the very existence of a "self."[27] And so, Nevelson insisted, even before the opening page of *Dawns + Dusks:* "This is not an autobiography, this is not a biography, this is a gift."[28]

But Louise Nevelson was a modernist down to the very core of her being. And as several scholars have noted, one of the hallmarks of American modernism from the 1930s to the 1960s was precisely, if somewhat counterintuitively, its adoption and adaptation of the High

Fig. 7. Mayor John V. Lindsay, Louise Nevelson, and Parks Commissioner August Heckscher in front of *Night Presence IV,* Fifth Avenue and 60th Street, New York, 1972 (later moved to Park Avenue and 92nd Street)

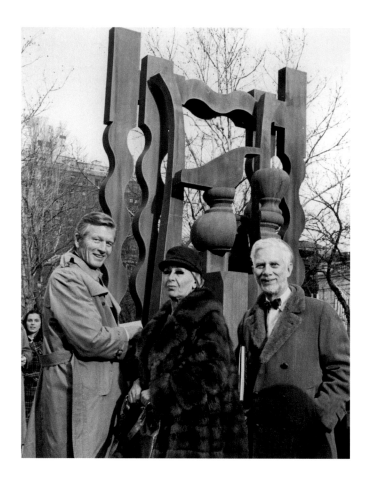

Romantic conception of the artist developed in the nineteenth century. As Harold Rosenberg famously wrote in his essay "The American Action Painters," Nevelson's contemporaries, the Abstract Expressionists, reacted against the politicized art of their predecessors while claiming, of course (as Nevelson did), to belong to the left. "The refusal of values did not take the form of condemnation or defiance of society, as it did after World War I. It was diffident. The lone artist did not want the world to be different, he wanted his canvas to be a world. Liberation from the object meant liberation from the 'nature,' society and art already there. It was a movement to leave behind the self that wished to choose his future and to . . . realize his total personality—myth of future self-recognition."[29]

Louise Nevelson's own particular "myth of future self-recognition" came to fruition rather later in her life, when she was in her fifties, but it continued until her death at the ripe age of eighty-eight in 1988. As she herself put it in 1977, "I think I did a good job for myself, yes."[30] One is forced to agree.

Fig. 8. Louise Nevelson, c. 1972–73. Photograph by Marvin Schwartz

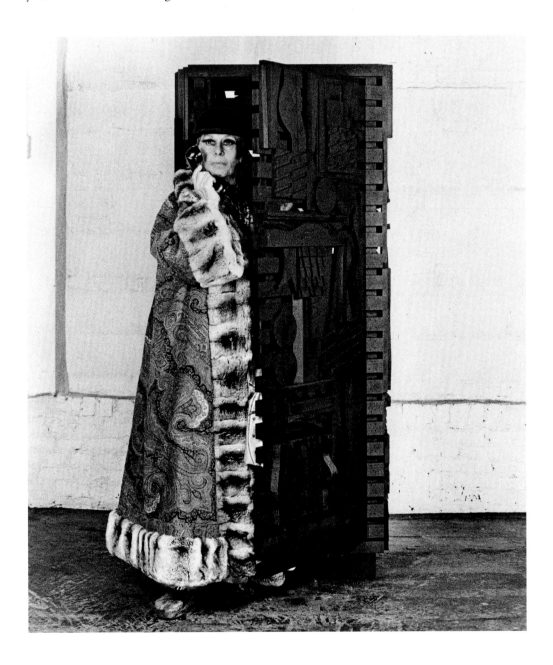

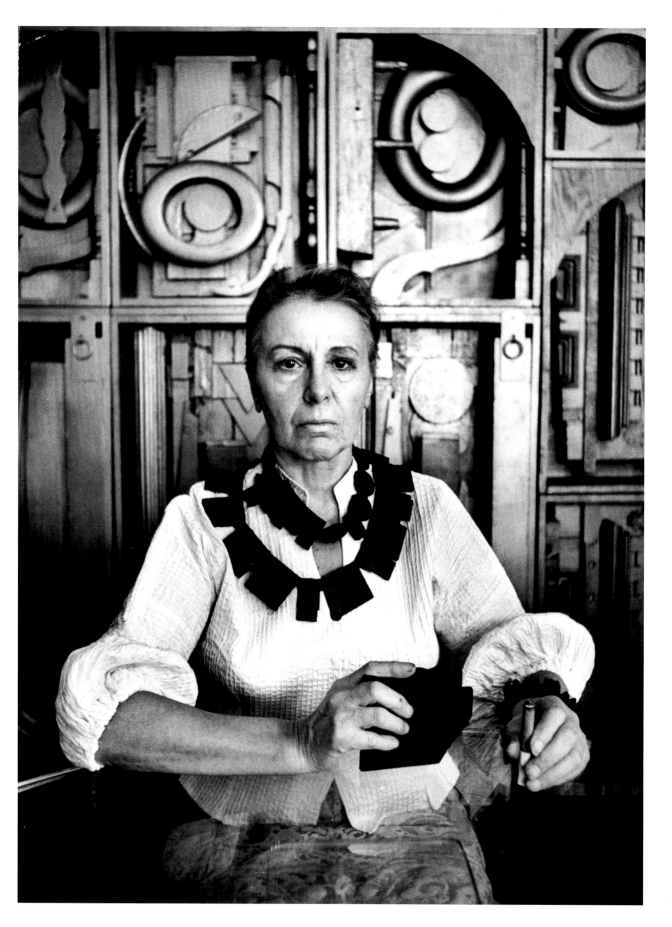

Ugo Mulas (Italian, 1928–1973), *Louise Nevelson with Her Sculpture "Royal Tide II,"* c. 1960. Gelatin-silver print, 15 × 10⅝ in. (38 × 27 cm). Louise Nevelson Papers, Archives of American Art, Smithsonian Institution

ARTHUR C. DANTO

BLACK, WHITE, GOLD MONOCHROME AND MEANING IN THE ART OF LOUISE NEVELSON

But when I fell in love with black, it contained all color. It wasn't a negation of color. It was an acceptance. Because black encompasses all colors. Black is the most aristocratic color of all. The only aristocratic color. For me this is the ultimate. You can be quiet and it contains the whole thing. There is no color that will give you the feeling of totality. Of peace. Of greatness. Of quietness. Of excitement. I have seen things that were transformed into black that took on just greatness. I don't want to use a lesser word. Now if it does that for things I've handled, that means that the *essence* of it is just what you call—alchemy.

—Louise Nevelson

Fig. 1. Plaster sculpture of Joan of Arc from the Rockland Public Library, Rockland, Maine

When Louise Nevelson, relatively late in her career, made the breakthrough in sculpture that established her as a peer of the great American painters of the 1950s, she made a singular use of black paint, which, taken together with their generous scale, gave her works a striking monochrome presence. It is only natural to ask what meaning black had for her as a color: night, death, mystery, the Absolute? It comes as something of a surprise, then, that black was not intended to contribute meaning to her work, but to induce a sort of alchemical transformation in work and viewer together, with monochrome black used only as a means. In a somewhat later stage, black was replaced with white. Though used to similar effect, white also carried a symbolic meaning or set of meanings, a double role carried equally by her next chromatic shift, in which her works were painted gold. This was the last of her experiments in monochromy, and she eventually returned to black as her default color. White and gold were temporary departures, and though I shall discuss them here, Nevelson's reflections on black have a philosophical subtlety that helps explain her feelings on the role and purpose of her art, intrinsically connected to how her works were to be experienced.

In an episode that must have had an immense meaning for Nevelson because it appears in most of her biographies, she recalls the answer she gave when she was nine years old to the question of what she was going to be when she grew up. The exchange took place in the local library in Rockland, Maine, the town where Nevelson spent her childhood. Looking at a large plaster sculpture of Joan of Arc standing in the library, she stated that she was going to be an artist, and then added: "No. I want to be a sculptor. I don't want color to help me" (fig. 1).[1] She frightened herself when she said this, since she had never had this thought before, and one wonders what she might have meant by it. In one interview she mentions that the statue had a patina.[2] I'll speculate that the plaster was painted with the greenish color that simulates bronze. Of course, the greenishness of oxidized bronze is a color, but it is the color of the statue, not of what the statue represents. I think that may be what Nevelson meant. She was not interested in creating an illusion of the kind a polychrome statue might achieve. A monochrome sculpture does not represent a monochrome person any more than a black-and-white illustration of Joan of Arc is a picture of a black-and-white person. In a note, the artist Mark Tansey, who works in monochrome (fig. 2) and likes to quip that he is saving color for his old age, writes: "In the beginning I was attracted to monochrome—black and white—because everything I liked was in it, from reproductions of Michelangelo to scientific illustration to *Life* magazine photos. Because this simple but versatile syntax was shared by art, fiction, and photographic reality, it made possible another level of pictorial fiction where

Fig. 2. Mark Tansey, *The Bricoleur's Daughter,* 1987. Oil on canvas, 68 × 67 in. (172.7 × 170.2 cm). Collection Emily Fisher Landau, New York (Amart Investments, LLC)

Fig. 3. Kazemir Malevich (Ukrainian, 1878–1935), *Black Square* (later version), c. 1923. Oil on canvas, 41¾ × 41¾ in. (106 × 106 cm). Russian State Museum, St. Petersburg

aspects of each could combine. . . . The picture could work as a hybrid form equidistant between the functions of painting, illustration, and photography."[3]

What meaning does the black in a black-and-white illustration then have? The answer, I think, is that it has none, any more than the blackness of the letters do in a printed page. The letters are black because that is the color of the ink—blackness adds nothing to what the printed words say. In a history of art furnished with black-and-white illustrations, the picture of Malevich's 1915 *Black Square* might be in the very black that Malevich used in the painting itself (fig. 3). But this would be entirely coincidental. You are not supposed to infer anything about the color of things from black-and-white pictures of them. One of the achievements of modernism was the dissociation of color in general from visual truth. Matisse's *Blue Nude* was not a painting of a blue woman (fig. 4). When Matisse was asked by someone in 1905 what color dress Madame Matisse was wearing when he painted her portrait—*Femme au chapeau* (fig. 5)—he answered, "Black, of course."[4] What other color would a respectable middle-class French woman wear in that era? But the dress as painted was not black. It was full of different colors, thus prompting the question. So why, when we see Nevelson's black painted sculpture, should we immediately think that the black must mean something specific? People thought that it must mean death or finality—just what Malevich's contemporaries wrongly but understandably felt about his *Black Square*—something negative and pessimistic.

As I see it, Nevelson intended black to have a function but not a fixed symbolic meaning. She used it not as a color but as a way to nullify color in pursuit of something more important. This was an immense breakthrough, but it is difficult to understand what *kind* of breakthrough because we spontaneously see black as a color with symbolic weight. But consider the following example. The calligrapher Chiang Yee once told me about a great Chinese painter of bamboos. A collector pestered him to make a bamboo painting for his collection. The painter, not having black paint near at hand, used instead the red paint that Chinese artists used for their seals. Though grateful to have the painting, the collector asked the painter where he had ever seen red bamboos. The painter responded with a question of his own: Where had the collector ever seen *black* ones? Most drawings—indeed, until recent times, most prints—were in black. Nothing chromatic was implied about the subject drawn,

Fig. 4. Henri Matisse (French, 1869–1954), *Blue Nude*, 1907. Oil on canvas, 36¼ × 55¼ in. (92.1 × 140.4 cm). Baltimore Museum of Art: Cone Collection, formed by Dr. Claribel Cone and Miss Etta Cone of Baltimore, Maryland, BMA 1950.228

Fig. 5. Henri Matisse (French, 1869–1954), *Femme au chapeau* (Woman with hat), 1905. Oil on canvas, 31¾ × 23½ in. (80.7 × 59.7 cm). San Francisco Museum of Modern Art, Bequest of Elise S. Haas, 91.161

and we accept that fact when we appreciate drawings, just as we accept the fact that a bronze sculpture of bamboos is not a sculpture of bronze-colored bamboos. The bronze color of sculpture, like the natural color of marble or of limewood, is the color of the material used, not the color of the object depicted. But if a sculptor painted the bamboos in black, why should the viewer read a black sculpture of bamboos as a sculpture of black bamboos? One of Nevelson's radicalisms was to try to block that inference through her use of black paint. She used black on her objects as a matter of course, just as she would have in making black drawings of them. The black implied nothing about the objects, any more than a black drawing implies something about the objects drawn. Her use of black paint was not like the use of yellows and reds in Anthony Caro's painted sculpture. Nevelson used black paint in a nonliteral way.

In an observation recorded by her associate and disciple Diana MacKown, Nevelson said that she had once made a sculpture of a black wedding cake. Her explanation of the process is somewhat difficult to understand, but she appreciated that it was a mistake. "There are no black wedding cakes," she said.[5] Somehow, it and a sculptural personage she was working on "had become realities." "And so I had to fight to come back." She moved beyond these works.[6] As I see it, a wedding cake has the same kind of antecedent identity as bamboo. One crosses a line when one makes them black. So we know that her "stacked walls," as she called them, were not black realities and that the black she used had, as she puts it, an "alchemical" function. It is as if her works were three-dimensional drawings of realities created by the viewers themselves; they were prompts for the imagination.

With this as background, let's consider an exchange Nevelson once had with a student after giving a lecture at Queens College. In the question period, the student, there to take notes for the school paper, asked, as if to make certain that she had grasped the main facts: "Your work is black and it is wood and it is sculpture."[7] That bare summary has the feel of a description in an auction catalogue, or a museum registrar's inventory: "black painted wood sculpture." "If that's what it appears like to you," Nevelson responded, "then you've missed the whole thing." And she elaborated: "The work that I do is not the matter and it isn't the color. I don't use color, form, wood as such. It adds up to the in-between place, between the material I use and the manifestation afterward; the dawns and the dusks, the places between the land and the sea. The place of in-between means that all of this that I use—and you can put a label on it like 'black'—is something I'm using to say something else."[8]

Minimally, I think of a work of art as consisting of a material object that embodies a meaning. Nevelson goes further. In describing the *object* one is not necessarily describing the *work*. The object is made of wood, but that does not mean that the nature of its material is part of the work's meaning. Paint, for example, was typically used by Nevelson to conceal the

Fig. 6. Louise Nevelson in her studio, c. 1974. Photograph by Ara Guler. Louise Nevelson Papers, Archives of American Art, Smithsonian Institution

material she was using, so the material—wood—though part of the object, need not be part of the meaning of the work. But is the color of the paint necessarily something to be taken into account when describing the work? The function of the black paint, as I began by saying, is to neutralize the question of color, just as it neutralizes the question of the material. These are answers to the question of what black paint *does*. It does these things because Nevelson's aim is, as she puts it, "alchemical." It is transformative. Her aim was not to make a black wooden thing but to *use* a black wooden thing to create an experience of something beyond black and wood. "When you use black it doesn't *hit* you." If it does, then, as she told the girl in Queens, "I've missed the boat." And the same thing holds true if what hits you is the fact that the material happens to be wood.

I say it *happens* to be wood because she makes it plain that she is not interested in the aesthetics of her material. In the fifties, wood sculptors were deeply interested in the reality of wood, in the aesthetics of its grain, in the surface beauty of mahogany, say, or oak, in the way that, when burnished, the surface catches the light. In ceramics there was a similar ethic of material integrity under which one prized the "clayness" of clay—its heaviness, its earthiness, its muddiness, it propensity to crack. It was considered transgressive to hide the reality of clay under paint. Nevelson began with wooden remnants, with scraps, odds and ends, things discarded, left over, displaced, found, free for the taking—boxes, kindling, spindles, table legs, chair backs, odd lots, cedar shakes, bits and pieces, handles, knobs. Part of her alchemy consisted in giving them a second life. Some of them may have been painted in their previous incarnations, or varnished or polished. The rest had the color and texture of raw wood, with splintered ends, saw marks, nail holes. Her alchemy consisted in concealing the differences, once the scraps had been fitted into a chorus of components, by covering them with the black paint that brought them into unity with one another. Their woodiness belonged to their previous life. "I don't use color, form, or wood as such." Everything has been transfigured and made one. "Everything doth change and suffer a sea change into something rich and strange," Shakespeare has Ariel sing. But the transformations in Ariel's song are these: eyes become pearls, lips become coral. If Nevelson were engaged in that order of alchemy, she might have used polychrome, painting each scrap of wood a different color—scarlet, aubergine, amethyst blue, topaz. The result would have been dazzling or garish. But she was after something else—higher, one might say, and more metaphysical:

> Now in the reality I built for myself, what did I do? I took one tone. I gave the work order; I neutralized it by one tone. One of the reasons I originally started with black was to see the forms more clearly. Black seemed the strongest and clearest. But then somehow as I worked and worked and worked it pleased me. You see, one way about my thinking—I didn't want it to be sculpture and I didn't want it to be painting. . . . But—the thing is that it's something *beyond* that we make. My work has never been black to me to begin with. I never think of it that way. I don't make sculpture and it isn't black and it isn't wood or anything, because I wanted something else. I wanted an essence.[9]

I think we must take the statement, "I don't make sculpture and it isn't black and it isn't wood" together with what Nevelson said to the student at Queens: "Of course the material is wood. Of course it's black, and of course it's sculpture." She dissolves the contradiction when she adds, "But those are the mechanics." So we are a long way from the artistic world in which Frank Stella said, "What you see is what you see." Nevelson is saying: What you see

is only what I am using to say something else by means of it—if all you see is what you see, I have failed.

There is a pivotal term in the philosophy of Hegel for which we have no equivalent in English. The word is *aufheben,* and it has in fact three meanings—something is preserved, or something is negated, or something is transcended. Hegel means all three. To experience an *Aufhebung,* one must experience something on three levels of consciousness. One must see that something is preserved but at the same time that it is negated and that it is transcended. This is the way the "mechanics" of wood, black, and sculpture operate in the experience of Nevelson's work—or the way she hoped they would operate. We see them but put them behind us, for we are now in a new realm. One function of painting the various fragments (or fragmentlike components) all one color is to convey the fact that they have been given a new role to play, a new functional identity in a large work of art. A piquant example would be the toilet seats that appear in *Royal Tide II* (see fig. 10). They are unmistakably what they are, so their identity is preserved. But that identity is negated by the way they are painted and fitted into a new complex in which identity is transcended. Giving the work a title marks this transcendence. (A separate study might be made of Nevelson's titles. They are always high-flown and poetic. Once she found herself as an artist, she rarely resorted to *Untitled.* Her titles were opportunities to give the imagination a shake.)

Her great 1958 exhibition *Moon Garden + One* was intended to be a single work consisting of the gallery space together with the extraordinary array of stacked walls and other pieces—including her first masterpiece, *Sky Cathedral* (fig. 7). She had all the functional furnishings in the gallery—the chairs, the desk, the tables—removed. Had the room been unlit, as Nevelson wished, the entire room, in effect, would have been monochrome (if it makes

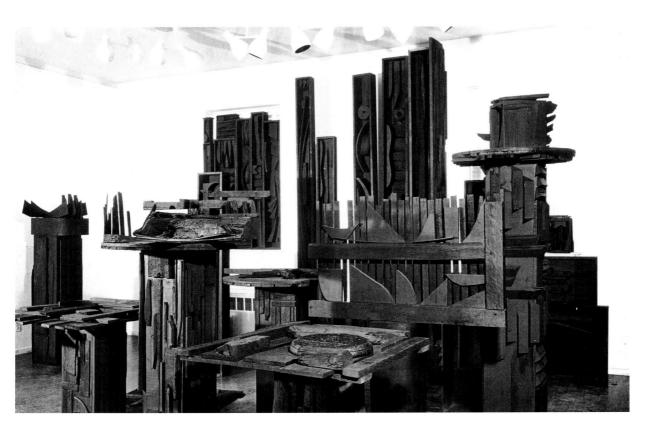

Fig. 7. Installation view of *Moon Garden + One* at Grand Central Moderns, New York, 1958

sense to speak of a dark unlit space as monochrome). Visitors to the exhibition would be engulfed in darkness, in which, bit by bit, the eyes would adjust, using contrasts to find the boundaries between the forms. The black with which the forms were painted would have served the same masking function as the room's own darkness: "As she attempted to relate each black construction to the next, she envisioned the gallery as one gigantic sculpture or 'ensemble.' 'Everything has to fit together, to flow without effort, and I too must fit,' she explained to a *Times* reporter."[10] And I think the intention was that the visitors themselves must fit, that they too were *aufgehoben* and taken into a new reality with a new identity. "This is the universe," she said, "the stars—the moon—and you and I, everyone."[11]

Let's now dwell for a moment on the last item of the student's list—that Nevelson's work was wood, black, and *sculpture*. Nevelson said that she didn't want the work to be painting and she didn't want it to be sculpture. The art world of that time emphasized the autonomy of the different media, which must not encroach into one another's territory. In Clement Greenberg's essay "Modernist Painting," published just two years after Nevelson's *Moon Garden + One* was installed, America's leading critic wrote:

> Each art had to determine, through its own operations, the effects exclusive to itself. By doing so it would, to be sure, narrow its area of competence, but at the same time it would make its possession of that area all the more certain.
>
> It quickly emerged that the unique and proper area of each art coincided with all that was unique in the nature of its medium. The task . . . became to eliminate from each art any and every effect that might conceivably be borrowed from or by the medium of any other art. Thus would each art be rendered "pure," and in its "purity" find the guarantee of its standards of quality as well as of its independence.[12]

Greenberg famously insisted that paintings in their nature must be flat and sculpture in *its* nature must be three-dimensional. Something was either sculpture *or* painting but not both. And, if it was three-dimensional, not *neither* painting nor sculpture either. There was no room in this world for Nevelson's work. In 1965, Greenberg wrote, "The rise of *assemblage*— which can be defined as three-dimensional art in a two-dimensional or pictorial context which yet escapes the confines of bas-relief—has not changed the situation either, although it has made the name of Louise Nevelson prominent."[13] It may have been in self-defense that Nevelson said, concluding her response to the Queens student, that what the latter had fixed on was "three-dimensional [but what the work] should do is bring you into the fourth." And she elaborated: her work must not get "caught in the matter of three dimensions."[14] That means that it must transcend sculpture, conceived in terms of "the mechanics."

Nevelson had a difficult time with the art criticism of the 1960s. Her biographer, Laurie Lisle, writes, "Her work was criticized for its emotionalism by critics and curators adhering to the minimalist aesthetic. Others, notably those in the 'formalist' establishment, were discomforted by her inability to adhere to certain conventions, such as the strict separation of wall-mounted painting and three-dimensional sculpture."[15] It is greatly to his credit that Hilton Kramer, a critic with whom I rarely agree, rejected the critical dogmas of the era and responded to what I think of as the transcendental aesthetics of Nevelson's work. Then, in the 1970s, critical discourse took a very different turn, and identity politics began to inflect everything. But that tended to beach Nevelson as an artistic thinker, though it paid due respect to her gender. Nevelson gained a great deal of sympathy for the difficulties she had

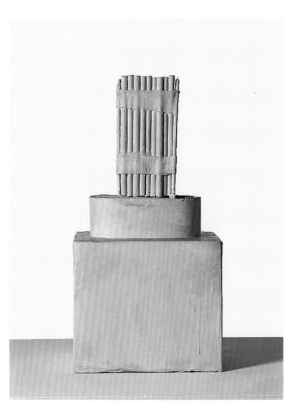

Fig. 8. Cy Twombly (American, born 1928), *Untitled (Roma)*, 1959. Cardboard, wood, and canvas, with synthetic polymer, 26⅜ × 13⅜ × 10⅜ in. (67 × 34 × 27 cm). Kunsthaus Zürich, Gift of the artist, 1994

encountered as a woman making her way in a misogynistic art world.[16] But she was too mainstream by then to receive the fresh critical assessment her achievement merited.

I shall now attempt to put my analysis of Nevelson's use of black into perspective by contrasting it with the white she used for her second epochal show, Dorothy Miller's *Sixteen Americans* at the Museum of Modern Art in 1959. "Sculptural components," Lisle writes, "were old banister balustrades, bits of molding, finials, newels, slats, knobs, dowels, mitered corners, lintels, studs, porch posts, rough old boards, lion-footed legs, even an old croquet set."[17] One of her assistants said, "This was here, that was there, and there was no discussion about why or what or how or anything." That is to say, there was no plan, there was no design. There could be no better word for how Nevelson composed her work than bricolage—a French term that means making do with what is at hand,[18] which the anthropologist Claude Lévi-Strauss used to characterize *la pensée sauvage* ("primitive thought"). When Nevelson painted these components white, the function of the paint was the same as in the black works—to mask the differences between the heterogeneous objects, to unify them under a single color, and to regiment them into a new order. "People think black is the only mysterious color," Nevelson said. "I've been thinking of trying something in white or perhaps Indian red. Brick red, you know? That's a marvelous color."[19]

Any color of paint would serve the purpose of masking and unifying what was at hand (which, in the spirit of bricolage, need not all have been made of wood). But an Indian red sculpture would have been like red bamboos. It would raise the question "Why red?" that could not be answered the way "Why black?" could be. And in any case, Nevelson *did* want white to carry a meaning in addition to having the uses for which she needed flat monochrome paint. This would not necessarily be obvious to a viewer. White is, even more than black, a natural candidate for masking and unifying. We have the expressions "whitewash" and "whiteout." In his sculpture, which also exemplifies the principle of bricolage, Cy Twombly slathers white paint over everything—palm leaves, branches, butt-ends of lumber, nails—without this signifying anything in its own right (fig. 8). But Nevelson's use of white was *declarative*. She was proclaiming a new stage in her work and in her career. In J. R. R. Tolkein's epic of the Hobbits, the wizard Gandolf the Grey battled a monster that stands in the way of the quest. The two combatants disappear over the edge of a precipice, and Gandolf is given up for lost. Later in the story he reappears, and the Hobbits greet him with shouts of "Gandolf the Grey!" He responds: "No. It is now Gandolph the White." He has earned through his heroic action a spiritual promotion.

The title of Nevelson's work for MoMA, *Dawn's Wedding Feast*, conveys her meaning of white (fig. 9). Its several components—*Dawn's Wedding Chapel, Dawn's Wedding Pillow, Dawn's Wedding Chest, Dawn's Wedding Cake*—are all painted with nuptial white. So were the various columns that constituted the ensemble. Disks representing the sun and the moon rested on two large columns. "It was," Nevelson said, "a kind of wish fulfillment, a transition to a marriage with the world. . . . Now the white, the title is *Dawn's Wedding Feast,* so it is early morning when you arise between night and dawn. When you've slept and the city has slept you get a psychic vision of an awakening, it is like celestial. White invites more activity. . . . I feel that the white permits a little something to enter. . . . White was more festive. Also the forms had just that edge."[20] The forms, as critics at the time suggested, had the lacy quality of gingerbread decoration on white Victorian New England houses. The entire ensemble expresses the ritual hope of a fresh beginning and a new stage of being, as well as a change of social status as expressed in the idiom of the lacy architectural embellishment. Nevelson's hope as an artist was that some visionary patron would purchase the entire work and "per-

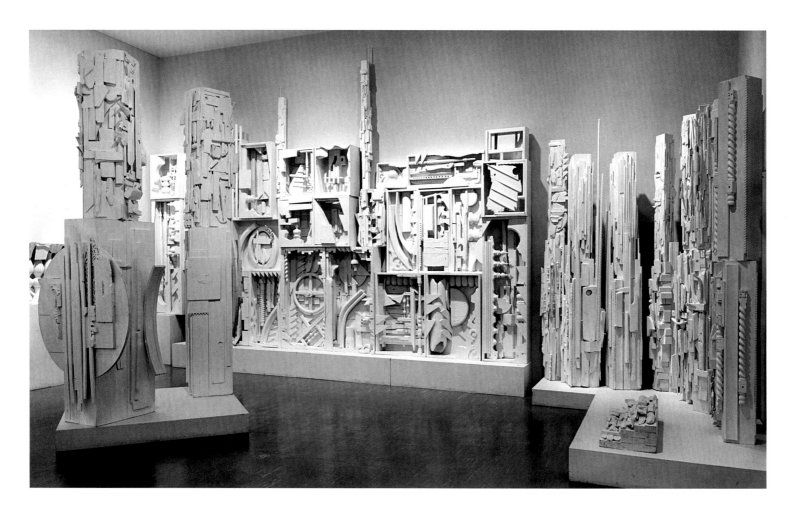

Fig. 9. Installation view of *Dawn's Wedding Feast* at the Museum of Modern Art, New York, 1959

haps enclose it . . . on a roof within a glass house and open to the public as a total environment." The glass would replace the darkness of *Moon Garden + One* with light. This, alas, did not work out, and the constituent parts of *Dawn's Wedding Feast* were separated and, in some cases, recycled.

Nevelson's third choice of monochrome takes the idea of alchemy perhaps too literally. The alchemist's dream, after all, was to transform crass matter into gold. Nevelson's thought was that gold "enhanced the forms, enriched them" (fig. 10). It is a noble element that resists oxidation, and, among other things, it symbolizes purity and goodness. After all, the use of gold leaf plays an important role in religious panels and altarpieces. And it was certainly the element that expressed hope. Nevelson archly observed, "They promised that the streets of America would be paved in gold." I don't think gold quite went with the austerity of the modernist aesthetic in the way that black and white did; it felt baroque. But I think there is a deeper reason. She told MacKown, "Museum people said 'Oh, now, what is going to be your next color?'"[21] And that sounded too much as if she were a fashion designer. "The only thing is that there was something drawing me to the black. I actually think that is my trademark and what I like best is the dark, the dusk. . . . I never felt I explored the ultimate black."[22]

I do not think she wanted her work to be seen in terms of "this year's color," as if she was marketing a line. But the word "trademark" is something of a giveaway. As experimental an artist as Nevelson was, there is something in American art that tends to encourage recognizability, even a kind of branding. It is important for museums and collectors that people be able instantly to identify something as "a Nevelson." She did ultimately go back to black,

DANTO

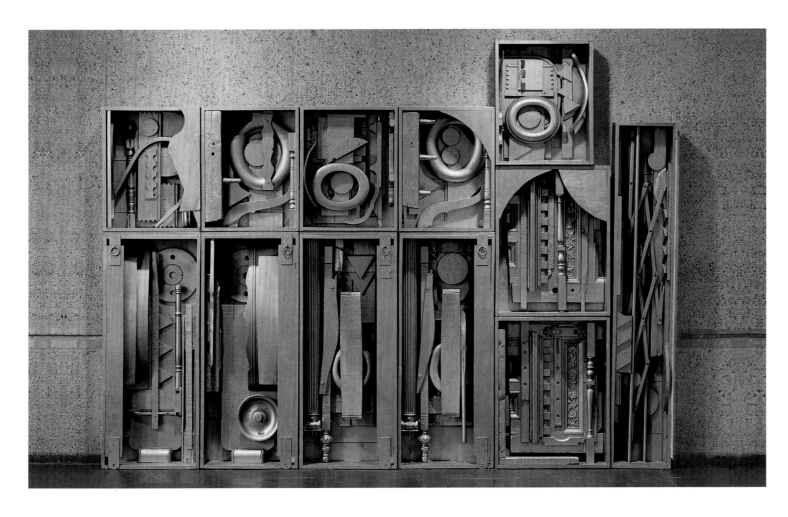

Fig. 10. Louise Nevelson, *Royal Tide II*, 1961–63. Painted wood, 94½ × 126½ × 8 in. (240 × 321.3 × 20.3 cm), base: 3 × 130 × 11 in. (7.6 × 330.2 × 27.9 cm). Whitney Museum of American Art, New York, Gift of the artist, 69.161a–n

the color of her first great successes. Her experiments from this point on were less in colors than in materials, like plastic. Her work was now her signature: the large black assemblage of disparate fragments, distributed into compartments stacked, one upon the other like tenements, immediately said "Nevelson."

The great interpretative question, as everywhere in modern art, is less what any given Nevelson means than what Nevelson means as an archetype, like "Calder," like "Moore," like "Giacometti." The sculptors whose work attained the iconic status of archetypes became natural candidates for public commissions. One would recognize them for what they were as one drove past. That happened with Nevelson of course, perhaps to the detriment of the meaning of her work. I think for that one must move among the looming pieces in such installations as *Moon Garden + One* or *Dawn's Wedding Feast* and feel transfigured, as one would have felt among the great monoliths of Stonehenge or the heads on Easter Island. One probably would not pause before individual monoliths and scan them for details as one would stand in front of paintings, eking out their meaning. That might be another part of the use of monochrome—to divert the viewer from the surface of the components in an environment, to transform them and the environment into something like the stone gardens of Japan, a site of spiritual encounter.[23] The "environment" was what spiritualized black.

HARRIET F. SENIE

LOUISE NEVELSON'S PUBLIC ART

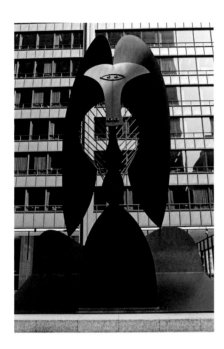

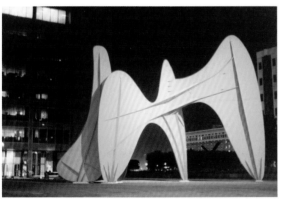

Fig. 1. Pablo Picasso (Spanish, 1881–1973), *Untitled,* 1967. Daley Plaza, Chicago

Fig. 2. Alexander Calder (American, 1898–1976), *La Grande Vitesse,* 1969. Grand Rapids, Michigan

Opposite: Louise Nevelson with *The Bendix Trilogy,* Southfield, Michigan, 1979. Photograph by Balthazar Korab

Louise Nevelson was one of the first artists and the only woman to emerge as a central figure in the public art revival of the late 1960s.[1] During this time, national agencies, civic entities, government programs, cities, corporations, universities, and religious institutions all began commissioning art to adorn their buildings and grounds, and above all enhance their public image. Nevelson's work today is found in all these sites.

In 1967 Louise Nevelson had her first major retrospective at the Whitney Museum of American Art, the Chicago Picasso was installed in front of a new civic building by Mies van der Rohe, and the National Endowment for the Arts (NEA) created its Art in Public Places program (fig. 1).[2] The first NEA-funded sculpture, Alexander Calder's *La Grande Vitesse,* was unveiled in downtown Grand Rapids, Michigan, in 1969, the same year as Nevelson's first public art commission (fig. 2). Although public art today may take any number of forms, at the time Nevelson entered the field, patrons primarily sought large-scale sculpture by artists with art world reputations.[3]

The history of this first wave of public art has been problematic. The art itself has been denigrated by critics as irrelevant to its site, has suffered material decay, and often has been moved and even reconfigured without any input from the artists or their representatives. Then, too, patrons have interpreted the works as emblems of their civic or corporate identities rather than as gifts of art for general enjoyment. It is high time, nearly forty years after this public art revival, to reconsider the place of works of art in public spaces and to revisit Nevelson's unique contribution.

The proliferation of large-scale modern sculpture in public sites was prompted by newly created funding opportunities and facilities for fabricating these works of art.[4] Federal urban renewal initiatives and local zoning ordinances provided economic incentives for the inclusion of open spaces that frequently became sites for art.[5] In 1967, Don Lippincott opened a foundry to fabricate such works and display them on a five-acre field in North Haven, Connecticut, in return for a percentage of future sales (fig. 3). He was "banking on the trend toward large-scale architectural works."[6] Lippincott's services were ideal for artists who worked in a minimal style characterized by a manufactured look. For Nevelson, fabricating works for outdoor sites meant working in metal instead of her favorite material, wood, but she announced with typical bravado, "The new materials like Plexiglas and Cor-ten are just a blessing for me. Because I was ready for them and the material was ready for me."[7]

From the start Nevelson approached this new opportunity in the improvisational manner that characterized her previous gallery and museum work. She discovered stacks of templates for machine forms and had them assembled and reassembled using cranes, creating the models afterward.[8] As she transferred her collagist way of working from wood to metal, she observed, "I found that in my hands . . . it was almost like butter—like working with whipped cream on a cake. I was using steel as if it was ribbon made out of satin."[9] By the time she began her public art career Nevelson had a fully developed public persona. Dramatically dressed, wearing her signature thick black false eyelashes, she enjoyed the opportunities to travel and meet people who were an essential part of her public commissions.[10] Referring to this new work simply as outdoor sculpture, she mused, "How I feel about outdoor sculptures . . . I felt that I had to claim spaces."[11] Elsewhere she observed, "Somehow it gave me another

dimension. It gave me the possibility of maybe fulfilling the place and space and environment that I have probably consciously, unconsciously, been seeking all my life."[12]

Commissions for interior spaces allowed her to work in her signature wood, creating the kind of installations on which her art-world reputation was based. Outdoor sites required permanent materials and called for a visual vocabulary of clearly legible forms somewhere between architectural and human scale. Unlike designated art spaces, these sites usually had no fixed physical or visual parameters. Nevelson developed two basic models for her outdoor art: an open screen (exemplified by the *Atmospheres and Environments* series) and groups of vertical sculptural elements, often evocative of trees or plantlike forms (seen in *Shadows and Flags* at Louise Nevelson Plaza in New York City). The former implicitly included the visual parameters of the site; the latter created a visual dialogue with existing greenery or substituted for it.

THE FIRST COMMISSION: PRINCETON UNIVERSITY

Nevelson's first public commission was part of the Putnam Sculpture Collection at Princeton University. The collection, established in 1968 as a memorial to John B. Putnam Jr., who interrupted his studies at the age of twenty-three to fight in World War II and died while flying a combat mission, was considered an extension of the university's art museum. The Putnam gift was motivated by a belief that modern sculpture was "becoming a symbol of a new creative freedom in man."[13] Nevelson's work was among the first seven sculptures purchased for the campus and the only one by a woman.[14]

Nevelson's *Atmosphere and Environment X* was installed in 1971 adjacent to Firestone Library, where it could be seen from various campus perspectives as well as from Nassau Street,

Fig. 3. Louise Nevelson working with Bob Giza, lead welder and craftsman at Lippincott Foundry, North Haven, Connecticut,1979. Photograph by Pedro E. Guerrero

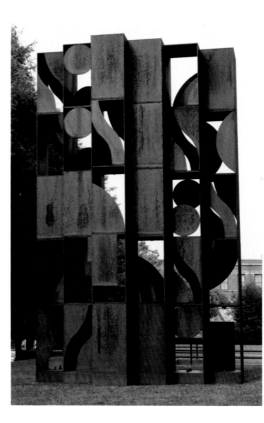

Fig. 4. Louise Nevelson, *Atmosphere and Environment X*, 1969–70. Putnam Sculpture Collection, Princeton University, Princeton, New Jersey

the town's main street (fig. 4). The twenty-one-foot Cor-ten sculpture suggests an architectural wall or screen.[15] As such, it frames and reframes views of the surrounding green and architectural landscape, creating a variety of constantly changing visual images as the viewer moves past it.[16] As Nevelson explained, "The landscape is the *atmosphere* that fills the spaces of the steel *environment;* the two together are the sculpture."[17]

CIVIC COMMISSIONS

Civic entities commissioned modern public art in the hope that it would provide a positive public image and a sense of civic pride.[18] In 1973, Nevelson's *Atmosphere and Environment XIII* was installed in the Civic Center Mall in Scottsdale, Arizona, an open, green parklike setting bordered by the city hall, a public library, and arts center (fig. 5).[19] Describing the visual experience of the work, dubbed *Windows to the West* by the Scottsdale Fine Arts Commission, Nevelson noted, "We look through the inside mass to see a multitude of paintings and photographs. The mountains, the trees and the skies of Arizona."[20] She defined the sculpture's surroundings as essential, determining both its appearance and content.

Although there were some initial complaints that the Cor-ten sculpture looked like junk, there were even more heated objections some twenty-five years later when the Scottsdale Public Art Program considered moving Nevelson's sculpture to make room for a newly commissioned work by James Turrell.[21] Over time Nevelson's work apparently prompted the sense of civic ownership originally intended by the commission.

Much of the new public art of the late 1960s and 1970s was commissioned by and for government sites. The federal government's General Services Administration (GSA) Art-in-

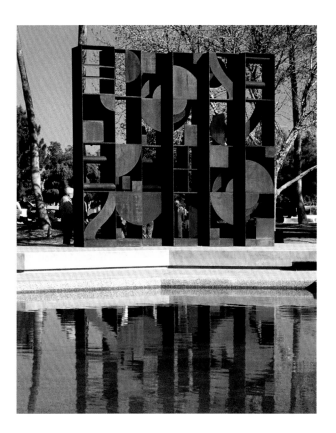

Fig. 5. Louise Nevelson, *Atmosphere and Environment XIII (Windows to the West)*, c. 1972–73. Scottsdale, Arizona. Commissioned by the Scottsdale Fine Arts Commission with assistance from the National Endowment for the Arts

Architecture program, created in the early 1960s and fully active by 1972, allocated a percentage of building costs for art. Under the leadership of Don Thalacker, it became a significant patron.[22] Nevelson's commission for the main entrance foyer of the James A. Byrne Federal Courthouse in Philadelphia was important for both the artist and the GSA program.[23] *Bicentennial Dawn* was installed in January 1976 to mark the nation's bicentennial (fig. 6). Heralded by a celebration replete with fireworks and attended by Philadelphia Mayor Frank L. Rizzo and First Lady Betty Ford, Nevelson's work was extolled by Emily Genauer in the *New York Post* as "more beautiful" than any other public sculpture anywhere in the country, including those by Picasso, Calder, and Henry Moore.[24] At a time when GSA commissions had been criticized as a waste of taxpayer money, the enthusiastic support for Nevelson's work seemed to solidify the program's future.

The interior lobby of *Bicentennial Dawn* allowed the artist to work in wood. Painted white, the installation consists of twenty-nine columns, some reaching a height of fifteen feet, arranged on three platforms covering a total area of nearly ninety by thirty feet. While Nevelson's first white environment, *Dawn's Wedding Feast,* had established Nevelson as a recognized modern artist, the GSA commission confirmed her status as a nationally renowned public artist. Nevelson saw white as "more festive" than black and felt that it "moves out a little bit into outer space."[25] For the site Nevelson selected in Philadelphia, the use of white definitely heightened the work's visibility; it was impossible to miss as you approached the building and walked through the space. The work, however, did not remain there.[26]

As the Philadelphia courts expanded and a larger staff required more offices, the law library was reinstalled in the space that originally housed the Nevelson. To accommodate the sculpture the GSA designed an extension to the lobby entrance, a space enclosed on three sides by glass, replicating the original dimensions of the site but with a slightly lower ceiling.

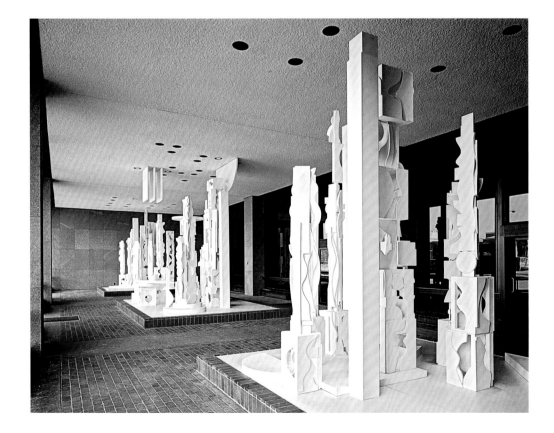

Fig. 6. Louise Nevelson, *Bicentennial Dawn*, 1976. James A. Byrne Federal Courthouse, Philadelphia

Reinstalled in the new space in 1991–92, *Bicentennial Dawn* could for a time still be entered directly from the lobby, but the viewer had to do this deliberately; the work was no longer on everyone's path. After the bombing of the Alfred P. Murrah Federal Building in Oklahoma City in 1995 and the September 11, 2001, attacks on New York and Washington, D.C., security became a primary issue in many aspects of the urban environment. In response to this new climate of concern, Nevelson's work was totally enclosed, now visible only through glass. So, although the sculpture itself remains unchanged, it is no longer experienced as a central element of the building's entrance.

NEVELSON'S NEW YORK SCULPTURES

I see New York City as a *great big sculpture.*

—Louise Nevelson

Nevelson's first public work in her adopted city of New York, *Night Presence IV,* was based on a small wooden sculpture of 1955 and fabricated at Lippincott in Cor-ten (fig. 7). Nevelson donated the twenty-two-and-a-half-foot-high sculpture to the city "in celebration of half a century of living and working as an artist in New York."[27] Installed temporarily at the entrance to Central Park at Fifth Avenue and 60th Street, where it was dedicated on Valentine's Day 1972, *Night Presence IV* was moved the following year to its permanent site at the top of a slight incline on the center mall of Park Avenue at 92nd Street. Nevelson chose the Park Avenue site with her dealer, Arnold B. Glimcher, who recalls that she wanted her work there as a kind of link between Spanish Harlem and the Upper East Side.[28] Indeed, *Night*

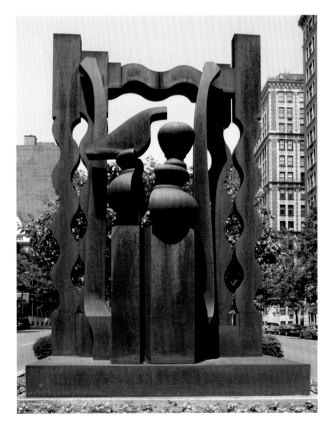

Fig. 7. Louise Nevelson, *Night Presence IV,* 1972. Park Avenue and 92nd Street, New York. Photograph by Robert A. Baron

Fig. 8. Louise Nevelson, *Shadows and Flags* (original installation), 1978, Louise Nevelson Plaza, New York

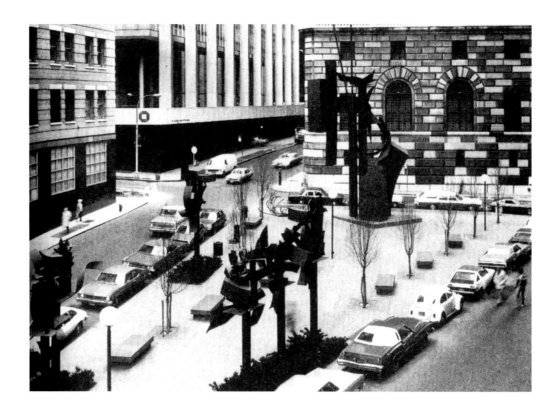

Presence IV, composed of four wavy columns framing a group of abstract shapes evocative of giant chess pieces, creates a monumental gateway to the north, visible to both pedestrians and car travelers.[29] Although few passersby seemed to notice it on a pleasant weekend afternoon in March 2006, all queried said they would miss it if it were gone.[30] Arguably, this sculpture too inspired a sense of civic ownership, albeit one that was not usually expressed and perhaps not even consciously sensed.

A few years after Nevelson gave *Night Presence IV* to New York the city commissioned her to design a traffic triangle—including sculpture, seating, and plantings—across the street from the Federal Reserve building in lower Manhattan. Funding for the sculptures was provided by the Mildred Andrews Fund, the same foundation that sponsored the Princeton sculpture collection. Construction, maintenance, and security, as well as the paving, benches, and trees, were provided by a group of local corporations.[31] After viewing the site from the upper floors of an adjacent office building Nevelson decided to place seven black welded steel sculptures on columns, ranging from twenty to forty feet high, so that they would "appear to float like flags" above the plaza.[32]

In 1977, at the initial dedication of the site then called Legion Memorial Square (bounded by Maiden Lane, Liberty Street, and William Street), Mayor Abraham Beame hailed Nevelson's sculpture as an antidote to a spate of recent violence in the city. "But this is the New York City we care about," the mayor stated, "and want to preserve."[33] A year later *Shadows and Flags* was dedicated by Mayor Ed Koch and David Rockefeller, and the site was renamed Louise Nevelson Plaza (fig. 8). The marriage of high art, local politics, and finance to promote a desirable civic image had become established practice.

Post September 11th, Nevelson Plaza was temporarily altered for security reasons. The Federal Reserve Police, which previously had no exterior security post downtown to monitor trucks entering the building, erected a standard guard booth surrounded by protective fencing at the northwest corner of the triangle. The benches that Nevelson had distributed

asymmetrically around the area were rearranged to form an open corridor completely visible from the booth. The sculpture at the center of the site's southern side was removed because it had been hit by a truck and the subsurface of the street needed repair. With the southwest corner of the triangle now completely void of any elements, the entire composition is badly misaligned. Then, too, the saplings chosen by Nevelson have grown into trees that in spring bloom obscure the smaller sculptures. Only the single giant sculpture centered on the western border was unchanged; it remained a monumental presence even here in an environment of skyscrapers. Recently installed signage across the street referred to the traffic island once again as Legion Memorial Square. There was nothing marking this as Louise Nevelson Plaza, and, indeed, it no longer was.

The former Louise Nevelson Plaza was redesigned by the Lower Manhattan Development Corporation (LMDC) in conjunction with the city's Department of Transportation (DOT) and its Department of Design and Construction (DDC).[34] The street will be repaired and the sculptures removed and restored during reconstruction. Eventually the main sculptural element will be installed on an elevated platform designed for sitting, creating a separate trapezoidal area at the triangle's western border (fig. 9). Newly designed benches will be placed in the remaining triangle on a surface of stabilized gravel inspired by the Luxembourg Gardens in Paris. A new security booth will be painted black, integrating it into the general design but also linking it visually with three of Nevelson's sculptures grouped along the northern leg of the site. The remaining three sculptures will be newly arranged along the southern leg. The plantings will be both different and differently dispersed than those chosen by the artist. The new design, scheduled for completion in fall 2007, looks as if it will be better as a public space than the original, both functionally and aesthetically. Nevertheless, this incarnation, defined once again as Louise Nevelson Plaza, will hardly reflect the artist's design.[35]

Fig. 9. Planned redesign for Louise Nevelson Plaza, New York, scheduled for completion in fall 2007. Client: Lower Manhattan Development Corporation. Design team: Smith-Miller + Hawkinson Architects; Ralph Lerner Architect PC; Quennell Rothschild & Partners, Landscape Architects. Three-dimensional rendering by Jason Carlow, Smith-Miller + Hawkinson Architects

A 1990 study of patterns of corporate collecting concluded, not surprisingly, that businesses acquire works of art mostly for purposes of public relations.[36] Gordon Bunshaft of Skidmore, Owings & Merrill, an architecture firm known for its art patronage, remarked, "Art is for the client, just like he buys good furniture."[37] Art provides a certain aura, changing the perception of corporate identity in a subtle, subliminal way.

In late 1978, Nevelson was chosen, as "one of the world's most acclaimed contemporary artists," to create a sculpture for Bendix corporate headquarters in Southfield, Michigan.[38]

Fig. 10. Louise Nevelson, *The Bendix Trilogy*, 1979. Bendix Corporation of America, Southfield, Michigan. Photograph by Balthazar Korab

When the commission was announced, the chairman and chief executive officer of Bendix, William M. Agee, stated, "I am confident *The Bendix Trilogy* will contribute much to Detroit's reputation as Renaissance City," a sentiment similar to that expressed at the dedication of Nevelson Plaza in New York. *The Bendix Trilogy*, dedicated in June 1979, consists of three Cor-ten and aluminum structures painted black (fig. 10). A forty-four-foot-high vertical sculpture and a horizontal twelve-foot-wide piece are installed in an exterior courtyard. Another thirty-foot-high column is sited in an interior atrium, separated from the exterior pieces by a three-story glass wall.

At the dedication Agee observed that Nevelson's sculpture was "helping Bendix develop its corporate personality to its full potential." He acknowledged that the "architectural environment . . . begged for a complement of appropriate art" and praised abstract art for allowing a range of individual experiences and interpretations. "Each of us can and will react in our own way to the way Ms. Nevelson applied her powers of fantastication [*sic*] to *The Bendix Trilogy*." Agee thus acknowledged the function of the sculpture named after the corporation: as corporate public relations, as architectural ornament, and as public benefit. He expected that Nevelson's art would "provide our people with a sense of wonder [and] . . . create a positive state of mind, and make the work environment more refreshing and livable." In other words, he hoped that *The Bendix Trilogy* might function much as art does in a museum setting. Indeed, Nevelson's obituary in *The Detroit News* made no distinction between *The Bendix Trilogy* and the Detroit Institute of Art's *Homage to the World*.[39]

When Bendix headquarters were sold to AlliedSignal the corporation donated Nevelson's sculpture to the Detroit Symphony Orchestra, which was building a performing arts, educational, and office complex on the land surrounding Orchestra Hall. In 1998 the three sculptures now known as *Trilogy* were installed in a courtyard between the office complex and a parking structure. Once again one of Nevelson's public sculptures was transformed in response to changing circumstances, this time of ownership rather than site demands.

Nevelson's largest and most complex indoor public sculpture environment, *Dawn's Forest* (1985–86), was commissioned by Georgia-Pacific Corporation and Metropolitan Life Insurance Company (Ga-Met) for the Georgia-Pacific Center in Atlanta. At this late stage in her public art career, Nevelson created installations using parts of previous works, transforming them in the process—re-collaging them, as it were. The largest central column of *Dawn's Forest* dates back to 1971, and other elements, extending from the western lobby corner to the eastern end of the mezzanine, were completed in 1976. The maquette of 1975–76 was donated to the High Museum of Art in Atlanta by the artist. According to corporate documents, it was "later rescaled as a site specific entity in 1985 for Ga-Met."[40]

An in-house publication reported the unveiling of the sculpture: "*Dawn's Forest* possesses a poetic quality, which exemplifies the extraordinary and mystical presence that has characterized Nevelson's art since her emergence as a major artist thirty years ago."[41] It also linked the sculpture to the branch of the High Museum at Georgia-Pacific Center, evidence of the corporate "commitment to the development of the arts in Atlanta." Information about the sculpture is available in the museum gallery bookstore and posted at the largest element next to the lobby information booth. Without an extensive study of audience response it is impossible to determine whether this deliberate linkage between corporate lobby and art space opens the sculpture to a personal art experience, but it certainly helps to frame it in an art context.

Religion if you feel it, belongs to the world. My sculpture in the Vatican, why not?
—Louise Nevelson

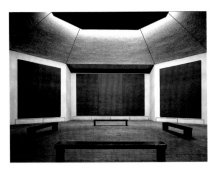

Fig. 11. Henri Matisse (French, 1869–1954), *Chapel of the Rosary at Vence, France*, 1950–51

Fig. 12. Mark Rothko (American, b. Latvia, 1903–1970), *The Rothko Chapel,* Houston, Texas. Northwest, North, and Northeast paintings, 1965–66

Art has long been used in churches and other religious buildings as a tribute, an expression of faith, and a spiritual aid for the congregation. In such a space, much as in a museum, a viewer slows down, looks intently and over time, and may begin in this quiet state a kind of visual meditation that is conducive to spiritual experience, regardless of specific religious affiliation. Traditionally, figurative styles were used to represent various deities and religious narratives. In the twentieth century, abstraction was used to create more generalized spiritual spaces.

In 1947, when Henri Matisse was nearly eighty, he designed a Dominican chapel for Notre-Dame du Rosaire in Vence in the south of France (fig. 11).[42] He depicted St. Dominic, the Virgin and Child, and the Stations of the Cross in abstract black line drawings on three white ceramic murals. He also designed the colorful stained-glass windows, vestments for the clergy (chasubles and copes), and altar cloths. The intense color of these elements stands in dramatic contrast to the otherwise stark white chapel.

In 1964 Dominique and John de Menil commissioned Mark Rothko to create a nondenominational chapel for Houston, clearly affirming their belief in the spiritual content of contemporary abstract art. The Rothko Chapel was dedicated in 1971 as "an intimate sanctuary available to people of every belief" (fig. 12).[43] Nevelson's commission for the Erol Beker Chapel of the Good Shepherd in New York's St. Peter's Lutheran Church, dedicated in 1977, was also intended to create a spiritual space where all would be welcome (fig. 13; see also Stanislawski essay fig. 1). But where Rothko used somber colors to create a deeply meditative space tinged with mourning, Nevelson created something closer to an atmosphere of ecstasy.

Under the ecumenical leadership of the Reverend Ralph Peterson, St. Peter's Lutheran Church evolved from a cultural enclave of German immigrants to a diverse congregation that reflected the changing demographics of the city and its cultural life, with a special emphasis on music and art.[44] Nevelson's commission was part of the development of a new building for the church in the new Citicorp headquarters in midtown Manhattan designed by Hugh Stubbins in the early 1970s.

Peterson believed in "the existence of 'visual spirituality,' something he felt Nevelson possessed and was capable of creating."[45] In order "to provide an environment that is evocative of another place, a place of the mind, a place of the senses," she filled the twenty-eight-by-twenty-one-foot, five-sided chapel with seven wooden sculptures painted white.[46] The north wall holds the *Cross of the Good Shepherd,* three hanging columns called *Trinity,* and floor-mounted candleholders. Abstract reliefs titled *Frieze of the Apostles, Cross of the Resurrection, Grapes and Wheat Lintel,* and *Sky Vestment-Trinity* cover the east, southeast, south, and west walls, respectively.

The dramatic image of Louise Nevelson arrayed in one of her typical brightly colored outfits standing in front of the altar wall evokes Matisse's chapel at Vence—essentially white but punctuated by brilliant color. The abstract forms that make up her various reliefs also echo the shapes Matisse used in his cutouts, but the overall effect is distinctly her own.

Prior to creating the Erol Beker Chapel, Nevelson made works for two synagogues, an interior installation for Temple Beth-El of Great Neck, New York (figs. 14, 15), and an exterior sculpture for Temple Israel in Boston (fig. 16). Although Nevelson was Jewish and contributed

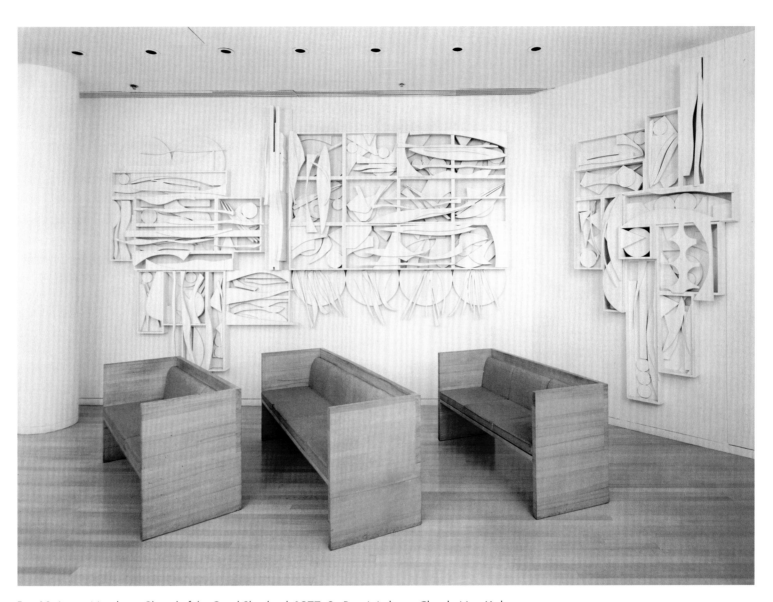

Fig. 13. Louise Nevelson, *Chapel of the Good Shepherd,* 1977. St. Peter's Lutheran Church, New York

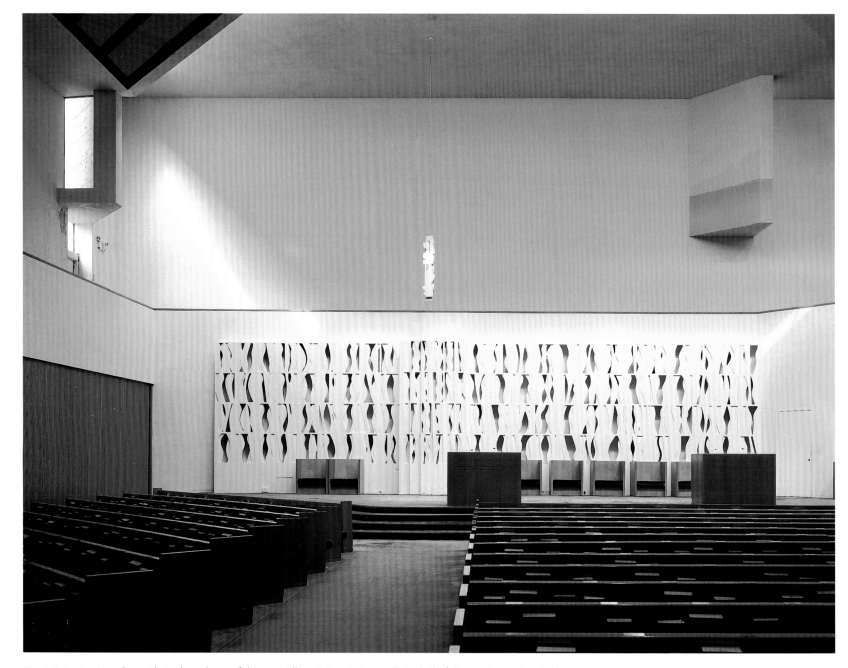

Fig. 14. Louise Nevelson, *The White Flame of the Six Million,* 1970–71. Temple Beth-El of Great Neck, New York

to Jewish organizations, she was not traditionally observant, and there is no indication that she approached these commissions differently from her other public commissions. In 1970 she provided the Bema Wall, Torah Ark, and Eternal Light of white wood for a new chapel designed by Armand Bartos for Temple Beth-El. *The White Flame of the Six Million,* a memorial to Jews who died in the Holocaust, was intended "to stimulate the imagination without disturbing meditation." The ensemble provides a complex visual focus. Although the temple brochure compares the abstract forms that define the wall as flamelike, one could also see abstracted bodies. Given Nevelson's background and interest in dance, she would certainly

Fig. 15. Open ark with Torah scrolls (detail of *The White Flame of the Six Million*), Temple Beth-El of Great Neck, New York

have been familiar with Matisse's various designs for *The Dance;* the first and second versions of 1931–32 seem especially relevant here. Matisse's abstracted curvilinear shapes and insistent use of negative space may have been subtly distilled in this work. The structure of Nevelson's installation is explicitly Jewish; it houses the sacred scriptures of the Torah and an Eternal Light. Its complex forms are unified by color, the overall composition greatly enhanced by the interesting play of light from above filtered through obliquely placed windows.

Nevelson's exterior sculpture for Temple Israel in Boston was part of a planned building expansion. The Architects Collaborative thought a sculpture would "establish an appropriate frame for the formal approach to the Temple and a counterbalance to the strength of the existing portico."[47] *Sky Covenant,* a twenty-foot-high and -wide Cor-ten sculpture dedicated in 1973, was described by Rabbi Roland Gittelsohn as symbolic of the universe.

> Twenty-five geometric boxes at first seem to have no relationship to one another. Disparate lines and curves, shapes and forms are apparently unconnected. But as one pushed beyond the separate boxes to encompass the whole, almost imperceptibly an over-all design emerges, a plan, a purposeful blending. It is virtually impossible to focus for long only on the bottom rungs; irresistibly the eye is drawn upward, as our earthly oneness reaches up in aspiration toward the Divine Oneness. The Creation myth is a Jewish view of the universe in words. *Sky Covenant* portrays a Jewish view of the universe in steel.[48]

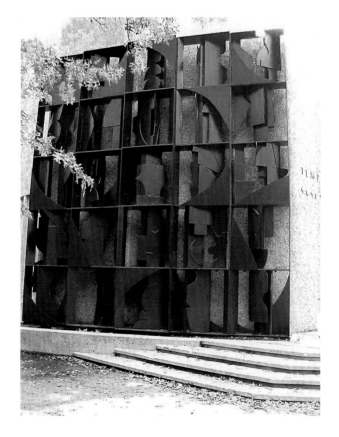

Fig. 16. Louise Nevelson, *Sky Covenant,* 1973. Temple Israel, Boston

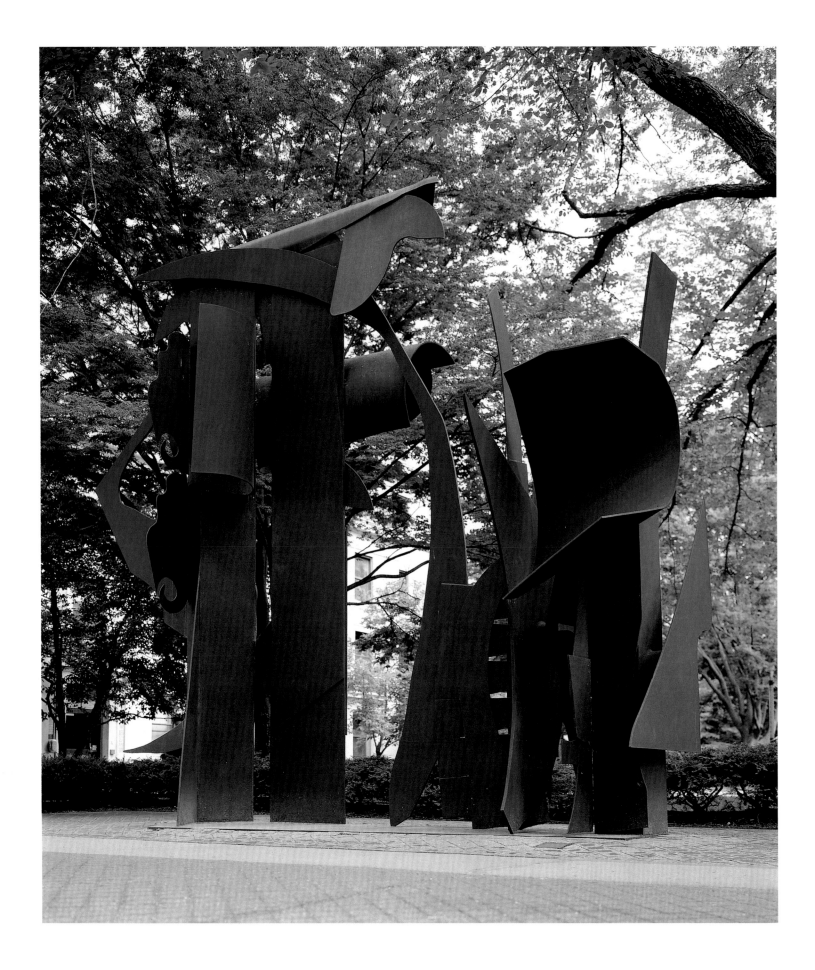

Initially advertised as weathering (self-rusting) steel, Cor-ten seemed like the ideal material for public art, durable and visually interesting with its ever-evolving patina. Over time, however, it has come to be one of the worst maintenance problems in the field. First, there is the issue of rust: people tend to associate it with decay. Then, more seriously, there is the unanticipated corrosion as sheets scale away. Nevelson's *Atmospheres and Environments* series, with its bolted, open boxes, tends to collect and hold water, exacerbating the problem. In 2005 the Fairmount Park Art Association in Philadelphia received a grant from the Getty Foundation for conservation of *Atmosphere and Environment XII* (1969–70). After treatment the sculpture, dismantled in 2002 because its formal structure had become severely compromised, will be reinstalled outside the west entrance of the Philadelphia Museum of Art.[49]

Then there is the issue of graffiti. This was a particular problem with Nevelson's Cor-ten *Transparent Horizon* in front of a dormitory at the Massachusetts Institute of Technology designed by I. M. Pei (fig. 17).[50] It is part of the university's public art collection, and not the only sculpture on campus with graffiti. Indeed, these material issues are not unique to Nevelson's public art, and new treatments are being investigated. Maintenance is also a concern with her wooden works; Nevelson felt that they should be repainted every ten years.[51] But since public art contracts rarely include maintenance requirements, it is left to the patron to care for a given piece.

THE PERILS OF PUBLIC ART

Without regularly scheduled maintenance surveys and treatments, material issues continue to detract from public art works. Nevelson's sculpture, like that of many other artists, has been used as an emblem of urban renewal, enlightened corporate practice, and spiritual focus. Abstract art, open to many interpretations, has often been appropriated by its patrons, obscuring its existence as art. Attributing a specific meaning to abstract art not only supports the premise that it has to have one but may preclude other personal readings the work ideally inspires. Put another way, it obscures the art in public art.

Indeed, public art is both art and public. Frequently, however, it is not respected as art either by its patrons or art critics. Re-siting or reconfiguring a work of art without consulting the artist or acknowledging these changes in appropriate public signage is evidence of this. Nevelson's public art has been largely ignored by the art world or compared unfavorably with her museum work. Nevelson considered her outdoor sculpture to be art and wanted it judged accordingly. In public art, however, other criteria apply as well.[52] Ideally, public art should improve or energize its site in some way, as well as prompt public engagement or use. This last element is the most difficult to gauge because there are few studies of audience response, and it is almost impossible to determine or measure subliminal perception. Nevertheless, all art proceeds from the premise that it makes a difference, that people are personally enriched by it. Art (in public or private spaces) is a gift, a prod to the imagination, a visual surprise, a key to a different reality. When a work of art prompts a sense of public ownership, whatever the circumstances, something important has transpired.

Reconsidering Nevelson's public art prompts revisiting the place of modern sculpture in our midst. Part of a genre once condemned as "plop art" (an art object without any relationship to its site), or a misuse of art in the service of establishment powers, it was superseded

Fig. 17. Louise Nevelson, *Transparent Horizon,* 1975. Massachusetts Institute of Technology, Cambridge, Massachusetts. Commissioned with MIT Percent-for-Art funds, 1975

Fig. 18. Olav Westphalen (German, born 1963), *Extremely Site-Unspecific Sculpture (E.S.U.S.)*, 2000. Stainless steel, fiberglass. A project of the Public Art Fund. Installed in Flushing Meadows, Corona Park, Queens, and in Tompkins Square Park, Manhattan

by work created specifically for its location, emphasizing the public aspect of public art. Site-specificity has had many different meanings in the history of contemporary art; to date there are ongoing interpretations.[53]

Henry Moore once said, "A successful piece of sculpture must work well everywhere. . . . A fine person cannot just be good at a party, he must behave consistently everywhere."[54] In 2000 the Public Art Fund in New York City presented *Olav Westphalen: Extremely Site-Unspecific Sculpture (E.S.U.S.)* (fig. 18). For this project the artist created an "artwork which functions equally well at almost any imaginable site at any time."[55] The mandate that public art must be specific to its site was thus challenged, albeit in a gently ironic and humorous way. More seriously, in the spring of 2006 the Public Art Fund installed five large sculptures (stabiles) by Alexander Calder in City Hall Park.[56] The public art revival of the late sixties appeared, officially, to be reexamining its roots.

Nevelson's signature style, unlike that of her male counterparts, was uniquely based on creating a sculptural environment rather than an art object. Her public art, rather than being site specific, is adapted to its site through placement or configuration. If her sculpture is better suited to a multiplicity of sites than many, or even most, it is because she thought like an "intuitive architect," in terms of total setting.[57] As she once proudly and correctly stated, "I am the grandmother of environment."[58]

PLATES

PLATE 1
Untitled, 1928
Crayon on paper, 17⅝ × 13⅜ in. (44.77 × 33.97 cm)
Whitney Museum of American Art, New York; Gift of the artist, 69.220

PLATE 2
Untitled, 1930
Graphite on paper, 12 × 17¾ in. (30.48 × 45.09 cm)
Whitney Museum of American Art, New York; Gift of the artist, 69.239

PLATE 3

Self-Portrait, c. 1940
Bronze unique cast, artist carved ebony base, 13¼ × 11¼ × 8 in.
(33.7 × 28.6 × 20.3 cm)
Collection of Feibes and Schmitt Architects, Schenectady, New York

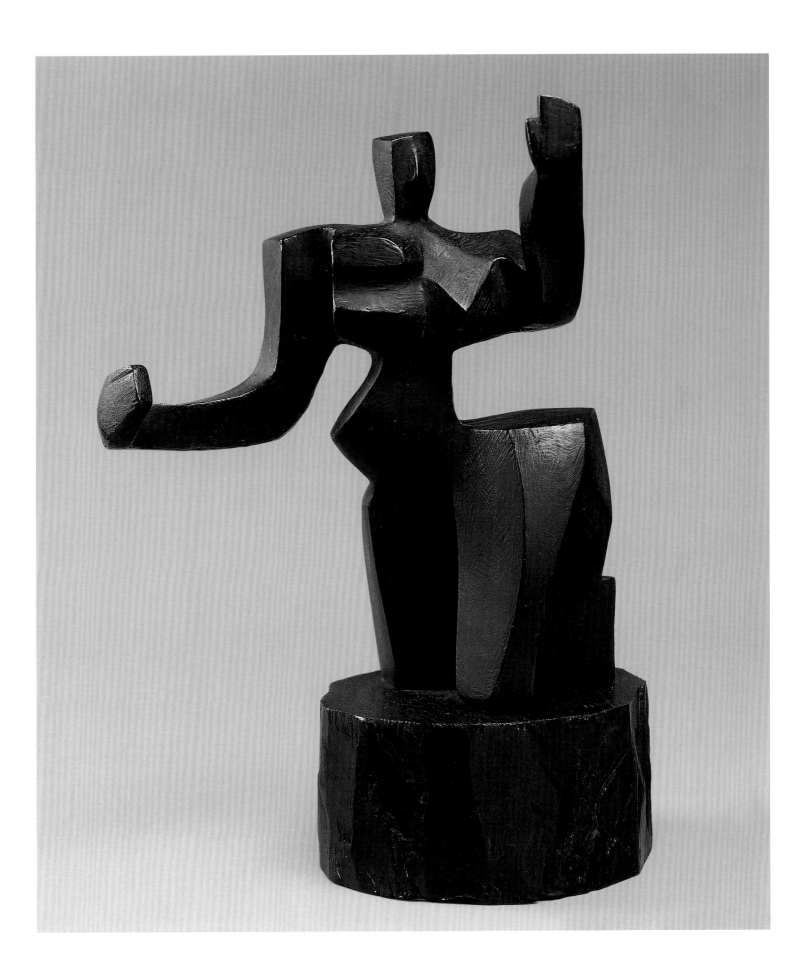

PLATE 4
Portrait of Louise Nevelson, c. 1943
Lotte Jacobi (American, b. West Prussia, 1896–1990), with Louise Nevelson
Pen on black and white photograph, 13 ¹⁵⁄₁₆ × 11 in. (35.4 × 27.9 cm)
Collection Diana MacKown, Ellington, New York

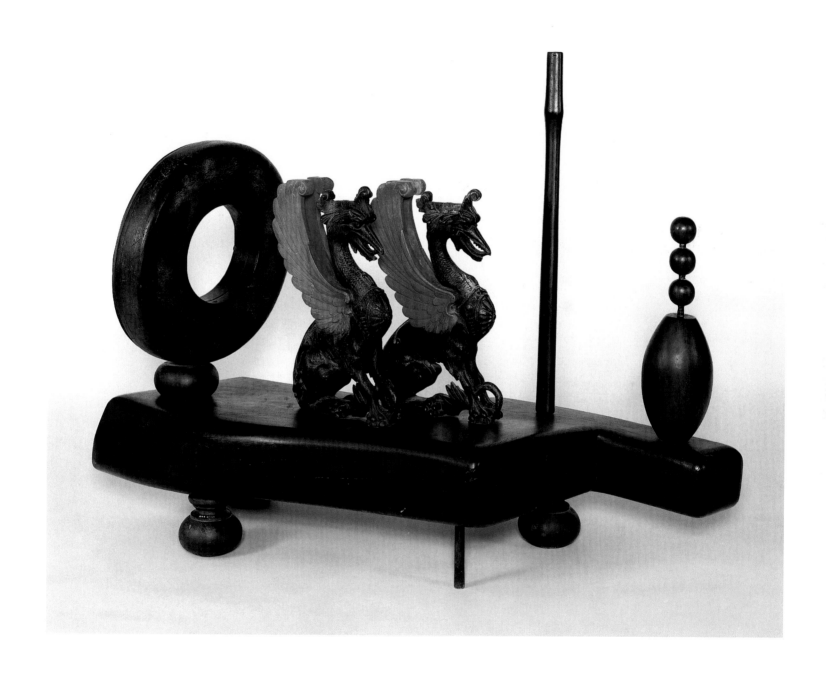

PLATE 5
Ancient City, 1945
Painted wood, 42 × 20 × 36 in. (106.7 × 50.8 × 91.4 cm)
Birmingham Museum of Art, Alabama; Gift of Mr. and Mrs. Ben Mildwoff
through the Federation of Modern Painters and Sculptors, 1961.147

PLATE 6
Moving-Static-Moving Figures, c. 1945 (installation view)
Terra-cotta and tattistone, dimensions variable
Whitney Museum of American Art, New York;
Gift of the artist, 69.159.1–15

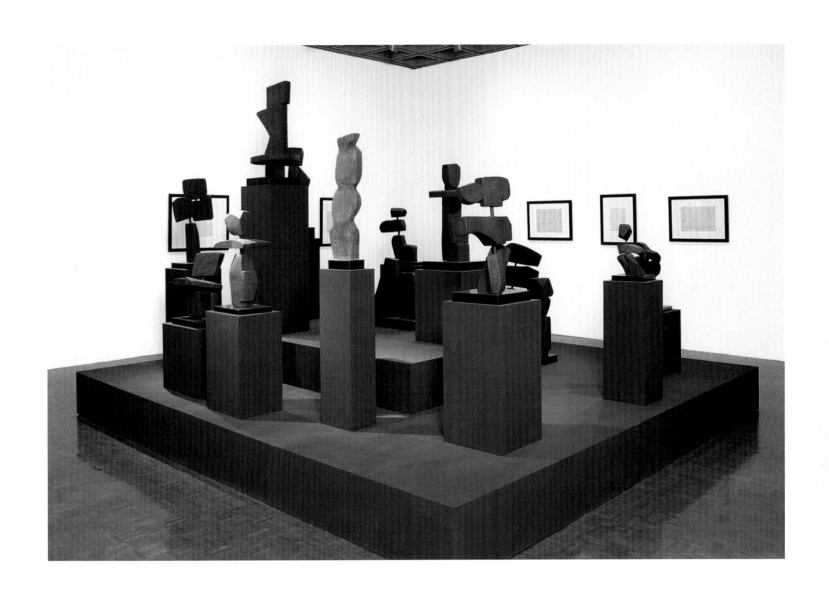

Details of *Moving-Static-Moving Figures,* c. 1945
Terra-cotta and tattistone, dimensions variable
Whitney Museum of American Art, New York;
Gift of the artist, 69.159.1–15

69.159.1

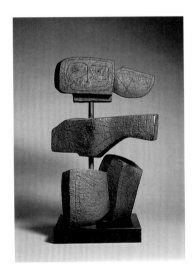

69.159.2

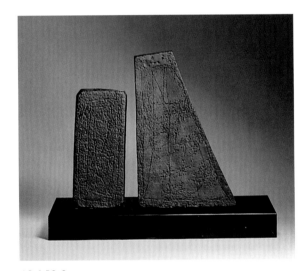

69.159.3

69.159.4

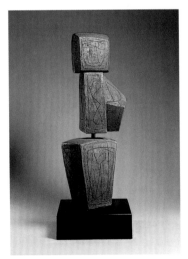

69.159.5

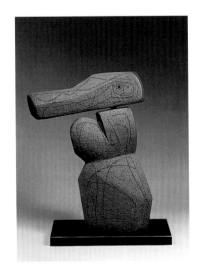

69.159.6

69.159.7

69.159.8

69.159.9

69.159.10

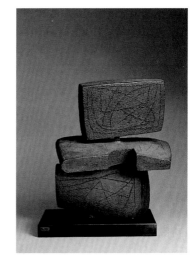

69.159.11

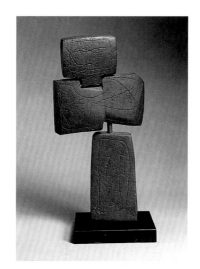

69.159.12

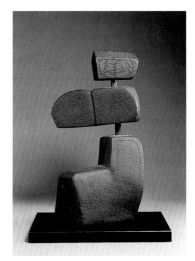

69.159.13

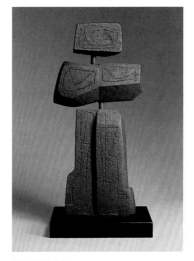

69.159.14

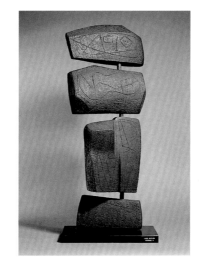

69.159.15

PLATE 7
Black Box (Seeing Through), c. 1950
Wood painted black, 10 × 6 × 3 in. (25.4 × 15.2 × 7.6 cm)
Collection of Feibes and Schmitt Architects, Schenectady, New York

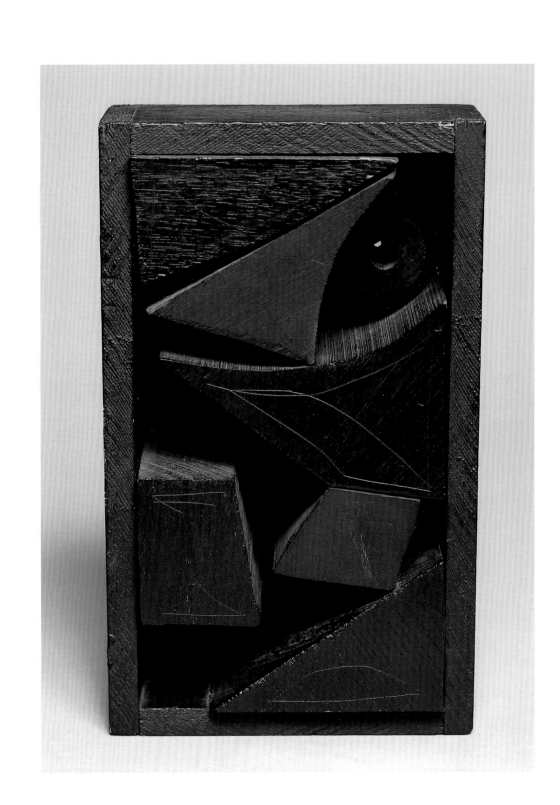

PLATE 8
Sky Cathedral Presence, 1951–64
Wood, paint, 122¼ × 200 × 23⅞ in. (310.5 × 508 × 60.6 cm)
Collection Walker Art Center, Minneapolis, Gift of Judy and
Kenneth Dayton, 1969

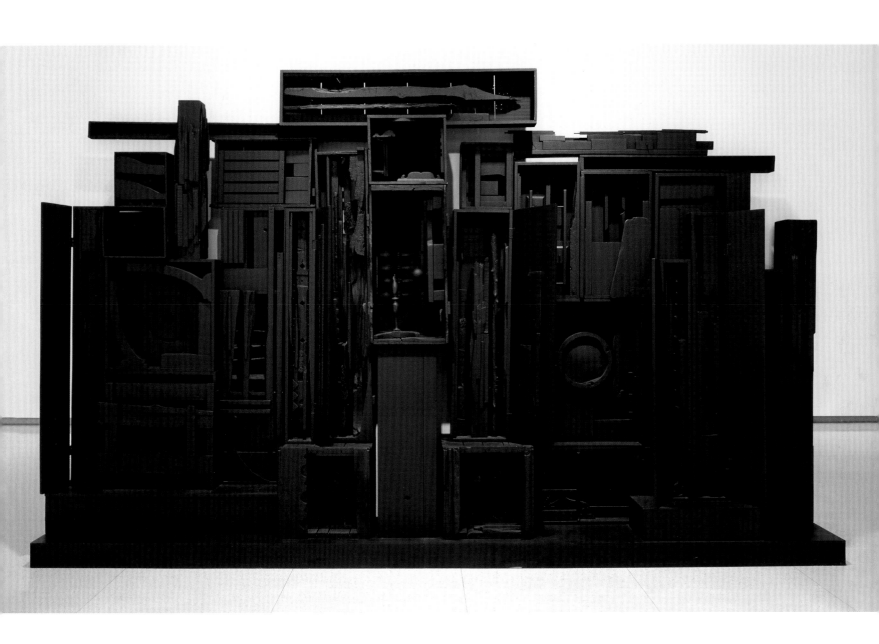

PLATE 9
Figure (related to *Goddess from the Great Beyond*), 1953–55
Etching and aquatint, $13\frac{11}{16} \times 8$ in. (34.8 × 20.3 cm)
Minneapolis Institute of Arts, The Edith and Norman Garmezy Prints
and Drawings Acquisition Fund, P.98.20.1

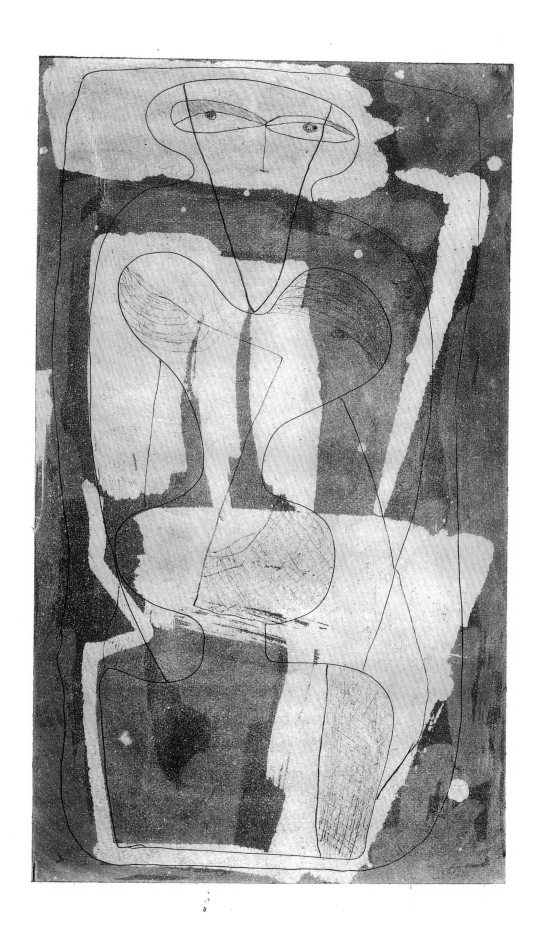

PLATE 10
Sunken Cathedral, 1953–55
Etching and drypoint on Japan paper, 20¾ × 14 in. (52.7 × 35.6 cm)
Fine Arts Museums of San Francisco, Gift of Hans Neukomm, 1999.25

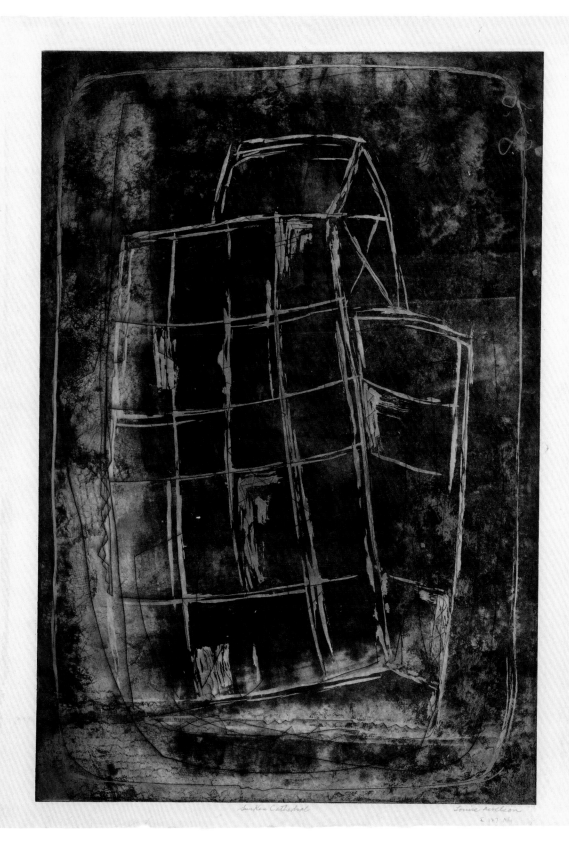

Sunken Cathedral Louise Nevelson
 E 127 No.

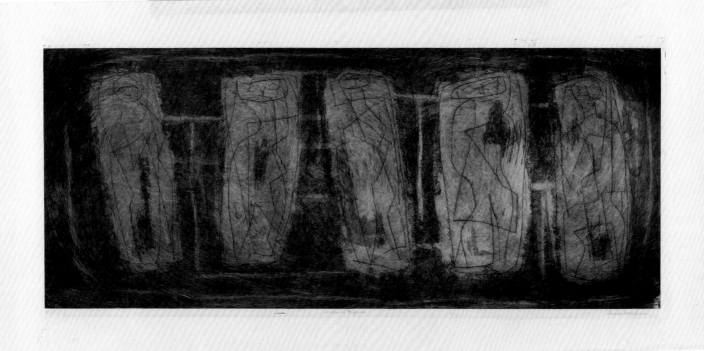

PLATE 11
Archaic Figures, 1953–55
Etching, 10 × 20⁹⁄₁₆ in. (25.4 × 52.2 cm)
Brooklyn Museum, Gift of Louise Nevelson, 65.22.7

PLATE 12
Moon Goddess I, 1953–55
Etching, 20½ × 9½ in. (52.1 × 24.1 cm)
Brooklyn Museum, Gift of Louise Nevelson, 65.22.18

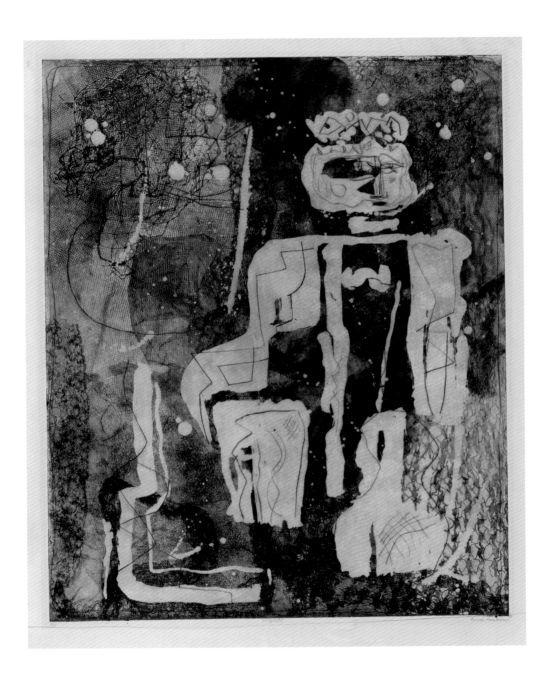

PLATE 13
Majesty, 1953–55
Etching, 25¹³/₁₆ × 19⅞ in. (65.6 × 50.5 cm)
Brooklyn Museum, Gift of Louise Nevelson, 65.22.29

PLATE 14
The King and Queen, 1953–55 (printed in 1965–66)
Etching on paper, 34 × 25¼ in. (86.3 × 64.1 cm)
Published by Pace Editions, Inc.

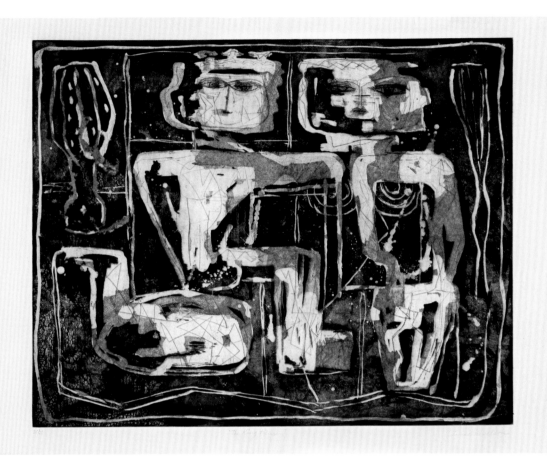

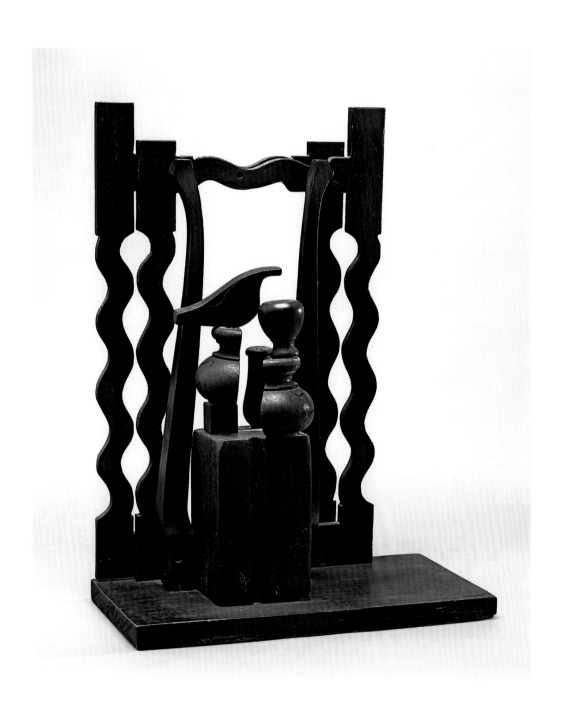

PLATE 15
Model for Night Presence IV, 1955
Painted wood, 28 × 20½ × 10½ in. (71.1 × 52.1 × 26.7 cm)
Collection of the Lowe Art Museum, University of Miami; Gift of the
Pace Gallery and partial purchase through the Lowe Docent Guild
and Museum Acquisitions Funds, 91.0412

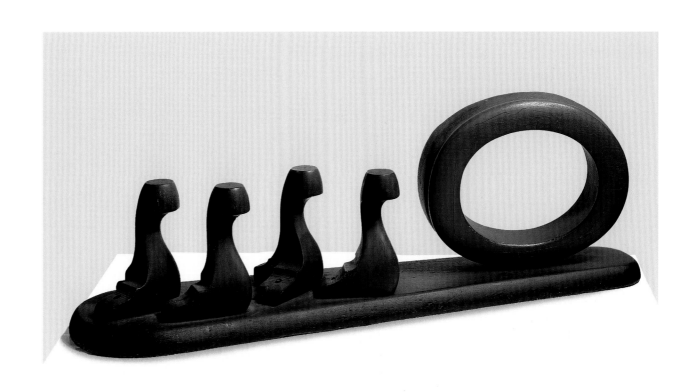

PLATE 16
Night Presence VI, 1955
Painted wood, 11 × 33 × 8½ in. (27.9 × 83.8 × 21.6 cm)
Private collection

PLATE 17
Night Landscape, 1955
Wood painted black, 35 ½ × 38 ½ × 15 in. (90.2 × 97.8 × 38.1 cm)
The Museum of Contemporary Art, Los Angeles, Gift of Mr. and
Mrs. Arnold Glimcher

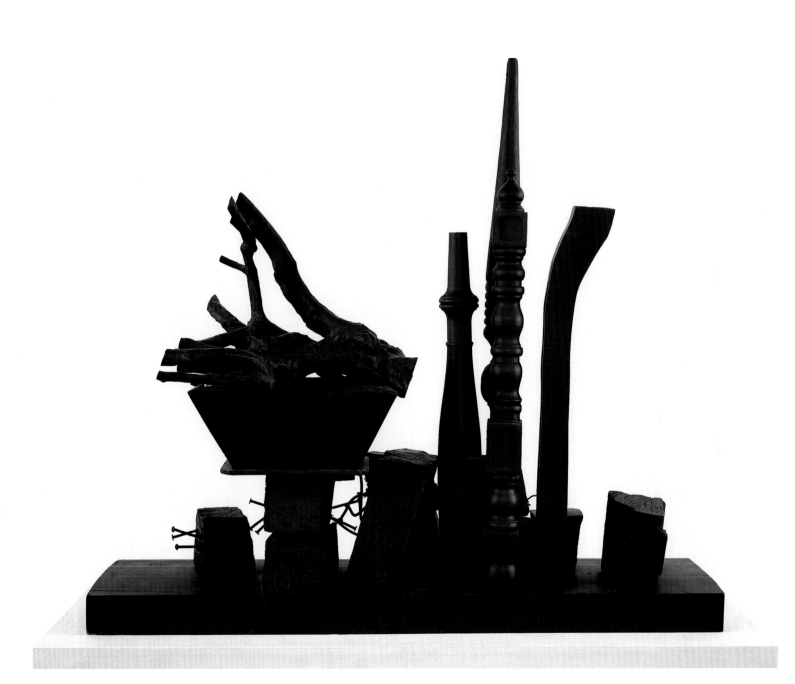

PLATE 18
Indian Chief, or *Chief,* 1955
Painted wood, 48 × 27 × 8¾ in. (121.9 × 68.6 × 22.2 cm)
Barrett M. Linde

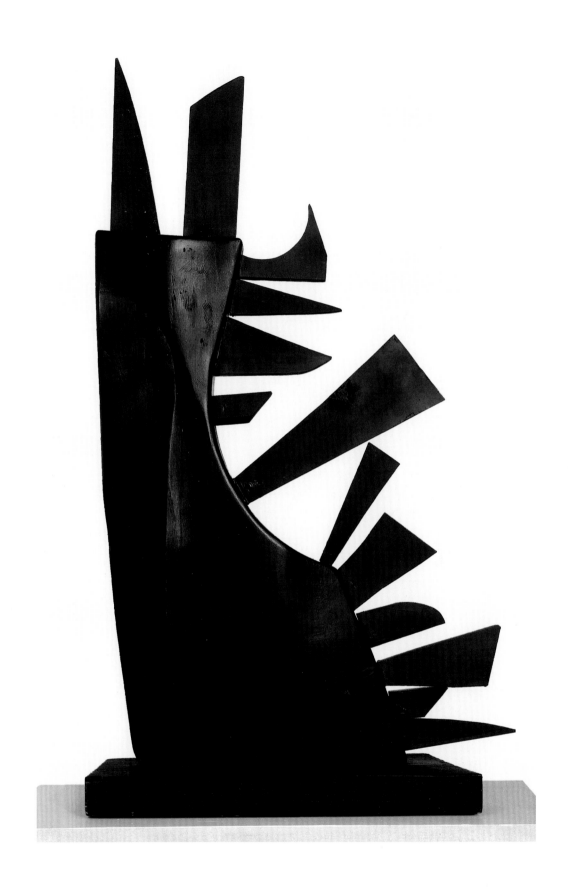

PLATE 19
First Personage, 1956
Painted wood, two sections; front: 94 × 37 1/16 × 11 1/4 in. (238.8 × 94.1 × 28.6 cm); back: 73 11/16 × 24 3/16 × 7 1/4 in. (187.2 × 61.4 × 18.4 cm)
Brooklyn Museum, Gift of Mr. and Mrs. Nathan Berliawsky, 57.23a–b

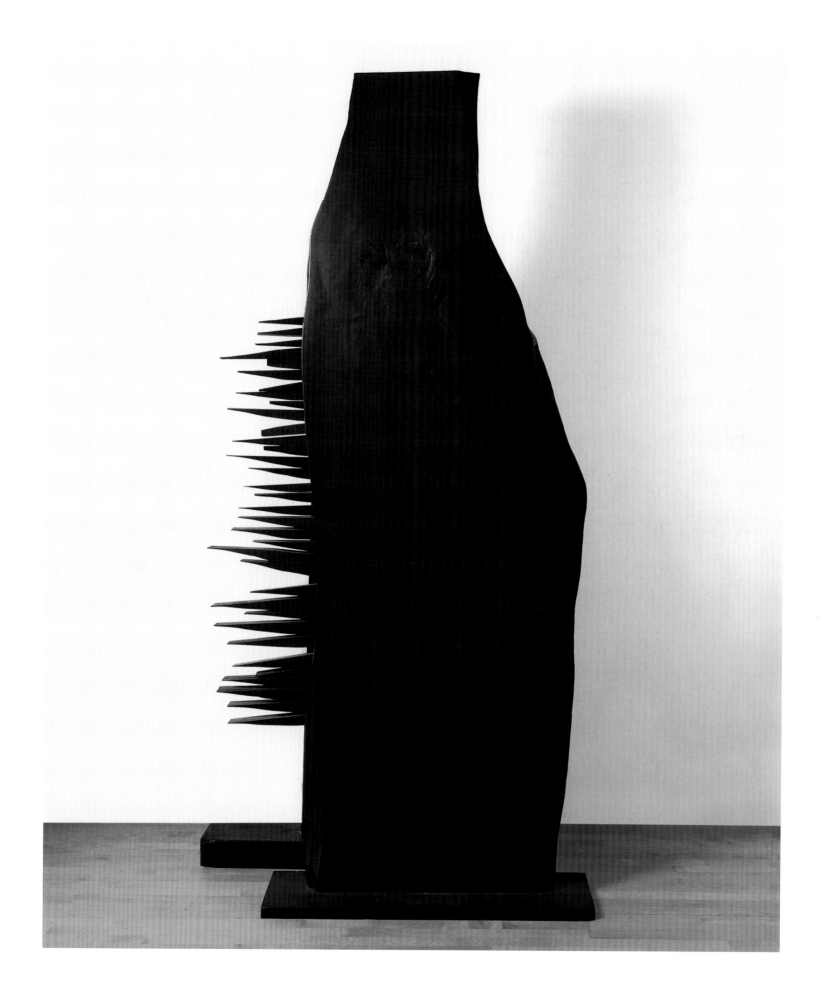

PLATE 20
Moon Fountain, 1957
Wood painted black, 43 × 36 × 34 in. (109.2 × 91.4 × 86.4 cm)
The Museum of Contemporary Art, Los Angeles,
Gift of Mr. and Mrs. Arnold Glimcher

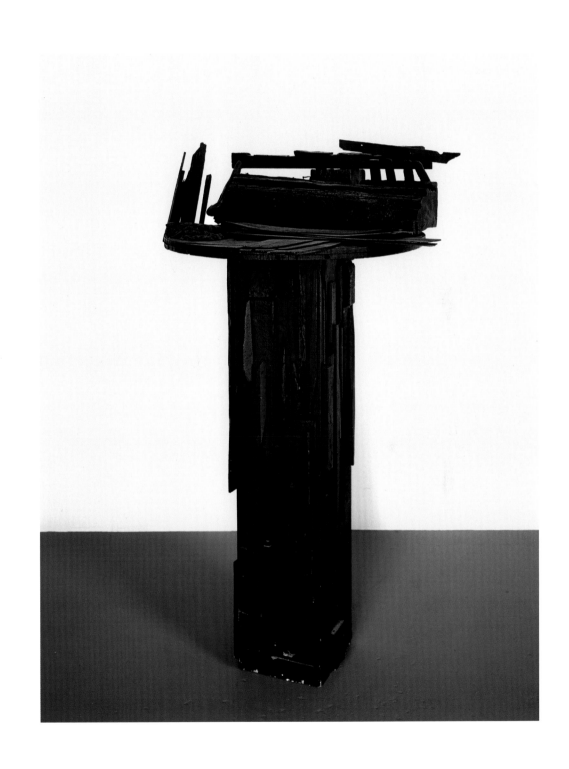

PLATE 21
Black Moon, 1959
Painted wood, 80¼ × 30 × 18 in. (203.8 × 76.2 × 45.7 cm)
Private collection

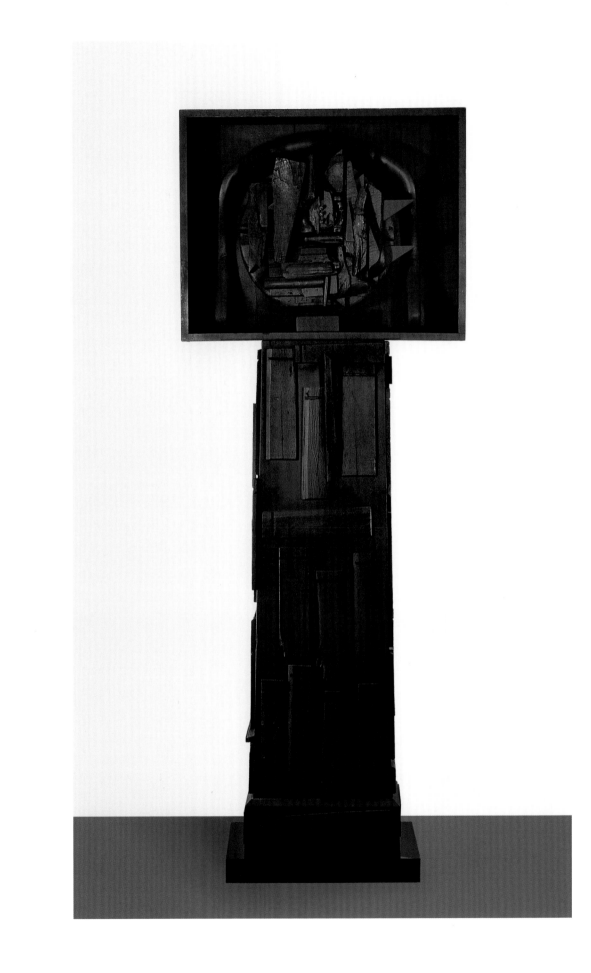

PLATE 22
Sky Cathedral/Southern Mountain, 1959
Wood painted black, 114 × 124 × 16 in. (289.6 × 315 × 40.6 cm)
The Museum of Contemporary Art, Los Angeles, Gift of the artist

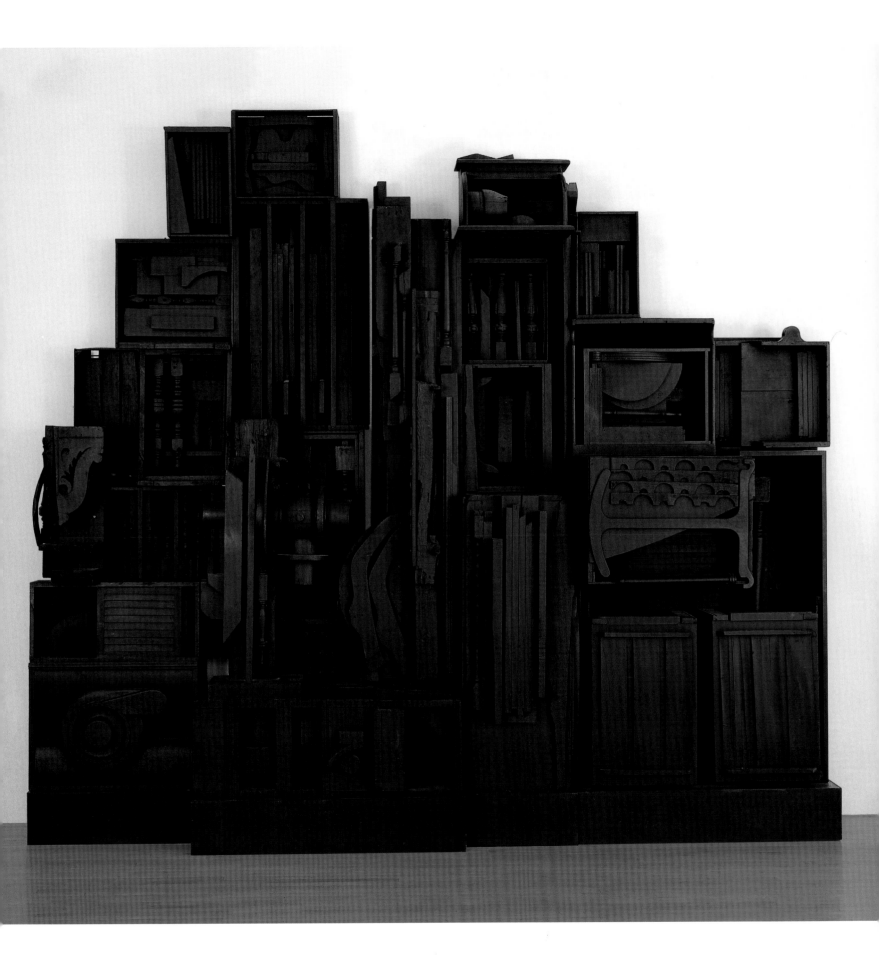

PLATE 23
Sky Garden, 1959–64
Painted wood, 61 1/2 × 99 3/4 × 17 in. (156.2 × 253.2 × 43.2 cm)
Collection of Harry W. and Mary Margaret Anderson

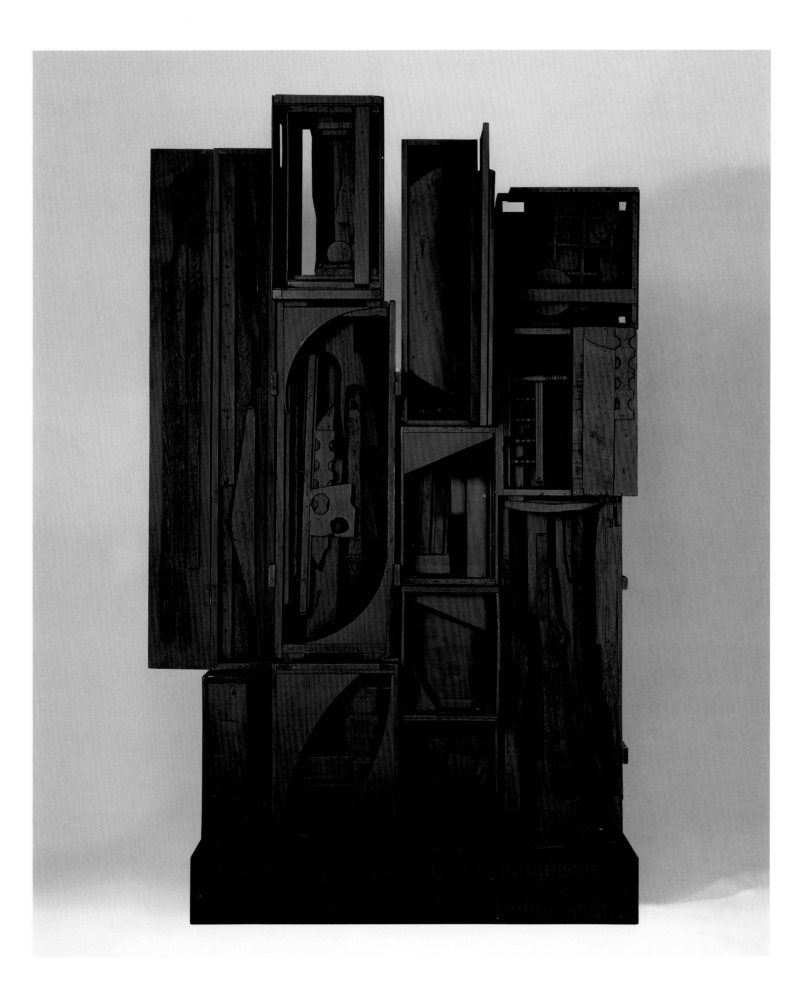

PLATE 24

Bride and Disk, 1959–67 (from *America-Dawn*, 1962; originally from
Dawn's Wedding Feast, 1959)
Painted wood; bottom: 60 × 23 × 23 in. (152.4 × 58.4 × 58.4 cm),
top: 50½ × 18 × 18 in. (128.3 × 45.7 × 45.7 cm), disk: 42 × 41 ×
3 in. (106.6 × 104.1 × 7.6 cm)
The Art Institute of Chicago, Grant J. Pick Purchase Fund, 1967.387

Groom and Disk, 1959–67 (from *America-Dawn*, 1962; originally
from *Dawn's Wedding Feast*, 1959)
Painted wood; bottom: 60 × 24 × 17 in. (152.4 × 61 × 43.2 cm),
top: 50½ × 20 × 19 in. (128.3 × 154.9 × 48.3 cm), disk: 57 × 42 ×
3 in. (144.8 × 106.7 × 7.6 cm)
The Art Institute of Chicago, Grant J. Pick Purchase Fund, 1967.387

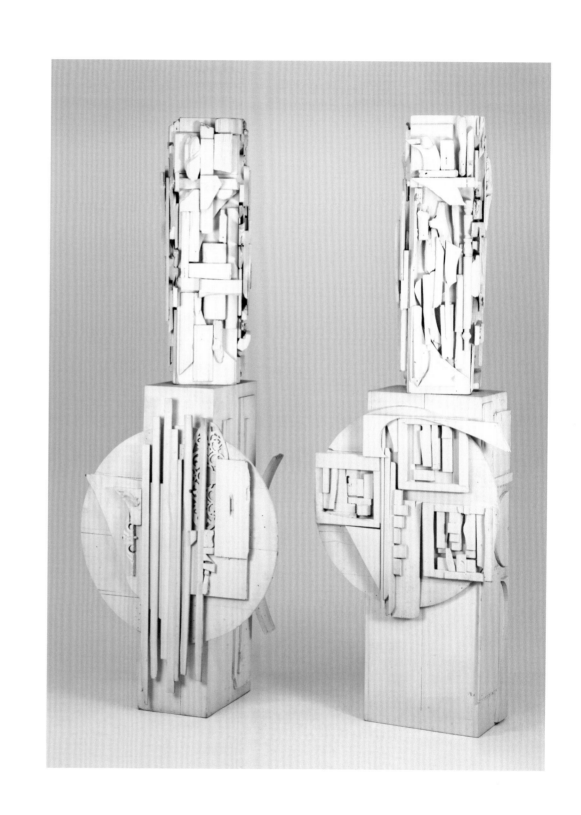

PLATE 25
Dawn's Wedding Chapel I, from *Dawn's Wedding Feast,* 1959
Painted wood, 90 × 51 × 6 in. (228.6 × 129.5 × 15.2 cm)
Mr. and Mrs. Richard S. Levitt

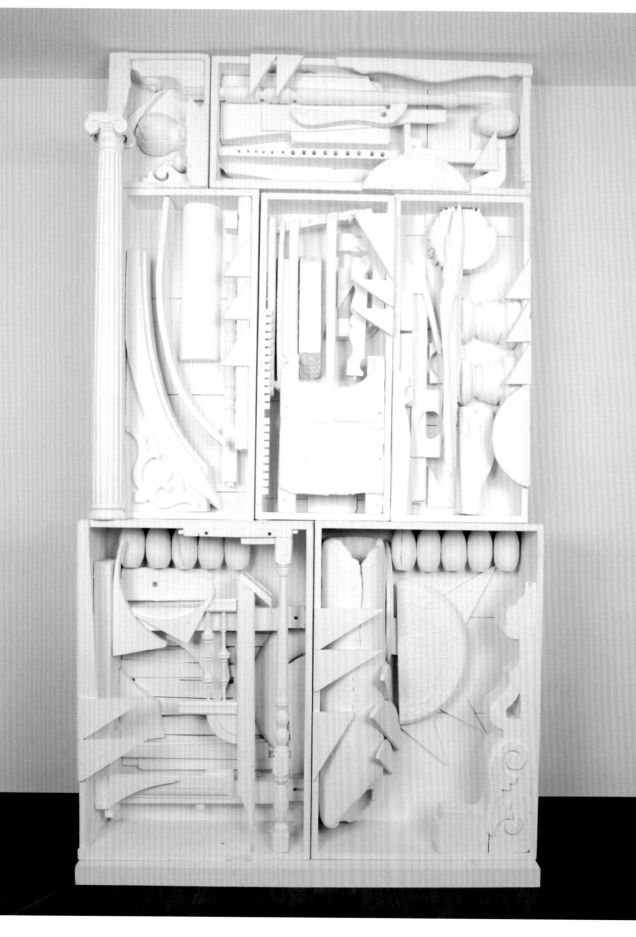

PLATE 26

Dawn's Wedding Chapel II, from *Dawn's Wedding Feast,* 1959
White painted wood, 115⅞ × 83½ × 10½ (294.3 × 212.1 × 26.7 cm)
Whitney Museum of American Art, New York; Purchase, with funds from
the Howard and Jean Lipman Foundation, Inc., 70.68a–m

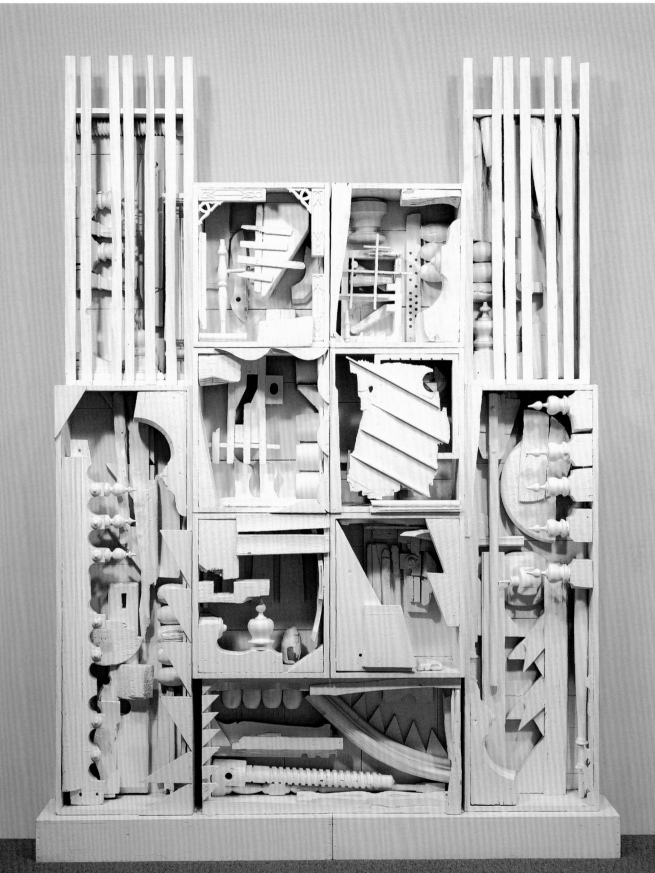

PLATE 27
Dawn's Wedding Chapel IV, from *Dawn's Wedding Feast,* 1959–60
Painted wood, 109 × 87 × 12½ in. (276.9 × 221 × 34.3 cm)
Courtesy PaceWildenstein, New York

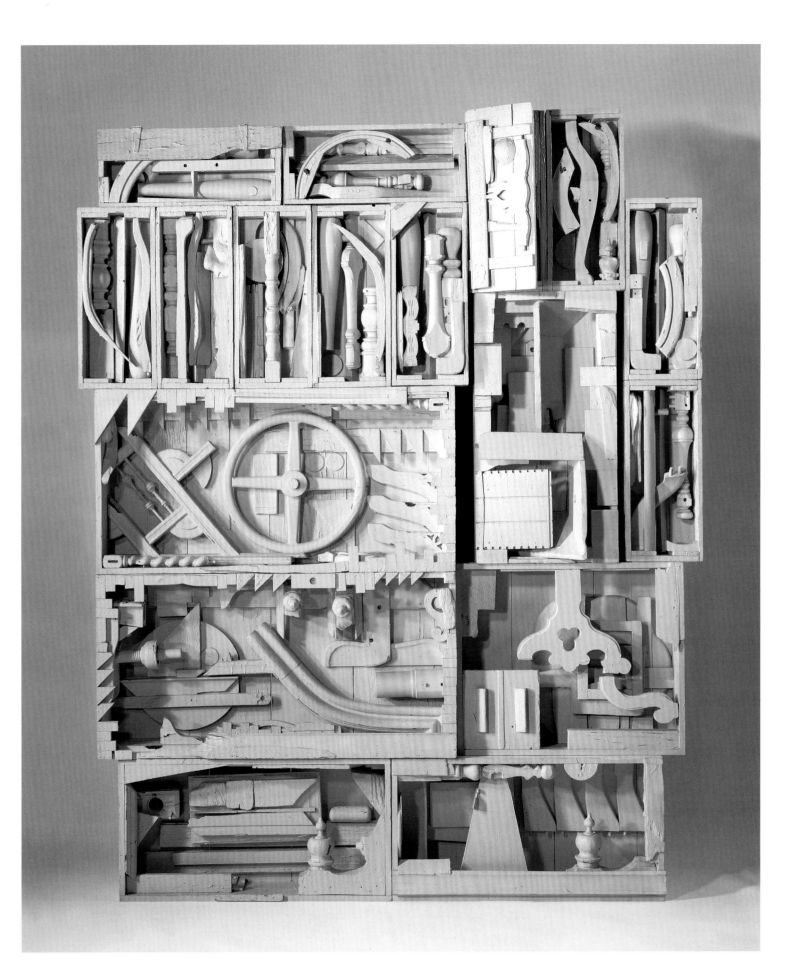

PLATE 28
Case with Five Balusters, from *Dawn's Wedding Feast,* 1959
Wood, paint, 27⅝ × 63⅝ × 9½ in. (70.2 × 161.6 × 24.1 cm)
Collection Walker Art Center, Minneapolis, Gift of Mr. and
Mrs. Peter M. Butler, 1983

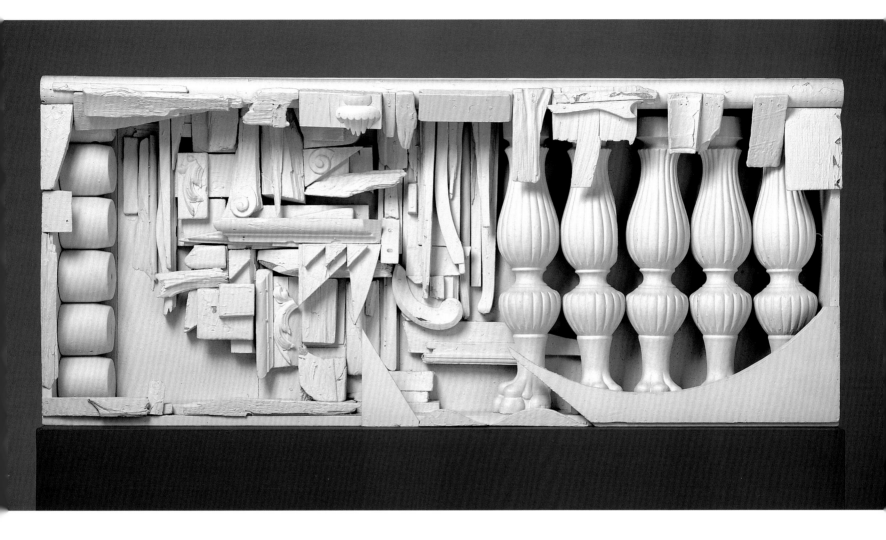

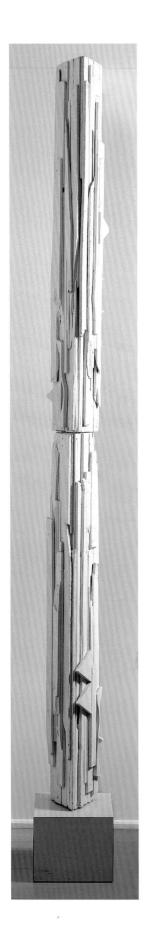
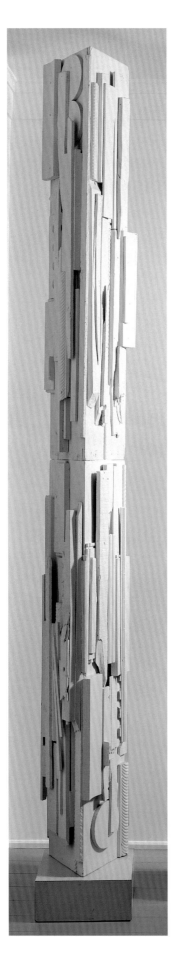

PLATE 29

Dawn Cathedral Column I, from *Dawn's Wedding Feast,* 1956–58
Painted wood, 95½ × 6 × 6 in. (242.6 × 15.2 × 15.2 cm)
Private collection

Dawn Cathedral Column II, from *Dawn's Wedding Feast,* 1956–58
Painted wood, 104 × 10 × 10 in. (264.2 × 25.4 × 25.4 cm)
Private collection

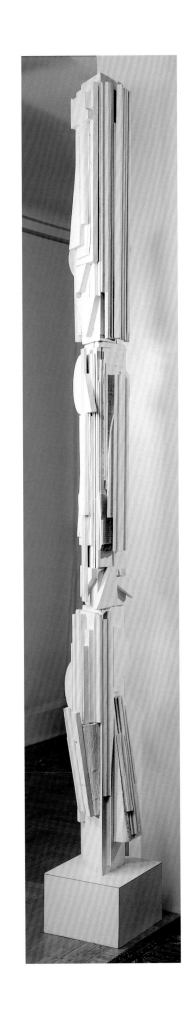

PLATE 30
New Dawn Cathedral Column, from *Dawn's Wedding Feast,* 1956–58
Painted wood, 109 × 12 × 12 in. (276.9 × 30.5 × 30.5 cm)
Merrin Family

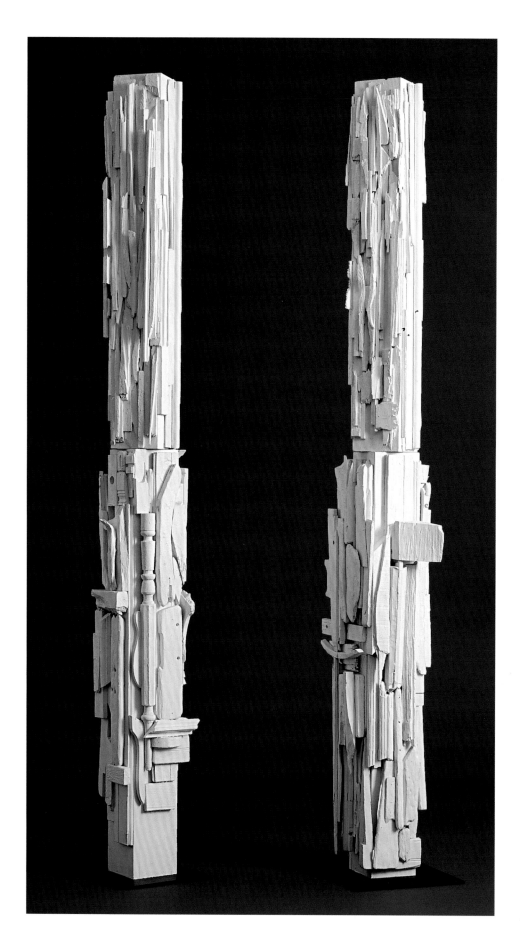

PLATE 31

Column from *Dawn's Wedding Feast,* 1959
Painted wood, 94⅛ × 18 × 18 in. (239.1 × 45.7 × 45.7 cm)
The Menil Collection, Houston, 78–159a

Column from *Dawn's Wedding Feast,* 1959
Painted wood, 94⅜ × 11 × 11 in. (239.7 × 27.9 × 27.9 cm)
The Menil Collection, Houston, 78–159b

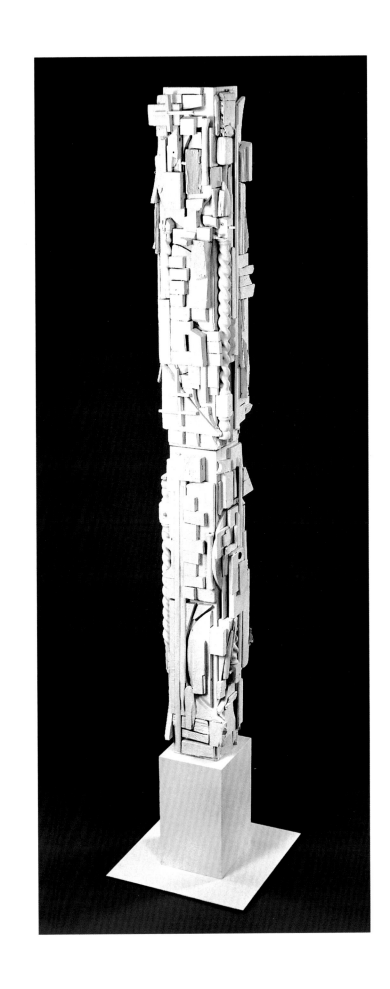

PLATE 32
White Column, from *Dawn's Wedding Feast*, 1959
Painted wood, 92½ × 11½ × 10 in. (235 × 29.2 × 25.4 cm)
National Museum of Women in the Arts, Washington, D.C.,
Gift of an anonymous donor

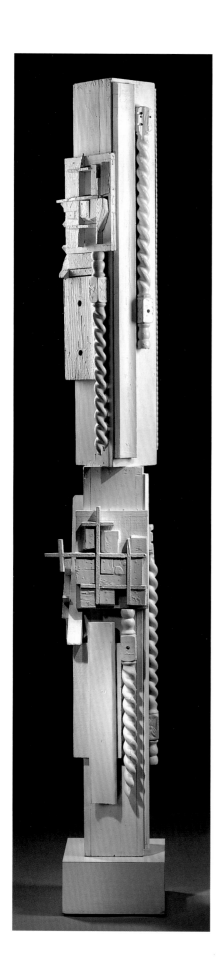

PLATE 33
Dawn Column I, from *Dawn's Wedding Feast,* 1959
Wood and found objects painted white, 92 × 10½ × 10 in.
(233.7 × 26.7 × 25.4 cm)
Collection of the Farnsworth Art Museum, Museum purchase, 1979, 79.81

PLATE 34

Hanging Column, from *Dawn's Wedding Feast*, 1959
Painted wood, 72 × 4½ × 4½ in. (182.8 × 11.4 × 11.4 cm)
Private collection, formerly Dorothy C. Miller Collection

Hanging Column, from *Dawn's Wedding Feast*, 1959
Painted wood, 72 × 5 × 5 in. (182.8 × 12.7 × 12.7 cm)
Private collection, formerly Dorothy C. Miller Collection

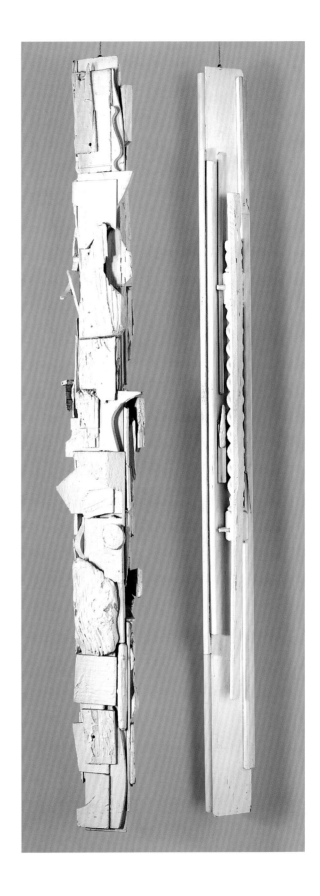

PLATE 35

Hanging Column, from *Dawn's Wedding Feast*, 1959
Painted wood, 72 × 6⅝ × 6⅝ in. (182.6 × 16.7 × 16.7 cm)
The Museum of Modern Art, New York, Blanchette Hooker
Rockefeller Fund, 1960

Hanging Column, from Dawn's *Wedding Feast*, 1959
Painted wood, 72 × 10⅛ × 10⅛ in. (182.6 × 25.7 × 25.7 cm)
The Museum of Modern Art, New York, Blanchette Hooker
Rockefeller Fund, 1960

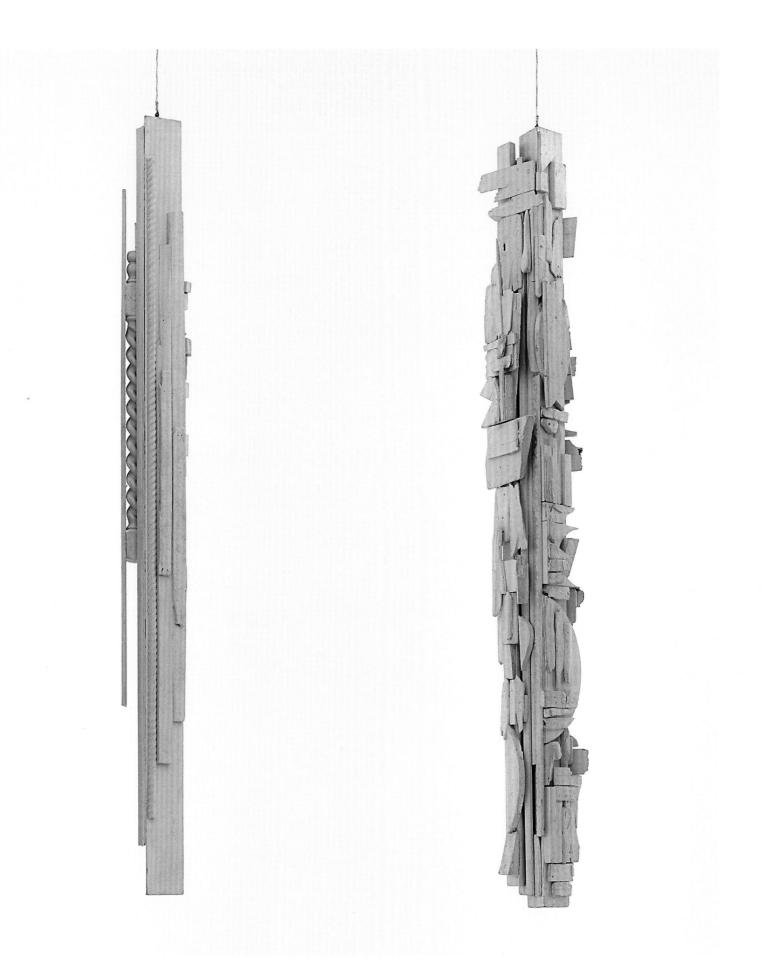

PLATE 36
Three Night Figures, 1960
Painted wood, 87 × 23 × 19 in. (221 × 58.4 × 48.3 cm)
The Jewish Museum, New York, Promised gift of Adele Weinberg

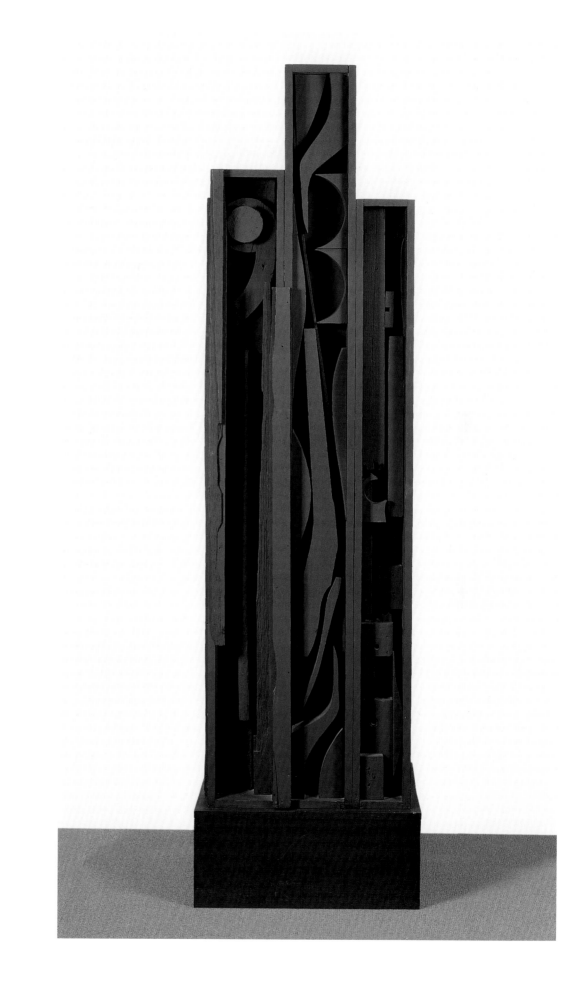

PLATE 37
Royal Tide I, 1960
Painted wood, 86 × 40 × 8 in. (218.4 × 101.6 × 20.3 cm)
Collection of Peter and Beverly Lipman

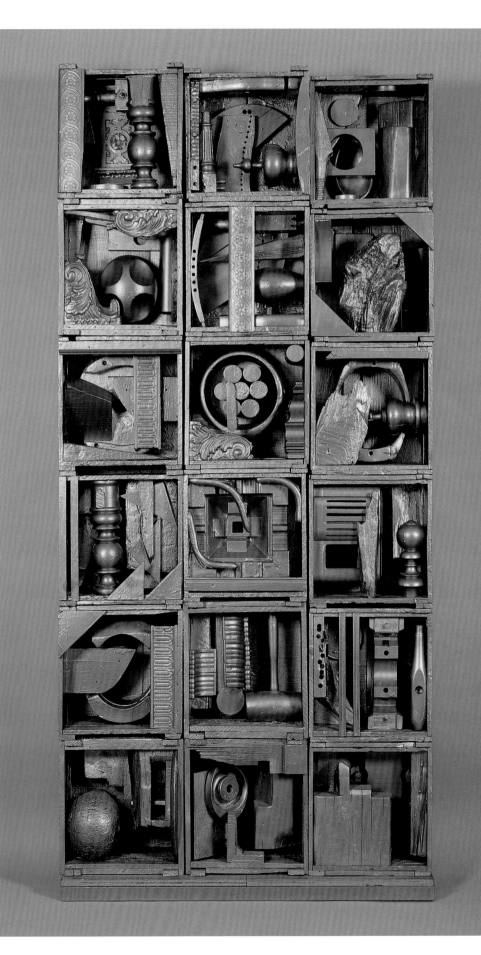

PLATE 38
Golden Gate, 1961–70
Painted wood, 96 × 64½ × 12 in. (243.8 × 163.8 × 30.5 cm)
Carol and Arthur Goldberg Collection

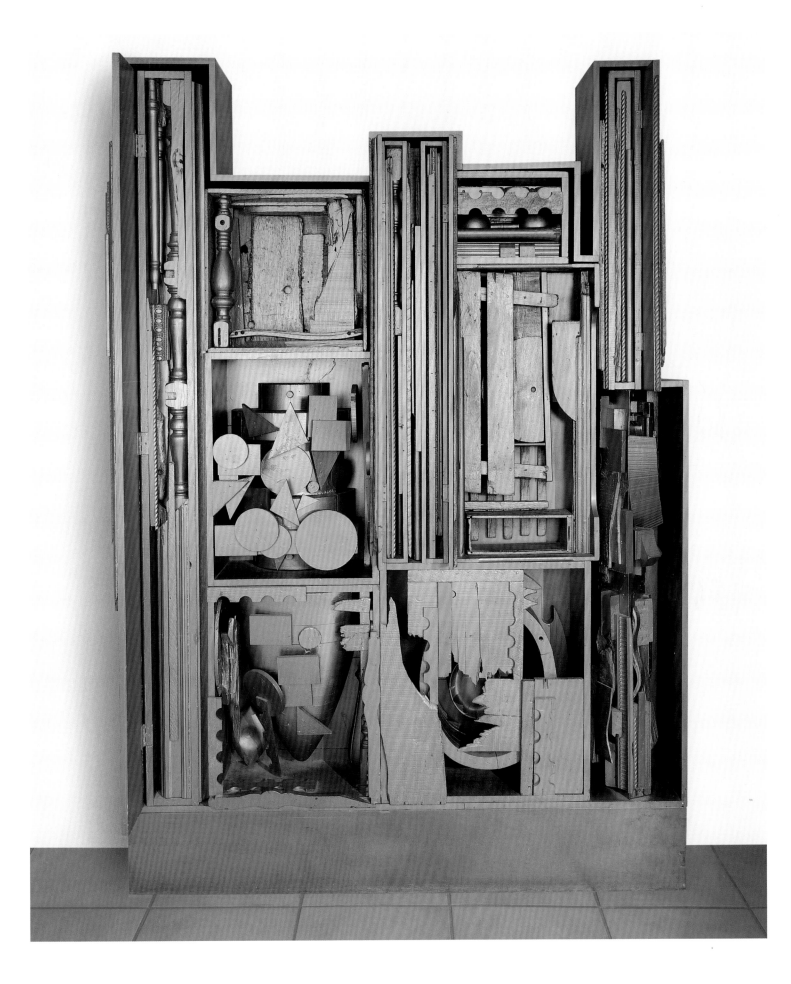

PLATE 39
Rain Forest Column XVIII, 1962
Painted wood, 109 × 14 × 14 in. (276.9 × 35.6 × 35.6 cm)
Private collection

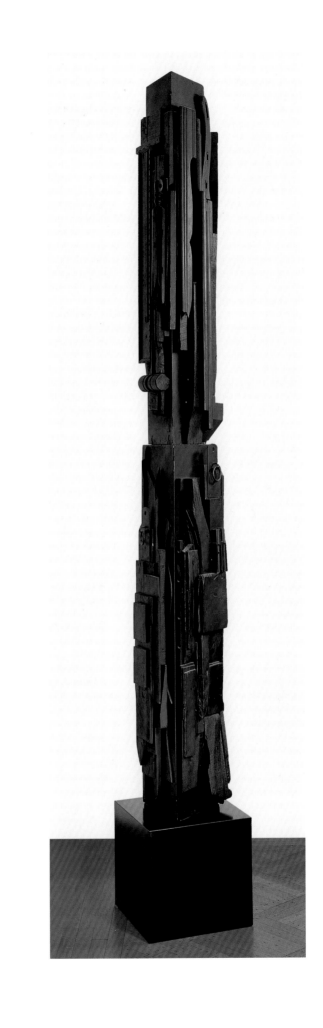

PLATE 40
Untitled, 1963
Lithograph on Rives BFK paper, 32½ × 23 in. (82.6 × 58.4 cm)
National Gallery of Art, Washington, D.C., Rosenwald Collection, 1964

PLATE 41
Untitled, 1963
Printed by Kenneth Tyler (American, b. 1931)
Tamarind Lithography Workshop
Color lithograph, 21⅞ × 17⅜ in. (55.5 × 44.2 cm)
The Metropolitan Museum of Art, New York, John B. Turner Fund,
1966 (66.587.1)

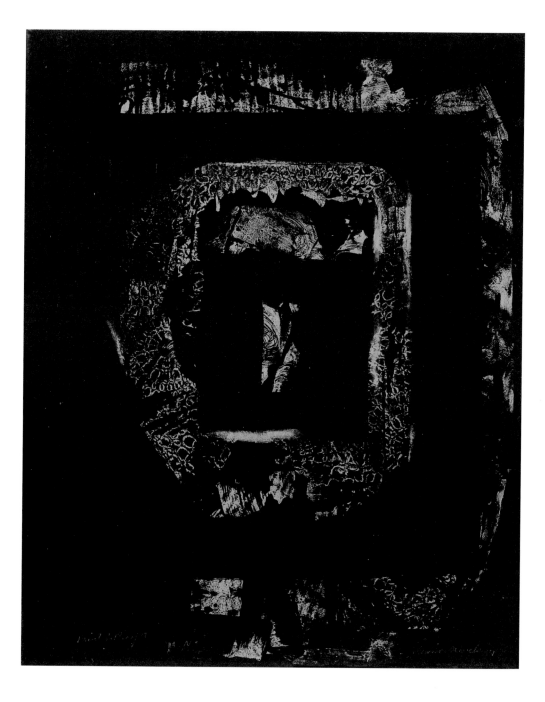

PLATE 42
Self-Portrait: Silent Music IV, 1964
Wood painted black, 90⅛ × 65½ × 18⅛ in. (229 × 166.5 × 46 cm)
Hyogo Prefectural Museum of Art, Japan

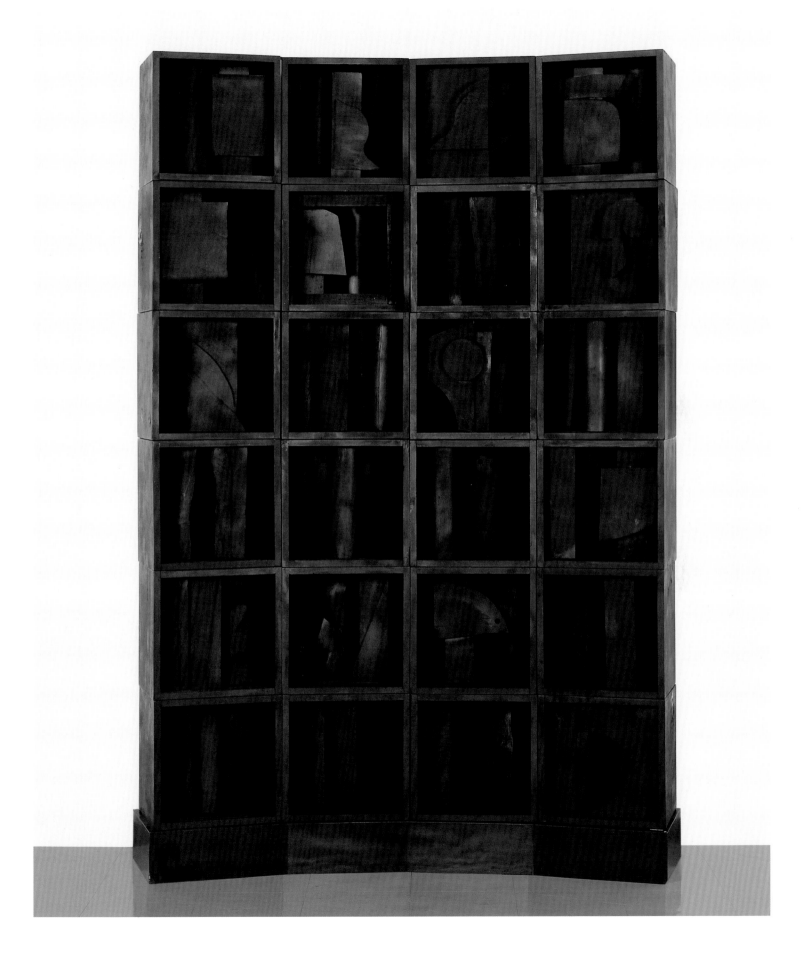

PLATE 43
Homage to 6,000,000 I, 1964
Painted wood, 91³⁄₈ × 225⁵⁄₈ × 11¹³⁄₁₆ in. (232 × 573 × 30 cm)
Osaka City Museum of Modern Art, Japan

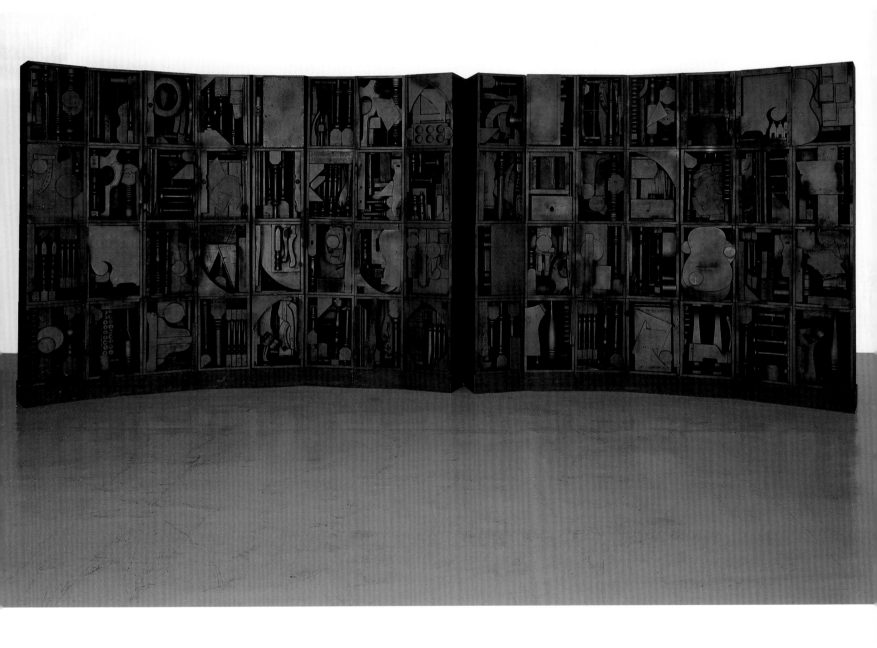

PLATE 44
Cascade, 1964
Painted wood, 100½ × 109 × 17½ in. (255.3 × 276.8 × 44.5 cm)
San Francisco Museum of Modern Art, Gift of an anonymous donor,
93.480.A–G

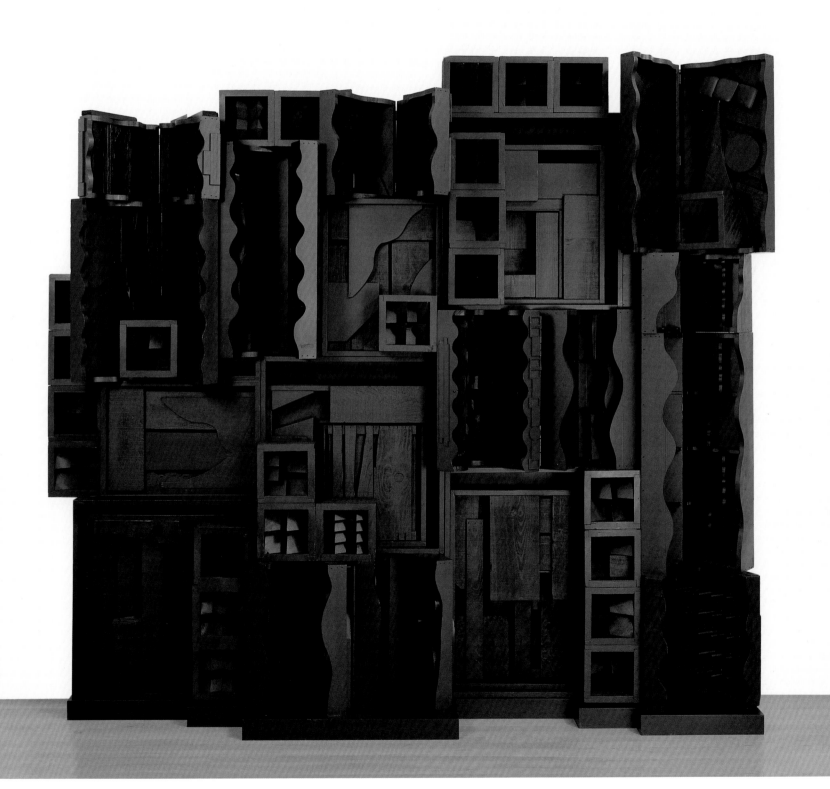

PLATE 45
Mrs. N's Palace, 1964–77
Painted wood, mirror, 140 × 239 × 180 in. (355.6 × 607.1 × 457.2 cm)
The Metropolitan Museum of Art, New York, Gift of the artist, 1985
(1985.41)

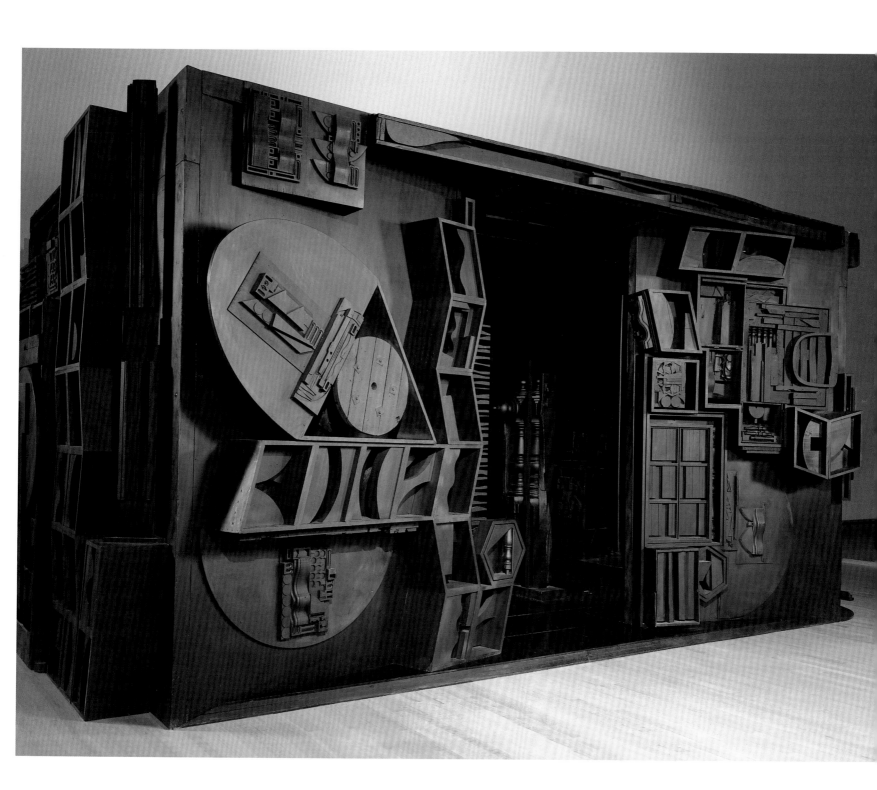

PLATE 46
Atmosphere and Environment II, 1966
Aluminum, black epoxy, enamel, 94 1/2 × 50 × 26 in. (240 × 127 x 66 cm)
Rosalind Avnet Lazarus

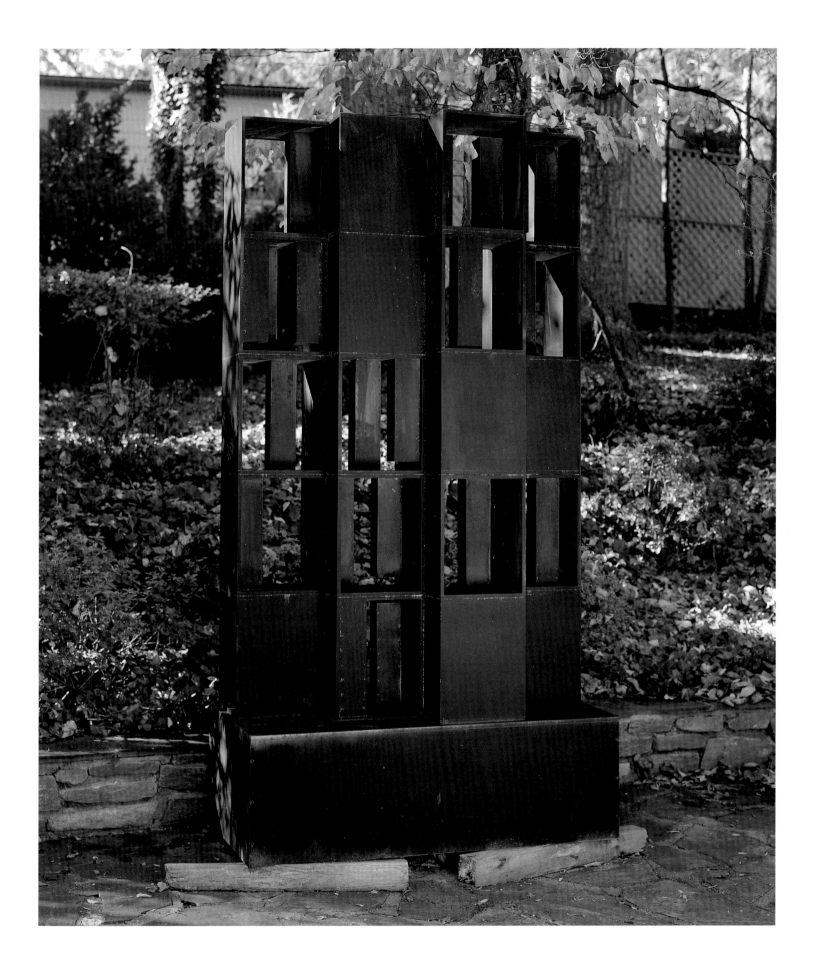

PLATE 47
Untitled, from the series *Façade: In Homage to Edith Sitwell*, 1966
Silkscreen on paper, 23 × 17 ½ in. (58.4 × 44.5 cm)
The JPMorgan Chase Art Collection, New York, 878

PLATE 48
Untitled, from the series *Façade: In Homage to Edith Sitwell*, 1966
Silkscreen on paper, 23 × 17½ in. (58.4 × 44.5 cm)
The JPMorgan Chase Art Collection, New York, 882

PLATE 49
Untitled, from the series *Façade: In Homage to Edith Sitwell*, 1966
Silkscreen on paper, 23 × 17½ in. (58.4 × 44.5 cm)
The JPMorgan Chase Art Collection, New York, 883

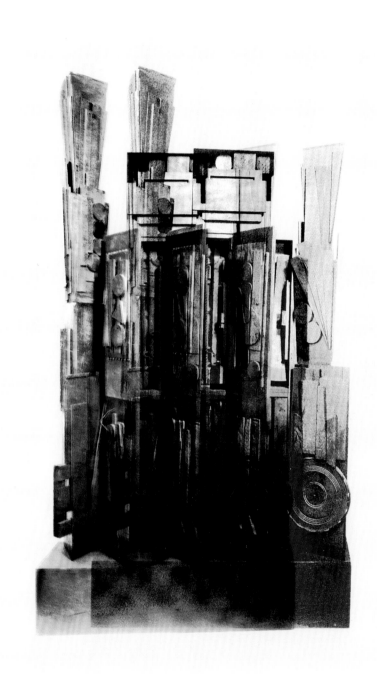

PLATE 50
Transparent Sculpture IV, 1968
Plastic, 8 × 12¼ × 11½ in. (20.3 × 31.1 × 29.2 cm)
Collection Albright-Knox Art Gallery, Buffalo, New York;
New York State Award/1968, 1968:8

PLATE 51
Transparent Sculpture VI, 1967–68
Plexiglas with nuts and bolts, 19 × 22 × 8½ in.
(48.26 × 55.88 × 21.59 cm)
Whitney Museum of American Art, New York; Purchase, with funds
from the Howard and Jean Lipman Foundation, Inc., 68.48

PLATE 52
Night-Focus-Dawn, 1969
24 painted wood boxes on base, 102 × 117 × 14 in.
(259.1 × 297.2 × 35.6 cm)
Whitney Museum of American Art, New York; Purchase,
with funds from Howard and Jean Lipman. 69.73a–y

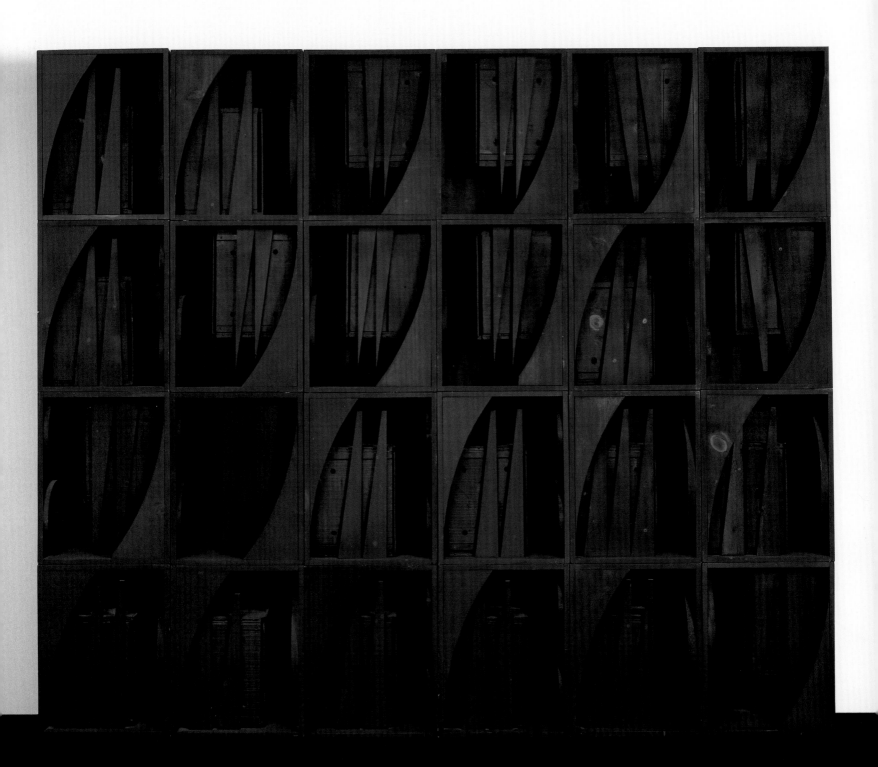

PLATE 53
Large Cryptic I, 1970 (closed and open views)
Black painted wood, 7 × 20 × 10¾ in. (17.8 × 50.8 × 27.3 cm)
Collection Emily Fisher Landau, New York (Amart Investments, LLC)

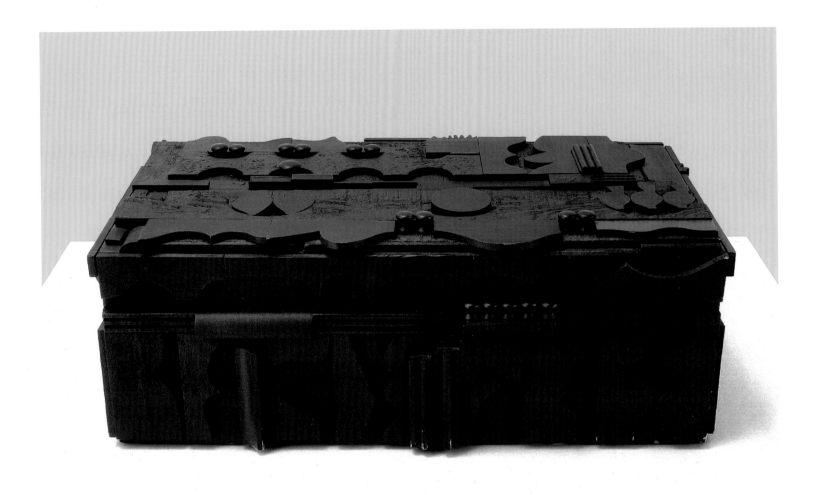

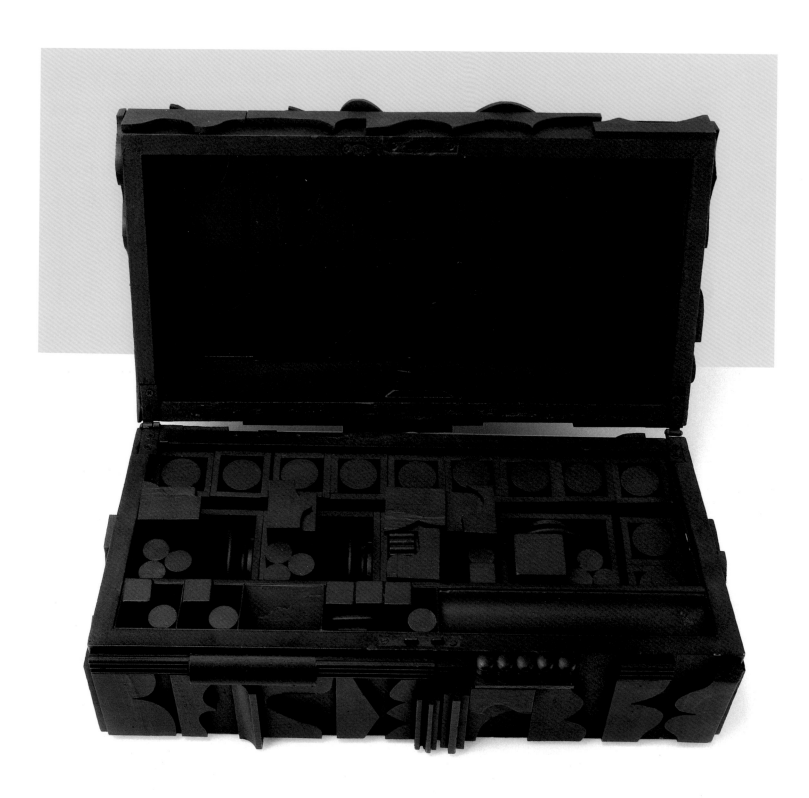

PLATE 54
Model for the White Flame of the Six Million, 1970
Painted wood, 22 ½ × 74 in. (57.2 × 188 cm)
Collection Reed and Delphine Krakoff, New York

PLATE 55

Dream House XXXII, 1972
Painted wood with metal hinges,
75⅛ × 24⅝ × 16⅞ in.
(190.8 × 62.6 × 42.9 cm)
Hirshhorn Museum and Sculpture
Garden, Smithsonian Institution, The
Joseph H. Hirshhorn Bequest, 1981

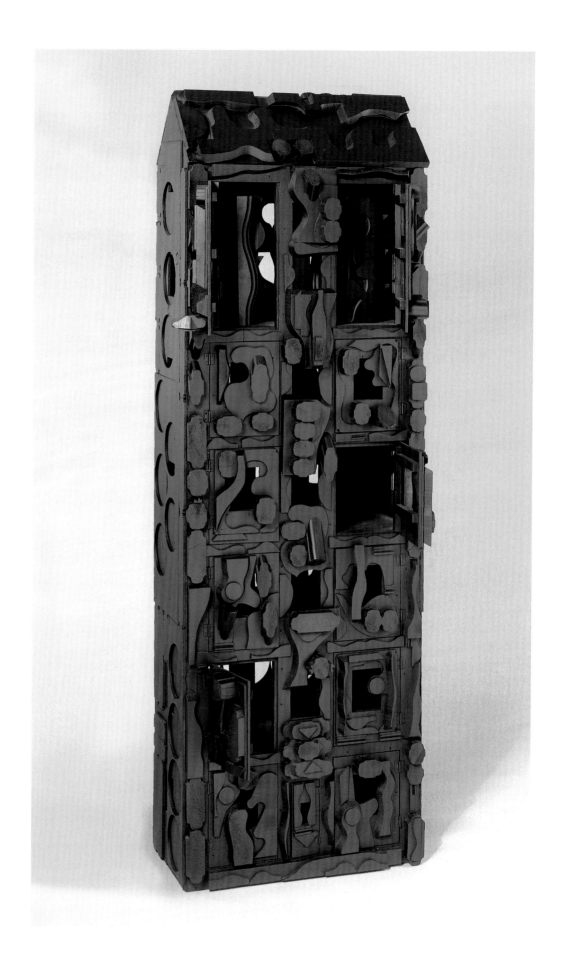

PLATE 56
End of Day XXXV, 1973
Painted wood, 32⅛ × 16½ × 2⅝ in.
(81.6 × 41.9 × 6.7 cm)
The Jewish Museum, New York, Gift of
Hanni and Peter Kaufmann, 1994–583

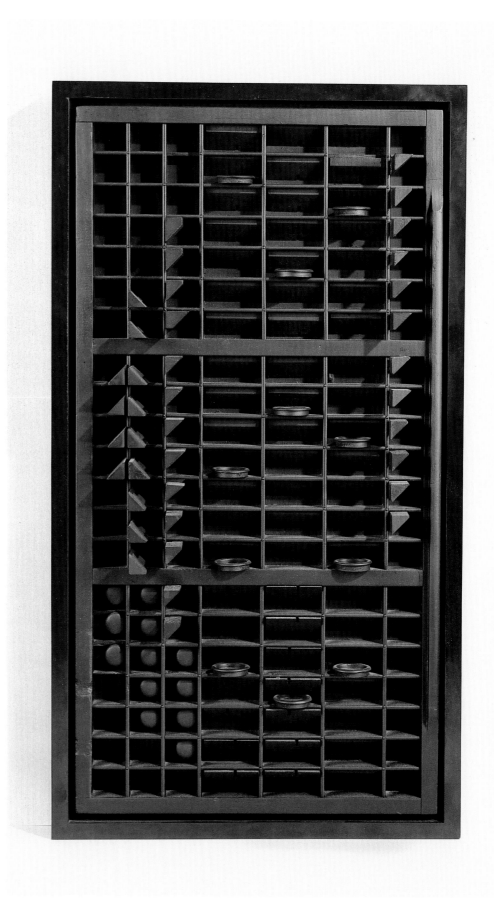

PLATE 57
Dawnscape, 1975
Cast paper relief, 28⅛ × 31½ in. (71.4 × 80 cm)
Smithsonian American Art Museum, Museum purchase, 1978.25

PLATE 58
Nightscape, 1975
Black cast paper relief, 27 × 31 in. (68.6 × 78.7 cm)
Published by Pace Editions, Inc.

PLATE 59
Morning Haze, 1978
White cast paper relief diptych, 33 × 46 in. (83.8 × 116.8 cm)
Published by Pace Editions, Inc.

PLATE 60
Untitled, 1981
Wood and cardboard collage on matboard, mounted on wood,
40⅛ × 32⅛ × ¾ in. (101.8 × 81.4 × 1.9 cm)
Solomon R. Guggenheim Museum, New York, Gift of the artist, 85.3270

PLATE 61
Ocean Gate, 1982
Steel, aluminum, and black paint, 145^{11}/$_{16}$ × 81^{7}/$_8$ × 68^{1}/$_8$ in.
(370.7 × 208 × 173 cm)
Fine Arts Museums of San Francisco, Museum purchase,
gift of Barbro and Bernard Osher, 2002.72a–f

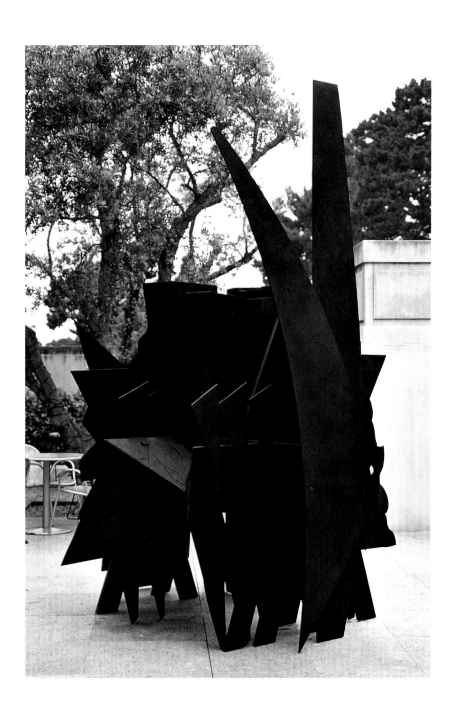

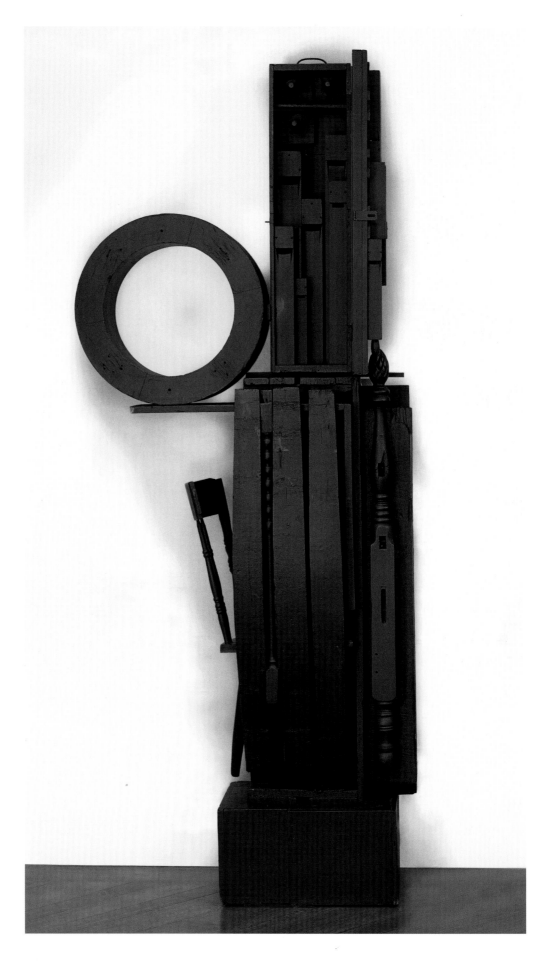

ARTIST INTERVIEWS
CHRONOLOGY
DOCUMENTATION

ested in time as such. And I'm not a scholar as such."[2] These statements are extremely important in their direct, nonhistorical approach to seeing art. To me, Nevelson's presence is as fresh and alive today as it was forty years ago.

Like Nevelson, my outward appearance reflects my art. While our motivations and materials may differ, I can speak only for myself as a sculptor. I do not separate myself from my form, therefore my morning begins by sculpting myself. I use different textures and layering, basically continuing that flow and energy into the studio.

Both Nevelson's *Transparent Horizon* and my work *Manipulating Fractions* create a kinetic feeling through layering and the placement of pieces. *Manipulating Fractions* uses stainless steel armatures for structure, shape, and design, while Nevelson, in her work, uses pieces of cut, bent, and welded Cor-ten steel. Both use fabricated forms to shape the composition of the works, and this produces the subtle essence of something in motion, which creates different visual forms and textures. Different systems of shaping of contours and patterns create this effect as well. For *Manipulating Fractions* it gives the feeling of openness, like stone wall builders in places like New England, placing stones in a particular functional way that creates a beautiful sculptural effect; the shaping of the form, going in and out, creates a different effect. *Transparent Horizon*, with the use of bent and twisted linear vertical shapes, flat, arched, and cut out, creates a more surreal effect.

Acid Rain, a large wall sculpture of mine, is installed in the Rose Bente Lee Gallery of the National Museum of Women in the Arts diagonally across from Louise Nevelson's *Reflections of a Waterfall II.* Both works are large-scale black wall reliefs and have in common such characteristics as patterning and layering of the materials, which create a voluptuous pulsating feeling of abstraction in the work. They speak to each other across the gallery's central space. Every person who enters that room can see the animated dialogue these two sculptures are having all day long.

I appreciate Nevelson's work and her philosophy about sculpture and art in general. I appreciate her understanding of the essence of what sculpture is and her ability to create her work in different media and in different sizes. When I see her work, I sense the hundreds and thousands of decisions that underlie the movements of her hands, arms, eyes, and body all recorded in the work. I see what she did in order to realize what she wanted to see, and I know we jointly occupy this same solid space.

INTERVIEW WITH MARK DI SUVERO (MARCH 1, 2006)

Mark di Suvero was born in 1933 in Shanghai, China, to Venetian parents. The family settled in San Francisco in 1941, and di Suvero received his bachelor's degree from the University of California, Berkeley, in 1956. The following year he came to New York, moving to Lower Manhattan, where he lives today. After an accident in 1960 left di Suvero critically injured, he overcame enormous physical obstacles to continue to create his work. First working with massive timber planks, he ultimately shifted to creating art of architectural scale with welded or bolted industrial-scale steel beams. As a contemporary American master, di Suvero is a dynamic force in sculpture today and a mentor to other artists. He has exhibited his monumental sculpture nationally and internationally in parks, urban settings, and major museums. He worked with community leaders and other artists to found the nonprofit Socrates Sculpture Park in Long Island City in 1986, an outdoor site showcasing the work of young artists.

Fig. 3. Mark di Suvero (American, born 1933), *Hankchampion*, 1960. Wood and chains, 80 × 151 × 112 in. (203.2 × 383.5 × 284.5 m). Whitney Museum of American Art, New York, Gift of Mr. and Mrs. Robert C. Scull, 73.85a–i

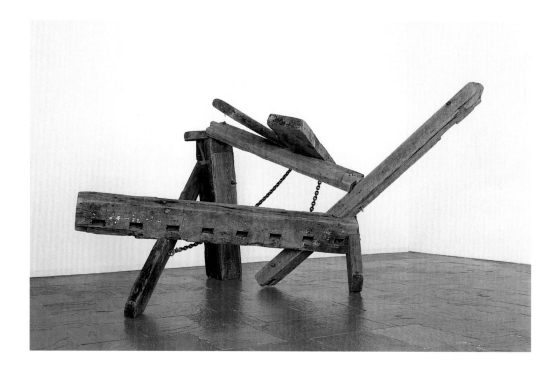

Di Suvero divides his time among three studios: Chalon-sur-Saone, France; Petaluma, California; and Long Island City, New York.

Mark di Suvero: I met Louise Nevelson twice. Once was at a ceremony at Brandeis in 1975. At that time, I had pleaded for amnesty for the people that were sent out of the States during Vietnam. Half the audience booed and half cheered. She was very supportive. The other time was up at Storm King Art Center where I said, "You're honoring me. You really should honor Isamu [Noguchi] and Louise [Nevelson]."

Brooke Kamin Rapaport: This was in the eighties?

A: Yes, 1985.
 I think that she was more influential for a younger generation than for me. I think there was the moment when she was radical. In her radicalness, it was linked . . . to Dada. But Dada artists were doing it for a moral [reason]. . . . Dada, after World War I, was a way of protesting the civilization. [Nevelson's work] looked like a Dada response to the world. No longer the voluminous forms of Henry Moore. It was the opposite. Picking up the scraps and giving value to what was rejected. That's what looked so radical in her work to us.
 Louise Nevelson always seemed to like "collections" of things. The way that she picked up scraps and put things together was much more related to the scrap sense that was around the Abstract Expressionists.

Q: You came to New York in 1957 for the first time and showed your work at the March Gallery. In that show you were making sculpture in plaster.

A: They were dipped plaster through a process with burlap. And conduit tubes of aluminum that I knew how to use as pins. That's when I started working with wood. But Nevelson was already recognized for her woodwork then. That was 1957 or '58.

Fig. 4. Mark di Suvero (American, born 1933), *Pre-Columbian*, 1965. Wood, steel, iron, tire, and paint, 98 × 171 × 110½ in. (248.9 × 434.3 × 280.7 cm). Fine Arts Museums of San Francisco, Gift of Mr. and Mrs. Lowell McKegney, 2000.170

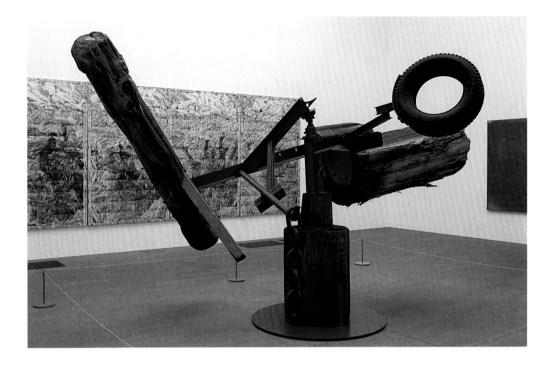

My training in wood was totally different. I worked in a boatbuilder's yard. It was called a shipyard, but we didn't build ships, we built boats. Barges, tugs. Most often it was wood boats. So that's one of the places where I learned carpentry. Boatbuilding is so different from normal carpentry because it involves bending, curves, special woodworking capacities.

Q: When you were making the plaster pieces, you then had a transition to hulking timber works.

A: I was working over on Avenue A [in New York] and they demolished the Eagle Pencil Company. I was able to drag the timber through the streets. It was that kind of work—of dragging things that were considered garbage through the streets. That was the relationship with Nevelson's work. She gave value to something that was considered junk or off limits. This never happened to Henry Moore and others who were working with more precious materials, like Seymour Lipton, and others of that generation. . . . She was certainly part of the avant-garde.

What happened to Dada? Rauschenberg is closer to Louise Nevelson than I am—the collection of scrap detritus.

Q: But the difference with Duchamp and Warhol and even Joseph Cornell is that they took those found objects and didn't alter them tremendously. Nevelson took remnants of the found object and painted them monochromatically to completely divorce the object from its heritage.

A: All of them carried the storm of the object along with it. She was an abstract artist. That was the big difference. They didn't give her the same kind of acceptance because people love a story.

Q: Nevelson was in *Sixteen Americans* in 1959 at the Museum of Modern Art.

A: Well, look at that show. It had Frank Stella and Jasper Johns. That was a big show. It was the breakthrough show.

Q: That show was a shift away from Abstract Expressionism. Did you see that show?

A: Oh, I did see it. I remember the striped paintings of Frank Stella. That's where Jasper Johns showed the target with the faces.

That was story coming back in, as we were talking about. The need to have a story. We saw her work more related to that craziness—the accelerated craziness when you have the awareness. The forms in junk.

Nevelson's gold and the white were in a Whitney show in the 1960s. The gold ones were very disturbing to me because she was tough, abstract, and real. It was this kind of pandering art. The gold ones looked like—it wasn't that she was sanctifying these scraps. They were disturbing in the sense that they looked like she wanted to make them into costume jewelry. Like glitz, glitter. Those pieces of hers—I was involved with people like Manuel Neri, James Brown, Bruce Connor. People who would be willing to pick up things and deal with them as anti-art—the gold, bronze. When she went gold, it seemed like she was taking a different path.

I liked her. I liked her big, batting eyelashes.

Q: When you came to New York, did you know her work?

A: Oh, yeah. She was in the magazines. Everyone looked at the magazines. What about her Jewishness? It's something that is very strange.

Q: In what way?

A: Strange in that—I worked in the rag market, in the textile trade. You see scraps. Scraps are one of the things that are constantly there. There was a little magazine that Sid Geist did called *Scrap*. I think that they dealt with Louise Nevelson.

Q: Talk a bit about your visceral reaction when you worked in wood.

A: Well, when I worked in wood, I wanted to do steel. After I got crippled, I finally did work in steel. But there's this thing. When you work with wood, you need your body. All of the tools are made for the body. When you work with steel, the machine is so much more. The weights are so much heavier and what you end up with are tools that allow you to work in steel, more for the handicapped. In the wood pieces I did, I was very interested in abstracted spatiality. I managed to handle the wood somewhat like steel because I knew how to pin and build the pieces so they would come apart.

Q: Even when you were working in wood, before the accident, you were yearning for steel?

A: Oh, yeah. Oh, yeah. I knew what I was doing. It was that I was struggling for a sense of space. What Louise Nevelson was doing was that she was collecting and presenting the wood like in a vitrine, but without the glass. It was a direct feeling that it was like the crazy lady you see pushing the pushcart. They are living in their own hyperaesthetic world that doesn't allow for the business of normality.

Her work was a positive affirmation, the emotional pull of her work. She was seen as a radical, you know?

Ursula von Rydingsvard was born in 1942 in Deensen, Germany, to Polish parents. Her early childhood was spent in nine post–World War II refugee camps for displaced Polish people, and the family finally immigrated to America in December of 1950 to settle in Connecticut. Von Rydingsvard came to New York in 1973 to study at Columbia University, where she received her M.F.A. in 1975. Soon after, she began to work in milled cedar, the wood that sustains her art today. Von Rydingsvard's massive and painstakingly cut and constructed abstract sculpture is known for its repetitive, labor-intensive process and for the artist's scrupulous attention to detail. Her work is in national and international public and private collections, including the Museum of Modern Art, the Brooklyn Museum, the Whitney Museum of American Art, the High Museum, the Walker Art Center, The Metropolitan Museum of Art, the Nelson-Atkins Museum, the Queens Family Courthouse in Jamaica, Queens, and the Bloomberg Corporation in New York.

Fig. 5. Ursula von Rydingsvard (American, born Germany, 1942), *For Paul,* 1990–92. Cedar and graphite 172 × 108 × 164 in. (436.9 × 274.3 × 416.6 cm). Storm King Art Center, Mountainville, New York

Fig. 6. Ursula von Rydingsvard (American, born Germany, 1942), *Na Onej Gorze,* 2002. Seven units of cedar and graphite, dimensions variable. Private collection

Brooke Kamin Rapaport: Ursula, I wanted to speak with you today about Louise Nevelson because of your prominence as a sculptor and because there are some commonalities between the two of you. Let me first mention the shared traits: you both are sculptors who work in wood, you both are women artists, you both immigrated to the United States from Eastern Europe, and you both use an abstract vocabulary to evoke memory or history. But there are clear differences: Nevelson used found objects to create her best-known sculpture in wood, and you create with milled cedar. She also used paint to completely mask the origins or history of that wood. Comments?

Ursula Von Rydingsvard: Maybe we could start with the last thing you said about masking her surfaces with paint. It is a way of getting more of a distance onto the wood. We often have associations with wood that have to do with a kind of domesticity. Wood homes, wooden furniture,

wooden implements that one uses to store or to cook with. It's a great way to take a step away from the nostalgia, worse yet, the quaintness sometimes associated with wood. . . . There is also an emotional arena when she steps into the black that is different from that of the gold or the white.

Q: The emotional arena—do you think that is bound to the monochrome paint, or lost?

A: The black takes it a step closer to what she needs and wants. She'll have pieces—balustrades, the rounds on the staircase—that's just a part of what she uses. You definitely have the taste, the feel that it's connected to a kind of domesticity with which she defines herself.

Even in the earliest of her drawings, that's what she goes to. In the first drawing I've seen of hers, done in 1905—when she was six years old—she draws the frames that hover over the chairs, the organic frames that meet one another, of wood. Obviously, the whole scene is very domestic. She chose to represent that in such detail that it is a foretelling of what is to come.

Also, she came from Kiev. I spent some time in Kiev. Many of the homes are made out of wood. Many of the interiors of these homes have wooden tables, furniture, bowls. I also think there's a way, having come to the United States as a child, she was cushioned by the coast of Maine that kept her close to nature. Later, coming to New York City, she claims this as the most exciting part of her life—there's a familiarity and comfort that she found in these wooden constructions. What she was picking up from the world around her were things she knew, understood, and could manipulate and control. . . . I think the core of her thinking, perhaps much of it unconscious, had a lot to do with her childhood that was most potent in Kiev, the place I believe to be a rich source for her work.

Q: Tell me why you choose to work in wood. It is hands-on, labor intensive. As a sculptor, why do you work in wood?

A: When I order my wood, I order fourteen skids. Each skid has ninety-six four-by-four beams, anywhere from sixteen to eighteen feet long. This is a semi truck loaded with wood. I say: "Ursula, this is it, this is the last load." I've been saying that for over thirty years. I always want to reassure myself that I have other options. The evolution of ideas is so connected to the process of my working. But I don't want to think that I am bound to the wood and all of the limitations in that material.

Ninety-five to ninety-seven percent of the work I've done is made in cedar. Cedar is soft, sexy, fleshy. I feel I can control it. . . . There is no concern for grain. Cedar has a much cleaner surface, a more neutral surface than many woods. I am now bending and layering thin slices of cedar. It's a whole other process that I've never used before. For me, this material lends itself to tremendous possibilities. Perhaps another reason for my using wood was that I grew up in barracks that were made of wood. This single layer of raw planks separated the interior of my home from the outside world. There was never any furniture in the house but of the crudest wood. I slept on wooden army bunk beds. I come from a long line of Polish peasant farmers, a culture that is heavily wooden. I can't tell you the real reason for my using wood. I can only hop around with my thoughts and stab at possibilities.

Q: When you were first working in wood, did you think about your past?

A: No. Not at all. I just do this because there are objects I feel driven to make. I just enjoy working with the cedar and reaping those kinds of images it can give me. I never think, "I grew up in barracks, therefore I use the cedar." That's a terribly limiting way to think. It's a killer.

Q: As an abstract artist there can be a content or narrative in your work. The works I saw recently in your studio, you explained they were dotted with balls that you said were reminiscent of the woolen popcorn stitch, which you call *bąbelki*, dotting on the hand-knit sweaters of your childhood.

A: I rarely want to tell stories to the viewer. When I talk about my work it doesn't feel like I'm telling a story. I'm groping for an image. It isn't like the stories that Kiki [Smith] talks about, as in *Little Red Riding Hood.* Or even Louise Bourgeois stories. I use my words like I use my bowls— over and over and over again—to take all of these trips, to alter all of these landscapes, to feel all of these objects. In some ways, these balls are objects that are stuck on. . . . It doesn't really tell a story, but there is an emotional content. Hopefully, it has a range that is narrow enough to be potent but general enough to have a lot of metaphorical connections.

Q: You have said that you respond most strongly to Louise Nevelson's works in black. The white and gold monochrome paint makes the wood into a completely different object. Is that what you are describing?

A: I also think that it was the time of the black walls that Nevelson was on a roll. I think it's not just the black, it's the work itself. It's evident that she was also trying to lighten it up. She loved brushing shoulders with princesses. I think that gold look had a special appeal. She describes going to The Metropolitan Museum of Art and seeing those gold kimonos, and the yellow chairs she saw in the antique shop that took her depression away from having given birth to her son. So she obviously had a love for that color, but I don't think she used it in a way that's very interesting. . . .
 I only saw her in the flesh a few times. There's a heady theater, a bigger-than-life peacock number that goes on . . . there's a podium on which she stands. I think she took theater classes. The public persona was consciously decided—beginning with her eyes. This world needs a wicked queen, a bitch queen. I also think that in private she could have been very vulnerable. . . .
 I preferred the long, flat wooden wall pieces when the matte black paint was not just freshly applied but more worn—more at one with the wood. Within each box she creates her private, disjointed, yet tightly organized world, then combines these boxes to make an even larger idiosyncratic universe having the possibility of no longer being an object but a wall capable of psychologically embracing your body.

CHRONOLOGY OF LOUISE NEVELSON'S LIFE

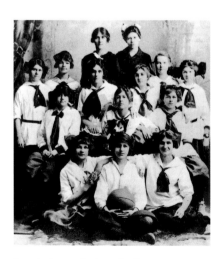

Fig. 1. Louise Berliawsky, c. 1915. Archives of American Art, Smithsonian Institution, Washington, D.C.

Fig. 2. Louise Berliawsky (bottom row, center) with the Rockland High School basketball team, 1916

1899

Leah Berliawsky is born on September 23 in Kiev, Ukraine, to Isaac Berliawsky and Minna Ziesel Berliawsky (née Smolerank).

1902 or 1903

Father immigrates to the United States from the Ukraine.

1905

Mother and children—Leah, older brother Nachman, and younger sister Chaya—join Isaac in the United States. After the children arrive in Boston their Hebrew names are Americanized; Leah becomes Louise, Nachman becomes Nathan, and Chaya becomes Anita. The family settles in Rockland, Maine, where Isaac Berliawsky works in construction and runs a lumberyard or junkyard.

1906

Youngest sibling, Lillian, is born in Rockland.

1918

Graduates from Rockland High School. Meets Charles Nevelson, the son of a wealthy shipping family from New York, and becomes engaged to him.

1920

Marries Charles Nevelson on June 12 at the Copley Plaza Hotel in Boston. The Nevelsons take two honeymoon trips, first to New Orleans, and then to Havana, Cuba. On their return, the couple moves into an apartment in the Washington Heights neighborhood of Manhattan.

1922

Son Myron (Mike) is born on February 23 in New York.

Begins taking voice lessons with Estelle Liebling, the Metropolitan Opera vocal coach.

1924

Moves, with husband and son, to Mount Vernon, New York, an upper-middle-class Jewish community in Westchester County, where Charles's brother and family also live.

Mid-1920s

Studies drawing with Anne Goldthwaite and painting and drawing with the artist couple Theresa Bernstein and William Meyerowitz. Also studies drama at a school founded by Princess Matchabelli and architect/sculptor Frederick Kiesler.

1926

After several costly business failures, Charles Nevelson leaves the Nevelson Brothers Company, the shipping business owned by Charles and his three older brothers. Charles sells the house in Mount Vernon and moves his family to Brooklyn. Their financial situation and standard of living steadily decline.

1927–28

Meets and takes private painting lessons with the German "non-objective" painter Baroness Hilla Rebay, who had recently immigrated to the United States.

1929–30

Enrolls full-time at the Art Students League in New York and studies with Kenneth Hayes Miller and Kimon Nicolaides.

1931

Nevelson separates from her husband.

Fig. 3. Louise Nevelson, *The Lady Who Sank a Thousand Ships (Helen of Troy)*, 1928. Oil on canvas. Collection Diana MacKown, Ellington, New York

Fig. 4. Louise Nevelson, 1931. Photograph by Empire Photographers. Collection Diana MacKown, Ellington, New York

Travels to Europe to study art at Hans Hofmann's school in Munich. Before departing, Nevelson leaves her son with her parents in Maine. Over the next several years, Mike attends boarding school and moves from one relative to another. Time spent living with his mother or his father becomes increasingly intermittent.

Works as an extra in films in Berlin and Vienna.

Visits Italy and then Paris, staying for several weeks. Spends time at the Louvre and at the Musée de l'Homme, where she becomes enthralled with the African sculpture on view.

Begins to write poetry.

1932
Returns to New York in the spring of 1932 but leaves again for Paris during the summer and spends more than a month there. Upon her return, Nevelson, often impoverished during this period, lives alone or with friends in various Manhattan studios, moving every year or two for about a decade.

Resumes classes at the Art Students League in the fall, studying drawing and painting with Hans Hofmann, now living in New York.

Meets the Mexican painter Diego Rivera through a mutual artist friend and works as one of his assistants in 1932 or 1933 on murals at the New Workers School, New York.

Begins to study modern dance with Ellen Kearns, a pursuit she follows for twenty years.

1933
Meets sculptor Chaim Gross and enrolls in his sculpture class at the Educational Alliance, New York, in late 1933 or early 1934.

Becomes enamored of work by painter Louis Eilshemius and begins to amass a large collection. By 1945, Nevelson owns more than 180 of his paintings, many of which she later had to sell for income.

1934
Studies life drawing and painting with George Grosz at the Art Students League.

Several of Nevelson's paintings are included in a group exhibition at Gallery Secession, New York, her first gallery showing.

1935
Exhibits one of her terra-cotta figures at the Brooklyn Museum in a group show of young sculptors arranged by the Gallery Secession. It is Nevelson's first museum showing.

Employed in the art teaching division of the Works Progress Administration (WPA), Nevelson teaches mural painting at the Flatbush Boys Club in Brooklyn. As part of this federal program, she goes on to teach art classes at various schools and institutions, including the Educational Alliance and the Young Men's Hebrew Association. Eventually she joins the fine arts division, first as a painter and then as a sculptor, working under the WPA through 1939.

1936
Shows five wood sculptures in a juried exhibition at the A. C. A. Gallery. The competition is judged by Stuart Davis, Yasuo Kuniyoshi, and Max Weber; Nevelson receives an honorable mention.

After running away and then being expelled from military academy in Maine, Mike Nevelson comes to New York and lives with his mother in her apartment on Bleecker Street. He enrolls at Stuyvesant, an all-boys public high school, and graduates in June 1940.

Fig. 5. Louise Nevelson, 1930s.
Collection Diana MacKown, Ellington,
New York

1941

Louise and Charles Nevelson legally divorce after a decade of separation.

Mike abandons undergraduate studies at New York University and joins the merchant marine.

First solo exhibition is held in September at the Nierendorf Gallery, New York. None of the works sell, although the show receives critical praise from Emily Genauer in the *New York World-Telegram* and Carlyle Burroughs in the *New York Herald Tribune*. Karl Nierendorf is the first dealer to represent Nevelson's work, and she shows with his gallery for the next seven years.

Moves into a loft on East Tenth Street, where she lives for the next three or four years.

1942

Has second solo exhibition at Nierendorf Gallery in October. Creates her first sculptures that incorporate found wood.

1943

Minna Berliawsky, the artist's mother, dies of lung cancer on March 11.

The Circus: The Clown Is the Center of His World, Nevelson's first thematic exhibition of sculpture, is held at the Norlyst Gallery in New York. At about the same time, she exhibits paintings and drawings at the Nierendorf Gallery.

Destroys about two hundred paintings and sculptures after the Nierendorf and Norlyst exhibitions close because she lacks storage space.

1944

Has first exhibition of abstract wood assemblages, *Sculpture Montages,* at Nierendorf Gallery.

1945

Buys a four-story house on East 30th Street in Manhattan and lives there until 1959. The house becomes a meeting place for artists and for organizations with which Nevelson is affiliated, including the Federation of Modern Painters and Sculptors, the Sculptors' Guild, and the Four O'Clock Forum.

1946

Nierendorf Gallery exhibits *Bronzes by Nevelson* in April.

Participates in the Whitney Museum of American Art's *Annual Exhibition of Contemporary American Sculpture, Watercolors, and Drawings* for the first time; Nevelson is included in the New York museum's annual exhibition a total of thirteen times (including one biennial) over the next twenty-seven years.

On October 10, Nevelson's father, Isaac Berliawsky, dies suddenly from heart failure.

1948

Karl Nierendorf dies and his gallery closes.

Travels to Europe, spending time in England, France, and Italy.

1949–50

Experiments briefly with etching at Atelier 17, a prestigious printmaking workshop run by the English artist Stanley William Hayter, who moved the workshop from Paris to New York at the beginning of World War II.

Works in terra-cotta, marble, aluminum, and bronze at the Sculpture Center, New York.

Late 1940s or Early 1950s

Makes two trips to Mexico with her sister, Anita, visiting museums in Mexico City and the Mayan ruins in the Yucatán peninsula.

Fig. 6. Exhibition *Sculpture Montages* at Nierendorf Gallery, New York, 1944

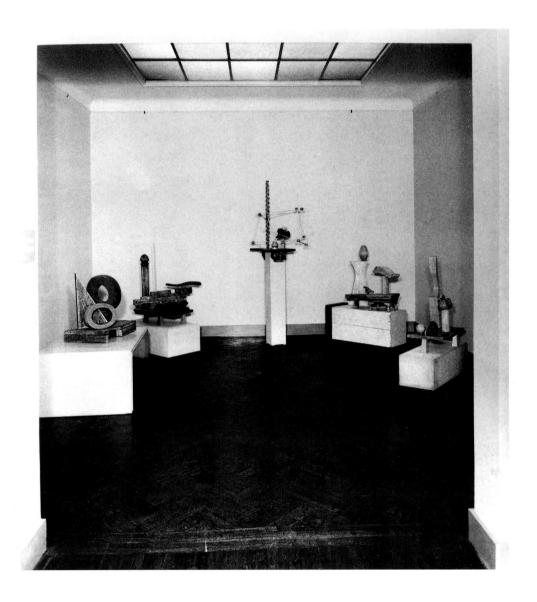

1950

Moonscapes, Nevelson's first exhibition of etchings, is held at the Lotte Jacobi Gallery in New York.

1952

Included in the National Association of Women Artists annual exhibition for the first time.

1953

Works regularly at Atelier 17 for two years. Peter Grippe, who had taken over the workshop after Hayter returned to Paris in 1950, introduces Nevelson to new graphic and printmaking techniques.

Begins producing a series of black wood landscape sculptures, including works such as *Moon Spikes* (1953) and *Night Landscape* (1955).

In April, the Four O'Clock Forum—founded by artists Will Barnet, Peter Busa, and Steve Wheeler—holds a meeting on the future of abstract art at Nevelson's home on East 30th Street. Nevelson participates on the panel with Richard Lippold, George Constant, and Philip Guston. Soon afterward she agrees to become a sponsor, holding regular meetings at her home and serving as a moderator at many of the debates, including one in 1954 in which Willem de Kooning is a panelist.

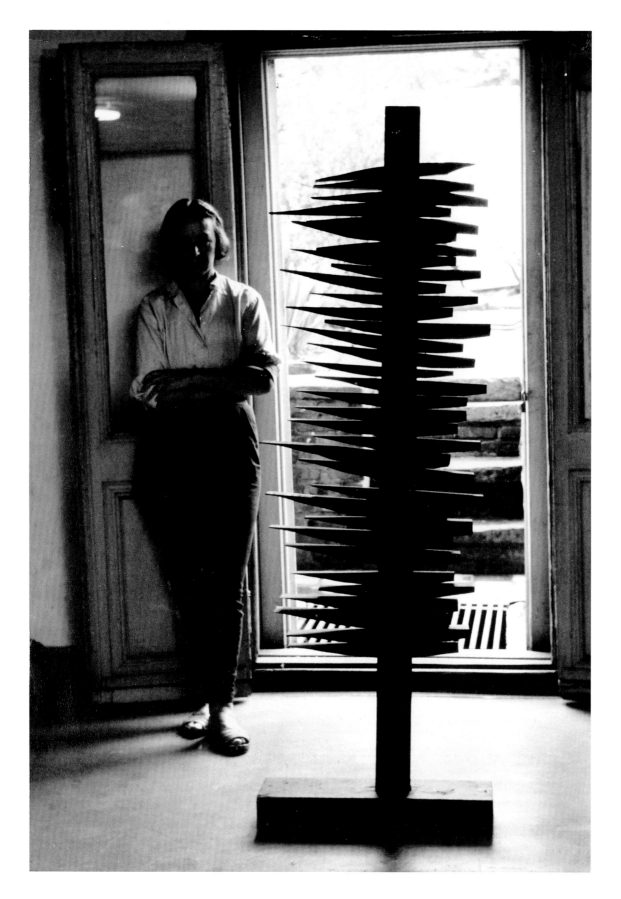

Fig. 7. Louise Nevelson in the kitchen of her East 30th Street home, c. 1954, with column from *First Personage*, completed in 1956

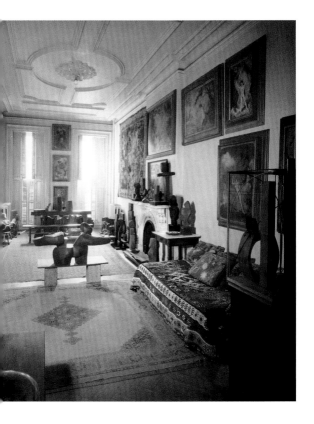

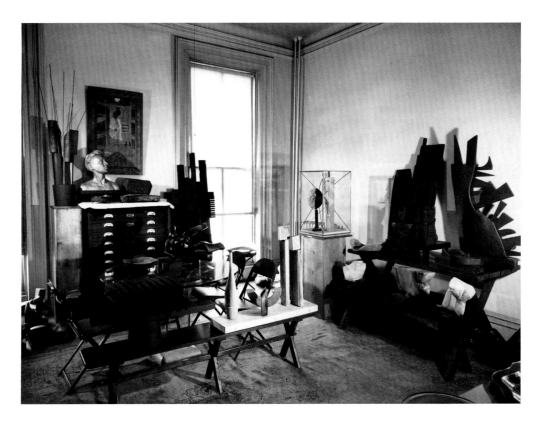

Fig. 8. Louise Nevelson's living room, East 30th Street house, New York, with her collection of paintings by Louis Eilshemius, 1955. Photograph by Jeremiah W. Russell

Fig. 9. East 30th Street studio, New York, 1955. Photograph by Jeremiah W. Russell

1954

Has several one-person shows in New York, including an exhibition of etchings and sculptures at the Lotte Jacobi Gallery and a sculpture exhibition at the Marcia Clapp Gallery.

1955

Nevelson's solo exhibition, the thematically titled *Ancient Games and Ancient Places,* is shown at the nonprofit gallery Grand Central Moderns, New York. Through 1958 the gallery continues to give the artist an annual show featuring her recent output of black wood sculptures presented in thematic installations.

1956

Second one-person exhibition at Grand Central Moderns, *The Royal Voyage (of the King and Queen of the Sea)* opens in February and features totemic sculptures, including the King, the Queen, and an Indian Chief, which resemble Native American, African, and Central American art forms.

The Whitney Museum of American Art acquires the small tabletop piece *Black Majesty* (1955) from *Ancient Games and Ancient Places* and features the sculpture in its annual exhibition. It is the first museum acquisition of the artist's work.

1957

Exhibition titled *The Forest* opens at Grand Central Moderns in January. *First Personage* (1956), the largest work in the exhibition, is acquired by the Brooklyn Museum.

Elected president of the New York chapter of Artists' Equity, a position that Nevelson holds through 1959.

Creates her first *Sky Cathedral,* a large-scale wall sculpture, for her brother's Thorndike Hotel in Rockland, Maine.

1958

For *Moon Garden + One* at Grand Central Moderns in January, Nevelson installs her

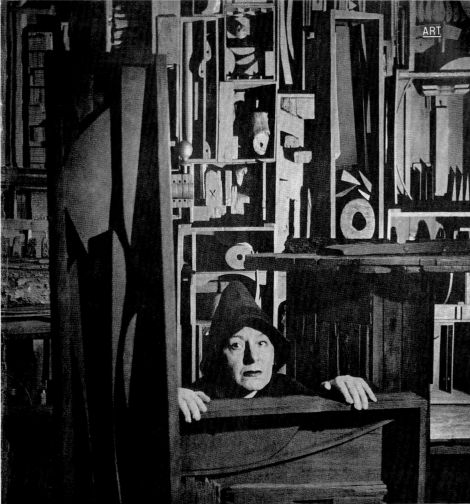

ILLUMINATED BY A GREENISH LIGHT, LOUISE NEVELSON CROUCHES IN A SECTION OF HER MOON GARDEN. BOXES RANGE FROM ONE TO TEN FEET HIGH

Weird Woodwork of Lunar World

Like a sorceress in her den, Sculptor Louise Nevelson (*above*) is peering out from an eerie world of her own making. Without resorting to eyes of newts or toes of frogs, she has conjured up a spectral sculptured landscape which she calls The Moon Garden. Recently the garden was installed in New York's Grand Central Moderns Gallery where it cast a spell upon the current art season.

The Moon Garden is composed of 116 boxes and circular shapes stacked or standing free. They are filled or covered with odds and ends of wood. The 57-year-old artist, who is the daughter of a Maine lumberman, scavenged the wood from beaches, demolished houses and antique shops and has cut or shaped it to her own desire. Everything is painted black because, says Miss Nevelson, "black creates harmony and doesn't intrude on the emotions." The entire Moon Garden was priced at $18,000. But since most gallerygoers didn't relish living totally in the dark of the moon, Miss Nevelson parted with individual boxes for as little as $95. Seven were sold.

CONTINUED 77

Fig. 10. Louise Nevelson with sculpture *Moon Garden* as shown in the May 24, 1958, issue of *Life* magazine

most ambitious environment to date. Free-standing works, such as *Moon Fountain* (1957), are completely surrounded by monumental sculptural walls called *Sky Cathedrals.* Blue lighting is used to illuminate the *Sky Cathedrals,* which are composed of stacked wooden boxes and found objects painted black. Later in the year, the Museum of Modern Art acquires a large *Sky Cathedral* (1958) from this show.

Exhibition of prints and drawings is held at the Esther Stuttman Galerie, New York. Nevelson also exhibits at Galerie Jeanne Bucher in Paris, increasing the artist's visibility on the international art scene.

In June, receives critical praise from the prominent art critic Hilton Kramer, who publishes a major article, "The Sculpture of Louise Nevelson," in *Arts* magazine.

1959

Sells her house on East 30th Street and moves to a house on Spring Street, where Nevelson resides until her death in 1988.

The Martha Jackson Gallery, which represents Nevelson's work from 1959–62, holds her next exhibition of monumental sculpture, titled *Sky Columns Presence.*

Receives Grand Sculpture Prize for her work in *Art U. S. A.* at the New York Coliseum.

In December, creates *Dawn's Wedding Feast,* a white room-size installation, for *Sixteen Americans* at the Museum of Modern Art. In this annual exhibition of cutting-edge talent, the sixty-year-old Nevelson is shown with Jasper Johns, Robert Rauschenberg, and Frank Stella, who are just beginning their careers. Though Nevelson hopes that a public institution will acquire *Dawn's Wedding Feast* intact, it fails to sell and the work is dismantled. Sections of it end up in various public and private collections, and other parts

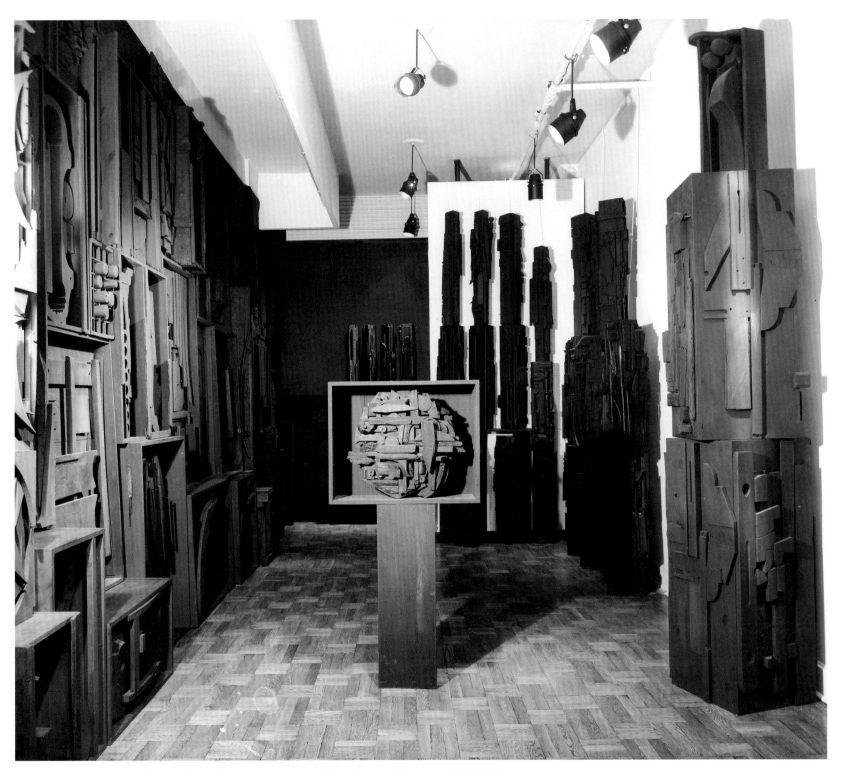

Fig. 11. Exhibition *Sky Columns Presence* at Martha Jackson Gallery, New York, 1959

of it are reconfigured or incorporated by Nevelson into subsequent works.

1960
Receives the Logan Prize in Sculpture from the Art Institute of Chicago for work shown in the museum's *63rd American Exhibition.*

Jean Arp writes a poem about Nevelson and her work and publishes it in *XXe Siècle.*

1961
In April, *The Royal Tides,* her first gold-painted sculptures, are shown at Martha Jackson Gallery. *Royal Tide I* (1960) is exhibited in October at the Museum of Modern Art's *The Art of Assemblage* and featured in the accompanying catalogue by William C. Seitz.

Meets Arnold B. Glimcher and shows for the first time at his Pace Gallery, located in Boston at this time.

ARTnews publishes her poem "Queen of the Black Black" in September 1961.

Participates in the *Pittsburgh International Exhibition of Contemporary Painting and Sculpture* at the Carnegie Institute. Also has a one-person exhibition at the Staatliche Kunsthalle in Baden-Baden, West Germany, where she shows a series of sculptural walls.

1962
Begins brief affiliation with the Sidney Janis Gallery, New York, becoming the first woman and first American sculptor represented by the gallery.

Becomes the first vice-president of the Federation of Modern Painters and Sculptors.

Joins the Sculptors Guild and is elected president of the National Artists' Equity, making Nevelson the first woman to hold this position.

Represents the United States at the *XXXI Biennale Internazionale d'Arte* in Venice with fellow artists Jan Müller, Loren MacIver, and Dimitri Hadzi. Nevelson creates *Voyage,* a large environment, for the Biennale's United States Pavilion.

Awarded Grand Prize in the First Sculpture International at the Torcuato di Tella Institute's visual arts center in Buenos Aires.

Whitney Museum of American Art acquires the black wall sculpture *Young Shadows* (1959–60).

Introduced to Diana MacKown, a young aspiring artist who soon begins working for Nevelson on an occasional basis.

1963
In January, Sidney Janis holds Nevelson's first and only solo exhibition with his gallery. Afterward, the artist and the dealer have a falling out, and Nevelson ends her affiliation with the gallery later in the year.

First London exhibition is held at the Hanover Gallery.

Receives Ford Foundation grant to work at the Tamarind Workshop in Los Angeles, where Nevelson completes an edition of twenty-six lithographs.

Re-elected president of the National Artist's Equity.

Hires MacKown to work with her full time, succeeding Theodore Haseltine, Nevelson's assistant since 1952. MacKown moves in with the artist at her home and studio on Spring Street. The two live, work, and travel together for the next twenty-five years until Nevelson's death. During this period, MacKown makes a series of tape recordings, photographs, and films of the artist.

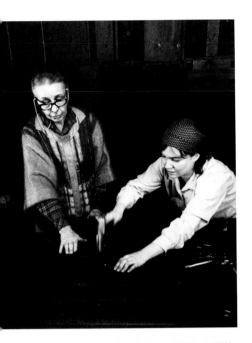

Fig. 12. Ugo Mulas (Italian, 1928–1973), *Louise Nelson Working with Her Assistant Diana MacKown,* c. 1960. Archives of American Art, Smithsonian Institution, Washington, D.C.

Fig. 13. Louise Nevelson, Alberto Giacometti, and Museum of Modern Art Curator Dorothy C. Miller in front of *Voyage* at the American Pavilion of the Venice Biennale, 1962. Photograph by Maryette Charlton

1964

Has several one-person exhibitions in Europe, including shows at Kunsthalle Bern, Gimpel und Hanover Galerie in Zurich, and Galleria d'Arte Contemporanea in Turin.

Solo exhibition is held at Pace Gallery, New York; Pace represents Nevelson from this time forward and presents frequent exhibitions of the artist's work.

Is included in *Documenta III* in Kassel, West Germany.

The book *Nevelson* by Colette Roberts, director of Grand Central Moderns, is published by Editions Georges Fall, Paris.

1965

Participates in the National Council on the Arts and Government in Washington, D.C.

Exhibits at Pace Gallery in New York, David Mirvish Gallery in Toronto, and Galerie Schmela in Düsseldorf, West Germany.

The Jewish Museum, New York, shows Nevelson's large-scale *Homage to 6,000,000 I* (1964), a memorial to the victims of the Holocaust, in its sculpture court in the late spring and summer. In the same year, the Israel Museum in Jerusalem acquires the monumental sculptural wall titled *Homage to 6,000,000 II* (1964).

Through the following year, produces two editions of lithographs and twelve of etchings at the Hollander Graphic Workshop in New York.

1966

Receives honorary doctorate in fine arts from Western College for Women in Oxford, Ohio.

In the summer, Nevelson's small wood sculpture *Night Image X* (1966) is included in

The Jewish Museum's exhibition of *The Harry N. Abrams Family Collection.*

Creates her first large-scale metal sculptures, a series called *Atmospheres and Environments,* which are fabricated from aluminum and steel.

Elected vice-president of the International Association of Artists.

Produces a portfolio of twelve serigraphs titled *Façade: In Homage to Edith Sitwell,* dedicated to the British poet, who died in 1964. Although inspired by Nevelson's favorite Sitwell poems, the prints are created using photographic collages of the artist's own sculpture that were silkscreened on paper.

Donates personal archive to the Archives of American Art, a branch of the Smithsonian Institution, and continues to add to it over the years. The archive consists of approximately twenty-one thousand items, including correspondence, photographs, scrapbooks, early watercolors, original essays and poetry, interviews, gallery records, and exhibition catalogues.

The Archives of American Art commissions Ugo Mulas to take a series of photographs of the artist, her house, and her collection.

1967

The January–February issue of *Art in America* features Dorothy Gees Seckler's article "The Artist Speaks: Louise Nevelson," which propounds and critically comments on Nevelson's ideas and attitudes at the time.

The Whitney Museum of American Art mounts the first retrospective exhibition of Nevelson's work (March 8–April 30). The show, curated by John Gordon, travels to the Rose Art Museum at Brandeis University in Waltham, Massachusetts, in late May.

Receives another fellowship to work at the Tamarind Workshop, Los Angeles.

Portfolio "9" is published by the Whitney Museum and includes Nevelson's *Dusk in August* among a group of lithographs by nine artists printed at the Hollander Workshop.

Begins making a series of tabletop works made of clear Plexiglas and titled *Transparent Sculpture.*

Participates in major group exhibitions, including *American Sculpture of the 1960s* at Los Angeles County Museum of Art, the

Guggenheim International in New York, *Sculpture in Environment* at the City of New York Arts Festival, and *Sculpture: A Generation of Innovation* at the Art Institute of Chicago.

1968
Façade: In Homage to Edith Sitwell, Nevelson's portfolio of twelve serigraphs, appears in The Jewish Museum's exhibition *Suites: Recent Prints* (March 14–September 2).

Nevelson's work is exhibited in *Documenta IV,* Kassel, West Germany.

June Wayne, director of the Tamarind Workshop, produces the film *The Look of a Lithographer,* which features Nevelson.

1969
Commissioned by Princeton University, Nevelson creates her first monumental outdoor sculpture, *Atmosphere and Environment X,* made of Cor-ten steel. It is installed in 1971, adjacent to the university's Firestone Library.

Wins a MacDowell Colony Medal in September.

A major retrospective of Nevelson's work is held in Texas at the Museum of Fine Arts, Houston, and at the College of Fine Arts, University of Texas at San Antonio.

Solo exhibitions are held at the Rijksmuseum Kröller-Müller in Otterlo, The Netherlands, and the Museo Civico di Torino (Turin).

Juilliard School of Music, New York, acquires the huge, black-painted wood sculptural wall *Nightsphere-Light* (1969).

A Plastic Presence, organized by the Milwaukee Art Center, opens on November 19 at The Jewish Museum and includes Nevelson's Plexiglas sculpture *Canada Series III* (1968).

Fig. 14. Louise Nevelson on the cover of the January 24, 1971, issue of the *New York Times Magazine,* with *Dawn's Wedding Chapel II* in the background

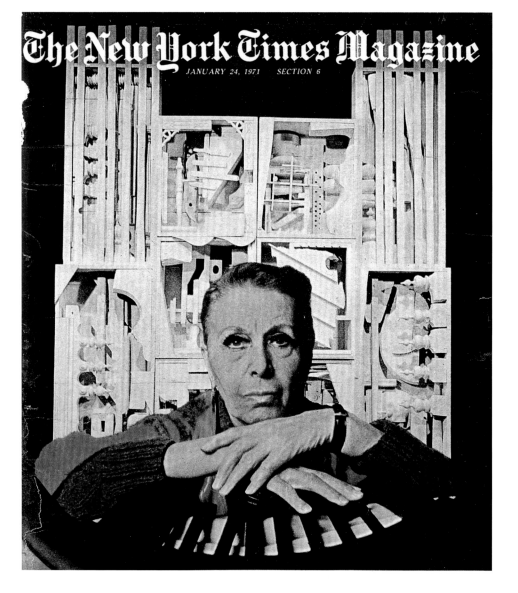

Fig. 15. Louise Nevelson with Dorothy Miller in Stockbridge, Massachusetts, July 1971. Photograph by Diana MacKown

Fig. 16. Louise Nevelson (second from right) with art critic Hilton Kramer (second from left), his wife Esta (left), and art patron Vera List (right) at the Inaugural Luncheon of the Women's Division of the American Jewish Congress, November 30, 1971. Photograph by Mike Zwerling. Archives of American Art, Smithsonian Institution, Washington, D.C.

The exhibition travels to Milwaukee and San Francisco in the winter and spring of 1970.

1970
Pace Graphics (now Pace Editions) publishes Nevelson's series of cast-paper relief prints.

Produces two lithographs at the Hollander Workshop for the television film *Making a Lithograph.*

Temple Beth-El in Great Neck, New York, commissions Nevelson to create *The White Flame of the Six Million,* a fifty-five-foot white wall sculpture in memory of those who died in the Holocaust. It is installed in the interior of the synagogue.

Introduced to couturier Arnold Scaasi through Arnold Glimcher. Scaasi begins collaborating with Nevelson on her wardrobe, creating lavish outfits for the artist.

Louise Nevelson: New Acquisitions at the Whitney Museum of American Art features

sculpture, prints, and early drawings and paintings given to the museum by the artist and the Howard and Jean Lipman Foundation.

1971
Pace Gallery exhibits a group of sculptures titled *Seventh Decade Garden,* made from painted and welded aluminum scraps. Nevelson also shows sculpture at the Makler Gallery in Philadelphia.

Given the Creative Arts Award in Sculpture from Brandeis University, as well as the Skowhegan Medal for Sculpture.

Louise Nevelson, a twenty-five-minute film directed by Fred Pressburger, airs on WCBS/Channel 2 in New York.

1972
Receives honorary degree, doctor of fine arts, from Rutgers University, New Brunswick, New Jersey.

Arnold B. Glimcher, director of Pace Gallery and Nevelson's longtime New York dealer, publishes his book *Louise Nevelson* (Praeger, New York).

As a gift to the city of New York, Nevelson creates the monumental Cor-ten steel sculpture *Night Presence IV* (based on her small 1955 wood sculpture of the same title). In February, the public work is installed at the entrance to Central Park at Fifth Avenue and 60th Street. The following year it is moved to its present site on Park Avenue and East 92nd Street, which was chosen by Nevelson and Glimcher.

Exhibits at Parker Street 470 Gallery in Boston, the Dunkelman Gallery in Toronto, and Pace Graphics in New York, where Nevelson's collages are shown for the first time.

The artist's first tapestry, *Sky Cathedral,* is produced by Gloria F. Ross in black wool

with a metallic thread image, based on a maquette created by Nevelson.

1973
Commissioned by Temple Israel, Boston, to create *Sky Covenant,* a large-scale Cor-ten steel wall sculpture for the exterior of its building.

The Cor-ten steel *Atmosphere and Environment XIII* (also known as *Windows to the West*) is installed in the Civic Center Mall of Scottsdale, Arizona, commissioned by the city with a grant from the National Endowment for the Arts (NEA).

Solo exhibition held at Studio Marconi in Milan and travels to the Moderna Museet, Stockholm.

In November, the Walker Art Center in Minneapolis presents a survey exhibition of Nevelson's wood sculpture, accompanied by a major catalogue by Walker director Martin Friedman. The exhibition travels for a year

and a half to five other museums: the San Francisco Museum of Art, the Dallas Museum of Fine Arts, the High Museum of Art in Atlanta, the William Rockhill Nelson Gallery in Kansas City, and the Cleveland Museum of Art.

Installation of the monumental outdoor sculpture *Dawn's Column* (1972–73), a commission for the Civic Center of Binghamton, New York.

Smith College in Northampton, Massachusetts, gives Nevelson an honorary degree.

1974
Nevelson's work is shown in solo exhibitions at national and international venues such as the Palais des Beaux Arts in Brussels; the Centre National d'Art Contemporain, Paris; the Neue Nationalgalerie, Berlin; Pace Gallery, Columbus; the Makler Gallery, Philadelphia; and Pace Gallery, New York.

Fig. 17. Louise Nevelson and Andrew Wyeth at a party at the Thorndike Hotel in Rockland, Maine, 1974. Archives of American Art, Smithsonian Institution, Washington, D.C.

Fig. 18. Louise Nevelson receiving an honorary degree from Columbia University, 1977. Archives of American Art, Smithsonian Institution, Washington, D.C.

1975

Transparent Horizon, a monumental Cor-ten steel outdoor sculpture, is commissioned by architect I. M. Pei and erected on the campus of the Massachusetts Institute of Technology, Cambridge, adjacent to his Landau Chemical Engineering Building.

The white-painted wood environment *Bicentennial Dawn* (1975–76) is commissioned for the lobby of the James A. Byrne Federal Courthouse, Philadelphia, as part of the federal government's General Services Administration Art-in-Architecture program. The installation is completed the following year in honor of the United States bicentennial. Philadelphia Mayor Frank L. Rizzo and First Lady Betty Ford attend the work's inauguration.

Solo exhibitions are held at galleries in Boston, Florence, Tokyo, and Turin.

1976

Dawns + Dusks, transcripts from Nevelson's taped conversations with Diana MacKown, is published by Charles Scribner's Sons.

The television film *Nevelson in Process* airs on WNET/Channel 13 in New York and then nationally.

Pieces from *Moon Garden + One* are exhibited in the Venice Biennale.

Nevelson's work is featured in *200 Years of American Sculpture* at the Whitney Museum of American Art.

Public commission *Sky Tree,* a fifty-two-foot-tall black Cor-ten sculpture, is installed in the Embarcadero Center in San Francisco.

1977

Installation of white-painted wood environment at the Erol Beker Chapel of the Good Shepherd in St. Peter's Lutheran Church, Citicorp Center, New York.

The culminating room-size work *Mrs. N's Palace* (1964–77) is exhibited at Pace Gallery, New York; Nevelson donates the work to The Metropolitan Museum of Art in 1985.

Metal Sculptures exhibition held at the Neuberger Museum of Art, Purchase College, State University of New York at Purchase.

Receives an honorary degree from Columbia University, New York.

1978

Summer Night Tree (1977–78), Nevelson's second NEA-funded public art commission, is erected in downtown Jackson, Michigan.

Installation of *Shadows and Flags,* a public commission consisting of seven Cor-ten steel sculptures painted black, ranging in height from twenty to forty feet, at Legion Memorial Square, an outdoor plaza bound by Maiden Lane, Liberty Street, and William Street in downtown Manhattan. The site is renamed Louise Nevelson Plaza the following year at the dedication ceremony attended by New York City Mayor Ed Koch and David Rockefeller. It is the first public plaza in New York to be named for an artist.

Receives commission for *Sky Gate–New York,* an outdoor sculpture for the Port Authority of New York and New Jersey at the World Trade Center, New York; the work is destroyed during the collapse of the Twin Towers on September 11, 2001.

Boston University gives the artist an honorary degree.

Begins making a series of jewelry, which Nevelson eventually donates (along with her designer clothes and Indian costumes and jewelry), to the Costume Institute of The Metropolitan Museum of Art, the Heard Museum in Phoenix, and the Costume Institute of the Phoenix Art Museum.

1979

Creates *The Bendix Trilogy,* three large-scale Cor-ten steel and aluminum sculptures, for the Bendix Corporation of America Headquarters Building in Southfield, Michigan.

The William A. Farnsworth Library and Art Museum organizes a Nevelson traveling exhibition, which opened in July and showed at three additional venues through April 1980 in West Palm Beach and Jacksonville, Florida, and Scottsdale, Arizona.

Fig. 19. Louise Nevelson receiving Women's Caucus for Art Award from President Jimmy Carter and Joan Mondale, 1979. Photograph by Carole Rosen. Archives of American Art, Smithsonian Institution, Washington, D.C.

Awarded the President's Medal of the Municipal Art Society of New York.

Elected a member of the American Academy of Arts and Letters, New York.

Receives Women's Caucus for Art Award and attends ceremony at the White House hosted by President Jimmy Carter and Joan Mondale.

The Whitney Museum of American Art commissions Pedro Guerrero to photograph Nevelson at home and at work for the catalogue of the exhibition *Louise Nevelson: Atmospheres and Environments.*

1980

Louise Nevelson: The Fourth Dimension opens at the Phoenix Art Museum in January and travels for a year to the Seattle Art Museum; the Winnipeg Art Gallery in Canada; the Museum of Art, University of Iowa in Iowa City; and the Dayton Art Institute in Ohio.

In honor of Nevelson's eightieth birthday, the Whitney Museum of American Art presents *Louise Nevelson: Atmospheres and Environments* (May 27–September 14), an exhibition of the artist's major black, white, and gold sculptural installations from 1955 to 1961, along with the more recent *Mrs. N's Palace.*

A major two-part exhibition is held in New York; maquettes for monumental sculptures are shown at Pace Gallery, and wood sculpture and collages are exhibited at Wildenstein & Co.

Begins a series of mixed-media collages, which Nevelson continues for the next several years.

Creates *Voyage I,* a thirty-foot-tall black Cor-ten sculpture, in an edition of three; two are installed, one in the Hallmark Center, Kansas City, and one at the University of Iowa, Iowa City.

Fig. 20. Louise Nevelson in her Spring Street studio, New York, c. 1979. Photograph by Pedro E. Guerrero

1981

Solo exhibitions are held at Wildenstein & Co., London, and the Galerie de France, Paris.

Travels with Diana MacKown to the Yucatán peninsula in Mexico.

Donates her collection of *santos* (Hispanic folk images and sculptures of saints) and Southwest Indian baskets to the Millicent Rogers Museum in Taos, New Mexico.

1982

Geometry + Magic, Diana MacKown's film about Nevelson, is shown in New York at the Cooper Union Forum in the fall.

Nevelson at Wildenstein Tokyo is held in Japan; artist attends the opening reception.

Public commission *Dawn Shadows,* a large outdoor steel sculpture, is installed in Madison Plaza, Chicago.

1983

Pace Gallery shows an exhibition of recent sculpture, titled *Cascades, Perpendiculars, Silence, Music.*

The black-painted steel sculpture *Sky Landscape* (1982–83), commissioned by the American Medical Association (AMA), is installed in front of the group's headquarters in Washington, D.C. Another version of the work is installed at the AMA's office in Chicago.

Double Image, a 1976 aluminum sculpture painted white, is featured in the inaugural installation of the sculpture court at the Whitney Museum's Philip Morris branch (now Altria) at 42nd Street and Park Avenue in New York.

Receives Gold Medal for Sculpture from the American Academy of Arts and Letters.

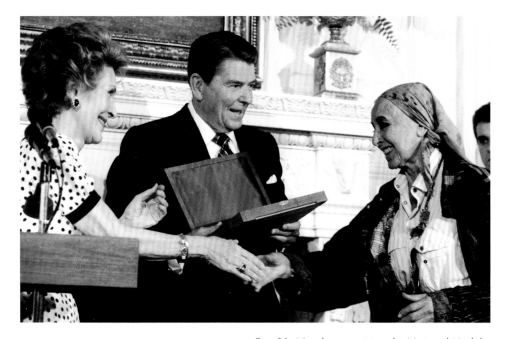

Fig. 21. Nevelson receiving the National Medal of Arts from President Ronald Reagan and First Lady Nancy Reagan at the White House, 1985

Fig. 22. Louise Nevelson commemorative stamps issued by the U.S. Postal Service in 2000

1984

Two public commissions installed—*Night Sail* (1983–84) at the Crocker Center, Los Angeles, and *Nightwave Moon* (1984) at the Kentucky Center for the Arts in Louisville.

1985

Awarded the National Medal of Arts and travels to Washington, D.C., to accept the award at a reception given by President Ronald Reagan and First Lady Nancy Reagan.

1986

Installation of *Dawn's Forest* (1985–86), an indoor public sculpture environment, at the Georgia Pacific Center in Atlanta.

Receives the Solomon R. Guggenheim Museum's Great Artist series award.

The Pratt Institute in New York gives Nevelson an honorary doctor of fine arts degree.

1987

In the fall, Nevelson is diagnosed with cancer.

1988

Louise Nevelson dies on April 17 at the age of eighty-eight at her home in New York City.

EXHIBITION HISTORY

SELECTED ONE-PERSON EXHIBITIONS

1941

Nevelson: Sculptures and Drawings, Nierendorf Gallery, New York, September 22–October

1942

Nierendorf Gallery, New York, opened in October

1943

Nevelson: Drawings, Nierendorf Gallery, New York, April 12–30

The Circus: The Clown Is the Center of His World, Norlyst Gallery, New York, opened on April 14

A Sculptor's Portraits in Paint, Nierendorf Gallery, New York, November 1–20

1944

Sculpture Montages, Nierendorf Gallery, New York, October 23–November 16

1946

Bronzes by Nevelson, Nierendorf Gallery, New York, April 15–27

1950

Moonscapes, Lotte Jacobi Gallery, New York

1954

Louise Nevelson, Lotte Jacobi Gallery, New York, January 5–23

Louise Nevelson, Marcia Clapp Gallery, New York, April

1955

Ancient Games and Ancient Places, Grand Central Moderns, New York, January 8–25

1956

The Royal Voyage (of the King and Queen of the Sea), Grand Central Moderns, New York, February 18–March 8

1957

The Forest, Grand Central Moderns, New York, January 4–23

1958

Moon Garden + One, Grand Central Moderns, New York, January 4–23

Graphics by Louise Nevelson, Esther Stuttman Galerie, New York, March 5–29

Galerie Jeanne Bucher, Paris

1959

Sky Columns Presence, Martha Jackson Gallery, New York, October 28–November 21

1960

Louise Nevelson, David Herbert Gallery, New York, January 6–February 6

The Sculpture of Louise Nevelson, Devorah Sherman Gallery, Chicago, March 29–April 30

Exposition L. Nevelson: Sculpteur, Galerie Daniel Cordier, Paris, opened in October

1961

The Royal Tides, Martha Jackson Gallery, New York, April 20–May 20

Galerie Schwarz, Milan, opened in April

Pace Gallery, Boston, opened in May

Louise Nevelson, Staatliche Kunsthalle, Baden-Baden, West Germany, September 24–October 22

1962

Daniel Cordier and Rudolphe Stadler Gallery, Frankfurt, January 18–February 28

Nevelson: Terra-Cottas, 1938–1948, Martha Jackson Gallery, New York, January 24–February 17

1963

Sidney Janis Gallery, New York, January 2–29

Louise Nevelson Bronzes, Martha Jackson Gallery, opened on May 11

Louise Nevelson, Hanover Gallery, London, November 6–December 6

Louise Nevelson: A Personal Collection: Rare Drawings, Etchings and Early Sculpture, Balin/Traube Gallery, New York, November 26–December 31

1964

Louise Nevelson, Gimpel und Hanover Galerie, Zurich, January 24–February 29

Louise Nevelson, Kunsthalle, Bern, Switzerland, May 20–June 21

Nevelson, Galleria d'Arte Contemporanea, Turin, Italy, April 8–May 3

Nevelson, Pace Gallery, New York, November 17–December 12

Pace Gallery, Boston

1965

Louise Nevelson: Homage to Six Million, The Jewish Museum, New York, May 7–September 12

Pace Gallery, New York

David Mirvish Gallery, Toronto

Galerie Schmela, Düsseldorf, March 27–April 27

1966

Nevelson at Pace: Four Enameled Aluminum Sculptures, Pace Gallery, New York, May 7–June 11

Nevelson, Ferus-Pace Gallery, Los Angeles, opened on December 11

1967

Louise Nevelson, Whitney Museum of American Art, New York, March 8–April 30; traveled to Rose Art Museum, Brandeis University, Waltham, Massachusetts, May 24–July 2

Louise Nevelson, Galerie Daniel Gervis, Paris, June 7–July 12

1968

Pace Gallery, New York, January 13–February 7

Façade: In Homage to Edith Sitwell, Everson Museum of Art, Syracuse, New York, January 31–February 23

Sculpture in Black, Arts Club of Chicago, September 23–October 26

1969

Louise Nevelson: Sculture, Litografie, Museo Civico di Torino, Turin, Italy, January 20–March 10

Louise Nevelson: Werke von 1959 bis 1961, Bürgermeister-Ludwig-Reichert-Haus, Ludwigshafen-am-Rhein, West Germany, February 28–March 23

Harcus Krakow Gallery, Boston, March 15–April 19

Louise Nevelson: Recent Wood Sculpture, Pace Gallery, New York, March 22–April 16

Louise Nevelson, Galerie Jeanne Bucher, Paris, May 2–June 7

Pace Gallery, Columbus

Louise Nevelson: Sculptures 1959–1969, Rijksmuseum Kröller-Müller, Otterlo, Netherlands, June 29–September 7

Louise Nevelson, Museum of Fine Arts, Houston, October 23–December 14; traveled to College of Fine Arts, University of Texas at San Antonio, January 15–February 15, 1970

Louise Nevelson: Black Walls and Sculptures: A Tenth Anniversary Exhibition, Martha Jackson Gallery, New York, December 2–20

1970

Louise Nevelson: New Acquisitions, Whitney Museum of American Art, New York, November 10–December 14

1971

Makler Gallery, Philadelphia

Louise Nevelson: Seventh Decade Garden, Pace Gallery, New York, May 8–June 19

Nevelson: Works of 1959–1963, Richard Gray Gallery, Chicago, December 14, 1971–January 14, 1972

1972

Graphics Gallery, Boston, January–February 6

Dunkelman Gallery, Toronto

Pace Graphics, New York

Louise Nevelson: Seventh Decade Garden Sculpture, Parker Street 470 Gallery, Boston, February 15–March 11

Louise Nevelson: Houses, Pace Gallery, New York, October 28–November 29

1973

Louise Nevelson: Work from 1955–1972, Studio Marconi, Milan, May 3–June; traveled to Moderna Museet, Stockholm, September 8–October 14

Louise Nevelson: Wood Sculptures, Walker Art Center, Minneapolis, November 10–December 30; traveled to San Francisco Museum of Art, January 25–March 10, 1974; Dallas Museum of Fine Arts, April 17–May 19, 1974; High Museum of Art, Atlanta, July 6–August 18, 1974; William Rockhill Nelson Gallery of Art, Kansas City, September 21–November 3, 1974; and Cleveland Museum of Art, January 28–March 9, 1975

1974

Palais des Beaux Arts, Brussels, opened in January

Louise Nevelson, Centre National d'Art Contemporain, Paris, April 9–May 13

Nevelson: Sky Gates and Collages, Pace Gallery, New York, May 4–June 8

Louise Nevelson, Neue Nationalgalerie, Berlin, June 5–July 1

Pace Gallery, Columbus

Makler Gallery, Philadelphia

Nevelson, C. W. Post Center Art Gallery, Long Island University, Greenvale, New York, October 25–November 27

Louise Nevelson as Printmaker, Cincinnati Art Museum, November 21, 1974–January 26, 1975

1975

Louise Nevelson, Minami Gallery, Tokyo, February 3–28

Louise Nevelson, Galleria d'Arte Spagnoli, Florence, February 11–March

Louise Nevelson: Recent Collages, Harcus Krakow Rosen Sonnabend Gallery, Boston, March 1–26

Galleria d'Arte l'Arcipelago, Turin, Italy

Hokin Gallery, Palm Beach, Florida

1976

Nevelson: Dawn's Presence-Two, Moon Garden + Two, 1969–1975, Pace Gallery, New York, February 14–March 13

Louise Nevelson as Printmaker, Herbert F. Johnson Museum of Art, Cornell University, Ithaca, New York, March 2–28

Makler Gallery, Philadelphia

Louise Nevelson: Grafica, Villa Pignatelli, Naples, May 9–30

1977

Louise Nevelson: Twelve Collage Drawings, Truman Gallery, New York, April 29–June 10

Nevelson at Purchase: The Metal Sculptures, Neuberger Museum of Art, Purchase College, State University of New York, Purchase, New York, May 8–September 11

Nevelson: Recent Wood Sculpture, Pace Gallery, New York, November 26, 1977–January 7, 1978

1978

Pace Gallery, Columbus

Louise Nevelson, Hokin Gallery, Palm Beach, Florida, February 8–March 6

Nevelson: Recent Wood Sculpture, Linda Farris Gallery, Seattle, June 24–August 27

Louise Nevelson: Sculpture and Graphics, Ulrich Museum of Art, Wichita State University, Kansas, September 12–October 15

Louise Nevelson: Boxes, Prints, Sculpture, B. R. Kornblatt Gallery, Baltimore, October 8–November 8

Louise Nevelson: Recent Works, Richard Gray Gallery, Chicago, October 14–November 30

Charles Burchfield Center, State University College at Buffalo, New York

1979

Makler Gallery, Philadelphia

Louise Nevelson, William A. Farnsworth
Library and Art Museum, Rockland, Maine,
July 13–September 30; traveled to Norton
Gallery and School of Art, West Palm Beach,
Florida, November 8, 1979–January 6, 1980;
Jacksonville Art Museum, Florida, January 17–
March 15, 1980; and Scottsdale Center for the
Arts, Arizona, March 28–April 30, 1980

1980

Louise Nevelson: The Fourth Dimension,
Phoenix Art Museum, January 11–February 24;
traveled to Seattle Art Museum, March–
May 18; Winnipeg Art Gallery, Canada,
June 20–August 10; Museum of Art,
University of Iowa, Iowa City, September 5–
October 12; Dayton Art Institute, Ohio,
November 14, 1980–January 7, 1981

*Louise Nevelson: Maquettes for Monumental
Sculpture,* Pace Gallery, New York, May 2–
June 27

Nevelson: Wood Sculpture and Collages,
Wildenstein & Co., New York, May 2–June 27

*Louise Nevelson: Atmospheres and
Environments,* Whitney Museum of American
Art, New York, May 27–September 14

1981

Louise Nevelson: Sculptures and Collages,
Wildenstein & Co., London

Pace Gallery, Columbus

Makler Gallery, Philadelphia

Louise Nevelson: Oeuvres 1953–1980, Galerie de
France, Paris, October 14–November 21

1982

Harcus Krakow Gallery, Boston, February 6–
March 10

Louise Nevelson: New Sculpture and Reliefs,
Richard Gray Gallery, Chicago, April 17–May

Fay Gold Gallery, Atlanta

Nevelson at Wildenstein Tokyo, Wildenstein &
Co., Tokyo

1983

*Cascades, Perpendiculars, Silence, Music: Louise
Nevelson,* Pace Gallery, New York, January 14–
February 19

Grey Art Gallery and Study Center, New York
University, New York

1984

Barbara Krakow Gallery, Boston, January 14–
February 9

Nevelson, Hokin Gallery, Bay Harbor Island,
Florida, February 10–March

Makler Gallery, Philadelphia

1985

Hokin Gallery, Palm Beach, Florida

Pace Gallery, New York, February 23–March 23

Louise Nevelson, Ivory/Kimpton Gallery, San
Francisco, March 21–April 20

The Art of Nevelson at the Farnsworth, William
A. Farnsworth Library and Art Museum,
Rockland, Maine, September 22–November 17

1986

Louise Nevelson, Galerie Claude Bernard,
Paris, January 23–February 22

Galerie Alice Pauli, Lausanne, Switzerland

Homage to Louise Nevelson: A Selection of Sculpture and Collages, Solomon R. Guggenheim Museum, New York, July 24–September 1

Louise Nevelson: Collages, Claude Bernard Gallery, New York, October 7–November 8

Louise Nevelson: Works in Wood, Bakalar Sculpture Gallery, List Visual Arts Center, Massachusetts Institute of Technology, Cambridge, Massachusetts, October 10–December 31

1987
Louise Nevelson: A Concentration of Works from the Permanent Collection of the Whitney Museum of American Art, Whitney Museum of American Art, Fairfield County, Connecticut, January 7–March 11, 1987; traveled to Muhlenberg College Center for the Arts, Allentown, Pennsylvania, opened April 2

1988
Louise Nevelson, Hokin Gallery, Palm Beach, Florida, February 1–20

1989
Louise Nevelson Remembered: Sculpture and Collages, Pace Gallery, New York, March 31–April 29

Louise Nevelson: In Retrospect, Richard Gray Gallery, Chicago, September 23–December

1991
Nevelson, Harry Remis Sculpture Court, Aidekman Arts Center, Tufts University, Medford, Massachusetts, October 1–31

1992
Louise Nevelson: In Retrospect, Hokin Gallery, Palm Beach, Florida, March 16–April 18

Louise Nevelson and a Selection of Pre-Columbian Art, Bellas Artes, Santa Fe, July 17–September 30

Wildenstein Gallery, Tokyo, October 19–November 20

Louise Nevelson: Black, White, and Gold, Pace Gallery, New York, October 23–November 28

1993
Louise Nevelson: Large Outdoor Metal Sculpture, Pace Gallery, New York, September 18–October 16

1994
Nevelson, Palazzo delle Esposizioni, Rome, July 28–October 31

1995
Monumental and Master Works by Louise Nevelson, Arij Gasiunasen Fine Art, Palm Beach, Florida, March 17–April 10

Louise Nevelson: Silent Music, Galerie Gmurzynska, Cologne, November 11, 1995–February 3, 1996

1996
Louise Nevelson: Sculptures et Oeuvres sur Papier, Galerie Marwan Hoss, Paris, September 25–November 16

Louise Nevelson, Museo Internazionale delle Ceramiche, Faenza, Italy, September 27, 1996–January 19, 1997

1997

Louise Nevelson: Sculpture and Drawings from the 1930s, Joan T. Washburn Gallery, New York, March 21–April 19

Louise Nevelson: Sculpture 1957–87, PaceWildenstein, New York, March 28–April 26

Louise Nevelson, Richard Gray Gallery, Chicago, April 4–May 31

Louise Nevelson: Collages, Locks Gallery, Philadelphia, September 5–October 31

Louise Nevelson: Collages, PaceWildenstein, Los Angeles, November 14, 1997–January 10, 1998

1998

Louise Nevelson: Structures Evolving, Whitney Museum of American Art, New York, April 29–September 13

Louise Nevelson: Skulpturen Collagen Zeichnungen, Galerie Lutz & Thalmann, Zurich, May 8–July 4

Sculptures in PPG Place, 1998 Three Rivers Arts Festival, Pittsburgh, May 27–July 31

Louise Nevelson: Sculpture and Drawings from the 1940s, Joan T. Washburn Gallery, New York, September 9–October 17

Louise Nevelson: Figurative Drawings and Ceramic Sculptures from the 1930s and 1940s, Bobbie Greenfield Gallery, Santa Monica, California, December 5, 1998–January 30, 1999

1999

Louise Nevelson: Drawings and Sculpture, News Art Centre Sculpture Park and Gallery, Roche Court, East Winterslow, Salisbury, England, September 11–November 6

Louise Nevelson: A Survey of Prints, Ernest Rubenstein Gallery at Educational Alliance, New York, September 23–October

Louise Nevelson: Sculpture and Collages, Locks Gallery, Philadelphia, October 1–October 30

Louise Nevelson: Sculpture and Collages, Baldwin Gallery, Aspen, Colorado, December 27, 1999–February 7, 2000

2000

Louise Nevelson, Fundação Arpad Szenes-Vieira da Silva, Lisbon, April 30–June 25

2002

Louise Nevelson: Structures Evolving, Samuel P. Harn Museum of Art, University of Florida, Gainesville, February 24–June 2

Louise Nevelson: Sculpture of the '50s and '60s, PaceWildenstein, New York, March 18–April 27

2003

Louise Nevelson: Selections from the Farnsworth Art Museum, Heckscher Museum of Art, Huntington, Long Island, New York, February 1–April 13; Everson Museum of Art, Syracuse, New York, May 4–June 29; Lyman Allyn Museum, New London, Connecticut; October 19–December 14; Evansville Museum of Arts and Sciences, Evansville, Indiana, January 14–March 7, 2004; Polk Museum of Art, Lakeland, Florida, April 4–May 30, 2004; Peninsula Fine Arts Center, Newport News, Virginia, June 27–August 22, 2004; Mitchell Art Gallery of St. John's College, Annapolis, Maryland, September 19–November 14, 2004; Minnesota Museum of American Art, St. Paul, December 12, 2004–February 6, 2005

Louise Nevelson: Luminous Voyage, Locks Gallery, Philadelphia, April 16–May 31

Louise Nevelson, JMG Galerie, Paris, September 20–November 15

2004

Louise Nevelson: Her Art, Her World, Evansville Museum of Arts, History and Science, Evansville, Indiana, January 11–March 7

Louise Nevelson: Wall Reliefs and Collages, Hackett-Freedman Gallery, San Francisco, June 3–July 31

Louise Nevelson, Galerie Thomas, Munich, November 11, 2004–January 22, 2005

2005

Louise Nevelson, Rosenbaum Contemporary, Gallery Center, Boca Raton, Florida, October 15–December 6

2006

Louise Nevelson: Small Works, Locks Gallery, Philadelphia, January 5–31

SELECTED GROUP EXHIBITIONS

1934

Salons of America, RCA Building, Rockefeller Center, New York, April 6–May 6

Eighteenth Annual Exhibition, Society of Independent Artists, Grand Central Palace, New York, April 13–May 6

Gallery Secession, New York, December 17, 1934–January 15, 1935

1935

Sculpture: A Group Exhibition by Young Sculptors, Brooklyn Museum, May 1–7

1936

A. C. A. Gallery, New York, June–July 4

1937

First Annual Membership Exhibition, American Artists Congress, New York, April 16–29

1943

31 Women, Art of This Century Gallery, New York, January 5–31

The Arts in Therapy, Museum of Modern Art, New York, February 2–March 7

1944

139th Annual Exhibition, Pennsylvania Academy of Fine Arts, Philadelphia, January 23–February 27

1946

Annual Exhibition of Contemporary American Sculpture, Watercolors, and Drawings, Whitney Museum of American Art, New York, February 5–March 13

1947

Annual Exhibition of Contemporary American Sculpture, Watercolors, and Drawings, Whitney Museum of American Art, New York, March 11–April 17

1948–49

Artists Gallery, Art Students League, New York

Sculpture Center, New York

1950

Annual Exhibition of Contemporary American Sculpture, Watercolors, and Drawings, Whitney Museum of American Art, New York, April 1–May 28

1952

60th Annual Exhibition, National Association of Women Artists, National Academy Galleries, New York, May 3–May 18

1953

Group Show of Sculptors, Grand Central Moderns, New York, January 3–24

Sculpture by Members of the National Association of Women Artists, Argent Gallery, New York, February–March 20

148th Annual Exhibition, Pennsylvania Academy of Fine Arts, Philadelphia, January 25–March 1

Annual Exhibition of Contemporary American Sculpture, Watercolors, and Drawings, Whitney Museum of American Art, New York, April 9–May 29

1955

63rd Annual Exhibition, National Association of Women Artists, National Academy Galleries, New York, May 12–29

Fourth Annual Exhibition of Paintings and Sculpture, Stable Gallery, New York, April 26–May 21

1956

Annual Exhibition of Contemporary American Sculpture, Watercolors, and Drawings, Whitney Museum of American Art, New York, April 18–June 10

Fifth Annual Exhibition of Paintings and Sculpture, Stable Gallery, New York, opened May 22–June

Annual Exhibition: Sculpture, Paintings, Watercolors, Drawings, Whitney Museum of American Art, New York, November 14, 1956–January 6, 1957

1957

LXII American Exhibition, Art Institute of Chicago, January 17–March 3

New York Artists Sixth Annual Exhibition, Stable Gallery, New York, May 7–June 21

Annual Exhibition: Sculpture, Paintings, Watercolors, Whitney Museum of American Art, New York, November 20, 1957–January 12, 1958

1958

Nature in Abstraction: The Relation of Abstract Painting and Sculpture to Nature in Twentieth-Century American Art, Whitney Museum of American Art, New York, January 14–March 16; traveled to Phillips Gallery, Washington, D.C., April 2–May 4; Fort Worth Art Center, Texas, June 2–June 29; Los Angeles County Museum, July 16–August 24; San Francisco Museum of Art, September 10–October 12; Walker Art Center, Minneapolis, October 29–December 14; City Art Museum of St. Louis, January 7–February 8, 1959

Pittsburgh International Exhibition of Contemporary Painting and Sculpture, Carnegie Institute, Pittsburgh, December 5, 1958–February 8, 1959

1959

67th Annual Exhibition, National Association of Women Artists, National Academy Galleries, New York, May 7–24

Work in Three Dimensions, Leo Castelli Gallery, New York, October 20–November 7

Art U. S. A., New York Coliseum, Grand Prize, April 3–19

63rd American Exhibition, Art Institute of Chicago, December 2, 1959–January 31, 1960

Sixteen Americans, Museum of Modern Art, New York, December 16, 1959–February 14, 1960

1960

70th Anniversary Exhibition, National Association of Women Artists, National Academy Galleries, New York, May 12–29

Annual Exhibition: Contemporary Sculpture and Drawings, Whitney Museum of American Art, New York, December 7, 1960–January 22, 1961

1961

The Art of Assemblage, Museum of Modern Art, New York, October 2–November 12; traveled to Dallas Museum for Contemporary Arts, January 9–February 11, 1962; and San Francisco Museum of Art, March 5–April 16, 1962

The Private Myth, Tanager Gallery, New York, October 6–26

Pittsburgh International Exhibition of Contemporary Painting and Sculpture, Carnegie Institute, Pittsburgh, October 27, 1961–January 7, 1962

1962

65th American Exhibition: Some New Directions in Contemporary Painting and Sculpture, Art Institute of Chicago, January 5–February 18

Art Since 1950, Seattle World's Fair, Seattle, April 21–October 21

United States Pavilion, *XXXI Biennale Internazionale d'Arte,* Venice, June 16–October 7

Modern Sculpture from the Joseph H. Hirshhorn Collection, Solomon R. Guggenheim Museum, New York, October 3, 1962–January 6, 1963

Annual Exhibition: Contemporary Sculpture and Drawings, Whitney Museum of American Art, New York, December 12, 1962–February 3, 1963

1964

159th Annual Exhibition, Pennsylvania Academy of Fine Arts, Philadelphia, January 25–March 1

Painting and Sculpture of a Decade, 1954–64, Tate Gallery, London, April 22–June 28

Boston Collects Modern Art, Rose Art Museum, Brandeis University, Waltham, Massachusetts, May 24–June 14

Between the Fairs: 25 Years of American Art, 1939–1964, Whitney Museum of American Art, New York, June 24–September 23

Documenta III, Kassel, West Germany, June 27–October 5

The Artist's Reality, New School Art Center, New York, October 14–November 14

Pittsburgh International Exhibition of Contemporary Painting and Sculpture, Carnegie Institute, Pittsburgh, October 30, 1964–January 10, 1965

Annual Exhibition of Contemporary American Sculpture, Whitney Museum of American Art, New York, December 9, 1964–January 31, 1965

1965

Collages and Constructions by Burri, Nevelson, Tàpies, and Van Leyden, Martha Jackson Gallery, New York, April 6–May 3

Sculpture: Twentieth Century, Dallas Museum of Fine Arts, May 12–June 13

American Sculpture of the 20th Century, Musée Rodin, Paris, June 22–October 10

Contemporary Art Acquisitions 1962–65, Albright–Knox Art Gallery, Buffalo, New York

Highlights of the '64–'65 Season, Larry Aldrich Museum, Ridgefield, Connecticut, opened in August

Kane Memorial Exhibition, Providence, Rhode Island

Art, an Environment for Faith: An Exhibition of Contemporary Art Presented by the Union of American Hebrew Congregations on the Occasion of Its 48th General Assembly, San Francisco Museum of Art, November 15–December 15

1966

Recent Works: Nevelson, Trova, Paolozzi, J. L. Hudson Gallery, Detroit, May 20–July 4

The Harry N. Abrams Family Collection, The Jewish Museum, New York, June 29–September 5

The Poetic Image, Hanover Gallery, London, June 28–September 9

68th American Exhibition, Art Institute of Chicago, August 19–October 16

Contemporary Painters and Sculptors as Printmakers, Museum of Modern Art, New York

Homage to Silence, or Metaphysika, Albert Loeb and Krugier Gallery, New York, October 18–November 19

First Flint Invitational, Flint Institute of Arts, Flint, Michigan, November 4–December 1

Annual Exhibition: Contemporary Sculpture and Prints, Whitney Museum of American Art, New York, December 16, 1966–February 5, 1967

1967

American Sculpture of the '60s, Los Angeles County Museum of Art, April 28–June 25; traveled to Philadelphia Museum of Art, September 15–October 29

The Helen W. & Robert M. Benjamin Collection, Yale University Art Gallery, New Haven, Connecticut, May 4–June 8

Sculpture: A Generation of Innovation, Art Institute of Chicago, June 23–August 27

Contrasts, Hanover Gallery, London, July 26–August 26

Sculpture in Environment, City of New York Arts Festival, New York, October 1–31

180 Beacon Collection of Contemporary Art, 180 Beacon Street, Boston, opened in October

Guggenheim International Exhibition: Sculpture from Twenty Nations, Solomon R. Guggenheim Museum, New York, October 20, 1967–February 4, 1968; traveled to Art Gallery of Ontario, Toronto, February–March 1968; National Gallery of Canada, Ottawa, April–May 1968; Montreal Museum of Fine Arts, June–August 1968

1968

Suites: Recent Prints, The Jewish Museum, New York, March 14–September 2

Documenta IV, Kassel, West Germany, June 27–October 8

Annual Exhibition: Contemporary American Sculpture, Whitney Museum of American Art, New York, December 17, 1968–February 9, 1969

1969

Tamarind: Homage to Lithography, Museum of Modern Art, New York, April 29–June 30

Twentieth-Century Art from the Nelson Aldrich Rockefeller Collection, Museum of Modern Art, New York, May 26–September 1

A Plastic Presence, The Jewish Museum, New York, November 19, 1969–January 4, 1970; traveled to Milwaukee Art Center (organizing venue), January 30–March 8, 1970; and San Francisco Museum of Art, April 24–May 24, 1970

1970

American Art Since 1960, Princeton University Art Museum, New Jersey, May 6–27

Expo '70, United States Pavilion, Japan World Exhibition, Osaka, March 15–September 13

Pittsburgh International Exhibition of Contemporary Art, Carnegie Institute, Pittsburgh, October 30, 1970–January 10, 1971

1971

Alexander Calder, Louise Nevelson, David Smith, Society of the Four Arts, Palm Beach, Florida, March 6–April 5

1973

Biennial Exhibition: Contemporary American Art, Whitney Museum of American Art, New York, January 10–March 18

American Art: Third Quarter Century, Seattle Art Museum, August 22–October 14

American Art at Mid-Century, National Gallery of Art, Washington, D.C., October 28, 1973–January 6, 1974

1974

Berenice Abbott, Helen Frankenthaler, Tatyana Grosman, Louise Nevelson, Smith College Museum of Art, Northampton, Massachusetts, January 17–February 24

Sculpture in the Park, Van Saun Park, Paramus, New Jersey, summer

Monumenta, Newport, Rhode Island, August 17–October 13

The Twentieth Century: 35 American Artists, Whitney Museum of American Art, New York, June–September

Fifteen American Artists, Denise René Gallery, Paris

1975

The Jewish Experience in the Art of the Twentieth Century, The Jewish Museum, New York, October 16, 1975–January 25, 1976

1976

200 Years of American Sculpture, Whitney Museum of American Art, New York, March 16–September 26

Ambient/Art 1915–1976 in *Environment, Participation, Cultural Structures: La Biennale di Venezia,* July 18–October 10

1977

Ferrara, Lichtenstein, Nevelson, Ryman, Sarah Lawrence Gallery, Bronxville, New York, September 15–October 9

Recent Works on Paper by American Artists, Madison Art Center, Madison, Wisconsin, December 4, 1977–January 15, 1978

1978

The Artist at Work in America, International Communications Agency, Bucharest, Romania

Perspectives '78—Works by Women, Albright College, Reading, Pennsylvania

Sculpture: A Study in Materials: Baizerman, Calder, Dehner, Hague, Hesse, Huntington, Lassaw, Nevelson, Smith, Stankiewicz, Vallila, Storm King Art Center, Mountainville, New York, May 17–October 30

L'Espace en Demeure: Louise Nevelson, Marie-Hélène Vieira da Silva, Magdalena Abakanowicz, Galerie Jeanne Bucher, Paris, October 11–November 18

Grid: Format and Image in the 20th Century, Pace Gallery, New York, December 16, 1978– January 20, 1979; traveled to Akron Art Institute, Ohio, March 24–May 7, 1979

1979

Women's Caucus for Art Honors Bishop, Burke, Neel, Nevelson, O'Keeffe, Middendorf/Lane Gallery, Washington, D.C., January 30– March 3

Collage: American Masters of the Medium, Montclair Art Museum, Montclair, New Jersey, March 25–June 24

Works on Paper U. S. A., Rockland County Center for the Arts, West Nyack, New York, April 8–May 20

Vanguard American Sculpture: 1913–1939, Rutgers University, New Brunswick, New Jersey, September 16–November 4; traveled to William Hayes Ackland Art Center, University of North Carolina, Chapel Hill, North Carolina, December 4, 1979– January 20, 1980

1980

Ten American Artists from The Pace Gallery, Wildenstein Gallery, London, June 18–July 18

Sculpture on the Wall: Relief Sculpture of the Seventies: Lynda Benglis, John Chamberlain, Bryan Hunt, Donald Judd, Ellsworth Kelly, Robert Morris, Louise Nevelson, George Segal, Frank Stella, University Gallery, University of Massachusetts at Amherst, March 29–May 4

1981

Sculptures and Their Related Drawings, Maris del Re Gallery, New York, March 3–31

1982

XXV Festival of Two Worlds, Spoleto, Italy, June–July

1983

Nevelson and O'Keeffe: Independents of the Twentieth Century, Nassau County Museum of Fine Art, Roslyn Harbor, New York, January 30–April 10

Sculpture: The Tradition in Steel, Nassau County Museum of Fine Art, Roslyn Harbor, New York, October 9, 1983–January 22, 1984

1984

American Women Artists (Part I: 20th Century Pioneers), Sidney Janis Gallery, New York, January–February 4.

1985

Eight Modern Masters, Amarillo Art Center, Amarillo, Texas, April 20–June 23

Transformations in Sculpture: Four Decades of American and European Art, Solomon R. Guggenheim Museum, New York, December 1985–February 12, 1986

1986

Contemporary Work from The Pace Gallery, Moody Art Gallery, Birmingham, Alabama

Relief Sculpture from the Hirshhorn Museum Collection, Hirshhorn Museum and Sculpture Garden, Washington, D.C., January 26– April 13

1987

Modern and Contemporary Masters, Richard Gray Gallery, Chicago, January 31–March 7

American Mastery: Eight Artists in the Permanent Collection of the Whitney Museum of American Art, Whitney Museum of American Art, New York, June 8, 1987– May 21, 1988

1989

Recent Acquisitions, Manny Silverman Gallery, Los Angeles

The "Junk" Aesthetic: Assemblage of the 1950s and Early 1960s, Whitney Museum of American Art, Fairfield County, Connecticut, April 7–June 14; traveled to Whitney Museum of American Art at Equitable Center, New York, June 30–August 23

Selections from the Collection of Marc and Livia Straus, Aldrich Museum of Contemporary Art, Ridgefield, Connecticut, June 25– October 8

Boîte Alerte, Renée Foutouhi Fine Art, New York

American Women Artists: The 20th Century, Knoxville Museum of Art, Tennessee, October 17, 1989–February 4, 1990, in conjunction with Bennett Galleries, Knoxville, October 27–November 26, 1989; traveled to Queensborough Community College Art Gallery, Bayside, New York, March 11–April 5, 1990

The Development of Sculptural Form: Auguste Rodin, Alexander Archipenko, Louise Nevelson, David Smith, Nancy Graves, Associated American Artists, New York, December 5–30

Unrealism, Paul Kasmin Gallery, New York, December 5, 1989–January 6, 1990

The Experience of Landscape: Three Decades of Sculpture, Whitney Museum of American Art, Downtown, Federal Reserve Plaza, New York, December 13, 1989–March 2, 1990

Contemporary Modern Masters: Selected Works, Ron Hall Gallery, Dallas, winter 1989–90

Sculptors Draw the Nude, Luise Ross Gallery, New York, winter 1989–90

Portrait of an American Gallery, Galerie Isy Brachot, Brussels, winter 1989–90

1990

Contemporary Illustrated Books: Word and Image, 1967–1988, Independent Curators Incorporated, New York; exhibited at Franklin Furnace Archive, Inc., New York, January 12–February; Nelson-Atkins Museum of Art, Kansas City, April 5–June 3; University of Iowa Museum of Art, Iowa City, February 8–April 7, 1991

Art in Europe and America: The 1950s and 1960s, Wexner Center for the Arts, Ohio State University, Columbus, February 17–April 22

GegenwartEwigkeit: Spuren des Transzendenten in der Kunst unserer Zeit (Present Eternity: Traces of Transcendence in the Art of Our Time), Martin-Gropius-Bau, Berlin, April 7–June 24

Two Decades of American Art: The 60s and 70s, curated by Leo Castelli, Nassau County Museum of Art, Roslyn Harbor, New York, May 20–September 3

Large-Scale Works by Gallery Artists and Sculpture and Painting, Pace Gallery, New York, July 16–August 24

Kunstlerinnen des 20 Jahrhunderts, Museum Wiesbaden, Germany, September 1–November 25

1991

Who Framed Modern Art or the Quantitative Life of Roger Rabbit, Sidney Janis Gallery, New York, January 10–February 9

20th Century Collage, Margo Leavin Gallery, Los Angeles, January 12–February 16

Abstract Sculpture in America: 1930–70, American Federation of Arts; exhibited at Lowe Art Museum, Coral Gables, Florida, February 7–March 31; Museum of Arts and Sciences, Macon, Georgia, April 19–June 30; Akron Art Museum, Ohio, August 24–October 20; Fort Wayne Museum of Art, Indiana, November 9, 1991–January 4, 1992; Musée du Québec, Quebec City, January 25–March 21, 1992; Terra Museum of American Art, Chicago, April 11–June 27, 1992

Sculpture, Pace Gallery, New York, March 9–May 4

The National Association of Women Artists: One Hundred Years, Museums at Stony Brook, Stony Brook, New York, April 7–June 23

Painting a Place in America: Jewish Artists in New York, 1900–1945, The Jewish Museum, New York, May 16–September 29

Contemporary Art: Paintings and Prints from Various Private Collections and the Harn Museum of Art Collection, Samuel P. Harn Museum of Art, University of Florida, Gainesville, May 16–June 30

Masterworks of Contemporary Sculpture, Painting and Drawing, the 1930s to the 1990s, Bellas Artes, Santa Fe, May 25–September 3

Louise Nevelson: Homage to 6,000,000, Samuel P. Harn Museum of Art, University of Florida, Gainesville, opened in June

Black and White, Renée Fotouhi Fine Art, East Hampton, New York, June 14–July 9

Small Sculpture in an Inner Space, Bellas Artes, Santa Fe, June 29–August 12

Le Collage au XXème Siècle, Musée d'Art Moderne et d'Art Contemporain, Nice, France, opened in July

Experiencing Sculpture: The Figurative Presence in America, 1879–1920, Hudson River Museum, Yonkers, New York, September 23, 1991–February 10, 1992

A Friend Remembers, Louise Nevelson: Work by Louise Nevelson from the Collection of Diana MacKown, Forum Gallery at Jamestown Community College, Jamestown, New York, November 9–December 19

Ten Sculptors of the New York School, Manny Silverman Gallery, Los Angeles, November 21, 1991–January 11, 1992

Sculptors' Drawings, Bellas Artes, Santa Fe, November 27, 1991–January 4, 1992

1992

Arte Americana, 1930–1970, Lingotto, Turin, January 8–March 31

Portraits, Plots and Places: The Permanent Collection Revisited, Walker Art Center, Minneapolis

Contemporary Wood Sculpture, Brooklyn Museum

Age of Bronze, Ramnarine Gallery, Long Island City, New York, September 12–October 10

1993

Sculptors on Paper, Linda Farris Gallery, Seattle, April 1–May 2

On Paper: The Figure in 20th Century American Art, Michael Rosenfeld Gallery, New York, June 10–July 30

The Second Dimension: Twentieth-Century Sculptors' Drawings, Brooklyn Museum, June 24–September 19

An Exhibition, Richard Gray Gallery, Chicago, October–November 13

In a Classical Vein: Works from the Permanent Collection, Whitney Museum of American Art, New York, October 21, 1993–April 3, 1994

1994

Sculptors' Maquettes, PaceWildenstein, New York, January 14–February 12

Sculpture, Nina Freudenheim Gallery, Buffalo, New York, January 22–March 2

30 YEARS—Art in the Present Tense: The Aldrich's Curatorial History 1964–94, Aldrich Museum of Contemporary Art, Ridgefield, Connecticut, May 15–September 17

The Art of Assemblage: 1950–1960s, Locks Gallery, Philadelphia, May 18–June 30

American Art in Italian Private Collections, American Academy in Rome, May 27–June 30

Martha Jackson Gallery, 1953 to 1979, Associated American Artists, New York, September 14–October 22

The Box: From Duchamp to Horn, Ubu Gallery, New York, October 29–December 10

Worlds in a Box, City Art Centre, Edinburgh, May 28–July 16; traveled to Graves Art Gallery, Sheffield, England, July 30–September 24; Sainsbury Centre for Visual Arts, University of East Anglia, Norwich, England, October 10–November 30; Whitechapel Art Gallery, London, December 4, 1994–February 12, 1995

1995

Black & White & Read All Over, Lasalle Partners at Nationsbank Plaza, Charlotte, North Carolina, January 16–October 31

Crossing State Lines: 20th Century Art from Private Collections in Westchester and Fairfield Counties, Neuberger Museum of Art, Purchase College, State University of New York, Purchase, New York, March 26–June 18

Group Show, PaceWildenstein, New York, May 20–September 8

Artist's Choice: Elizabeth Murray, Modern Women, Museum of Modern Art, New York, June 20–August 22

Out of Wood: Arp, Calder, Cornell, Diller, Ernst, Joostens, Nevelson, Popova, Torres-Garcia, Rachel Adler Fine Art, New York, October 26–December 30

1996
Contemporary Art/Recent Acquisitions, The Jewish Museum, New York, October 27, 1996–March 30, 1997

1997
Going the Distance, Rosemont College Gallery, Rosemont, Pennsylvania

Landscape: The Pastoral to the Urban, Center for Curatorial Studies, Bard College, Annandale-on-Hudson, New York, June 15–August 23

Inaugural Exhibition Ace Gallery Mexico, Ace Gallery, Mexico City, September 9–November 15

1998
Then and Now: Art Since 1945 at Yale, Yale University Art Gallery, New Haven, Connecticut, February 10–July 31

Portraits from the Collection of Michael Chow, PaceWildenstein, Los Angeles, February 14–28

Group Show, PaceWildenstein, Los Angeles, March 12–April 4

Sculpture, PaceWildenstein, Los Angeles, September 3–October 3

1999
Important Sculptors of the Twentieth Century, Stamford Sculpture Walk, Stamford, Connecticut, June 1–August 31

Contemporary American Masters: The 1960s, Nassau County Museum of Art, Roslyn Harbor, New York, June 13–September 12

The American Century: Art and Culture, 1950–2000, Whitney Museum of American Art, New York, September 26, 1999–February 13, 2000

Kunstwelten im Dialog: von Gauguin zur globalen Gegenwart, Museum Ludwig, Cologne, November 15, 1999–March 19, 2000

2000
True Grit: Lee Bontecou, Louise Bourgeois, Jay DeFeo, Claire Falkenstein, Nancy Grossman, Louise Nevelson, Nancy Spero, Michael Rosenfeld Gallery, New York, March 9–May 6

Welded Sculpture of the Twentieth Century, Neuberger Museum of Art, Purchase College, State University of New York, Purchase, New York, April 30–August 27

Art at Work: Forty Years of the Chase Manhattan Collection, Queens Museum of Art, Flushing Meadows, New York, May 23–October 1

Sensual Lines: American Figurative Drawings, Michael Rosenfeld Gallery, New York, November 2, 2000–January 13, 2001

2001
The Cultural Desert: Art, Medicine & Environment, Mayo Clinic, Scottsdale, Arizona, November 29, 2001–April 22, 2002; companion exhibition: *Inside Contemporary Sculpture,* Scottsdale Museum of Contemporary Art, Arizona, January 19–April 21, 2002

The Lenore and Burton Gold Collection of 20th Century Art, High Museum of Art, Atlanta, March 3–27

Summer in the City, PaceWildenstein, New York, June 1–September 12

Abstraction: The Amerindian Paradigm, Palais des Beaux-Arts, Brussels, June 29–September 16; traveled to Instituto Valenciano de Arte Moderno, Valencia, Spain, October 18, 2001–January 7, 2002

2002

Women Artists: Their Work and Influence, 1950–70, Gallery Paule Anglim, San Francisco, January 9–February 2

Moderna Museet c/o Magasin 3, Magasin 3 Stockholm Konsthall, Stockholm, March 23–June 16

True Grit: Seven Female Visionaries Before Feminism, Marsh Art Gallery, University of Richmond Museums, Richmond, Virginia, August 21–September 29

2003

Louise Nevelson—Hugo Weber: Weber der fünziger Jahre, Galerie Lutz & Thalmann, Zurich, March 14–May 3

Nevelson—Vari: A Dialog, Nohra Haime Gallery, New York, May 7–June 28

FORM(ATION): Modern and Contemporary Works from the Feibes & Schmitt Collection, Charles R. Wood Gallery, Hyde Collection, Glens Falls, New York, September 9–December 7

Four Originals: Cassatt, O'Keeffe, Nevelson, Frankenthaler, Nassau County Museum of Art, Roslyn Harbor, New York, September 21, 2003–January 4, 2004

2004

An American Odyssey 1945/1880, Circulo de Bellas Artes, Madrid, April 13–May 30; traveled to Domus Artium 2002 (DA2), Salamanca, Spain, June 10–July 31; Kiosco Alfonso, A Coruña, Spain, September 2–October 2; Queensborough Community College, City University of New York, Queens, October 24, 2004–January 15, 2005; Weber Fine Art, Greenwich, Connecticut, October 15–November 30

Collective Perspectives: New Acquisitions Celebrate the Centennial, The Jewish Museum, New York, November 5, 2004–March 6, 2005

2005

Eye Contact: Painting and Drawing in American Art, Michael Rosenfeld Gallery, New York, May 20–August 5

Art in the Gardens, LongHouse Reserve, East Hampton, New York, April 30–September 24

Collecting for the Cause: Activist Art in the 1960s and '70s, Smart Museum of Art, University of Chicago, December 17, 2005–March 12, 2006

EXHIBITION CHECKLIST

Unless otherwise indicated, works were to be shown at both venues of the exhibition: The Jewish Museum, New York, and the Fine Arts Museums of San Francisco, de Young. Those works designated DE YOUNG were shown only at the second of the two venues.

SCULPTURE

Self-Portrait, c. 1940
Bronze unique cast, artist carved ebony base, 13¼ × 11¼ × 8 in. (33.7 × 28.6 × 20.3 cm)
Collection of Feibes and Schmitt Architects, Schenectady, New York
Plate 3

Ancient City, 1945
Painted wood, 42 × 20 × 36 in. (106.7 × 50.8 × 91.4 cm)
Birmingham Museum of Art, Alabama; Gift of Mr. and Mrs. Ben Mildwoff through the Federation of Modern Painters and Sculptors, 1961.147
Plate 5

Moving-Static-Moving Figures, c. 1945
Terra-cotta and tattistone, dimensions variable
Whitney Museum of American Art, New York; Gift of the artist, 69.159.1–15
Plate 6

Black Box (Seeing Through), c. 1950
Wood painted black, 10 × 6 × 3 in. (25.4 × 15.2 × 7.6 cm)
Collection of Feibes and Schmitt Architects, Schenectady, New York
Plate 7

Sky Cathedral Presence, 1951–64
Wood, paint, 122¼ × 200 × 23⅞ in. (310.5 × 508 × 60.6 cm)
Collection Walker Art Center, Minneapolis, Gift of Judy and Kenneth Dayton, 1969
Plate 8

Model for Night Presence IV, 1955
Painted wood, 28 × 20½ × 10½ in. (71.1 × 52.1 × 26.7 cm)
Collection of the Lowe Art Museum, University of Miami; Gift of Pace Gallery and partial purchase through the Lowe Docent Guild and Museum Acquisitions Funds, 91.0412
Plate 15

Night Presence VI, 1955
Painted wood, 11 × 33 × 8½ in. (27.9 × 83.8 × 21.6 cm)
Private collection
Plate 16

Indian Chief, or *Chief,* 1955
Painted wood, 48 × 27 × 8¾ in. (121.9 × 68.6 × 22.2 cm)
Barrett M. Linde
Plate 18

Night Landscape, 1955
Painted wood, 35½ × 38½ × 15 in. (90.2 × 97.8 × 38.1 cm)
The Museum of Contemporary Art, Los Angeles, Gift of Mr. and Mrs. Arnold Glimcher
Plate 17

First Personage, 1956
Painted wood, two sections; front: 94 ×
37 1/16 × 11 1/4 in. (238.8 × 94.1 × 28.6 cm); back:
73 11/16 × 24 3/16 × 7 1/4 in. (187.2 × 61.4 × 18.4 cm)
Brooklyn Museum, Gift of Mr. and Mrs.
Nathan Berliawsky, 57.23a–b
Plate 19

Moon Fountain, 1957
Painted wood, 43 × 36 × 34 in. (109.2 × 91.4 ×
86.4 cm)
The Museum of Contemporary Art, Los
Angeles, Gift of Mr. and Mrs. Arnold
Glimcher
Plate 20

Sky Cathedral #2, 1957
Wood painted black, approx. 144 in.
(365.8 cm) long
Collection of Peter and Beverly Lipman
Not illustrated
DE YOUNG

Black Moon, 1959
Painted wood, 80 1/4 × 30 × 18 in. (203.8 ×
76.2 × 45.7 cm)
Private collection
Plate 21

Sky Cathedral/Southern Mountain, 1959
Painted wood, 114 × 124 × 16 in. (289.6 ×
315 × 40.6 cm)
The Museum of Contemporary Art, Los
Angeles, Gift of the artist
Plate 22
DE YOUNG

Sky Garden, 1959–64
Painted wood, 61 1/2 × 99 3/4 × 17 in. (156.2 ×
253.2 × 43.2 cm)
Collection of Harry W. and Mary Margaret
Anderson
Plate 23
DE YOUNG

Bride and Disk, 1959–67 (from *America-
Dawn,* 1962; originally from *Dawn's Wedding
Feast,* 1959)
Painted wood; bottom: 60 × 23 × 23 in.
(152.4 × 58.4 × 58.4 cm), top: 50 1/2 × 18 × 18 in.
(128.3 × 45.7 × 45.7 cm), disk: 42 × 41 × 3 in.
(106.6 × 104.1 × 7.6 cm)
The Art Institute of Chicago, Grant J. Pick
Purchase Fund, 1967.387
Plate 24

Groom and Disk, 1959–67 (from *America-
Dawn,* 1962; originally from *Dawn's Wedding
Feast,* 1959)
Painted wood; bottom: 60 × 24 × 17 in.
(152.4 × 61 × 43.2 cm), top: 50 1/2 × 20 × 19 in.
(128.3 × 50.8 × 48.3 cm), disk: 57 × 42 × 3 in.
(144.8 × 106.7 × 7.6 cm)
The Art Institute of Chicago, Grant J. Pick
Purchase Fund, 1967.387
Plate 24

Case with Five Balusters, from *Dawn's Wedding
Feast,* 1959
Wood, paint, 27 5/8 × 63 5/8 × 9 1/2 in. (70.2 ×
161.6 × 24.1 cm)
Collection Walker Art Center, Minneapolis,
Gift of Mr. and Mrs. Peter M. Butler, 1983
Plate 28

Dawn's Wedding Chapel I, from *Dawn's
Wedding Feast,* 1959
Painted wood, 90 × 51 × 6 in. (228.6 × 129.5 ×
15.2 cm)
Mr. and Mrs. Richard S. Levitt
Plate 25

Dawn's Wedding Chapel II, from *Dawn's
Wedding Feast,* 1959
White painted wood, 115 7/8 × 83 1/2 × 10 1/2
(294.3 × 212.1 × 26.7 cm)
Whitney Museum of American Art, New
York; Purchase, with funds from the Howard
and Jean Lipman Foundation, Inc., 70.68a–m
Plate 26

Dawn's Wedding Chapel IV, from *Dawn's Wedding Feast,* 1959–60
Painted wood, 109 × 87 × 12½ in. (276.9 × 221 × 34.3 cm)
Courtesy PaceWildenstein, New York
Plate 27

Dawn Cathedral Column I, from *Dawn's Wedding Feast,* 1956–58
Painted wood, 95½ × 6 × 6 in. (242.6 × 15.2 × 15.2 cm)
Private collection
Plate 29

Dawn Cathedral Column II, from *Dawn's Wedding Feast,* 1956–58
Painted wood, 104 × 10 × 10 in. (264.2 × 25.4 × 25.4 cm)
Private collection
Plate 29

New Dawn Cathedral Column, from *Dawn's Wedding Feast,* 1956–58
Painted wood, 109 × 12 × 12 in. (276.9 × 30.5 × 30.5 cm)
Merrin Family
Plate 30

Column from *Dawn's Wedding Feast,* 1959
Painted wood, 94⅛ × 18 × 18 in. (239.1 × 45.7 × 45.7 cm)
The Menil Collection, Houston, 78–159a
Plate 31

Column from *Dawn's Wedding Feast,* 1959
Painted wood, 94⅜ × 11 × 11 in. (239.7 × 27.9 × 27.9 cm)
The Menil Collection, Houston, 78–159b
Plate 31

White Column, from *Dawn's Wedding Feast,* 1959
Painted wood, 92½ × 11½ × 10 in. (235 × 29.2 × 25.4 cm)
National Museum of Women in the Arts, Washington, D.C., Gift of an anonymous donor
Plate 32

Dawn Column I, from *Dawn's Wedding Feast,* 1959
Wood and found objects painted white, 92 × 10½ × 10 in. (233.7 × 26.7 × 25.4 cm)
Collection of the Farnsworth Art Museum, Museum purchase, 1979, 79.81
Plate 33

Hanging Column, from *Dawn's Wedding Feast,* 1959
Painted wood, 72 × 6⅝ × 6⅝ in. (182.8 × 16.7 × 16.7 cm)
The Museum of Modern Art, New York, Blanchette Hooker Rockefeller Fund, 1960
Plate 35

Hanging Column, from *Dawn's Wedding Feast,* 1959
Painted wood, 72 × 10⅛ × 10⅛ in. (182.8 × 25.7 × 25.7 cm)
The Museum of Modern Art, New York, Blanchette Hooker Rockefeller Fund, 1960
Plate 35

Hanging Column, from *Dawn's Wedding Feast,* 1959
Painted wood, 72 × 4½ × 4½ in. (182.8 × 11.4 × 11.4 cm)
Private collection, formerly Dorothy C. Miller Collection
Plate 34

Hanging Column, from *Dawn's Wedding Feast,* 1959
Painted wood, 72 × 5 × 5 in. (182.8 × 12.7 × 12.7 cm)
Private collection, formerly Dorothy C. Miller Collection
Plate 34

Royal Tide I, 1960
Painted wood, 86 × 40 × 8 in. (218.4 × 101.6 × 20.3 cm)
Collection of Peter and Beverly Lipman
Plate 37

Golden Gate, 1961–70
Painted wood, 96 × 64½ × 12 in. (243.8 ×
163.8 × 30.5 cm)
Carol and Arthur Goldberg Collection
Plate 38

Rain Forest Column XVIII, 1962
Painted wood, 109 × 14 × 14 in. (276.9 ×
35.6 × 35.6 cm)
Private collection
Plate 39

Cascade, 1964
Painted wood, 100½ × 109 × 17½ in. (255.3 ×
276.8 × 44.5 cm)
San Francisco Museum of Modern Art, Gift
of an anonymous donor 93.480.A–G
Plate 44
DE YOUNG

Homage to 6,000,000 I, 1964
Painted wood, 91⅜ × 225⅝ × 11¹³⁄₁₆ in. (232 ×
573 × 30 cm)
Osaka City Museum of Modern Art, Japan
Plate 43

Self-Portrait: Silent Music IV, 1964
Wood painted black, 90⅛ × 65½ × 18⅛ in.
(229 × 166.5 × 46 cm)
Hyogo Prefectural Museum of Art, Japan
Plate 42

Mrs. N's Palace, 1964–77
Painted wood, mirror, 140 × 239 × 180 in.
(355.6 × 607.1 × 457.2 cm)
The Metropolitan Museum of Art, Gift of the
artist, 1985 (1985.41)
Plate 45

Atmosphere and Environment II, 1966
Aluminum, black epoxy, enamel, 94½ × 50 ×
26 in. (240 × 127 × 66 cm)
Rosalind Avnet Lazarus
Plate 46

Transparent Sculpture VI, 1967–68
Plexiglas with nuts and bolts, 19 × 22 × 8½ in.
(48.26 × 55.88 × 21.59 cm)
Whitney Museum of American Art, New
York; Purchase, with funds from the Howard
and Jean Lipman Foundation, Inc., 68.48
Plate 51

Transparent Sculpture IV, 1968
Plastic, 8 × 12¼ × 11½ in. (20.3 × 31.1 × 29.2 cm)
Collection Albright-Knox Art Gallery,
Buffalo, New York; New York State
Award/1968, 1968:8
Plate 50

Night-Focus-Dawn, 1969
24 painted wood boxes on base, 102 × 117 ×
14 in. (259.1 × 297.2 × 35.6 cm)
Whitney Museum of American Art, New
York; Purchase, with funds from Howard and
Jean Lipman. 69.73a–y
Plate 52
DE YOUNG

Large Cryptic I, 1970
Black painted wood, 7 × 20 × 10¾ in.
(17.8 × 50.8 × 27.3 cm)
Collection Emily Fisher Landau, New York
(Amart Investments, LLC)
Plate 53

Model for the White Flame of the Six Million,
1970
Painted wood, 22½ × 74 in. (57.2 × 188 cm)
Collection Reed and Delphine Krakoff,
New York
Plate 54

Dream House XXXII, 1972
Painted wood with metal hinges, 75⅛ × 24⅝ ×
16⅞ in. (190.8 × 62.6 × 42.9 cm)
Hirshhorn Museum and Sculpture Garden,
Smithsonian Institution, Washington, D.C.,
The Joseph H. Hirshhorn Bequest, 1981
Plate 55

End of Day XXXV, 1973
Painted wood, 32⅛ × 16½ × 2⅝ in.
(81.6 × 41.9 × 6.7 cm)
The Jewish Museum, New York, Gift of
Hanni and Peter Kaufmann, 1994–583
Plate 56

Ocean Gate, 1982
Steel, aluminum, and black paint,
145¹¹⁄₁₆ × 81⅞ × 68⅛ in. (370.7 × 208 × 173 cm)
Fine Arts Museums of San Francisco,
Museum Purchase, Gift of Barbro and
Bernard Osher 2002.72
Plate 61
DE YOUNG

Mirror-Shadow VII, 1988
Painted wood, 94 × 37½ × 19 in.
(238.8 × 95.3 × 48.3 cm)
Carolyn and Preston Butcher
Plate 62

WORKS ON PAPER

Untitled, 1928
Crayon on paper, 17⅝ × 13⅜ in.
(44.77 × 33.97 cm)
Whitney Museum of American Art, New
York; Gift of the artist, 69.220
Plate 1

Untitled, 1930
Graphite on paper, 12 × 17¾ in.
(30.48 × 45.09 cm)
Whitney Museum of American Art,
New York; Gift of the artist, 69.239
Plate 2

Lotte Jacobi (American, b. Prussia,
1896–1990), with Louise Nevelson
Portrait of Louise Nevelson, c. 1943
Pen on black and white photograph,
13¹⁵⁄₁₆ × 11 in. (35.4 × 27.9 cm)
Collection Diana MacKown, Ellington,
New York
Plate 4

Archaic Figures, 1953–55
Etching, 10 × 20⁹⁄₁₆ in. (25.4 × 52.2 cm) (sheet)
Brooklyn Museum, Gift of Louise Nevelson,
65.22.7
Plate 11

Figure (related to *Goddess from the Great
Beyond*), 1953–55
Etching and aquatint, 13¹¹⁄₁₆ × 8 in. (34.8 ×
20.3 cm)
The Minneapolis Institute of Arts, The Edith
and Norman Garmezy Prints and Drawings
Acquisition Fund, P.98.20.1
Plate 9

The King and Queen, 1953–55 (printed
1965–66)
Etching on paper, 34 × 25¼ in. (86.3 × 64.1 cm)
Published by Pace Editions, Inc.
Plate 14

Majesty, 1953–55
Etching, 25¹³⁄₁₆ × 19⅞ in. (65.6 × 50.5 cm)
Brooklyn Museum, Gift of Louise Nevelson,
65.22.29
Plate 13

Moon Goddess I, 1953–55
Etching, 20½ × 9½ in. (52.1 × 24.1 cm)
Brooklyn Museum, Gift of Louise Nevelson,
65.22.18
Plate 12

Sunken Cathedral, 1953–55
Etching and drypoint on Japan paper, 20¾ ×
14 in. (52.7 × 35.6 cm)
Fine Arts Museums of San Francisco, Gift of
Hans Neukomm, 1999.25
Plate 10

Untitled, 1963
Lithograph on Rives BFK paper, 32½ × 23 in.
(82.6 × 58.4 cm)
National Gallery of Art, Washington,
Rosenwald Collection, 1964
Plate 40

Untitled, 1963
Printed by Kenneth Tyler (American, b. 1931)
Tamarind Lithography Workshop
Color lithograph 21⅞ × 17⅜ in. (55.5 × 44.2 cm)
The Metropolitan Museum of Art, New York,
John B. Turner Fund, 1966 (66.587.1)
Plate 41

Untitled, from the series *Façade: In Homage
to Edith Sitwell,* 1966
Silkscreen on paper, 23 × 17½ in. (58.4 ×
44.5 cm)
The JPMorgan Chase Art Collection, New
York, 878
Plate 47

Untitled, from the series *Façade: In Homage
to Edith Sitwell,* 1966
Silkscreen on paper, 23 × 17½ in. (58.4 ×
44.5 cm)
The JPMorgan Chase Art Collection, New
York, 882
Plate 48

Untitled, from the series *Façade: In Homage
to Edith Sitwell,* 1966
Silkscreen on paper, 23 × 17½ in. (58.4 ×
44.5 cm)
The JPMorgan Chase Art Collection, New
York, 883
Plate 49

Dawnscape, 1975
Cast paper relief, 28⅛ × 31½ in. (71.4 × 80 cm)
Smithsonian American Art Museum,
Washington, D.C., Museum purchase,
1978.25
Plate 57
DE YOUNG

Nightscape, 1975
Cast paper relief, 27 × 31 in. (68.6 × 78.7 cm)
Published by Pace Editions, Inc.
Plate 58

Morning Haze, 1978
Cast paper relief print, 33 × 46 in. (83.8 ×
116.8 cm)
Published by Pace Editions, Inc.
Plate 59

Untitled, 1981
Wood and cardboard collage on matboard,
mounted on wood, 40⅛ × 32⅛ × ¾ in.
(101.8 × 81.4 × 1.9 cm)
Solomon R. Guggenheim Museum, New
York, Gift of the artist, 85.3270
Plate 60

SELECTED BIBLIOGRAPHY

Adlow, Dorothy. "'Sixteen Americans,' A Vigorous Display." *Christian Science Monitor,* December 19, 1959, 10.

Arp, Jean. "Louise Nelson." *XXe Siècle* (June 1960): 19.

"Art: Adventurous Sculptress." *Newsweek,* November 9, 1959, 119.

"Art: All That Glitters." *Time,* August 31, 1962, 40.

"Art: One Woman's World." *Time,* February 3, 1958, 58.

Ashton, Dore. "About Art: Louise Nevelson Shows Wood Sculptures." *New York Times,* February 21, 1956, 31.

———. "Art: Forest Sculptures; Pieces Hewn in Wood by Louise Nevelson Evoke Arboreal Metaphors." *New York Times,* January 8, 1957, 34.

———. "Art: Worlds of Fantasy; Louise Nevelson's Sculpture at Jackson Gallery—Works by Richenburg Shown." *New York Times,* October 29, 1959, 44.

———. "U. S. A.: Louise Nevelson." *Cimaise* (April–June 1960): 26–36.

Baldwin, Carl. "In the Galleries: Louise Nevelson." *Arts* (January 1958): 55.

Baro, Gene. *Nevelson: The Prints.* New York: Pace Editions, 1974.

Baur, John I. H. *Nature in Abstraction.* New York: Whitney Museum of American Art and Macmillan, 1958.

Bethany, Marilyn. "A Sculptor's Environment." *New York Times Magazine,* April 27, 1980, 132–33, 136.

Bober, Natalie S. *Breaking Tradition: The Story of Louise Nevelson.* New York: Atheneum, 1984.

Bongartz, R. "'I Don't Want to Waste Time,' says Louise Nevelson at 70." *New York Times Magazine,* January 24, 1971, 12–13, 30–34.

Brenson, Michael. "She Belonged to Sculpture and the Night." Review of *Louise Nevelson: A Passionate Life,* by Laurie Lisle. *New York Times Book Review,* March 25, 1990, 15, 16.

Canaday, John. "Art: Ingenuity of Louise Nevelson." *New York Times,* November 4, 1972, 29.

———. "Display at Pace Gallery Called Her Best Yet," *New York Times,* November 21, 1964, 25.

———. "Louise Nevelson and the Rule Book." *New York Times,* April 6, 1969, D25.

Cavaliere, Barbara. "Louise Nevelson." *Arts* (February 1978): 32.

Celant, Germano. *Nevelson.* Rome: Edizioni Charta, Milan and Palazzo delle Esposizioni, 1990.

Coates, Robert M. "The Art Galleries." *New Yorker,* January 2, 1960, 61.

Conroy, Sarah Booth. "Nevelson at Eighty." *Horizon* (March 1980): 62–67.

Coutts-Smith, Kenneth. "Nevelson." *Arts Review* (London) (November 16–30, 1963): 16.

Devree, Howard. "Modern Sculpture." *New York Times,* October 11, 1942, X5

Diamonstein, Barbaralee. "Louise Nevelson: 'It Takes a Lot to Tango.'" *ARTnews* (May 1979): 69–72.

———. "Louise Nevelson: A Conversation with Barbaralee Diamonstein." In *Nevelson: Maquettes for Monumental Sculpture.* Exh. cat. New York: Pace Gallery, 1980.

Foster, Hal. "Reviews: New York." *Artforum* (February 1978): 68.

Friedman, Martin. *Nevelson: Wood Sculptures.* Exh. cat. Minneapolis: Walker Art Center, with New York: E. P. Dutton, 1973.

Genauer, Emily. "Abstract Art with Meaning: A World." *New York Herald Tribune,* January 12, 1958, sec. 6, 14.

———. "A Scavenger's Black Magic." *New York World Journal Telegram,* March 12, 1967, 33.

Gilbert, Lynn, and Gaylen Moore. *Particular Passions: Talks with Women Who Have Shaped Our Times.* New York: Clarkson N. Potter, 1981.

Glimcher, Arnold B. *Louise Nevelson.* New York: Praeger, 1972; rev. ed., New York: E. P. Dutton, 1976.

Glueck, Grace. "White on White: Louise Nevelson's 'Gift to the Universe.'" *New York Times,* October 22, 1976, 29.

Goldberg, Vicki. "Creators on Creating: Louise Nevelson." *Saturday Review,* August 1980, 34–37.

Gordon, John. *Louise Nevelson.* Exh. cat. New York: Whitney Museum of American Art, and Praeger, 1967.

Hammel, Lisa. "Louise Nevelson Has Plan for Living: A House That Is One Large Sculpture." *New York Times,* April 28, 1967, 45.

Hess, Thomas B. "U.S. Art, Notes from 1960." *ARTnews* (January 1960): 25–29, 56–58.

Hughes, Robert. "Night and Silence: Who Is There?" *Time,* December 12, 1977, 59–60.

———. "Sculpture's Queen Bee," *Time,* January 12, 1981, 66–72.

———. "Tsarina of Total Immersion," *Time,* June 16, 1980, 76.

Johnson, Una. *Louise Nevelson: Prints and Drawings, 1953–1966.* Exh. cat. New York: Brooklyn Museum and Shorewood Publications, 1967.

Kramer, Hilton. "Art." *Nation,* January 26, 1963, 78–79.

———. "Art: A Nevelson Made to Last." *New York Times,* December 9, 1977, C17.

———. "Nevelson: Her Sculpture Changed the Way We Look at Things," *New York Times Magazine,* October 30, 1983, 28, 30, 69, 72, 73, 81.

———. "Nevelson's Dazzling Feats." *New York Times,* May 11, 1980, sec. 2, 1, 30–31.

———. "The Sculpture of Louise Nevelson." *Arts* (June 1958): 26–29.

Kroll, Jack. "Reviews and Previews: Louise Nevelson." *ARTnews* (May 1961): 10–11.

Lipman, Jean. *Nevelson's World.* Introduction by Hilton Kramer. New York: Hudson Hills Press in association with the Whitney Museum of American Art, 1983.

Lisle, Laurie. *Louise Nevelson: A Passionate Life.* New York: Summit, 1990.

Louise Nevelson. Exh. cat. Paris: Galerie Daniel Gervis, 1967.

Louise Nevelson. Exh. cat. Houston: Museum of Fine Arts, Houston, 1969.

Louise Nevelson. Exh. cat. Rockland, Maine: William A. Farnsworth Library and Art Museum, 1979.

Louise Nevelson: Atmospheres and Environments. Exh. cat. Introduction by Edward Albee. New York: Whitney Museum of American Art with Clarkson N. Potter, 1980.

Louise Nevelson: First London Exhibition. Exh. cat. London: Hanover Gallery, 1963.

Louise Nevelson: The Fourth Dimension. Exh. cat. Essay by Laurie Wilson. Phoenix: Phoenix Art Museum, 1980.

Louise Nevelson Remembered. Exh. cat. New York: Pace Gallery, 1989.

Mellow, James R. "In the Galleries: Personages at Sea." *Arts* (February 1956): 52.

Miller, Dorothy C., ed. *Sixteen Americans.* Exh. cat. New York: Museum of Modern Art, 1959.

Munro, Eleanor. *Originals: American Women Artists.* New York: Simon and Schuster, 1979.

Nemser, Cindy. *Art Talk: Conversations with Twelve Women Artists.* New York: Charles Scribner's Sons, 1975.

Nevelson, Louise. "Art at the Flatbush Boys Club." *Flatbush Magazine* (June 1935): 3.

———. *Dawns + Dusks.* Edited by Diana MacKown. New York: Charles Scribner's Sons, 1976.

———. "Do Your Work." In "Why Have There Been No Great Women Artists?: Eight Artists Reply." *ARTnews* (January 1971): 41, 43.

———. "Nevelson on Nevelson." *ARTnews* (November 1972): 66–68.

———. "Queen of the Black Black." In Philip Pearlstein, "The Private Myth." *ARTnews* (September 1961): 45.

———. "The Sculptor." *Newsweek,* July 4, 1976, 53.

———. Statement in "Period Rooms—The Sixties and Seventies." *Art in America* (November–December 1970): 129.

Nevelson. Exh. cat. Foreword by Kenneth Sawyer; poem by Jean Arp; commentary by Georges Mathieu. New York: Martha Jackson Gallery, 1961.

Nevelson. Exh. cat. New York: Pace Gallery, 1964.

Nevelson at Purchase: The Metal Sculptures. Exh. cat. Purchase, N.Y.: Neuberger Museum, State University of New York at Purchase, 1977.

Nevelson: Recent Wood Sculpture. Exh. cat. New York: Pace Gallery, 1969.

Nevelson: Recent Wood Sculpture. Exh. cat. New York: Pace Gallery, 1977.

Nevelson: Sky Gates and Collages. Exh. cat. New York: Pace Gallery, 1974.

Nochlin, Linda. "Why Have There Been No Great Women Artists?" *ARTnews* (January 1971): 22–29.

O'Doherty, Brian. "Art: Four Sculptors Manipulate Third Dimension; Louise Nevelson and de Creeft Have Shows." *New York Times,* April 24, 1961, 35.

O'Hara, Frank. "Reviews and Previews: Sculpture 1955." *ARTnews* (September 1955): 51.

A Plastic Presence. Exh. cat. Milwaukee: Milwaukee Art Center, 1969.

Porter, Fairfield. "Reviews and Previews: Louise Nevelson." *ARTnews* (January 1955): 46.

Preston, Stuart. "Art: 'Sixteen Americans,'" *New York Times,* December 16, 1959, 50.

———. "The Rising Tide of Exhibitions for 1958: Mysterious Dreamland." *New York Times,* January 12, 1958, X18.

Ratcliff, Carter, ed. *Louise Nevelson: Sculptures and Collages.* Exh. cat. London: Wildenstein, with New York: Pace Gallery, 1981.

Raynor, Vivien. "In the Galleries: Louise Nevelson." *Arts* (September 1961): 40.

———. "Louise Nevelson at Pace." *Art in America* (January–February 1973): 114–15.

Riley, Maude. "Irrepressible Nevelson." *Art Digest* (April 15, 1943): 18.

Roberts, Colette. *Nevelson.* Paris: Editions Georges Fall, 1964.

Roosevelt, Felicia. *Doers and Dowagers.* New York: Doubleday, 1975.

Rosenblum, Robert. "Louise Nevelson." *Arts Yearbook 3: Paris/New York* (1959): 136–39.

Russell, John. "Louise Nevelson Dies at 88; Enduring Force in Art World." *New York Times,* April 18, 1988, A1.

Sawin, Martica. "In the Galleries: Louise Nevelson." *Arts* (December 1959): 57.

Schuyler, James. "Reviews and Previews: Louise Nevelson." *ARTnews* (December 1959): 19.

Schwartz, Constance. *Nevelson and O'Keefe: Independents of the Twentieth Century.* Exh. cat. Roslyn Harbor, N.Y.: Nassau County Museum of Fine Art, 1983.

Schwartz, Ellen. "Two from Nevelson: A Stunning Chapel and a Palace for the Child in All of Us." *ARTnews* (February 1978): 54–55.

Seckler, Dorothy Gees. "The Artist Speaks: Louise Nevelson." *Art in America* (January–February 1967): 32–43.

Seitz, William. *The Art of Assemblage.* New York: Museum of Modern Art, 1961.

———. *2 Pittori 2 Scultori.* Organized for the 31st Venice Biennale by the International Council of the Museum of Modern Art, New York, 1962.

Shirey, David L. "Louise Nevelson." In *Nevelson: Wood Sculpture and Collages.* Exh. cat. New York: Wildenstein, 1980.

Sieberling, Dorothy. "Weird Woodwork of Lunar World." *Life,* March 24, 1958, 77–80.

Smith, Dido. "Louise Nevelson." *Craft Horizons* (May–June 1967): 44–49, 74–79.

Stevens, Mark. "The Wood Witch." *Newsweek,* December 19, 1977, 95–96.

Strickler, Carolyn. "Interview with Louise Nevelson." *Creative Crafts* (January/ February 1964): 2–4.

Stroup, Jon. "Tunnard and Nevelson." *Art Digest* (November 15, 1944): 14.

Tyler, Parker. "Reviews and Previews: Louise Nevelson." *ARTnews* (January 1958): 54.

Wilson, Laurie. "Bride of the Black Moon: An Iconographic Study of the Work of Louise Nevelson," *Arts* (May 1980): 140–48.

———. *Louise Nevelson: Iconography and Sources.* New York: Garland, 1981.

ARCHIVAL MATERIALS

Approximately 21,000 items from Louise Nevelson's personal archive were donated by the artist to the Archives of American Art, Smithsonian Institution, Washington, D.C. Most documents are now available on microfilm, which are duplicated in five regional offices: Boston, Detroit, Houston, New York, and San Francisco. The following transcripts of taped interviews with Nevelson can be found in the archives indicated below:

Belloli, Jay. Sound and Moving Image Collections, Walker Art Center Archives, Minneapolis, 1971.

Braun, Barbara (with Paul Anbinder and Jean Lipman). Given by *Publishers Weekly* to the Archives of American Art, Smithsonian Institution, Washington, D.C., 1982.

Friedman, Martin. Sound and Moving Image Collections, Walker Art Center Archives, Minneapolis, 1973.

Glimcher, Arnold. Arnold Glimcher Papers, New York, 1970 and 1971.

———. Oral History Program, Archives of American Art, Smithsonian Institution, Washington, D.C., 1973.

Jacobowitz, Arlene. Brooklyn Museum Library, New York, 1965.

Kissel, Howard. New York, 1972. Given by the artist to the Archives of American Art, Smithsonian Institution, Washington, D.C.

Rago, Laurie Elliot. New York, 1958 and 1959. Given by the artist to the Archives of American Art, Smithsonian Institution, Washington, D.C.

Roberts, Colette. Arnold Glimcher Papers, New York, 1964.

———. Oral History Program, Archives of American Art, Smithsonian Institution, Washington, D.C., 1968.

Seckler, Dorothy Gees. Oral History Program, Archives of American Art, Smithsonian Institution, Washington, D.C., 1968.

Streeter, Tal. Given by the artist to the Archives of American Art, Smithsonian Institution, Washington, D.C., 1959.

Waterman, Edward C. New York, 1960. Given by the artist to the Archives of American Art, Smithsonian Institution, Washington, D.C.

Wilson, Laurie. Laurie Wilson Files, New York, 1976 and 1977.

FILMS AND BROADCAST MATERIALS

About the Arts, interview with Barbaralee Diamonstein-Spielvogel. Videocassettes. Barbaralee Diamonstein-Spielvogel Collection of interviews of prominent people in the arts, Motion Picture and Television Reading Room, Library of Congress, Washington, D.C.

Geometry + Magic: Louise Nevelson. Directed by Diana MacKown. Color film, 28 min. New York, Iron Crystal Films, 1982.

The Look of a Lithographer. Produced and
 written by June Wayne. Black-and-white
 film, 45 min. Albuquerque, N.M.,
 Tamarind Institute, 1968.

Louise Nevelson. Directed by Fred Pressburger.
 Color film, 25 min. Spectra Films, Inc.,
 1971. Aired on WCBS/Channel 2, New
 York, 1971.

*Louise Nevelson: Interview with Martin
 Friedman at Nevelson's Studio in New York
 City.* Directed by Ron McCoy. Video,
 approx. 30 min. Minneapolis, Walker Art
 Center, 1973.

*Louise Nevelson: Interview with Martin
 Friedman at the Walker Art Center
 Auditorium.* Directed by Ron McCoy.
 Video, 100 min. Minneapolis, Walker Art
 Center, 1973.

Making a Lithograph. Television film. New
 York, Hollander Workshop, 1970.

Nevelson in Process. Produced and directed by
 Susan Fanshel and Jill Godmilow. Color
 film, 28 min. New York, WNET/
 Channel 13, 1976.

NOTES

LOUISE NEVELSON: A STORY IN SCULPTURE

1. Dorothy C. Miller Papers, Archives of American Art, Smithsonian Institution, Oral History Interview by Paul Cummings with Dorothy C. Miller. May 26, 1970–September 28, 1971, p. 173 of transcript.

2. Rauschenberg was cognizant of the dramatic turn away from Abstract Expressionism toward new work. In a 1965 interview with the Archives of American Art, Rauschenberg said: "There was something about the self assertion of abstract expressionism that personally always put me off, because at that time my focus was as much in the opposite direction as it could be." See "Interview with Robert Rauschenberg Conducted by Dorothy Seckler in New York, December 21, 1965," Archives of American Art, Smithsonian Institution, Washington, D.C., 2.

3. Louise Nevelson, *Dawns + Dusks,* Diana MacKown, ed. (New York: Charles Scribner's Sons, 1976), 133. Nevelson, who often adjusted her birth year to make herself younger, also stated: "Don't forget, dear, that I was fifty-eight in 1958 when I was in the show at the Museum of Modern Art—*Sixteen Americans.* And they were all much, much younger than I." This statement would have made the artist's birth year 1900 rather than 1899.

4. "The Grande Dame of Contemporary Sculpture," from John Canaday, "Display at Pace Gallery Called Her Best Yet," *New York Times,* November 21, 1964, 25. "Sculpture's Queen Bee" from Robert Hughes, *Time,* January 12, 1981. ". . . grand mistress of the marvelous," from Dore Ashton, "Art: Worlds of Fantasy," *New York Times,* October 29, 1965, 44. ". . . a national monument" from John Canaday, "Art: Ingenuity of Louise Nevelson," *New York Times,* November 4, 1972, 29. "One of America's most imaginative and original sculptors on the American Scene," from Dorothy Adlow, "'Sixteen Americans' A Vigorous Display," *Christian Science Monitor,* December 19, 1959, 10.

5. Nevelson, *Dawns + Dusks,* 187. Nevelson was introduced to the fashion designer Arnold Scaasi in the late 1960s, and he created clothing for the artist from then on.

6. Louise Nevelson papers, Archives of American Art, New York, Reel D296B, frame 81.

7. Author interview with Edward Albee, November 3, 2005.

8. Linda Nochlin, "Why Have There Been No Great Women Artists?" *ARTnews* (January 1971): 22–39, 67–71.

9. "Eight Artists Reply" to "Why Have There Been No Great Women Artists?" *ARTnews* (January 1971): 41.

10. Laurie Lisle, *Louise Nevelson: A Passionate Life* (New York: Summit, 1990), 18. Some details of the artist's biography are drawn from Lisle's book.

11. Library of Congress website, "Immigration/Polish-Russian: A People at Risk," http://memory.loc.gov/learn/features/immig/alt/polish5.html, accessed September 26, 2006.

12. Nevelson, *Dawns + Dusks,* 2.

13. Ibid., 7.

14. Laurie Lisle wrote of Isaac Berliawsky in her biography: "In Rockland, where he was described as a peddler in the city directory, he used to walk door-to-door and to the town dump with a hemp grain bag, scavenging bottles, paper, scrap

metal, wheels, rags, old clothes, used furniture, and other discarded items to sell from a junkyard near his home " (26). In *Dawns + Dusks,* Nevelson stated that her father "had lumber and he had maybe a lumberyard" (10).

15. Commenting on Nevelson's eccentric costuming, Edward Albee said that when the two friends got together, she would wear a shapeless, comfortable robe. However, "the public dressing was calculated, shrewd. I loved her juxtapositions: leather jackets with lace. It was wonderful." Author interview with Edward Albee, November 3, 2005. Martin Friedman, former director of the Walker Art Center in Minneapolis, commented recently that Nevelson's visit to Minneapolis during her 1973 exhibition was "like the visit of Catherine the Great. She perfected, honed her public persona." Author interview with Martin Friedman, October 19, 2005.

16. Nevelson, *Dawns + Dusks,* 14.

17. Arnold B. Glimcher, *Louise Nevelson* (New York: Praeger, 1972), 20.

18. Author's telephone conversation with Maria Nevelson, April 17, 2006.

19. Lisle, *Louise Nevelson,* 79.

20. Nevelson stated that, "When Hofmann was in Germany, he knew already that Hitler was coming into power. . . . That's why he wanted to get out." *Dawns + Dusks,* 51. In the same period, Nevelson met and became acquainted with Diego Rivera and Frida Kahlo, Arshile Gorky, Matta, and Boris Margo. She alludes to knowing the Abstract Expressionists by their early work and affiliation with the WPA. She mentions Willem de Kooning, Mark Rothko, Franz Kline, and Jackson Pollock on page 68. With the Depression looming over the American economy and artists especially hard-hit by the lack of job opportunity, Nevelson was hired to work on the government WPA Art Project.

Between 1935 and 1939 she worked in the art-teaching division, initially in Brooklyn.

21. Smithsonian Institution, Archives of American Art, Washington, D.C., and New York, Colette Roberts Papers. Reel 2744, frame 910.

22. Nevelson, *Dawns + Dusks,* 44.

23. Nevelson's exhibition *The Circus: The Clown Is the Center of His World* was held in New York in 1943 at the Norlyst Gallery on West 57th Street, and the objects were not strictly Cubist in nature. She used found wood objects to create circus figure assemblages, although they retained their original color and were not painted monochromatically. Works from this exhibition are apparently destroyed.

24. Author interview with Martin Friedman, October 19, 2005.

25. Jackson Pollock, radio interview with William Wright, Westerly, Rhode Island, 1951.

26. Unpublished interview with Louise Nevelson by Dean Swanson, chief curator, and Gwen Lerner, registrar, Walker Art Center, Minneapolis, and Richard Solomon, Pace Editions, Inc., New York, May 1973.

27. Nevelson, *Dawns + Dusks,* 76.

28. Ibid.

29. Brooklyn Museum Library Artists' Files, New York. Transcript of Louise Nevelson interviewed by Arlene Jacobowitz, May 3, 1965, for the "Listening to Pictures" gallery, 13.

30. Jean Lipman, *Nevelson's World* (New York: Hudson Hills in association with the Whitney Museum of American Art, 1983), 52. Nevelson also told Laurie Lisle a remarkably complicated interpretation of this work: "She explained that the rectangular base . . . symbolized the city; its square pedestal, consciousness; its hollow round form, the sun; its tall object, the cold seasons; its shaft with three rounded forms, the warm seasons; while

its pair of menacing carved red-winged griffins, with the bodies of lions and the heads of eagles, flight." See Lisle, *Louise Nelson,* 185.

31. Author interview with Edward Albee, November 3, 2005.

32. Nevelson, *Dawns + Dusks,* 126.

33. Laurie Wilson, "Bride of the Black Moon: An Iconographic Study of the Work of Louise Nevelson," *Arts* (May 1980): 141. Wilson describes Nevelson's trip to Guatemala in the winter of 1950–51.

34. Author's telephone conversation with Diana MacKown, April 11, 2006.

35. "Art Notes," *Cue* (October 4, 1941).

36. Maude Riley, "A Sculptor's Portraits," *Art Digest* (November 15, 1943): 19.

37. H. D. (Howard Devree), "Modern Sculpture," *New York Times,* October 11, 1942.

38. Hilton Kramer, "The Sculpture of Louise Nevelson, *Arts* (June 1958): 26.

39. Nevelson, *Dawns + Dusks,* 130.

40. Wilson, "Bride of the Black Moon," 140. Wilson proposes that three main themes are found in Nevelson's art: royalty, marriage, and death. See also Laurie Wilson, *Louise Nevelson: Iconography and Sources,* Ph.D. dissertation, City University of New York, 1978.

41. Lisle, *Louise Nevelson,* 187.

42. Smithsonian Institution, Archives of American Art, Washington, D.C., and New York. Colette Roberts Papers, Reel 2744, frame 913. In the Colette Roberts papers, the dealer wrote of Nevelson of the 1948 to 1949 period: "Curious about Pre-Columbian art and Indian contemporary culture, Nevelson sets out for Mexico. She stays in Mexico City, Yucatán, Oaxaca. She also travels for 6 weeks through Guatemala. North American Indian could still be found in reservations in Maine, where antique shops used to present much of their industrious work."

43. D. A. [Dore Ashton], "About Art: Louise Nevelson Shows Wood Sculptures," *New York Times,* February 21, 1956, 31. J. R. M. [James R. Mellow], "In the Galleries: Personages at Sea," *Arts* (February 1956): 52.

44. Nevelson, *Dawns + Dusks,* 4, 15. She said: "In spring, I remember the trees were so rich, the foliage was so rich that when we were running through it, practically all we could see was this *green,* above our heads like umbrellas. *Big* umbrellas, weighing down. And you recognized that if a branch fell, it would *kill* you."

45. Ibid., 128. In describing the working process to create *First Personage,* the artist told Diana MacKown: "[As] I was filing and working away at it there was a knot where the mouth was supposed to be, just a plain knot, and I, being so concentrated, all of a sudden I saw this knot, mouth moving. And the whole thing was black by then and it frightened me."

46. See C. B. [Carl Baldwin], "In the Galleries: Louise Nevelson," *Arts* (January 1958): 55; P. T. [Parker Tyler], "Reviews and Previews: Louise Nevelson," *ARTnews* (January 1958): 54; Emily Genauer, "Abstract Art with Meaning: A World," *New York Herald Tribune,* January 12, 1958; "Art: One Woman's World," *Time,* February 3, 1958, 58; Dorothy Sieberling, "Weird Woodwork of Lunar World," *Life,* March 24, 1958, 77–80; and Stuart Preston, "The Rising Tide of Exhibitions for 1958, Mysterious Dreamland," *New York Times,* January 12, 1958.

47. Arne Glimcher has an extensive description of the installation of *Moon Garden + One* at Grand Central Moderns. See Glimcher, *Louise Nevelson,* 89.

48. Richard B. Marshall, *Louise Nevelson: Atmospheres and Environments* (New York: Clarkson N. Potter, in association with the Whitney Museum of American Art, 1980), 78.

49. Arne Glimcher wrote that the relationship between Nevelson and the Martha Jackson Gallery provided financial security for the artist. "They gave Nevelson a contract that guaranteed her substantial yearly sales or purchases, and the gallery became her representative. . . . Here was a dealer who not only liked her work but was willing to advance money." See Glimcher, *Louise Nevelson,* 95. Dore Ashton wrote in the *New York Times* of Nevelson's debut show at Martha Jackson Gallery in 1959 that the artist "surpasses everything she has done before." See Ashton, "Art: Worlds of Fantasy," 44.

50. Nevelson, *Dawns + Dusks,* 138.

51. Lipman, *Nevelson's World,* 135.

52. Nevelson, *Dawns + Dusks,* 145.

53. Brian O'Doherty, "Art: Four Sculptors Manipulate Third Dimension; Louise Nevelson and de Creeft Have Shows," *New York Times,* April 24, 1961.

54. Nevelson, *Dawns + Dusks,* 163.

55. Grace Glueck, "White on White: Louise Nevelson's 'Gift to the Universe,'" *New York Times,* October 22, 1976.

56. Nevelson, *Dawns + Dusks,* 190.

LOUISE NEVELSON'S SELF-FASHIONING: "THE AUTHOR OF HER OWN LIFE"

1. Arnold B. Glimcher, *Louise Nevelson* (New York: Praeger, 1972), 25–26.

2. Edward Albee, "Louise Nevelson: The Sum and the Parts," in *Louise Nevelson: Atmospheres and Environments* (New York: Whitney Museum of American Art with Clarkson N. Potter, 1980), 17.

3. Ibid., 12.

4. Witness the recent outrage over James Frey's *A Million Little Pieces* and its forcible removal from Oprah's Book Club. As these words are being written, months after the revelation of the many distortions in this ostensible autobiography, it remains number two on the *New York Times* paperback bestseller list and still in the category of "nonfiction." Its publisher, the formidable Doubleday and Anchor Books, at first seemed to deny that an autobiography had to be true, but representatives later were forced to admit that "it is not the policy or stance of this company that it doesn't matter whether a book sold as nonfiction is true." All new editions of the book contain an author's note in which Frey acknowledges that much of what he wrote is, in fact, not true, but he defends his action and insists that he is contributing to the ongoing debate over the boundaries between fact and fiction. His book was replaced in Oprah's Book Club with Elie Wiesel's *Night,* which skyrocketed to first place in the *Times*'s nonfiction list. That work is itself a highly stylized account of Wiesel's Holocaust years, but given Wiesel's iconic status and the problem of Holocaust denial, no one I am aware of (myself included) has dared to question the veracity of his account. In general, see my *Autobiographical Jews: Essays in Jewish Self-Fashioning* (Seattle: University of Washington Press, 2004), introduction and conclusion, for an extended discussion of my method in analyzing autobiographies as historical sources and why I have not applied my method to Holocaust memoirs. Regarding the use of the term self-fashioning, see Stephen Greenblatt, *Renaissance Self-Fashioning: From More to Shakespeare* (Chicago: University of Chicago Press, 1980).

5. It is sad to report that the most extensive biography, Laurie Lisle's *Louise Nevelson: A Passionate Life* (New York: Summit, 1990), is chock-full of basic errors—and embarrassing howlers—about East European Jewish history: on pages 14–15 the attempt to describe the background

of Nevelson's father includes eight errors: (a) "for as long as anyone could remember Russia's Christians had persecuted the Jews as the murderers of Christ." In fact, there were no Jews allowed in the Russian Empire until the Partitions of Poland in 1772, 1793, and 1795, and the statement that Jews were not allowed, as "murderers of Christ," into the empire comes from Empress Elizabeth's decree on December 16, 1743; (b) "in the first half of the nineteenth century, Nicholas I attempted to wipe out Judaism altogether . . . "— There was no such policy on Nicholas's part. See my *Tsar Nicholas I and the Jews: The Transformation of Jewish Society in Russia, 1825–1855* (Philadelphia: Jewish Publication Society, 1983); (c) "the Pale of Settlement . . . restricted Jews to hundreds of impoverished villages"—the Pale included dozens of large cities, including such important centers as Vilna, Kovno, Grodno, Minsk, and Odessa; hundreds of small towns (called *shtetlekh*—the plural of *shtetl,* the word for small market town in Yiddish, which were quite definitely not "villages") and thousands of villages proper; (d) "A few decades later, a neo-Orthodox movement brought this climate of tolerance to an end."—There was never such a movement; (e) "Although laws were passed to protect Jews from pogroms, they were in fact used to justify midnight searches by the police for those without residence papers."—No such laws were ever passed, and police raids to ferret out Jews (and others) illegally living in Kiev, Moscow, or St. Petersburg had nothing to do with such nonexistent laws and were, in any event, not carried out at midnight (a confusion here perhaps of later Stalinist police tactics?); (f and g) "Since only those in certain occupations—professionals, factory workers, agricultural laborers, servants, and prostitutes—were allowed to live outside the ghetto"—there was never

any "ghetto" in the Russian Empire, and prostitutes were never legally granted permission to live outside the Pale of Settlement; and (h) "Because of a high birthrate, cleanliness enforced by religious rules . . . " The high Jewish birthrate was caused by a low infant-mortality rate, not by any "cleanliness" on the part of the Jewish population (a term impossible to define unless used here as a euphemism for the Jewish laws of menstrual purity, which some have tied to the high birthrate, though there is absolutely no scholarly evidence to sustain this connection).

6. See Natan Meir, "The Jews in Kiev, 1859–1914: Community and Charity in an Imperial Russian City," Ph.D. diss., Columbia University, 2004.

7. Louise Nevelson, *Dawns + Dusks,* Diana MacKown, ed. (New York: Charles Scribner's Sons, 1976), 4.

8. See Benjamin Nathans, *Beyond the Pale: The Jewish Encounter with Late Imperial Russia* (Berkeley: University of California Press, 2002).

9. Nevelson, *Dawns + Dusks,* 9–10.

10. Ibid., 10.

11. Ibid.

12. "Reminiscences of Louise Nevelson: Oral History, 1977," New York's Art World Project, Columbia University Oral History Collection, 41–42.

13. Ibid., 1.

14. Ibid., 14.

15. Glimcher, *Louise Nevelson,* 19.

16. Ibid., 19–20.

17. Ibid., 25.

18. Ibid., 20.

19. Nevelson, *Dawns + Dusks,* 28.

20. Ibid., 31.

21. Ibid., 32.

22. Ibid., 37.

23. Ibid., 38.

24. Ibid., 42.

25. Ibid., 49.

26. Ibid., 72.

27. See my *Autobiographical Jews,* 141.

28. Nevelson, *Dawns + Dusks,* handwritten comment on inside cover.

29. Harold Rosenberg, "The American Action Painters," in his *The Tradition of the New* (New York: Horizon Press, 1959), 30–31. See Clement Greenberg and Serge Guilbaut's characteristically more ideologized variations on this point in Greenberg's "Toward a New Laocoon," reprinted in Charles Harrison and Paul Wood, eds., *Art in Theory 1900–2000* (Oxford: Blackwell, 2000), 564–67, and Guilbaut's *How New York Stole the Idea of Modern Art* (Chicago: University of Chicago Press, 1983), 197–249. I am indebted to Noam Elcott and Juliet Koss for these references.

30. "Reminiscences of Louise Nevelson: Oral History, 1977," 35.

BLACK, WHITE, GOLD: MONOCHROME AND MEANING IN THE ART OF LOUISE NEVELSON

Epigraph: Louise Nevelson, *Dawns + Dusks,* Diane MacKown, ed. (New York: Charles Scribner's Sons, 1976), 126.

1. Ibid., 14.

2. Arnold B. Glimcher, "Interview with Louise Nevelson," Archives of American Art, Smithsonian Institution, 1972.

3. Arthur C. Danto, *Mark Tansey: Visions and Revisions* (NewYork: Harry N. Abrams, 1992), 128.

4. T. J. Clark, *Farewell to an Idea: Episodes from a History of Modernism* (New Haven: Yale University Press, 1999).

5. Nevelson, *Dawns + Dusks,* 128.

6. She destroyed *Dawn's Wedding Cake,* which was white, but this was because it was not purchased and she wanted to recycle its parts.

7. Nevelson, *Dawns + Dusks,* 125.

8. Ibid.

9. Ibid., 123.

10. Laurie Lisle, *Louise Nevelson: A Passionate Life* (New York: Summit, 1990), 208.

11. Ibid., 209.

12. Clement Greenberg, "Modernist Painting," in Greenberg, *The Collected Essays and Criticism,* John O'Brian, ed. (Chicago: University of Chicago Press, 1993), 4:86.

13. Ibid., 4:217.

14. Nevelson, *Dawns + Dusks,* 125.

15. Lisle, *Louise Nevelson,* 256.

16. See Randy Rosen and Catherine C. Brawer, *Making Their Mark: Women Artists Move into the Mainstream, 1970–1985* (New York: Abbeville , 1985), 30.

17. Lisle, *Louise Nevelson,* 220.

18. In *The Bricoleur's Daughter,* Mark Tansey depicts a young girl who has found her way into the dark interior of her father's workshop. She is standing on a box in front of a compartmented set of shelves, stacked from floor to ceiling, holding orderly rows of tools, scraps of wood, and odd assemblages of objects that form still-lifes, all sunk in deep shadow. The shadows transfigure the shelves into something as imposing as the façade of a cathedral, ascending into darkness. The girl has brought a flashlight that catches some jars of brushes in its beam and turns them into shadows that suggest another reality altogether. The scene feels like a variation of the Allegory of the Cave in Plato's *Republic,* which paints, in words, a picture of the human condition, according to which we don't see things so much as shadows of things. I have always supposed the array of shelves was inspired by one of Louise Nevelson's sculptures, composed of spaces filled with objects of obscure utility but no obvious specific purpose. In one of her "environments"—a genre she claims to have invented—the space of the gallery was unilluminated or barely illuminated by a few dim blue bulbs. I wonder how it

never occurred to her to have the visitors equipped with flashlights, like the bricoleur's daughter, creating looming shadows as the edges of her constructions caught the light. In a 1938 Surrealist exhibition in Paris, Man Ray, who was in charge of lighting, distributed flashlights "in case someone wanted to see something," since there was no overhead lighting at all. The viewers shone the light in one another's faces, but a different etiquette would doubtless have prevailed in New York. See Caroline Cros, *Marcel Duchamp* (London: Reaktion, 2006), 100.

19. Nevelson, *Dawns + Dusks,* 138.

20. Ibid., 144.

21. Ibid.

22. Ibid., 145.

23. "When I first claimed the word *environment* for myself I was in Japan. I was on a panel and I said, 'I am the grandmother of environment.' Nobody did until I did—make a whole environment. It was *Moon Garden + One,* at the Grand Central Moderns." Ibid., 130.

LOUISE NEVELSON'S PUBLIC ART

1. Although there were quite a few established women painters, there simply was no other woman sculptor with Nevelson's art world reputation and representation by a major New York gallery, Pace (now PaceWildenstein), which was instrumental in obtaining her commissions.

2. The NEA program funded public art by providing matching grants for communities or civic organizations. For a history of the early years of this program, see John Beardsley, *Art in Public Places* (Washington, D.C.: Partners for Livable Places, 1981).

3. Over time public art took on the role and appearance traditionally filled by landscape architecture and land reclamation; street furniture and other urban amenities; aspects of social intervention; and even public spectacles such as parades and firework displays. The first two approaches are discussed in Harriet F. Senie, *Contemporary Public Sculpture: Tradition, Transformation, and Controversy* (New York: Oxford University Press, 1992), 140–215. For a survey of socially based art, see, for example, Mary Jane Jacob, Michael Brenson, and Eva M. Olson, *Culture in Action: A Public Art Program of Sculpture Chicago* (Seattle: Bay, 1995); Suzanne Lacy, ed., *Mapping the Terrain: New Genre Public Art* (Seattle: Bay, 1995); and Arlene Raven, ed., *Art in the Public Interest* (Ann Arbor, Mich.: U.M.I. Research Press, 1989).

4. For a more detailed discussion of the public art revival of the late 1960s, see Senie, *Contemporary Public Sculpture.*

5. On the federal level, the Great Society Task Force was created in 1964, the Department of Housing and Urban Development was created in 1965, and a year later the Model Cities Act was passed. See Mark I. Gelfand, *A Nation of Cities: The Federal Government and Urban America, 1933–1965* (New York: Oxford University Press, 1975), 348–87, for a discussion of federal legislation affecting cities. For a discussion of relevant zoning developments, see Donald H. Elliott and Norman Marcus, "From Euclid to Ramapo: New Directions in Land Development Controls," *Hofstra Law Review* (spring 1973): 1–10.

6. Lippincott is quoted in Grace Glueck, "Art Notes," *New York Times,* July 16, 1967, sec. 2, 19. This new practice was reported in both art and architectural journals. See, for example, "Welded Giants," *Architectural Forum* (April 1967): 52–57; "Lippincott Environmental Arts," *Art in America* (September/October 1967): 124. Lippincott's work was highly praised in Barbara Rose, "Blow Up: The Problem

of Scale in Sculpture," *Art in America* (July 1968): 80–90.

7. Louise Nevelson, *Dawns + Dusks,* Diana MacKown, ed. (New York: Charles Scribner's Sons, 1976), 170.

8. My thanks to Arnold B. Glimcher, director of PaceWildenstein, for describing Nevelson's working process in a telephone conversation, April 24, 2006. In Arnold B. Glimcher, *Louise Nevelson* (New York: Praeger, 1972), 146, Glimcher observed that "metal is attended by concepts of immortality to which Nevelson was not averse."

9. Nevelson, *Dawns + Dusks,* 171.

10. Conversation with Joyce Schwartz, April 10, 2006. Schwartz worked at Pace Gallery from 1971 to 1981 and was in charge of pursuing public art commissions for gallery artists.

11. Jean Lipman, *Nevelson's World* (New York: Hudson Hills in association with the Whitney Museum of American Art, 1983), 169.

12. Nevelson, *Dawns + Dusks,* 171.

13. Patrick Kelleher, *Living with Modern Sculpture* (Princeton, N.J.: Princeton University Art Museum, 1982), 12. All stipulations of the bequest are recounted here. For Nevelson's work, see 76–79.

14. Works by Michael Hall, Jacques Lipchitz, Eduardo Paolozzi, Arnaldo Pomodoro, David Smith, and Tony Smith were also acquired at this time. The selection committee consisted of Princeton alumni Alfred H. Barr Jr. (class of 1922), Thomas P. F. Hoving (1953), William H. Millikin (1911), and Patrick Kelleher (M.F.A. 1922, Ph.D. 1947), then director of the Princeton University Art Museum.

15. Interestingly, there was initially a question of whether the piece was to be treated as art or architecture under local zoning regulations. The art category sought by university officials eventually prevailed.

16. As associate director of the Princeton University Art Museum from 1982 to 1985, I had ample opportunity to observe it.

17. Lipman, *Nevelson's World,* 163.

18. Perhaps the most famous example of this is Calder's *La Grande Vitesse* in Grand Rapids. A two-dimensional image of Calder's sculpture was eventually adopted as a civic emblem, depicted on official stationery, garbage trucks, and street signs. The site, originally called Vandenberg Plaza, was later renamed Calder Plaza.

19. The work was commissioned by the NEA Art in Public Places program, the same program that funded Calder's *La Grande Vitesse,* and the Scottsdale Fine Arts Commission.

20. Nevelson is quoted in the program for the Nevelson Gala, n.p. A program insert titled "What to look for in Scottsdale's great new sculpture" compared the experience to viewing the local landscape: "Like a desert sunset, it is never the same; always a sunset but always intriguingly different."

21. My thanks to Wendy Raisanen, collection manager for the Scottsdale Public Art Program, for this information and other material pertaining to the commission.

22. The GSA program was modeled after the Treasury Department's Section of Painting and Sculpture (later the Section of Fine Arts, known as Section), established in 1934, which also commissioned art for federal buildings by allocating 1 percent of construction costs. It was terminated in 1943 because of the war effort. While the New Deal program was part of the total government relief program prompted by the Depression, the GSA program was part of a larger urban renewal effort directed at the deteriorating conditions of U.S. cities. For a history of the Art-in-Architecture program, see Donald W. Thalacker, *The Place of Art in the World of Architecture* (New York and London: Chelsea House and R. R. Bowker, 1980).

23. Nevelson was selected by an NEA-

appointed panel: Suzanne Delehanty, director, Institute of Contemporary Art, University of Pennsylvania, Philadelphia; Thomas W. Leavitt, director, Herbert F. Johnson Museum of Art, Cornell University, Ithaca, New York; Anne d'Harnoncourt, curator of twentieth-century painting, Philadelphia Museum of Art; and Theodore Bartley, J. Roy Carrol Jr., and Alfred Clauss, representing the Federal Court Architects and Engineers of Philadelphia. For a discussion of the GSA commission, see Thalacker, *Place of Art,* 120–24. All quotations, unless otherwise noted, are taken from this source.

24. Emily Genauer's article appeared in the *New York Post,* January 17, 1976.

25. Ibid.

26. My thanks to Eileen Giordano, Fine Arts Officer, GSA, for details on the work's history. Author's telephone conversation with Giordano, April 4, 2006.

27. Margot Gayle and Michele Cohen, *Guide to Manhattan's Outdoor Sculpture* (New York: Prentice Hall, 1988), 255.

28. Author's conversation with Arnold B. Glimcher, April 24, 2006. According to "Park Ave Address for 4½-Ton Sculpture," *New York Times,* November 20, 1973, Nevelson would have preferred a site at Lincoln Center but she already had a work installed at the Juilliard School of Music, part of the complex. *Nightsphere-Light,* a forty-seven-foot-long wood wall relief painted black, was acquired in 1969. It covers a wall in the school's theater lobby.

29. The sculpture's nonobjective forms have prompted some far-fetched comparisons. Joseph Lederer, *All Around the Town: A Walking Guide to Outdoor Sculpture in New York City* (New York: Charles Scribner's Sons, 1975), 154–55, observed that the work "calls up the image of Manhattan with two vertical wave patterns, making one think of the Hudson and East Rivers, while the varied vertical

projections in between evoke the silhouetted figures of the Man scape."

30. The issues of both informational labels and measuring audience response continue to be problematic. On Park Avenue, for example, some people expressed the desire to know what the sculpture meant, and a few were puzzled by the *IV* in the title. At the very least public art should be accompanied by labels with at least as much information as is routinely provided in a museum. Audience response is difficult to monitor. For a discussion of some results, see Harriet F. Senie, "Reframing Public Art: Audience Use, Interpretation, and Appreciation," in Andrew McClellan, ed., *Art and Its Publics* (Malden, Mass.: Blackwell, 2003), 185–200.

31. Funding was provided by American International Group, Chase Manhattan Bank, Chubb Corporation, Continental Insurance Companies, Federal Reserve Bank of New York, Home Insurance Company, Royal Bank and Trust Company, and Sylvan Lawrence Company. See Chase Manhattan Bank News Release, September 8, 1978. The press release refers to the area as a vest-pocket park.

32. Gayle and Cohen, *Guide to Mahattan's Outdoor Sculpture,* 21. When the Art Commission approved the seven sculptures for permanent installation on March 14, 1977, no mention was made of Nevelson's role beyond her creation of the sculptures. In actuality, she selected the benches and plantings and the placement of all elements.

33. Jennifer Dunning, "Financial Area to Get a New Park," *New York Times,* August 5, 1977.

34. LMDC provided the funds and design. The project will be realized by the Department of Transportation (DOT) and DOT's Design and Construction Department. Suchi Sanagavarapu is the project manager at the Lower Manhattan Borough Commissioner's Office for DOT.

The Art Commission not only approved
the new design unanimously, but
commended it on March 14, 2005
(certificate 22117, file 4165 H-K). About a
year earlier (July 21, 2004), when the Art
Commission approved conservation for
the Nevelson sculptures, it noted "that
Louise Nevelson created this group of
sculptures specifically for this plaza, and
that the integrity of the artist's vision must
be maintained when any work is under-
taken in this space" (certificate 21924, file
4165 E-G). What constituted the artist's
vision is precisely what was not documented
initially and is in question here.

35. It is one of the hazards of public art that
no site can be assumed permanent.
However, any time a site is changed or
works of art rearranged it alters the
artist's vision. At the very least this is a
distortion of the artist's initial intentions;
in principal it is an infringement of his or
her First Amendment rights. But in the
end, it boils down to a legal issue of
property or contract rights. In all fairness
to artists and the spirit in which public
art is commissioned, they or their
representatives should be consulted, and
any alterations to the original design
should be noted clearly at the site.

The First Amendment protects freedom
of speech; a work of art is an artist's
speech. However, when the work is
abstract and perceived to have no content
other than a formal one, protection is not
a guarantee. Outcomes are determined
by laws of property, with works of art
considered comparable to any other
purchased entity. For a discussion of the
protection of public art or the absence
thereof, see Harriet F. Senie, *The Tilted
Arc Controversy: Dangerous Precedent?*
(St. Paul: University of Minnesota Press,
2002), 114–20. See also Senie, "Public Art
and the Legal System," *Public Art Review*
(fall/winter 1994).

36. Rosanne Martorella, *Corporate Art* (New
Brunswick, N.J., and London: Rutgers
University Press, 1990).

37. Author's interview with Gordon Bunshaft,
April 1978.

38. This and subsequent quotations,
unless otherwise noted, are taken from
"Dedication of the Bendix Trilogy,"
June 21, 1979, distributed as part of the
press kit.

39. Joy Kakanson Colby, "Acclaimed Sculptor
Nevelson, 87, Turned Style into Substance,"
Detroit News, April 19, 1988.

40. "Nevelson, Louise (1899–1988):
Identification," EDL & Associates, n.d.

41. "Nevelson Sculpture Unveiled at Georgia-
Pacific Center," *CenterLine,* April/May
1986, n.p.

42. For a detailed discussion of Matisse's
chapel, see Marie-Alain Couturier and
Louis-Bertrand Rayssiguier, *Henri Matisse:
The Vence Chapel, the Archive of a Creation*
(Milan: Skira, 1999).

43. Http://www.menil.org/rothko/html,
accessed March 20, 2006.

44. Peterson previously served as director of
the department of ministry, vocation, and
pastoral services at the World Council of
Churches, the largest ecumenical
organization in the world. The ecumenical
movement, according to *The Oxford
Dictionary of the Christian Church,* F. L.
Cross, ed. (Oxford: Oxford University
Press, 1993), 443, advocated Christian
unity over "differences of creed, ritual, and
polity." For an analysis of this commission,
see Wesley P. Jessup, "Louise Nevelson
and the Erol Beker Chapel" (M.A. thesis,
City College of New York, 1999). All
information and quotes pertaining to
Nevelson's commission, unless otherwise
noted, are from this source.

45. David Masello, *New York's Fifty Best Art in
Public Places* (New York: New York City
& Company, 1999), 66–67.

46. Nevelson is quoted in Jean Lipman,

Nevelson's World, 132. She also stated, "The chapel was designed to be universal; it's a symbol of freedom. It has attracted every denomination. . . . If people can have some peace while they are there, and carry it with them in their memory bank, that will be a great achievement for me" (130).

47. My thanks to Meaghan Dwyer, archivist at Temple Israel, for documents pertaining to this work. The temple held an exhibition to mark its 150th anniversary in 2004, and a volunteer researcher created an ad hoc fact sheet for the sculpture. All quotes, unless otherwise noted, are from this source.

48. Rabbi Roland Gittelsohn, *Sermons in Steel, Stone and Thread,* n.d. Temple archivist Meaghan Dwyer believed the publication to date from the late 1970s or early 1980s.

49. My thanks to Laura Griffiths, assistant director of the Fairmount Park Art Association, for information on the conservation of this sculpture. See also the association's announcement of the award, "Fairmount Park Art Association Receives Getty Grant," August 2, 2005, http://fpaa.org/whts_new_nevel.html, accessed January 27, 2006. Some of Nevelson's other Cor-ten works have required conservation. *Sky Covenant* (1973) at Temple Israel in Boston was painted black ten years after its installation. Information about the treatment is found in the temple's ad hoc fact sheet, cited above.

50. For a discussion of this sculpture, see *Art and Architecture at MIT: A Walking Tour of the Campus* (1982; 2d ed., 1988), 79–80. My thanks to Hiroko Kikuchi for sending me this publication.

51. Conversation with Arnold B. Glimcher, April 24, 2006. According to Glimcher, it was important to Nevelson that the works stay pristine.

52. I originally presented these remarks in "Responsible Criticism: Evaluating Public Art," Public Art Network keynote address, Americans for the Arts Pre-Conference, Portland, Ore., June 2003.

53. For a detailed analysis of the various definitions of site specific and the evolution of its meaning, see Miwon Kwon, *One Place After Another: Site Specific Art and Locational Identity* (Cambridge, Mass.: MIT Press, 2002).

54. Moore is quoted in Henry J. Seldis, *Henry Moore in America* (New York: Praeger, 1973), 14. For a discussion of Moore's public art, see Harriet F. Senie, "Implicit Intimacy: The Persistent Appeal of Henry Moore's Public Art," in Dorothy Kosinski, ed., *Henry Moore: Sculpting the Twentieth Century* (Dallas: Dallas Museum of Art; New Haven: Yale University Press, 2001), 277–86.

55. Public Art Fund press release, "In the Public Realm: Olav Westphalen: Extremely Site-Unspecific Sculpture (E.S.U.S)," http://www.publicartfund.org/pafweb/realm/00/westphalen_o_00.html, accessed April 3, 2006. The sculpture was exhibited first at the Whitney Museum of American Art (Philip Morris), then at Tompkins Square Park, and finally in Flushing Meadows Corona Park.

56. "Alexander Calder in New York," e-mail press release from Anne Wehr, Public Art Fund. The exhibition was to run almost a year, from April 24, 2006, to March 18, 2007.

57. Conversation with Joyce Schwartz, April 10, 2006.

58. Nelson, *Dawns + Dusks,* 130.

THREE ARTISTS REFLECT ON LOUISE NEVELSON

1. Jan Garden Castro, "The Language of Life: A Conversation with Chakaia Booker," *Sculpture,* January/February 2003.

2. Arnold B. Glimcher, "Interview with Louise Nevelson," Archives of American Art, Smithsonian Institution, 1972.

INDEX

ILLUSTRATION CREDITS

Boldface numerals refer to page numbers.

Copyright for all artworks by Louise Nevelson reproduced in this volume are © The Estate of Louise Nevelson/Artists Rights Society (ARS), New York

Abbreviations
AAA: Image courtesy of the Louise Nevelson Papers, Archives of American Art, Smithsonian Institution
ARS: Artists Rights Society, New York
MMA: The Metropolitan Museum of Art, New York
MoMA: Digital image © The Museum of Modern Art/Licensed by SCALA/Art Resource, New York
WMAA: Whitney Museum of American Art (art collection)
FMAL: Frances Mulhall Achilles Library, Whitney Museum of American Art (archival photographs)

Front cover: Courtesy Walker Art Center, Minneapolis

Frontmatter: **i** The Lotte Jacobi Collection, University of New Hampshire. **ii** Courtesy Center for Creative Photography, University of Arizona, © 1991 Hans Namuth Estate. **iii** © Arnold Newman/Getty Images. **iv** © 1975 The Richard Avedon Foundation. **v** Courtesy of the Cecil Beaton Archive, Sotheby's. **vi** © The Robert Mapplethorpe Foundation/Art + Commerce.

Back cover: WMAA

Rapaport Essay: **Frontispiece** MoMA. **4** MoMA. **5** AAA (top), MoMA, courtesy Louise Bourgeois (bottom). **7** From Laurie Lisle, *Louise Nevelson: A Passionate Life* (New York: Summit, 1990) (top), from Louise Nevelson, *Dawns + Dusks,* edited by Diana MacKown (New York: Charles Scribner's Sons), 195 (bottom). **8** From Arnold B. Glimcher, *Louise Nevelson* (New York: Praeger, 1972), 42. **9** Art © Estate of David Smith/licensed by VAGA, New York, photograph © 2006 President and Fellows of Harvard College (left), © 2006 The Isamu Noguchi Foundation and Garden Museum, New York/ARS, photograph by Kevin Noble, courtesy The Noguchi Museum, New York (center), © 2006 Estate of Alexander Calder/ARS (right). **11** Photograph by Ferdinand Boesch, courtesy PaceWildenstein, New York. **12** © 2006 ARS/ADAGP, Paris/Succession Marcel Duchamp, courtesy Philadelphia Museum of Art (top), © 2006 Andy Warhol Foundation for the Visual Arts/ARS (bottom). **13** AAA. **14** FMAL. **15** FMAL. **16** From *Arts* (May 1980): 140. **17** MoMA. **18** Photograph © The Cleveland Museum of Art. **19** From Jean Lipman, *Nevelson's World* (New York: Hudson Hills in association with the Whitney Museum of American Art), 119, 120. **20** FMAL. **23** Photograph © The Israel Museum, Jerusalem. **24–25** © 1987 MMA, photograph by Lynton Gardiner.

Stanislawski Essay: **Frontispiece** AAA. **27** Photograph © Pedro E. Guerrero, FMAL. **31** AAA. **33** AAA. **34** Courtesy Diana MacKown, Ellington, N.Y., photograph by Richard Goodbody. **36** New York City Parks Photo Archive. **37** Photograph © Marvin Schwartz, New York, FMAL.

Danto Essay: **Frontispiece** © Ugo Mulas Estate, Milan, AAA. **39** From Marjorie East et al., *The Rockland Public Library: Its First Hundred Years* (Rockland, Me.: FOL, 1998), 26. **40** © Mark Tansey, courtesy Gagosian Gallery, New York, photograph by Robert McKeever, New York (top), Photograph by Erich Lessing/Art Resource, New York (bottom). **41** © 2006 Succession H. Matisse, Paris/ARS, courtesy The Baltimore Museum of Art (left), © 2006 Succession H. Matisse, Paris/ARS, photograph by Ben Blackwell, courtesy San Francisco Museum of Modern Art (right). **42** © Ara Guler, c. 1974, AAA. **43** FMAL. **45** © Cy Twombly. Courtesy Gagosian Gallery, New York, photograph © 2006 Kunsthaus Zürich. **46** MoMA. **47** Photograph by Sandak, Inc., WMAA.

Senie Essay: **Frontispiece** Photograph © Balthazar Korab Ltd. **49** © 2006 Estate of Pablo Picasso/ARS, photograph © Robert Frerck/Odyssey/Chicago (top), © 2006 Estate of Alexander Calder/ARS, photograph courtesy Grand Rapids History & Special Collections, Archives, Grand Rapids Public Library, Grand Rapids, Mich. (bottom). **50** Photograph © Pedro E. Guerrero, FMAL (left), Photograph by David Kukin (right). **51** Photograph by Chris Loomis © 2006 Scottsdale Cultural Council/Scottsdale Public Art Fund. **52** Photograph courtesy of the U.S. General Services Administration's Art in Architecture Program. **53** Photograph © 2006 Robert A. Baron **54–55** Courtesy Lower Manhattan Development Corporation and Smith-Miller + Hawkinson Architects. **56** Photograph © Balthazar Korab Ltd. **58** © 2006 Succession H. Matisse, Paris/ARS, photograph © Réunion des Musées Nationaux/Art Resource, New York (top), © 1998 Kate Rothko Prizel & Christopher Rothko/ARS, photograph by Hickey and Robertson (bottom). **59** Courtesy of St. Peter's Lutheran Church, photograph by Thomas Loof. **60** Courtesy Temple Beth-El, Great Neck, N.Y., photograph © Paul Rocheleau. **61** Courtesy Temple Beth-El, Great Neck, N.Y., photograph © Paul Rocheleau (top), image courtesy Temple Israel Archives, Boston (bottom). **62** Massachusetts Institute of Technology, Cambridge, Mass., photograph by George Bouret, 2006. **64** Courtesy Public Art Fund, photograph by Eileen Travell.

Plates: **66–67** WMAA. **69** © The Hyde Collection, Glens Falls, N.Y., photograph by Michael Fredricks. **70** The Lotte Jacobi Collection, University of New Hampshire, photograph by Richard Goodbody. **73** WMAA. **74–75** WMAA, photographs by Sheldan C. Collins. **77** © The Hyde Collection, Glens Falls, New York, photograph by Michael Fredricks. **79** Courtesy Walker Art Center, Minneapolis. **89** Photograph by Richard Goodbody. **93** Photograph by Dean Beasom. **101** Photograph by Paula Goldman, courtesy The Museum of Contemporary Art, Los Angeles. **105** © The Art Institute of Chicago, photograph by Robert Hashimoto. **107** Photograph by Alex Steinberg. **109** WMAA, photograph by Jerry L. Thompson. **111** Photograph courtesy PaceWildenstein. **113** Courtesy Walker Art Center, Minneapolis. **114–15** Photograph by Richard Goodbody. **116** Courtesy The Menil Collection, Houston, photograph by Hickey and Robertson, Houston. **117** Courtesy National Museum of Women in the Arts, Washington, D.C., photograph by Lee Stalsworth. **118** Photograph by Melville D. McLean. **119** Photograph by Arthur Evans. **121** MoMA. **123** Photograph by Richard Goodbody. **125** Photograph by Sheldan C. Collins. **127, 129** Photograph by Richard Goodbody. **130** Image © 2006 Board of Trustees, National Gallery of Art, Washington, D.C. **131** Photograph © 2006 MMA. **137** Courtesy San Francisco Museum of Modern Art, photograph by Ben Blackwell. **139** © 1987 MMA, photograph by Lynton Gardiner. **141** Photograph by Dean Beasom. **142–43, 145** Photograph by Richard Goodbody. **147** WMAA, photograph by Geoffrey Clements. **149** WMAA. **150–51** Courtesy Fisher Landau Center for Art, photograph by Hermann Feldhaus, New York. **152** Photograph by Ellen Page Wilson, courtesy PaceWildenstein. **154** Photograph by John Parnell. **160** Photograph by Ben Blackwell.

Three Artists Reflect on Louise Nevelson: **163–64** © Chakaia Booker, courtesy Marlborough Gallery, New York, photograph by Nelson Tejada. **166** © Mark di Suvero, courtesy of the artist and Spacetime C.C., photograph by Geoffrey Clements, courtesy WMAA. **167** © Mark di Suvero, courtesy of the artist and Spacetime C.C., courtesy Fine Arts Museums of San Francisco. **169** © Ursula von Rydingsvard, courtesy of the artist.

Chronology: **172** AAA (top), From Louise Nevelson, *Dawns + Dusks,* edited by Diana MacKown (New York: Charles Scribner's Sons), 26 (bottom). **173** Courtesy Diana MacKown, Ellington, N.Y. (top), Courtesy Diana MacKown, Ellington, N.Y., photograph by Richard Goodbody (bottom). **174** Courtesy Diana MacKown, Ellington, N.Y., photograph by Richard Goodbody. **175** FMAL. **176** Courtesy Diana MacKown, Ellington, N.Y., photograph by Richard Goodbody. **177** Photograph by Jeremiah W. Russell, FMAL. **178** Photograph by Richard Goodbody. **179** Photograph by Geoffrey Clements, FMAL. **180** © Ugo Mulas Estate, Milan, AAA. **181** Photograph by Maryette Charlton. **182** Photograph by Richard Goodbody. **183** Photograph by Diana MacKown (top), Photograph by Mike Zwerling, AAA (bottom). **184–86** AAA. **187** Photograph © Pedro E. Guerrero, FMAL. **188** Courtesy Ronald Reagan Library (top), Louise Nevelson Stamp Series © 2000 United States Postal Service, all rights reserved, used with permission (bottom).

CONTRIBUTORS

Brooke Kamin Rapaport is an independent curator and writer. From 1989 to 2002 she was assistant curator and then associate curator of contemporary art at the Brooklyn Museum, where she organized numerous exhibitions and wrote catalogues for *Vital Forms: American Art and Design in the Atomic Age, 1940–1960* (2001, with Kevin L. Stayton), *Twentieth-Century American Sculpture at the White House: Inspired by Rodin* (1998), and the retrospective *Leon Polk Smith: American Painter* (1995). Prior to her tenure at the Brooklyn Museum she worked at the Whitney Museum of American Art and the Jamaica Arts Center in New York. Rapaport is a contributing editor and frequent writer for *Sculpture* magazine.

Arthur C. Danto, Emeritus Johnsonian Professor of Philosophy at Columbia University, has written extensively on art and philosophy. He is the author of *After the End of Art* (1996), *Playing with the Edge: Photographic Achievement of Robert Mapplethorpe* (1995), *Beyond the Brillo Box: The Visual Arts in Post-Historical Perspective* (1992), and *Encounters and Reflections: Art in the Historical Present* (1990), which won the National Book Critics Circle Award for Criticism. His most recent book, *Unnatural Wonders: Essays from the Gap Between Art and Life* (2005), was nominated for the 2006 National Book Critics Circle Award for Criticism. He is the art critic for the *Nation* and is a contributing editor of *Artforum*.

Gabriel de Guzman, curatorial program coordinator at The Jewish Museum, has served as coordinator for a number of exhibitions at the museum, including *Joan Snyder: A Painting Survey, 1969–2005* (2005), *Collective Perspectives: New Acquisitions Celebrate the Centennial* (2004), and *Schoenberg, Kandinsky, and the Blue Rider* (2003).

Harriet F. Senie is director of museum studies and professor of art history at the City College of the City University of New York. She is also on the art history faculty of the Graduate Center of the City University of New York. Her books on public art include *The Tilted Arc Controversy: Dangerous Precedent?* (2001) and *Contemporary Public Sculpture: Tradition, Transformation, and Controversy* (1998). She has published a variety of articles on memorials and public art projects and is a contributor to *Public Art Review* and *Sculpture* magazines. She previously served as associate director of the Princeton University Art Museum and gallery director at the State University of New York, Old Westbury.

Michael Stanislawski teaches modern Jewish history and Eastern European Jewish history as Nathan J. Miller Professor of Jewish History at Columbia University. He also serves as the director of the undergraduate program on human rights and the chair of the interdepartmental program of Yiddish studies. He has published numerous books on Jewish history and identity, including *Autobiographical Jews: Essays in Jewish Self-Fashioning* (2004), *Zionism and the Fin-de-Siècle: Cosmopolitanism and Nationalism from Nordau to Jabotinsky* (2001), *For Whom Do I Toil? Judah Leib Gordon and the Crisis of Russian Jewry* (1988), and *Psalms for the Tsar: A Minute-Book of a Psalms-Society in the Russian Army, 1864–1867* (1988).

THE JEWISH MUSEUM BOARD OF TRUSTEES

OFFICERS

Leni May, Chairman

Barry J. Alperin, President

Jeanette Lerman, Vice Chairman

Betty Levin, Vice Chairman

Benjamin Winter, Vice Chairman

Joshua Nash, Vice President

James A. Stern, Treasurer

Robert A. Pruzan, Assistant Treasurer

Lynn Tobias, Secretary

Phyllis Mack, Assistant Secretary

Ann H. Appelbaum, Assistant Secretary, ex-officio

Joan Rosenbaum, Helen Goldsmith Menschel Director, ex-officio

MEMBERS

Leslie E. Bains

Corrine Barsky

William H. Berkman

Jacques Brand

Jonathan H. F. Crystal

Charles de Gunzburg

Craig Effron

Susan Feinstein

Sheri Gellman

Nomi P. Ghez

Richard Hochhauser

Barbara S. Horowitz

Francine Klagsbrun

Hirschell Levine

Ira A. Lipman

Martin D. Payson

Barbara Perlmutter

John A. Ross

Amy Rubenstein

Bernard Spitzer

David J. Topper

Mindy Utay

John L. Vogelstein

Teri Volpert

Irving Weiser

Joseph Wilf

LIFE MEMBERS

E. Robert Goodkind*

Eugene Grant

Fanya Gottesfeld Heller

Robert J. Hurst*

Dr. Henry Kaufman

Ellen Liman

Susan Lytle Lipton*

Morris W. Offit*

Richard Scheuer*

H. Axel Schupf*

Romie Shapiro

Stuart Silver

James L. Weinberg*

Mildred Weissman

ADVISORS

Dr. Arnold M. Eisen

Rabbi Michael Greenbaum

Lilyan Seixas

*Chairman Emeritus